THE REVENGE
OF THE PHILISTINES

THE REVENGE
OF THE PHILISTINES

Art and Culture, 1972–1984

Hilton Kramer

THE FREE PRESS
A Division of Macmillan, Inc.
NEW YORK

The Free Press
A Division of Macmillan, Inc.
866 Third Avenue, New York, N.Y. 10022

Collier Macmillan Canada, Inc.

Printed in the United States of America

printing number

 2 3 5 6 7 8 9 10

Library of Congress Cataloging-in-Publication Data

Kramer, Hilton.
 The revenge of the Philistines.

 Includes index.
 1. Modernism (Art) I. Title.
N6465.M63K74 1985 709'.04 85–13132
ISBN 0–02–918470–3

For Esta, with love

Contents

Preface

The essays and reviews collected in this volume, all of them written in the years 1972–1984, are drawn from one of the most remarkable periods in the history of modern art—the period in which modernism itself, though triumphant in the museums, the academy, and the marketplace, and otherwise firmly established in the mainstream of cultural life, came increasingly to be thought of as having run its course as a vital artistic imperative. These pieces are drawn, in other words, from the period which a great many observers of the contemporary art scene have now come to regard as the beginning of the ''postmodern'' era.

To apply the term *postmodern* to this period involves us, to be sure, in a certain paradox. For modernism has everywhere achieved an unprecedented measure of acceptance and popularity. In the visual arts, as in a great many other areas of contemporary cultural life, it continues to serve as one of the dominant modes of sensibility. It remains a touchstone of quality. It accounts for much that is new in art, even in the 1980s; and it accounts for even more of what we esteem in the art of the recent past. New reputations are made every day by artists whose work derives, in one degree or another, from a distinctly modernist outlook; and ambitious, large-scale exhibitions devoted to the classics of modernist art have for some time now been routinely hailed by both critics and the public as welcome and edifying events—but as events, it is important to note, which enlarge our sense of tradition rather than shock us with revelations of the unknown.

At the same time, however, this widespread acceptance of modernism, which amounts to its institutionalization, has itself prompted a revolt against some of modernism's most cherished standards and beliefs. No sooner had modernism completed its difficult and much-contested passage into the mainstream of cultural life than it found itself under fire again. Only this time the attack upon it did not come from its traditional enemies among the philistines, who by now had either been won over to its cause or effectively silenced by modernism's overwhelming success. It came from certain of its erstwhile friends and allies—knowledgeable insiders who professed to find in this phenomenon of success a sure sign that the creative energies of modernism were exhausted or misdirected or somehow corrupted. The reasons for the revolt varied—at one extreme they were purely aesthetic and at the other, purely political—but the verdict tended to be the same: Whether modernism was judged to have failed in its essential mission (by selling out, for example, to its historical antagonist, the middle class) or—more benignly—to have completed its creative tasks, it was found all the same to be in urgent need of amendment or transformation.

It is in the effort lavished by both artists and critics on this project of amendment and/or transformation that the special character of the postmodernist outlook is to be found. What makes this outlook so paradoxical is the fact that it does not so much reject modernism (even when it purports to do so) as attempt to absorb and supplant it. The modernist achievement is at once taken for granted, and taken to be inadequate, incomplete, or otherwise ripe for modification and revision. The very notion of what is "advanced" in art—which is a modernist idea—is shifted from a modernist to a postmodernist perspective. And while this shift is not necessarily intended to serve the interests of the philistine mind in revenging itself on what are perceived to be the usurpations of modernism, the change of attitude that results from this postmodernist initiative has nonetheless brought a certain measure of comfort and satisfaction to those who have long harbored deep feelings of suspicion and aversion for everything associated with the modernist aesthetic. In the strange new world of postmodernist culture, political radicals and aesthetic reactionaries often find themselves allied against a common enemy: that mainstream modernism which has now become so deeply integrated into the cultural life of the middle class.

It is for this reason, above all, that we are so often made to feel that we are living, at the moment, through a period of momentous and contradictory changes in the life of art. Modernism remains a vital force in

the life of art today—in my view, its *most* vital force—both as a high ideal and as the basis of our established culture, yet it now faces a challenge unlike any it has met with in this century. The imperatives of a vigorous postmodernist movement are everywhere evident and nowhere entirely distinguishable from a grievous and sometimes nihilistic academicism serving a variety of aesthetic and political interests. The outcome to be expected from this state of affairs is neither foregone nor entirely foreseeable. It will be determined, first of all, by the works of art which artists create in response to this historic situation. But it will also be shaped to some degree by the discussion and debate that attends to their creation and reception. It is as a critical contribution to this discussion that the essays and reviews in this volume have been written.

A word about the organization of this book:

It is by no means intended to be a complete record of my writings on art in the period under review. For much of this period I served as the chief art critic of *The New York Times*, and in that capacity I often wrote two, three, or more articles a week on the current exhibition scene. The sum total of these articles and reviews would constitute too large a body of writing for a single volume even in the unlikely event that it was all worth preserving or that a publisher could be persuaded to bring it out. In any case, many of the events reviewed in those articles are now mercifully forgotten, and I am happy to leave them in the obscurity they have so quickly earned for themselves.

What I have brought together here are those articles—from the *Times*, from *The New Criterion*, where the bulk of my critical writing has appeared since its founding in 1982, and from other publications—that address themselves in one way or another to the issues that it is the purpose of this book to explore. The revivals and the revisionist history that have followed in the wake of the postmodernist eruption; the central position still accorded to the classic figures of modernist art; the range of aesthethic expression that characterizes contemporary art in the era of stylistic pluralism; the place now occupied by photography in the world of art exhibitions and art criticism; the critical debates that have resulted from this changing scene; the artists who have lately emerged as its representative talents, and the institutions and impulses that have lately made a definitive response to it—these constitute the principal lines of inquiry that I have set out to examine in this book.

Except for minor deletions and corrections, none of the articles in this volume has been altered or revised. They appear here as they were written, and in this respect, as in others, may be read as an unrevised critical chronicle of an extraordinary period.

H.K.

FEBRUARY 1985
Westport, Connecticut

Acknowledgments

Grateful acknowledgment is made to the editors of the following publications, in which the articles and reviews collected in this volume first appeared: *The New York Times, The New Criterion, The American Scholar, Commentary, The New Republic*, and *Portfolio*. Two of the essays have already appeared in book form: "Encountering Nevelson" served as the introduction to Jean Lipman's *Nevelson's World* (Hudson Hills Press, 1983), and "Julian Schnabel" was published in Volume 3 of *Art of Our Time* (Rizzoli Publications, 1984), the catalogue of the Doris and Charles Saatchi Collection.

Special thanks to my colleagues at *The New Criterion*—Samuel Lipman, Erich Eichman, Eva Szent-Miklosy, Robert Richman, and Colleen Babington—for their unfailing support and wise counsel, and to my editors at The Free Press—Edward Rothstein and Erwin Glikes—for their sensitive and unstinting work on my behalf. Also to Nancy Spector for assistance in bibliographical research.

My deepest debt of gratitude is acknowledged in the dedication of this book.

Postmodern: Art and Culture in the 1980s

We live now amidst the ruins of a civilization, but most of these ruins are in our minds.

—John Lukacs
The Passing of the Modern Age

We do not nowadays refute our predecessors, we pleasantly bid them good-bye.

—George Santayana
Character and Opinion in the United States

Nothing has been more remarkable in the cultural life of the past decade than the speed with which the imperatives of the modern movement have been stripped of their authority. Twenty years ago it was rank heresy to suggest that modernism might already have entered upon its decline. The assumption was that the modernist spirit was not to be construed as a period phenomenon but as a permanent and irreversible condition of cultural life. Ten years ago it was still controversial, though no longer unthinkable, to claim that a decisive break had already occurred. Defections from modernist orthodoxy were too widespread to be discounted, yet there was a distinct reluctance to explore—or even, indeed, to acknowledge—their implications. Today, however, it is suddenly chic to speak of a "postmodernist" art, and scandal no longer attaches to the idea that modernism has run its

1

course. Even the stoutest defenders of the old absolutes concede that *something* has happened.

It was to be expected, of course, that modernism would be significantly modified once its tenets came to dominate the culture it had long sought to topple and displace. Modernism was born, after all, in a spirit of criticism and revolt. It was predicated on the existence of an official culture—at once bourgeois in its origin, unenlightened in its intellectual outlook, and philistine in its taste—that would remain adamant in its resistance to fundamental change. (Never mind that this view of bourgeois culture was something of a fiction, omitting as it did all reference to the complexity and dynamism of its achievements. It was a fiction that served to strengthen the conviction of the avant-garde that bourgeois culture had forfeited its right to exist.) What in fact happened, however, did not conform to the myth of bourgeois resistance to change. In due course, bourgeois culture adroitly accommodated itself to virtually every aesthetic challenge mounted by its avant-garde adversaries. What was condemned in one generation was embraced in the next. The periodic transformation of the "accursed" into the accepted and then, more often than not, into the official and beloved soon became fixed as the pattern by which bourgeois culture sustained itself. Thus, through a series of enlightened adjustments and measured increments, the *révolté* impulses of the avant-garde were absorbed into the cultural mainstream.

Once established, this pattern of challenge and assimilation was bound to alter the outlook of both parties. Each came to have a stake in the power and vitality of the other. Like partners in a stormy but enduring marriage, the avant-garde and the bourgeoisie came more and more to depend on each other and even to resemble each other. The avant-garde developed a keen sense of how far it could go—or, as Jean Cocteau shrewdly put it, of how far it could go in going too far— without causing some irreversible rupture. Bourgeois culture, for its part, acquired a finely developed sense of what could be absorbed and what deferred. For this process of selection and adjudication, it created special institutions—museums and exhibition societies, schools, publications, foundations, etc.—which functioned, in effect, as agencies of a licensed opposition. This was something new in the history of Western culture—bourgeois liberalism's most distinctive political contribution to the life of culture.

The consequences of this institutionalization of the avant-garde proved to be more profound than either party could have foreseen. For

the dissident avant-garde it secured a fixed position in the cultural system. For the system itself it provided a steady source of new energy and ideas—a dynamism analogous to that of the economic and political life of bourgeois society. Much—if not quite everything—that we continue to esteem in the creative achievements of the last two centuries owes its existence to this curious compact between the bourgeoisie and its licensed opposition. But the dynamism of the avant-garde, with its unremitting appetite for innovation and its steady erosion of established values—including the values established by its own efforts—came in time to exert a powerful control over the very culture it still ostensibly "opposed." So completely did bourgeois society cede its cultural initiatives to this licensed opposition that the terms of their compact came to be fatefully altered. It was now the avant-garde that dominated cultural life—thus, in effect, ceasing to function as an authentic avant-garde—and the surviving remnants of bourgeois "reaction" that went through the motions of a principled resistance.

This, essentially, is the course that has brought us into the "postmodern" era. The culture of modernism has triumphed in the schools, in the marketplace, in the media, and in virtually every other citadel of opinion and influence. Yet this triumph has proved to be remarkably hollow—a victory that is, in some respects, indistinguishable from defeat. For something very odd happened to the culture of modernism while it was achieving its unexpected ascendancy over our institutions and our tastes. It was, so to speak, subverted from within. It developed an unmistakable affinity—even a certain envy and nostalgia—for the bourgeois culture it had worked so hard to discredit. It acquired a yearning for what had been destroyed. To satisfy this yearning, it launched itself on a program of excavating the ruins of the very civilization it had buried. And in true romantic fashion, the discoveries it made among the ruins of that civilization were promptly upheld as models of excellence and guides to creation.

The revival of nineteenth-century Salon painting and Beaux Arts architecture, the sweeping revaluation of German Romantic painting and of the American artists of the Hudson River School, the elevation of Victorian and Pre-Raphaelite art, and the boom in Art Nouveau design and even in Art Deco ornament—these are but the most spectacular symptoms of a craving that is central to the whole aesthetic outlook of postmodernist art. About these revivals of bourgeois art and design, which now enjoy such impressive critical favor, it is sometimes said that they signify little more than the gyrations of the art market and the

special tastes of a generation of art historians too young to have partici-
pated in the classic battles of modernism. There may be some truth in
this, but as an explanation it does not take us very far. Neither the art
market nor the world of scholarship on which it depends functions in a
void. They too are subject to the pressures that shape the life of culture.
A reversal of this magnitude requires a larger perspective. For what,
after all, is being sought out in these revivals of bourgeois styles? What,
indeed, does it mean to revive a discredited style?

We may take it as axiomatic in our culture that every revival of a
style involves something more than style. All revivals are governed by
the sense of loss that overtakes our culture when it comes to feel that its
ambitions are faltering and its momentum declining. What determines
the course of a revival is not so much the study of the past, which only
accelerates in a particular direction when the need for it is keenly felt,
as the present condition of culture itself. A revival of bourgeois art
would have been unthinkable, for example, in the heyday of the Ab-
stract Expressionist movement. It had to wait for the breakdown and
demystification of the modernist ethos that came in the 1960s. This
brought with it not only certain changes in contemporary style—the
most important of which was the emergence of Pop art—but a decisive
shift away from the attitude of high seriousness that had long been a
fundamental component of the modernist outlook. It was only then, in
the more "swinging" and accommodating atmosphere created by this
shift in attitude, that the revival of bourgeois styles would be permitted
to flourish without impediments or constraints.

In this altered atmosphere, the traditions governing nineteenth-
century bourgeois art and architecture were seen to embody a great
many envied qualities and capacities. They were taken, indeed, to rep-
resent a better world than ours—specifically, the world as it was seen to
exist before it had been systematically stripped of its pretensions and
extravagances (and thus of its fun!) by the dour moral injunctions of
modernism. What was now admired in these rediscovered styles of the
last century had nothing whatever to do with a strict aesthetic probity,
the traditional hallmark of the modernist outlook. On the contrary, it
was their freedom from modernist constraints—from modernist
"conscience"—that commended these styles to their new admirers.
The productions of bourgeois art were now admired for their ampli-
tude and flamboyance, for their easy access to grand gestures and a
showy sociability, even for their mediocrity and frivolity. What ap-
pealed also was their high technical proficiency combined with an un-
embarrassed espousal of sentiment, anecdote, and declamatory rheto-

ric. In the period that saw Andy Warhol emerge as the very model of the new artist-celebrity, moreover, sheer corniness was not longer looked upon as a failure of sensibility, nor was superficiality—or even vulgarity—regarded as a fault. Bad taste might even be taken as a sign of energy and vitality, and "stupid art"—as its champions cheerfully characterized some of the newer styles that began to flourish in the late seventies and early eighties—could be cherished for its happy repudiation of cerebration, profundity, and critical stringency. Try to imagine Arshile Gorky or Mark Rothko or Robert Motherwell countenancing such a turnabout in attitudes and you have a vivid sense of the differences separating the last stages of modernist orthodoxy from the very different moral climate of postmodernist art.

What is essential to understand about this "reactionary" phenomenon is that it is itself a creation of modernist culture—albeit, of modernism at the end of its tether. It is not the work of aesthetic conservatives. Salon painting and Beaux Arts architecture had always retained their popularity among the so-called philistines even when the tide of modernist influence was running high. But this philistine element, despite its commanding numbers, was incapable of exerting any real pressure on the course of the culture from which it felt itself spiritually estranged. Its outlook was backward, in any case, and its energies numbed. Even its negativism was more a matter of sentiment than of ideas. It could withhold support—and did—but when it came to artistic initiatives of its own it had nothing to offer.[1] The revival of bourgeois art was thus left for the modernists themselves to carry out, and this naturally determined its outcome. It guaranteed that the revival would convert bourgeois art into terms compatible with modernist taste.

Exactly how this conversion was accomplished tells us much about the inner dynamics of modernist sensibility, especially its tendency to empty art of its "content" and establish style as its true subject matter. (That we feel obliged to place the word *content* in quotation marks is itself a reflection of this tendency.) For the purposes of this conversion, no instrument has proved to be more powerful or more pervasive than the attitude of irony we call Camp, which has the effect of neutralizing the substance and aggrandizing the style of whatever it embraces. Irony ridicules, of course, and ridicule normally wounds and discred-

[1]Thus the attempt of Huntington Hartford to revive the Pre-Raphaelites when he founded the Gallery of Modern Art in the early 1960s came to nothing. What Hartford's efforts demonstrated was that it was not the art itself but the attitude one adopted toward it that was the critical factor in negotiating a revival.

its. But the ridicule of Camp is a mock ridicule that contains a large element of praise, accommodation, and affection. Irony of this special sort places us in a relation of comic intimacy with the objects of its attention. It encloses them in an atmosphere of flirtation and familiarity. The antagonism normally associated with the ironic attitude is merely feigned. By focusing on what is truly outrageous in these objects, and then lavishing a fulsome solicitude upon precisely that aspect of them, Camp makes a joke of the offending attributes while at the same time suggesting that there is something endearing—even, perhaps, something necessary and redeeming—in their very absurdity.[2]

Camp, in short, confers legitimacy on what it pretends to ridicule. But the kind of legitimacy it confers is distinctly double-edged. For what it offers to the cognoscenti—a "forbidden" pleasure in objects that are corny, exaggerated, "stupid," or otherwise acknowledged to have failed by the respectable standards of the day—is not at all the same as what it bequeaths to the "straight" public that believes itself to be abiding by those very standards. The Camp attitude thus works to preserve modernism's distinction between the avant-garde and the philistines—between "us" and "them"—even while engaged in the task of reviving the philistine art that the avant-garde had formerly consigned to oblivion. The same act of rehabilitation that allows "us" to enjoy the inanities of Salon painting as absurd comedy also supplies "them" with new masterpieces to admire without irony. In that division of taste lies the essence of the revival of nineteenth-century bourgeois art.

The gratifications of Camp are all the sweeter, of course, because of this success in persuading an eager public to accept its jokes as the real thing. This is something the public readily consents to do, usually with gratitude and a sigh of relief, a feeling that it has at last had restored to it the kind of art it can really understand and respond to. To the delight and astonishment of the public, it also seems the modish thing to do. From the Camp point of view, however, "they" still understand nothing, since "they" don't get the joke. The esoteric pleasures to be derived from the art remain a sort of cult possession. (Thus, though the avant-garde may have ceased to exist *as* an avant-garde, its spirit lives on in this power to "nominate" the objects of esoteric delectation.) And it is not only the "lay" public that can be counted on to respond

[2]We are thus reminded that the origin of Camp is to be found in the subculture of homosexuality. Camp humor derives, in its essence, from the homosexual's recognition that his condition represents a kind of joke on nature, a denial of its imperatives, and thus a mode of psychological artifice.

to the stratagems of Camp sensibility. Even more essential to their success is the alacrity with which the professional art world falls into line. The whole apparatus of curators, dealers, critics, art historians, and collectors, having been rigorously schooled by the lessons of modernism to be on the alert for a new trend to exploit, promptly goes into action, organizing exhibitions, making "discoveries," creating new reputations and new markets, etc., while remaining oblivious to the comic implications of its new role in the postmodern scenario and indifferent to the corruption of standards that results from its efforts.

The implications of this phenomenon are by no means simply comical, however. Much is at stake in the outcome. And what is primarily at stake is the concept of seriousness. Against the concept of seriousness, Camp invokes an alternative standard—the facetious, which has proved to have a far more insidious power to shape the course of culture than anyone has yet acknowledged. (Not the least of its power lies in the fact that it is not taken seriously enough to examine.) The facetious does not repudiate high culture in favor of its middlebrow or lowbrow substitutes, but on the contrary remains devoted to it, as the parasite remains devoted to its host, and prospers by cheerfully degrading its characteristic modes of discourse. These, as Marcel Duchamp was the first to demonstrate, are in fact essential to the facetious outlook, but toward them—and the concept of seriousness they embody—it adopts an attitude of blithe impiety and insouciance. (Andy Warhol remains the outstanding example in the visual arts, John Cage in music, John Ashbery in poetry, and Donald Barthelme in prose fiction. The later work of Philip Johnson is the most celebrated example in architecture.) The strategy of the facetious in relation to the serious is not a strategy of direct attack but a strategy of inversion.

It is worth recalling, in this context, that in her famous "Notes on 'Camp'" Susan Sontag described Camp as "the sensibility of failed seriousness." Now this embrace of "failed seriousness" was not to be construed as a failure of mind. It was deemed to be an accomplishment of mind—a mode of aesthetic transcendence. It was welcomed as one of the essential preconditions for achieving what Miss Sontag, in another of her definitions of Camp, spoke of as "the consistently esthetic experience of the world." In contrast to the sensibility of high culture, which she found to be "basically moralistic," Miss Sontag upheld Camp sensibility as "wholly esthetic." Camp was indeed acclaimed as "a solvent of morality."

"Notes on 'Camp,'" the pronouncement that marked the successful entry of Camp into the realm of established culture, was first pub-

lished in *Partisan Review* in 1964 at the very moment when Pop art was taking the art world—and the media—by storm. (It was this pronouncement that made Miss Sontag herself a media figure.) This important essay can now be seen to have performed for critical discourse a service very much akin to that which Pop art performed for the fine arts. It severed the link between high culture and high seriousness that had been a fundamental tenet of the modernist ethos. It released high culture from its obligation to be entirely serious, to insist on difficult standards, to sustain an attitude of unassailable rectitude. It relaxed the tension that had always existed between the fierce moral imperatives of modernism—its critical conscience—and its appetite for novel aesthetic gratifications.[3] "The whole point of Camp," Miss Sontag wrote, "is to dethrone the serious," thereby defining the special temper of postmodernist culture.

It was thus in the 1960s that there was launched on a significant public scale the whole complex of attitudes that signaled the decline of the modernist outlook and its absorption into the looser, less stringent, and more avowedly hedonistic and opportunistic standards of postmodernist culture. Art historians, bemused by a development that effectively dissolves the standards on which their whole intellectual enterprise is founded—for Camp also severs the link between connoisseurship and the concept of quality—have not shown much of an inclination to explore this fateful turn in our artistic affairs. Interestingly, it is the architectural historians who have faced up to the matter with more candor, and it is in the architectural literature that some of these salient meanings of postmodernist culture can be most clearly glimpsed.

In Charles Jencks's *Modern Movements in Architecture* (1973), for example, there is an admirably plain-spoken account of the pivotal role of Camp in the new architecture of the sixties. With appropriate acknowledgments to Miss Sontag, Mr. Jencks observes that "the Camp attitude is essentially a mental set towards all sorts of objects which *fail from a serious* point of view." He goes on:

> Instead of condemning these failures, [the Camp attitude] partially contemplates them and partially enjoys them . . . it tries to outflank all the

[3]"Ordinarily we value a work of art because of the seriousness and dignity of what it achieves," Miss Sontag wrote. "But," she added, "there are other creative sensibilities besides the seriousness (both tragic and comic) of high culture. . . . And one cheats oneself, as a human being, if one has *respect* only for the style of high culture, whatever else one may do or feel on the sly."

other stereotyped views of failure which are morbid or moralistic and substitute a sort of cheerful openmindedness. It starts from failure and then asks what is left to enjoy, to salvage. It is realistic, because it accepts monotony, cliché and the habitual gestures of a mass-production society as the norm without trying to change them. It accepts stock response and ersatz without protest, not only because it enjoys both, finding them "real," but because it seeks to find those usually disregarded moments of interest (the fantastic hidden in the banal). Thus the epitome "it's so bad that it's good," which accepts the classifications of traditional culture but reverses the verdict.[4]

Mr. Jencks is an exceptionally intelligent critic, and while he is not unsympathetic to certain aspects of Camp architecture, he has a very clear view of its character, and remains undeceived about its quality. He understands very well that Camp represents a collapse of standards, and he knows, too, what this collapse brings in its wake. "The Camp artist . . ." writes Mr. Jencks, "sends up his critics with the riposte 'there are no rules, anything goes,' cheerfully shuffles form regardless of content (with an eye on the audience) and does not try to produce integrated, serious works. He is content to remain in farce, in sin, in short, in Camp."

In Mr. Jencks's account, the cynicism of the Camp attitude is patent, and so is the narcissism that it engenders. The Camp architect, he writes, "knows (in his candid moments) that his works are not the profound jewels he sells them as. This is the point that must be stressed to avoid confusion: candor. The Camp architect admits at once that whoever he is, it is much more important than whatever he does." Under the Camp dispensation, the only effective standard is notoriety, not quality; and criticism surrenders to the exigencies of publicity. "One must cultivate naïvety and forgetfulness," Mr. Jencks writes, "because the memory of fashion cycles has to be short-lived if the process is to go on. In fact comparison with the past and a critical temper upset the process at once." No wonder, then, that Susan Sontag called her first volume of essays—the book that included "Notes on 'Camp'"

[4]Isn't this, by the way, a fairly accurate description of the attitude that took possession of a good deal of "serious" movie criticism in the sixties? The practice of lavishing extravagant praise on failed and even trashy movies from the Camp point of view had probably existed from the time that movies were first produced. But in the sixties it came to be codified as a respectable critical method, and now virtually dominates the movie reviews in our major newspapers and magazines. This, too, must be counted as an aspect of postmodernist culture.

and in general celebrated the so-called new sensibility—*Against Interpretation*.

The "underlying genesis of Camp in architecture," Mr. Jencks points out, lies in "the movement of formalism"—which is to say, in an architectural aestheticism that has divorced itself from its functionalist origins and become pure style. And he unflinchingly traces the course that has led from formalism to Camp—which, in one of its aspects, is formalism become ironical about itself—to the sheerest nihilism. As a kind of centerpiece in this discussion of Camp in contemporary architecture Mr. Jencks gives us a lengthy quotation from a dialogue between Susan Sontag and Philip Johnson, recorded by the BBC in 1965, on the subject of artistic morality. It is in the utterances of Philip Johnson, who began his career as the quintessential formalist and then emerged in the uproar of the sixties as the undisputed leader of the Camp style, that we hear the chilling voice which sums up the spiritual bankruptcy of the postmodern era: "What good does it do you to believe in good things? . . . It's feudal and futile. I think it much better to be nihilistic and forget all that. I mean, I know I'm attacked by my moral friends, er, but really don't they shake themselves up over nothing?"

"There thus develops underneath [Camp's] grinning optimism," Mr. Jencks writes, "a strong pessimism: nothing can be changed, we are all determined by the process, it will end in disaster. Camp is eternally hopeful and yet eternally apocalyptic." The cult of the facetious, it appears, leads us straight back to the spiritually impoverished culture of the waste land. Which, it will be remembered, it was one of the foremost functions of the modernist vision to subject to the most stringent moral analysis.

Well, the philistines have certainly had their revenge—even if they have had to leave it to their enemies to secure it for them. Our cities now boast expensive new buildings that remind them—almost—of the good old days. In our museums everything from Salon painting to the inanities of kitsch has been dusted off, freshly labeled, and solemnly placed on exhibition, almost as if the modern movement had never altered our view of them. Scholars can always be found to study these objects, and critics to praise them almost as if they believed them to be worthy of their attention. Almost, but not quite. For history, though it can be revised, can never be repealed, and it is an illusion—one of many illusions induced by the Camp phenomenon—to believe other-

wise. We have only to confront the real thing—say, the great Picasso retrospective of 1980 or the Cézanne exhibition of 1977, to name but two of the outstanding events of the last decade—to be reminded of the crucial differences that separate the essentially factitious claims of the postmodern era from the central achievements of modernism itself.

Only now, perhaps, are we in a position to appreciate the extent to which so many postmodern developments in art are actually antimodernist in spirit, a betrayal of the high purposes and moral grandeur of modernism in its heyday. Philip Johnson's new buildings have removed any last doubts that might have been entertained on this score, and Andy Warhol is now the classic example of the artist who is more important for "what he is" than for "whatever he does." To say that such figures and their many artist-confreres represent a decisive break with the tradition that comes out of Cézanne, Picasso, Matisse, Mondrian, et al. is only to state the obvious.

Yet modernism, though now stripped of the nearly absolute authority it formerly wielded in artistic matters, is anything but dead. It survives as a vital tradition—the only really vital tradition that the art of our time can claim as its own. The revenge of the philistines is by no means complete. Inevitably, our relation to this modernist tradition is not what it once was. We are far more aware than earlier generations needed to be of its many divisions and contradictions and countervailing currents, and more knowledgeable, too, of what is central and what is merely peripheral and even destructive to its creative life. The modern movement was always, perhaps, a more complex and pluralistic phenomenon than its more doctrinaire champions—and, for that matter, its more doctrinaire enemies—could ever bring themselves to recognize. It required a certain historical distance to see it whole—to see what it was and what it was not. In this respect, at least, postmodernist art has certainly performed a service of sorts, albeit at a great cost in spirit. In a purely negative way, it has placed the modernist heritage in dramatic historical relief, and thus helped to redefine its importance to us. It is, in any case, only in relation to the paradoxes of this situation that the art history of the last decade can be readily understood. Which is also to say that it is only in the differences that separate the imperatives of modernism from those of postmodernist art that the present prospects for art can be clearly discerned.

SEPTEMBER 1982

I. Revivals and Revisionism

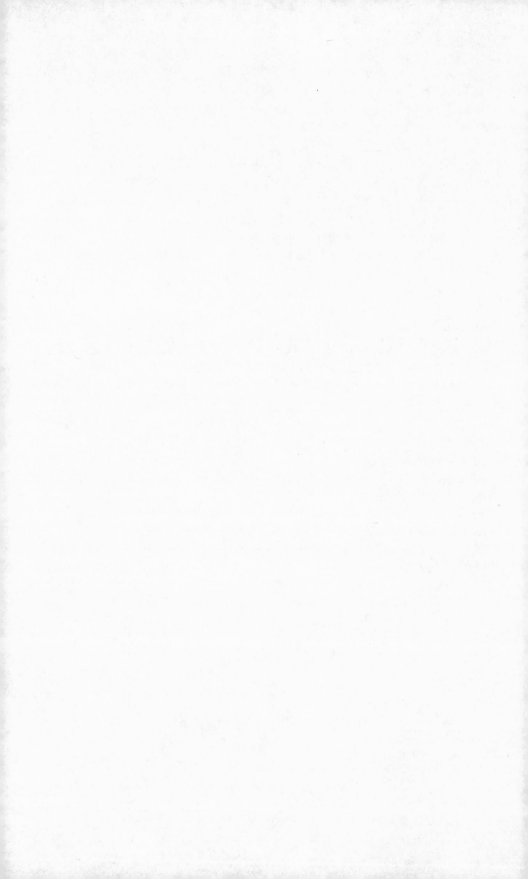

1. The André Meyer Galleries at the Met

The inauguration of the André Meyer Galleries at the Metropolitan Museum of Art is, by any standard of reckoning, a major event in the art life of New York, and thus in the art life of the nation. Here, at last, our greatest collection of nineteenth-century European art has been mounted with the requisite amenity and splendor and on a scale appropriate to its preeminent place in the history of our culture. Although much has occurred in the art of the twentieth century—especially in its more obstreperous, revolutionary movements—to challenge the authority of these nineteenth-century masters, their art remains the very fulcrum of our own, a primary source of pleasure, inspiration, and instruction at every level of our cultural life.

Even the rebel movements of the present century, moreover, owe much to the initiatives of this nineteenth-century art. To have it restored to us in something close to its full glory is, therefore, a development of considerable importance. For it reestablishes a crucial link with the part of the past that has most directly shaped and guided us, and that remains a standard of excellence down to the present day.

It is somewhat misleading, however, to speak of nineteenth-century "European" art in this context. Except for Goya, whose death in 1828 marked the end of a golden age in Spanish painting, and Constable and Turner in England, what is meant—for the most part—is French art

and, most particularly, French painting. This is the art that has long enjoyed the loyalty and admiration of the most vital artistic elements in our own culture, and it is altogether right that it should be accorded so central a place in this nineteenth-century collection.

It is in the line that is traced from Goya and David and Ingres to Delacroix and Courbet and Manet and the Impressionists, and thence to Cézanne and Seurat and their fellow Postimpressionists, that we still find the greatest art of this prodigious period. If this is the conventional view of the matter—and it is—then it must be said that the conventional view is, in this case, the correct view.

Thus, although we may have reason to regret the absence of certain German painters of the nineteenth-century—Wilhelm Leibl (1844–1900), sometimes said to be the Courbet of German painting, is the one I would most like to have seen included here—even the greatest of them is unlikely to mean as much to us as the great French painters whose work *is* included. The course of history—and I mean aesthetic history—has resulted in a creative attachment to the latter for which there is no parallel in the art of nineteenth-century Central Europe (despite the appeal that German art once exerted on American taste). This is not the kind of attachment that can be willed into existence by art historians after the fact. It either is—or is not—part of the fabric of our cultural life.

Then, too, when we look at some of the marginal talent that has been mustered here from Hungarian, Russian, Italian, and later Spanish painting—much of it mercifully confined to the fringes of the collection—it is clearly a blessing that the Met's resources have placed severe limits on its ability to forage in such unpromising terrain. Certain schools of art, like certain vintages of wine, are simply not meant to travel. They must be savored on native ground or not at all.

A far more serious problem arises in precisely the area where the Meyer Galleries' installation is strongest—in the Met's capacious collection of French painting itself. This collection is not only very large, it is also very mixed; and it includes a sizable quantity of work that may claim an historical interest but that is of dubious—and in some cases, not even dubious—artistic quality. I mean, of course, the work of the official Salon painters that was so popular in its day and so beloved by the American collectors who were among the original patrons of the museum. Let it be remembered that long before the Met ac-

quired its marvelous collection of Impressionists, it had come into possession of a considerable tonnage of this Salon art.

As every student of the period knows, nineteenth-century French painting from Courbet onward was a ferocious battleground on which the greatest talent of the age often found itself locked in combat with the benighted taste of the Academy and the Salon. The outcome of this historic conflict is also well known. It was the painters of the avant-garde—as we now think of them—who triumphed artistically while the favorites of the Salon, despite the enormous privileges and patronage they enjoyed, sank deeper and deeper into silliness, sentimentality, and aesthetic impotence.

Had the Met's nineteenth-century galleries been inaugurated a generation earlier, there can be little question but that the bulk of these academic effusions would have been allowed to rest undisturbed in the museum's storerooms, where they had for so long—and so justly—been gathering dust. It is the destiny of corpses, after all, to remain buried; and Salon painting was found to be very dead indeed.

But nowadays there is no art so dead that an art historian cannot be found to detect some simulacrum of life in its moldering remains. In the last decade, there has, in fact, arisen in the scholarly world a powerful subprofession that specializes in these lugubrious disinterments, and its exertions on behalf of the dead bones of the Salon have now acquired a certain intellectual chic even among connoisseurs who surely know the difference between a work of art that still lives for us and one that does not. As a result, this revisionist view of nineteenth-century painting has begun to influence the actions—if not always the actual taste or judgment—of the curators who are in a position to decide on exactly what it is appropriate to hang in their museums. Suddenly all sorts of allowances are being made for bad paintings on various extra-aesthetic grounds.

The new installation of nineteenth-century French painting at the Met does not really question the standard, or prerevisionist, modern view of the period. It gives priority of place and number to the greatest painters. Yet it also temporizes, and hedges its bet, so to speak, by cramming quantities of Salon painting into the so-called subsidiary galleries that are adjacent to those featuring the work of the acknowledged masters. In other words, the dead are admitted into the company of the living. Thus, in addition to the nineteen paintings by Corot, twenty-one by Courbet, twenty-one by Manet, twenty-eight by

Monet, nineteen by Cézanne, fifteen by Renoir, and the three glorious galleries teeming with the works of Degas in various media, there are now also to be seen in the Meyer Galleries the paintings of Meissonier, Regnault, Bouguereau, Gérôme, Bonnat, Cabanel, Winterhalter, and other votaries of academic taste.

What, it may be asked, is wrong with such an open-minded, up-to-date attitude toward the past? The answer, I'm afraid, is that it corrupts the museum function. It blurs the distinction that should obtain between documentation and discrimination. We look to art museums for a sense of quality—for a standard of excellence—and in a great museum we naturally expect this standard to be upheld without compromise. It alters the very purpose of the art museum when the inanities of kitsch—for that is what the bulk of this Salon painting actually amounts to—are admitted into the precincts of high achievement. For what it suggests, despite all pronouncements to the contrary, is that the difference between high achievement and its opposite is exaggerated and not really that important. The labels on the pictures may say one thing, but the presence of so many really bad paintings in a major museum display says something else, and says it loudly.

How, then, are we to account for this curious turnabout that places a meretricious little picture like Gérôme's *Pygmalion and Galatea* under the same roof with masterpieces on the order of Goya's *Pepito* and Manet's *Woman with a Parrot*? What kind of taste is it—or what standard of values—that can so easily accommodate such glaring opposites?

The answer, I think, is to be found in that much-discussed phenomenon—the death of modernism. So long as the modernist movement was understood to be thriving, there could be no question about a revival of painters like Gérôme or Bouguereau. Modernism exerted a moral as well as an aesthetic authority that precluded such a development. But the demise of modernism has left us with few, if any, defenses against such incursions of debased taste. Under the new postmodernist dispensation, anything goes—and who is to say that Gérôme is not actually to be preferred to Manet or Cézanne? After all, there were many people in the nineteenth century—and for that matter, well into the twentieth—who were absolutely certain that he was.

It is as an expression of this postmodernist ethos—and a very conspicuous one, too—that the new installation of nineteenth-century art at the Met needs, I think, to be understood. What we are

given in the beautiful André Meyer Galleries is the first comprehensive account of the nineteenth century from a postmodernist point of view in one of our major museums. You may be certain that it will not be the last.

<div align="right">APRIL 13, 1980</div>

2. A Turner for the Eighties

There are exhibitions that give us pleasure, and there are exhibitions that offer us instruction, but there are few exhibitions that combine these functions with quite the same degree of success as that achieved by the show called "Turner and the Sublime," which has now come to the Yale Center for British Art in New Haven.

Its principal focus is on rarely seen watercolors by the greatest of the British landscape painters, J. M. W. Turner (1775–1851). Of the 123 watercolors, prints, and drawings contained in the exhibition, some sixty items are drawn from the vast Turner Bequest housed in the British Museum in London. Among them are some of the most remarkable watercolors ever committed to paper. This in itself makes it a show of unusual interest.

But if "Turner and the Sublime" is pleasurable, first of all, for the artistic rarities it brings us, it has another importance as well. For it places Turner firmly and unequivocally in the cultural context of his time, and by doing so, it significantly alters our understanding of his art by recalling us to the ideas that governed it.

Thus, the Turner that we see in this exhibition—and that we read about in the superb catalogue accompanying the show—differs in some important respects from the "modern" Turner we have been taught to admire in recent years. This is a Turner nurtured on eighteenth-century ideas of "the sublime," and therefore deeply attached to a cer-

tain idea of nature. It is not the Turner who was conceived to be a kind of precursor of contemporary color painting.

Fifteen years ago, when the Museum of Modern Art mounted its great Turner exhibition, the emphasis was inevitably placed on the radical innovations in color and form to be found in his work. Abstract color painting was in its heyday in the 1960s, and Turner was enlisted as a kind of father figure—or great-grandfather figure, perhaps—of the movement.

The representational element in Turner's landscapes and seascapes was never denied, of course, but it tended somehow to be discounted. "Eventually," wrote Lawrence Gowing at the time, "no single touch of paint corresponded to any specific object." What mattered, above all, were those amazing configurations of color and light that were no longer seen to be intimately bound to their earthly subjects but, on the contrary, to have an independent—which is to say, an abstract— existence of their own.

Andrew Wilton, who organized the present exhibition and wrote the catalogue, takes a very different view of Turner's essential quality. (Significantly, Mr. Gowing's catalogue for the 1966 exhibition at the Modern isn't even listed in the bibliography of this catalogue.) Far from being a prophet of abstraction, Mr. Wilton's Turner is a more literary painter—an artist whose work remained deeply entrenched in "the traditional view of the alliance between painting and poetry," which had formed the basis of his art from the outset. According to this perspective, nature—and the ideas that shaped Turner's perception of it—are once again central to everything the artist achieved. Included in this judgment is the late work, which has been especially favored by partisans of abstract color painting.

Foremost among these ideas was the concept of the sublime. This is not a concept easily accommodated by the modern mind, which tends to be deeply skeptical of the kind of meanings that notions of the sublime attributed to certain realms of experience. For the concept of the sublime, especially as it was applied to nature, invoked something more than mere grandeur or immensity—though a sense of grandeur and immensity were certainly essential to it. It contained a religious and ethical element, and defined a lofty spiritual attitude.

"The sense of elevation toward the supreme Good, toward God, is frequently understood," writes Mr. Wilton in his discussion of the sublime. "The enlargement and enrichment of the mind in contemplating

the wonders of creation is thought of as a noble, uplifting experience.'' This, it will be readily seen, is not an idea that sits easily in the mind today, though I suppose the ideology of the ecology movement might be said to be a distant, politicized offspring of the same impulse.

It was one of Turner's distinctive achievements to create a mode of landscape painting that answered to this lofty conception of art, in which the needs of the spirit and the observation of nature were intimately joined. Important to recall in this context is the fact that landscape was not traditionally regarded as a sufficiently lofty subject for great painting. It was Turner, as much as anyone, who made it one.

He was well equipped for the task, too. He had begun his career as an accomplished topographical illustrator, and both his gift for observation and his power of achieving prodigious feats of faithful representation grew to be epic in scale. He was also steeped in the poetry and literary theory of his day—he wrote poetry of a sort himself—and was very conscious of applying to his depiction of awesome subjects in nature the visionary ideas he had garnered from his literary education. Thus, Turner's achievement in giving us what Mr. Wilton nicely describes as a ''vividly convincing likeness of immense spaces, panoramic views and infinitely receding vistas seen in all kinds of atmospheric conditions'' had a literary as well as a visual basis. It was not simply the accomplishment of a master technician.

In the work that Mr. Wilton has selected for this exhibition, there is inevitably less emphasis on the formalist aspect of his painting and a greater concentration on the subject matter of his art. The whole exhibition is arranged, in fact, according to the artist's subjects—the sea, darkness, cities, mountains, lakes, etc. This is a very uncommon practice in museum exhibitions today, yet it proves to be an entirely appropriate one for an oeuvre like Turner's. His subjects live for us again with something akin to the reality they obviously had for him.

It has often been observed that every period reinterprets the artists of the past in terms that are congruent with the interests of the present. In this respect, as in others, ''Turner and the Sublime'' is very much an exhibition of the 1980s. When, in the final pages of Mr. Wilton's commentary, we find him speaking of Turner as an exponent of the Realist impulse, it naturally rings a bell. After the ''abstract'' Turner of the sixties, here we are given a ''realist'' Turner for the eighties. Whether the latest one is deemed to be the true and essential Turner will depend, of course, on one's point of view. But there can be no

question about the fact that Mr. Wilton has brilliantly succeeded in restoring our sense of the complexity—and, yes, the sublimity—of Turner's art.

"Turner and the Sublime" was originally organized for the Art Gallery of Ontario in Toronto, and after it closes at the Yale Center for British Art in New Haven, it will travel to the British Museum in London. The catalogue will henceforth be an essential work of reference for its subject and period.

FEBRUARY 20, 1981

3. "The Age of Revolution" I

An age that has witnessed the virtual collapse of vanguard ideology, that has lived to see the myth and the mystique of the artist's resistance to society succeeded by a period of détente and accommodation, will naturally be moved to make some wholesale revisions of the past. No longer will the martyrdom of the avant-garde command the same exclusive prestige. No longer will an art upholding "official" standards be so automatically rejected. As contemporary taste grows more expansive and eclectic, historical research is less inhibited in acknowledging the quality and accomplishment of artists who do not conform to simpleminded scenarios of revolt. Artists who once served, and served brilliantly, the interests of established power are granted a new aesthetic visibility—are granted, indeed, an aesthetic existence independent of their social role.

This fateful turn of the *Zeitgeist* is not, to be sure, an unmixed blessing. It has already been responsible for dumping a great deal of deservedly forgotten art on the international exhibition scene—paintings by Victorian hacks, by time-servers of the official Salon, and by sundry other inglorious flatterers of low-grade taste—and we are bound to see a great deal more such rubbish before this impulse runs its course. It is all part of the comedy of culture, and it is a little easier to endure if per-

ceived for what it is: a form of farce that points to something perfectly serious and far-reaching.

For there is a positive side to this impulse, too—an eagerness to re-examine the past with a fresh eye and an open mind in order to distinguish the realities of achievement from the myths that have obscured them. It is this positive side of the current revisionism that is responsible, certainly, for the extraordinary exhibition of "French Painting 1774–1830: The Age of Revolution" that has now come to the Detroit Institute of Arts.

This is the exhibition, jointly organized by the Detroit Institute, the Metropolitan Museum of Art, and the Louvre and shown in its entirety earlier this season at the Grand Palais in Paris, that was reduced in scope (from 206 to 150 paintings) for its American showing by the Met's director, Thomas P. F. Hoving. What we see in Detroit and what will be seen in New York—is three-fourths of a great exhibition. It is still a magnificent show, but its very grandeur makes its abridgment all the more lamentable.

For make no mistake about it, this is indeed an unusual exhibition. The great names we all know from this period—David and Ingres, Delacroix and Géricault—are here in force, represented by paintings of an importance one scarcely dreamed of ever seeing on this side of the Atlantic: David's *Belisarius* from the Museum of Fine Arts in Lille; Ingres's *Jupiter and Thetis* from the Granet Museum in Aix-en-Provence; Delacroix's *Liberty Leading the People* from the Louvre, and, also from the Louvre, Géricault's *Wounded Cuirassier*, to name but a very few of the most outstanding. For the paintings of David and Ingres alone, the exhibition would be unforgettable.

Yet "The Age of Revolution" is very largely an exhibition of "unknown" artists—unknown, that is, to all but a very few specialists in the period. It includes the work of ninety-three painters, many of them among the most celebrated artists of their day but, until this exhibition restored them to our attention, among the most thoroughly forgotten in ours. The great surprise of the show is in discovering how powerful many of these painters now look to us.

One might recall, for example, the name of Ary Scheffer, if only because Baudelaire made this unlucky artist the object of special abuse in his pamphlet "The Salon of 1846," but one is scarcely prepared for the overwhelming eloquence of the large picture called *St. Thomas Preaching During a Storm* painted some twenty-three years before Baude-

laire consigned him to oblivion. In Detroit, this painting hangs in close proximity to Delacroix's *Liberty*, and is anything but diminished by the juxtaposition. The paintings are remarkably alike, and Scheffer's precedes Delacroix's by seven years.

Nearby hangs another surprise—a vast sea painting called *Devotion of Captain Desse* (1830), almost in the Turner class and clearly influenced by the English master, by Théodore Gudin, another of the painters we may vaguely recall from Baudelaire (who dismissed him with swift contempt in the same "Salon"). And so it goes at every turn in this exhibition, which embraces the tumultuous period beginning with the coronation of Louis XVI as King of France and ending with the July Revolution of 1830. We move from revelation to revelation as the painting—and with it, the whole complex course of French culture and society in this crucial period—unfolds before our eyes.

For this is painting that exists in a certain relation to power, painting eager to serve and celebrate the social order and unhesitating in embracing the most didactic themes. The themes may vary, and the pictorial styles employed for their expression vary too, whether Neoclassic or Romantic or some less easily categorized amalgam of both, and undergo sudden and remarkable changes in this period. But the didactic impulse remains fundamental, holding sway over the very idea of what it is in the nature of art to be.

In this respect, as in others, Delacroix's *Liberty Leading the People*, painted in 1830, is in the direct line of paintings like Joseph-Benoit Suvée's *Death of Admiral de Coligny*, painted in 1787 on the eve of the Revolution, and both paintings gain something from being seen in this relation.

The Suvée is, in any case, another of the show's revelations—a painting of great dramatic power based on an episode in Voltaire's epic poem the *Henriade*. The painting of "The Age of Revolution" is at once a secular and a social art, and I suppose the greatest astonishment for us is to see the extent to which the demands of social ideology are given priority over purely stylistic considerations. The effect of the exhibition is to leave us not with a clear sense of a single stylistic development but with a sense of the great variety and richness of stylistic impulse that flowered in the service of political imperatives.

To say this is, of course, to touch on only certain aspects of a large and many-sided exhibition. We are clearly in for some major revisions in the history of French painting as the result of this exhibition, and no

one interested in painting—or indeed, in modern history—can afford to miss it.

The scholars who organized "The Age of Revolution"—Robert Rosenblum, professor of fine arts at New York University; Pierre Rosenberg, curator of painting at the Louvre; and Frederick J. Cummings, director of the Detroit Institute—have given us an exhibition that will long be remembered, and the catalogue they and their colleagues have produced is a marvel of its kind. It runs 712 pages, includes reproductions and commentaries on all the paintings (including those omitted from the Detroit and New York showings), and is certain to become a standard reference for years to come.

MARCH 16, 1975

4. "The Age of Revolution" II

The great exhibition called "French Painting 1774–1830: The Age of Revolution" has finally come to the Metropolitan Museum of Art—a little cramped for space, to be sure, and stripped of a few more of the paintings that originally belonged to it but still a resplendent event that no one interested in the art of painting will want to miss. Despite the Met's grievous mishandling of this important show and its petty reprisals against those who dared to criticize its actions—I understand that none of the scholars who organized the exhibition was even invited to a preview—we have much to be grateful for. An era hitherto obscured by false assumptions and lazy scholarship has been triumphantly illuminated, and a great many paintings of outstanding quality have been rescued from neglect and indifference. This is truly an exhibition that rewrites the history of an entire epoch.

Crowded with contradictory impulses and swift reversals of fortune, the period that extends from the coronation of Louis XVI in 1774 to the July Revolution of 1830 is not an easy epoch to understand. Its art was dominated by a standard of public rectitude that is alien to

everything the modern mind has come to value in the aesthetic enterprise—and it was beholden to political myths we have every reason to despise. Yet it also saw the beginning of those more private and personal avowals of feeling we recognize as our own, and it testifies at every level to an artistic rigor that even the most confirmed champion of the modernist spirit might envy. It recalls us to a time when painters had important public duties to perform, and reminds us that these were by no means inimical to achievements of the greatest splendor. It thus revises not only the history of a period but our deepest understanding of the artistic vocation itself.

It requires, then, a certain leap of the mind—and a certain suspension of disbelief in the pieties of that distant era—to appreciate the achievements that are set before us in this exhibition. We are obliged to recognize certain hierarchies of value, especially those determining the content of painting, that steadfastly obtained for the artists in question, inspiring some of their most glorious efforts, but that subsequently earned the opprobrium of the greatest artistic minds. The summit of all ambition could be reached by the painters of the period only through history painting—the *grand genre* that glorified established power and offered moral instruction to the society it dominated. As Pierre Rosenberg writes in his introduction to the great catalogue of this exhibition: "While this hierarchy of content is not understood today, it had a profound significance during an epoch in which painting sought to, at times had to, have a profound meaning, elevate the spirit, present a moral lesson or serve as an example."

So it is history painting, culling emblematic episodes from the writings of antiquity and the exploits of the national past, venturing into classical mythology and the more calculated mythologies of current politics, that occupies the center of this exhibition. At the same time, surrounding this *grand genre*, are the satellite categories of painting— portraiture, still life, landscape, and scenes of everyday life—that amplify and amend the spirit of high purpose so beautifully dramatized in the history paintings and in the end, subtly but unmistakably, offer a more personal and disaffected alternative to their majesterial catalogue of officially approved feelings. An exhibition so largely given over to the kind of art that affirms the social order ends on a note not exactly of subversion, but of the sort of imaginative independence that would lead, a generation hence, to the disruptive heresies of modernism.

There are thus many plots and subplots to be followed in this exhibition, which opens with Callet's elegant *Portrait of Louis XVI* and ends

with Delacroix's eloquent *Liberty Leading the People*. Like a Shakespear-
ean scenario, it embraces both the heroic and the homely, and succeeds
by this very variety in giving us a comprehensive sense of the human as
well as the artistic motives that inspired so many formidable talents. It
is the great virtue of this exhibition, too, that so many of these talents
are newly discovered—or, to be precise, rediscovered, for considerable
care has been taken to recover the work of painters who were recog-
nized in their day, mainstays of the official Salon, but who had since
become casualties of those massive changes of taste that followed in the
wake of the modernist challenge.

We owe to this exemplary effort of scholarship and connoisseurship
the presence here of such paintings as Drouais's *Marius at Minturnae*
(1786) and Scheffer's *Saint Thomas Preaching During a Storm* (1823), Su-
vée's *Death of Admiral de Coligny* (1787) and Vafflard's *Young and His
Daughter* (1804), to mention only the most outstanding of the paintings
by obscure artists that have been rescued from oblivion for this occa-
sion and that are unlikely to be allowed to sink again from sight for a
long time to come. (Unfortunately, one of the most impressive of these
rediscoveries—Gudin's large, dramatic painting of a shipwreck, *Devo-
tion of Captain Desse*, painted in 1830, and one of the most powerful
paintings in the original exhibition—is not included at the Met. Owing
to some undisclosed dispute between the Met and the Museum of Fine
Arts in Bordeaux, the latter would not allow this painting and two
others—one of them a Delacroix—to be shown in New York.)

It has been said that "French Painting 1774–1830" is very largely
an exhibition of unknown artists—unknown to the twentieth century,
that is—and there is a great deal of truth in this observation. Certainly
of the ninety-two painters represented here only a handful have found
their way into the basic histories of Western painting. One thing this
exhibition does not do, however, is dislodge these eminences from their
place at the summit of artistic achievement in their time. The anthol-
ogy of masterworks by David, Ingres, Géricault, and Delacroix that
has been gathered here, besides being an immense and illuminating
pleasure in itself, easily confirms their stellar distinction. We learn
much about Drouais—and about his teacher David—by seeing his *Ma-
rius at Minturnae* in the company of so many of the master's paintings,
just as the spirit of Géricault and Delacroix is amplified for us by the
presence of Scheffer's powerful *Saint Thomas*. But this does not result in
any diminution of the masters' status. Here, as in the minds of their
contemporaries, they reign supreme.

And what supremacy it is! If only for the Davids that have been brought together here—the *Funeral of Patroclus* from the National Gallery in Dublin, the *Portrait of Count Stanislas Potocki* from Warsaw, *Belisarius* from Lille, *Hector and Andromache* from Paris, *Mars Disarmed by Venus and the Three Graces* from Brussels, added to those from American collections (including the surprising *Portrait of Lavoisier and His Wife* from Rockefeller University in New York)—this exhibition would be an event. To follow the vicissitudes of David's career in this show is an education in itself—and not only in the art of painting. As a connoisseur of both pictorial form and political power, and of the kind of social and professional preferment to be derived from them, David was indeed a genius.

The ease with which he adjusted his political convictions to every change of regime is well known, and it is not something we nowadays admire. But I cannot see that it ever adversely affected his art. On the contrary, this vaunted dictator of taste was remarkably open and sensitive to whatever new artistic currents were making themselves felt. He was a great innovator in his own right, yet not above responding to the strengths of others. In the context of the present exhibition, he is restored to us as a living artist, open to experience, testing new methods and vulnerable to new feelings. The cardboard figure of history is replaced by the emphatic presence of a powerful and developing personality.

One of the aims of this exhibition has been to overturn simplistic notions, long held dear in established accounts of this complex period, of a hard and fast division between the Neoclassic and the Romantic styles. Opinions will naturally differ over the exact extent to which this aim has been accomplished. Certainly the belief in a strict chronological succession of one mode of feeling and expression by another had been definitively abolished. Gone forever, too, is the idea that the Neoclassic style was somehow "inspired" by the Revolution of 1789. Professor Antoine Schnapper calls our attention to the fact that the Revolution did not really effect any significant change in pictorial style, though it did significantly alter the social organization of the world of artists and their patrons. The Neoclassic impulse had been in evidence since the middle of the eighteenth century, and it was still flourishing when Napoleon fell from power.

But so were the other impulses that are fully represented in this exhibition. Professor Robert Rosenblum claims—and the exhibition that he has helped to organize bears him out—that "by the end of the Napo-

leonic era, French painting had become more complex and diverse than at any earlier point in its history.'' Even the Romantic school was divided between the romance of nature and the appeals of the supernatural. What is incontrovertibly established here is the essential pluralism of the artistic enterprise in this era of official styles, government commissions, and carefully monitored Salon exhibitions. (Is there, perhaps, a lesson in this for the art of our own time, which has already seen a vast increase in government subsidies to the arts and is likely to see even greater subsidies in the future?) But an acknowledgment of this pluralism does not quite erase distinctions between styles. Style is based on strong conviction, and conviction—at least for the tenure of its hold on the artistic sensibility—tends to be narrow and sectarian. The Neoclassic and the Romantic impulses may overlap in time, but they do not, as I read this exhibition, coalesce in spirit or in practice. At the level of genius, at least, they remain gloriously distinct, and each contributes its large share of glory to this unforgettable exhibition.

JUNE 22, 1975

5. Landseer: The Victorian Paragon

The large Landseer exhibition that has now been installed with a good deal of pomp and solemnity at the Philadelphia Mueum of Art is, without question, one of the most problematic events to be offered to the art public in a great many years. The revival of extinct reputations from the ranks of nineteenth-century Academic painting is no longer the novelty or scandal it once was, of course. Slowly but inexorably, these revivals have become an established datum of cultural life.

By now an entire generation of students and museumgoers has come of age without any personal memory of the time—which to some of us seems just the other day—when the majority of these Academic worthies, to the extent that they were remembered at all, were looked upon as little more than figures of fun. Even so, it hardly seemed possi-

ble that things had gone so far that we would one day live to see Landseer himself—the quintessential embodiment of Victorian philistinism—rehabilitated to something like his former glory. Revisionism has indeed come a long way.

Sir Edwin Landseer (1802–73) was the most eminent of Victorian painters. In his own lifetime—and from a remarkably early age, too; he began exhibiting at the Royal Academy in London when he was thirteen years old!—his paintings of dogs, stags, children, and sundry other beasts won him the adoration of a large British public that was otherwise indifferent to matters of aesthetic discrimination. He proved in time to be a great favorite of no less a power than Queen Victoria, who not only collected his work with enthusiasm, but welcomed the artist himself as a guest at her various residences. (He was knighted in 1850.) The English aristocracy embraced Landseer as a kindred spirit, lavishing him with commissions, heaping praise on his accomplishments, and showering him with innumerable invitations to their vast homes and their preposterous hunting parties. He was similarly esteemed by many of the leading writers of his day, among them Sir Walter Scott and Charles Dickens.

It was for good reason, then, that a recent biographer of Landseer, Campbell Lennie, called him "the Victorian Paragon." For a good deal of his life, he seemed, indeed, to be such an exemplary figure— gifted, virtuous, industrious, hearty, companionable, and hugely successful, the most published artist in Britain at a time when the sale of engravings was often the key to a painter's prosperity. Yet this paragon of the Victorian virtues died a mental and physical ruin. He suffered his first mental breakdown while still in his thirties. As he grew older, he showed unmistakable signs of paranoia, drank heavily, and found it increasingly difficult to bring his projects to completion.

The wonder is that an artist so profoundly afflicted could still accomplish so much. (Among the other ambitious projects completed when Landseer was struggling against his own disintegration were the lions in Trafalgar Square that have long been familiar to every visitor to London.) For as the pressures of his prodigious career combined with failing health to exert their toll, Landseer sank ever more deeply into a slough of melancholy, alcoholism, insomnia, and madness.

It took a while longer for his reputation to fall into a similar ruin. But fall it did, and so precipitously as to seem for much of the twentieth century to be irretrievable. When, for example, the late Andrew Carnduff Ritchie organized an exhibition of "Masters of British Painting,

1800–1950'' at the Museum of Modern Art in New York in 1956—an event that was not without a hint of the revisionism to come—Landseer was nowhere in sight. His name did not even figure on the list of artists that, for one reason or another, had to be omitted. He was clearly regarded as beneath consideration. And lest this seem like an eccentric judgment on Mr. Ritchie's part, it is worth remembering that he was assisted in his choices by a committee consisting of Sir Philip Hendy, then director of Britain's National Gallery; Sir John Rothenstein, then director of the Tate Gallery; and Sir Herbert Read, then the most renowned art critic in the English-speaking world.

Yet a mere quarter of a century later we are being treated to an exhibition on an outsize scale—more than one hundred paintings and a great many drawings, engravings, and watercolors—that is obviously designed to reestablish Landseer as a major figure. (Organized by Joseph Rishel, curator of European painting before 1900 at the Philadelphia Museum, and Richard Ormond, deputy director of the National Portrait Gallery in London, the exhibition is a joint Anglo-American enterprise and will be shown at the Tate Gallery.) What are we to make of this historic turnabout? Has a lost master now been triumphantly restored to us, or is this event yet another example of the way Camp taste, complaisant scholarship, and the gyrations of the art market nowadays combine to elevate inferior talents to positions of unearned visibility and acclaim?

The answers to these questions turn out to be a little less simple than one had supposed. About the artist's gifts, for example, the exhibition leaves little room for doubt. Landseer was indeed endowed with extraordinary powers from an early age; and throughout a long career, he developed them with an immense concentration of energy and skill. Alas, it was what he did with all that energy and skill that causes this exhibition to be so highly problematical for long stretches at a time. Early on, he found his—and his public's—favorite subject in dogs. It nearly ruined him, and it certainly ruins a great deal of the present exhibition. No doubt his interest in his canine subjects was genuine enough to begin with—though as early as 1820, when he painted the large canvas called *Alpine Mastiffs Reanimating a Distressed Traveler*, he was not averse to turning it into the kind of cheap melodrama that would score an easy success.

And there was worse to come as Landseer increased both his skill and his eagerness to please. Frequently humanizing these canine subjects, he took also to allegorizing them into arch moralistic anecdotes.

The sentimentality and pomposity of these dog paintings are really un-
endurable, and so are their fatuous attempts at humor and—even
worse—clever social commentary. In the end, I doubt if Landseer him-
self could any longer distinguish between what was genuine in his feel-
ing for these subjects and what was contrived to oblige a client and
gratify a silly public.

He painted children pretty much as he painted dogs, but with even
less feeling for their actuality and an even greater determination to
make them appealing. Human subjects were not, in any case, Land-
seer's forte. Except for certain portraits of male friends—the early por-
trait of Sir Walter Scott, for example—Landseer's paintings of adults
are singularly unpersuasive. They are polite, flattering, respectful,
and dull. There is far more conviction to be found in his informal
sketches of Thackeray, Paganini, and Sydney Smith, and a lot more
emotion, too.

He was a lot better at painting stags and sheep and other creatures
removed from the sentimental domesticity of the Victorian hearth.
These, too, he was inclined to allegorize, but there is no question, I
think, that they often elicited in Landseer a profound emotional re-
sponse. Especially in certain paintings of stags—most particularly in
that eerie nocturnal painting called *The Challenge* (circa 1844)—
Landseer really triumphed. In that painting and in the even more dour
and violent and visionary painting called *Man Proposes, God Disposes*
(1863-64), which depicts two fierce polar bears attacking the remains
of a shipwreck in a bleak arctic setting, Landseer found subjects that
fully accorded with the darkest aspects of his own personality—
precisely what he was obliged to disguise and suppress in the bulk of his
work—and we are made to feel the strength and intensity of the artist
and the man virtually for the first time.

It is only in the bleakest of Landseer's paintings—and *Man Proposes,
God Disposes* is surely the bleakest of them all—that we see the artist
stepping out of his familiar social role and attempting to come to terms
with his troubled inner spirit. And it is in such pictures that we come to
understand what it must have cost him all those years to go on produc-
ing the awful succession of sweet, showy, sentimental pictures that
make up the bulk of this exhibition and that won Landseer his immense
popularity and success. *Man Proposes, God Disposes* is Landseer's *Dover
Beach*; and with that painting, at least, he joins the ranks of those dis-
abused Victorian prophets whom we still have ample reason to admire
and to heed.

Fine as this and a few other late pictures in the exhibition are, however, there are not enough of them to sustain a show conceived on this monumental scale. Landseer's oeuvre does not finally lend itself to the kind of blockbuster presentation we are being offered on the present occasion. The critics and connoisseurs who for so many years relegated his work to the ranks of minor Academic artists were not, as it turns out, wholly wrong, after all. They had a point, and it says something about the taste and the values of our own time that the organizers of this exhibition, in their enthusiasm to rehabilitate a lost reputation, seem so completely to have missed it.

NOVEMBER 29, 1981

6. "The Natural Paradise"

What are we to make of the fact that two of the major New York museums normally specializing in modernist art—the Museum of Modern Art and the Whitney Museum of American Art—are currently showing sizable exhibitions that take as their point of departure the revival of interest in the classics of nineteenth-century American realism?

A few weeks ago, the Whitney opened its show of selections from the private collection of Mr. and Mrs. John D. Rockefeller III—a very pleasant, placid, unspectacular exhibition of (mainly) small nineteenth-century American realist paintings guaranteed to act as a soothing poultice for sensibilities inflamed by a surfeit of modernist art. Now the Museum of Modern Art has mounted a larger, grander, more ambitious exhibition—"The Natural Paradise: Painting in America, 1800–1950"—that confers on this interest in nineteenth-century American painting the aura of a compelling idea.

The Whitney show, it is safe to say, will influence nobody's thinking about anything. It is a sop to Bicentennial piety that affords us, almost inadvertently, a glimpse of some very nice pictures. By design, as it were, it makes no distinction between significant and insignificant works of art; and with ideas of any sort it has absolutely nothing to do.

The show that Kynaston McShine has organized under the title of "The Natural Paradise" at the Modern, though likewise occasioned by the Bicentennial, is something else entirely. It is, first of all, marvelous to look at. It is also very much based on an idea—in my opinion, a completely false idea, but an idea that has been floating around college campuses and the New York art world for some years, winning some surprising converts. The nice thing about "The Natural Paradise," however, is that the pleasures it offers us are not in any way dependent on our assenting to its mistaken assumptions. It is, in a sense, two shows, one for the masses and one for the classes—I mean those university classes that are so reluctant to take seriously any picture unequipped with a certified passport to intellectual respectability.

There is, I think, a certain element of comedy in all this—but again, the comedy is in the idea, not in the pictures, the selection of which is, for the most part, really splendid. Startling as it may be to see Thomas Moran's *The Chasm of the Colorado* or Frederic Edwin Church's *Rainy Season in the Tropics* or Fitz Hugh Lane's *Owl's Head, Penobscot Bay, Maine*, or Albert Bierstadt's *Sunset in the Yosemite Valley* resplendently displayed on the walls of the Museum of Modern Art, which was founded nearly fifty years ago to show us art of a very different character, the pictures themselves are glorious. We are also treated in this exhibition to a more lavish survey of paintings by an earlier generation of American modernists—John Marin, Marsden Hartley, Georgia O'Keeffe, Arthur G. Dove, et al.—than we have been able to see at the Modern in some years. And there are some delightful surprises all along the way—from a painting of the 1920s by the forgotten Gottardo Piazzoni that gives us a view of the California coast as Puvis de Chavannes might have painted it to a 1917 picture of the Hudson River Palisades by the well-known Marin that startles us with its unexpected form.

Visually, then, "The National Paradise" is a show of absorbing interest. But a show of this sort, abounding in pictures of a kind that do not normally fall within the purview of the Modern, needed—as we say in the newspaper business—a "peg," and there was one readily at hand in an essay called "The Abstract Sublime" that Professor Robert Rosenblum published in *Art News* some fifteen years ago. This essay has proven to be remarkably durable. Henry Geldzahler reprinted it in the catalogue for the Metropolitan's exhibition of "New York Painting and Sculpture: 1940–1970" in 1969, and it has elsewhere too acquired a kind of canonical status.

For Professor Rosenblum, the abstract painters Clyfford Still, Jackson Pollock, Barnett Newman, and Mark Rothko exist in a "tradition" that has its roots in the theory and practice of the Sublime that dominated a good deal of aesthetic thinking in the late eighteenth and early nineteenth century in Europe. The paintings of James Ward, Caspar David Friedrich, J. M. W. Turner, and John Martin were invoked to establish a link between this romantic concept of the Sublime and its new abstract embodiment in the New York School. Acknowledging that the "line from the romantic Sublime to the abstract Sublime is broken and devious," Professor Rosenblum nonetheless insisted on its artistic and spiritual reality.

Professor Rosenblum returned to this theme in his book *Modern Painting and the Northern Romantic Tradition*, and in an essay called "The Primal American Scene," written for the catalogue of Mr. McShine's exhibition, he has applied its basic assumptions to a revision of the entire history of American art. In the 1961 essay, American painters such as Bierstadt and Church were mentioned only in passing. In the new essay, they occupy center stage. Fifteen years later, this vaunted "tradition" looks a good deal less "broken and devious"—at least to Professor Rosenblum—than it used to.

It is all, I am afraid, the sheerest hokum—brilliant hokum, amusing hokum, but hokum all the same. Clyfford Still does not come out of a "tradition" spawned in the work of Caspar David Friedrich, and Barnett Newman's work bears no relation whatever to Bierstadt's or Church's. When Professor Rosenblum wrote, as he did in 1961, that "what used to be pantheism has now become a kind of 'paint-theism,'" he was allowing a facile use of words to function as a substitute for visual and historical intelligence.

The best thing to be said about this sort of special pleading was said recently by the historian Peter Gay in his book *Art and Act*. "The causal leap of influence," Professor Gay wrote, "requires demonstration more cogent than a resemblance that the historian finds plausible." Professor Rosenblum has never been able to give us such a demonstration—for understandable reasons.

One can see, however, why Mr. McShine found this concept of a "tradition" so appealing. It allowed him the freedom to hang Newman, Still, et al., on the same "line" with Bierstadt, Church, Sargent, Ryder, Hartley, and whatever other painters he found to his liking. There was a wonderful, built-in face-saving device for the museum in

all this too: a big exhibition, certain to please large numbers of people who care nothing for modernist art, could be made to seem to be a highly original explication of the roots of modernist art. Never mind that "The Natural Paradise" gives these people a false idea of what the roots of modernist art really are. Anyone who cares about *that* can always, I suppose, visit the museum's permanent collection. There you will find no trace of the fictions that dominate "The Natural Paradise."

OCTOBER 10, 1976

7. The Isolation of Thomas Eakins

Thomas Eakins (1844–1916) was at once the most powerful and the most problematic American painter of his generation. In his lifetime he was also one of the most isolated. Outside a small circle of friends, family, students, and acolytes in the Philadelphia of his day, his art seems not to have elicited a very wide response. Historians have tended—a little too eagerly perhaps—to attribute this public resistance to Eakins's art to the genteel taste of the day, a taste that Eakins famously opposed. Yet I wonder if the spell cast by the genteel tradition entirely accounts for Eakins's failure to win a public for his art in his lifetime. For even today, when he is everywhere acclaimed as an American classic and generally thought to be the greatest American painter to emerge from the nineteenth century, his art remains curiously isolated.

No American painter in this century has found anything in it to build upon and develop. Realists like Henri and the painters of the Ashcan School paid it reverent lip service, but in practice they much preferred the kind of sparkling painterly virtuosity that Eakins scorned. In our day Eakins's putative heirs have strayed still further from the master's course, honoring him with their words but betraying him by their deeds. Andrew Wyeth, for example, has succeeded only in softening and sentimentalizing one aspect of the Eakins inheritance,

while Raphael Soyer has reduced another aspect of this tough-minded art to the sheerest schmaltz. Even the revival of realism in the last decade has not found in Eakins either an inspiration or a model. It has bypassed him altogether. However we may want to account for this phenomenon, it most certainly cannot be ascribed to any lingering attachment to the sentiments of the genteel tradition. We must look to Eakins himself—to his art and to the special spirit that governed its development—to explain his peculiar isolation.

The Eakins retrospective organized by Darrell Sewell at the Philadelphia Museum of Art has given us a splendid opportunity to see this artist at full strength, and to explore the question of his oddly orphaned status in the presence of his greatest works.[1] It is unlikely that we shall ever again see an Eakins exhibition that improves on this one. More than 140 items—paintings, sculptures, watercolors, drawings, and photographs—have been assembled for this occasion, and while not every last one of them can be said to be a masterpiece, they all have something to contribute to an understanding of Eakins's achievement. If certain aspects of that achievement continue to elude us, it is not because anything important has been withheld.

What strikes one straightaway in this exhibition is the almost desperate earnestness that is present in Eakins's art, from the outset, as a formative impulse. An attitude of extreme moral gravity permeates the artist's every effort. It is obviously more important to him than anything that might be described as an "aesthetic" consideration. He is intent upon making his art a vehicle of truth, and truth is understood to be something verifiable—something that can be touched, measured, or dissected. For this purpose, science—whether involving the study of anatomy or discoveries in the mechanics of visual perception—is deemed a more reliable guide than anything to be found in art. Eakins was, in fact, deeply suspicious of the power of art to misrepresent life— and, given the inane conventions that governed so much of the official art of his time, who could blame him? But his interest in science was not, all the same, strictly scientific. It was moral. It was a way of keeping his art fixed on a truthful course.

It was inevitable, then, that the touchstone of an art conceived in such terms would come to rest on the question of representational accuracy. Even in an age which placed a high value on fidelity to nature

[1]A slightly abridged version of the exhibition will travel to the Museum of Fine Arts in Boston.

in art, Eakins was something of a fanatic on this score. He carried it well beyond its customary limits and, at times, even beyond the point where it yielded him a significant artistic result. In his preparations for painting *The Fairman Rogers Four-in-Hand* (1879–80), for example, Eakins not only observed and sketched this highly decorative horse-drawn vehicle in action, both in Philadelphia and in Newport, but also made use of the revelatory Eadweard Muybridge photographs of horses in motion that were first published only a year before work commenced on the picture. Muybridge's was the latest "scientific" research on this subject, and it was clearly the challenge of accurately representing the action of the four horses in the picture that captured Eakins's interest. With his usual zeal to be truthful in his depictions, he also made wax models directly from the horses. As Mr. Sewell reminds us, however, Eakins "corrected the horses' legs [in the wax models] to conform to the Muybridge photographs." Direct observation unaided by "scientific" verification was judged to be insufficient, and not only for the representation of horses. One of Eakins's students later recalled that the coach in the finished picture was actually painted from a perspective drawing supplied by the manufacturer.

It is not for this reason, however, that *The Fairman Rogers Four-in-Hand* is a surpassingly dull painting.[2] Artists less gifted than Eakins have contrived to produce far livelier pictures out of equally disparate materials and similarly contradictory principles. The real reason for the failure of the painting lies elsewhere. It lacks what for Eakins was always the essential element in art: a moral imperative. Representational accuracy, "scientific" or otherwise, was a necessary coefficient of this moral imperative in art, but it was not in itself a sufficient basis for it. That is one reason why much of Eakins's sculpture is now so boring. Sculpture for Eakins was largely a problem-solving medium. It

[2]Lloyd Goodrich, in his monograph on Eakins, seems to me entirely correct in his judgment of this painting: "*A May Morning in the Park* [as *The Fairman Rogers Four-in-Hand* was originally called] may well be one of the first paintings produced anywhere in which the gaits of trotting horses are accurately represented. As representation of motion, down to such details as the blurring of the turning wheels, the picture records motion with complete truth. Yet it is arrested motion, naturalistically rendered, not movement in the forms themselves, as created by the masters of plastic movement. Eakins's own small Newport sketch conveys more sensation of movement, perhaps because it is more freely and broadly handled" (*Thomas Eakins*, Volume I, page 265). Mr Goodrich's two volume study of the artist, published by the Harvard University Press as part of the Ailsa Mellon Bruce Studies in American Art sponsored by the National Gallery of Art, is certain to remain the definitive work on the artist for many years to come.

was not a medium of expression. He used it to provide himself with models that would be anatomically correct and also offer certain clues to form. But it was in the painting, not the sculpture, that his forms were fully realized. Sculpture remained a tool. It was only in painting that Eakins achieved—or indeed attempted—complete mastery.

Where we find that mastery most fully developed is in Eakins's portraits, and there his scientific interests are clearly subordinated to other, more compelling, concerns. In the portraits he also concentrated on realizing a certain kind of "truth," to be sure, but it was no longer a truth that could be measured or dissected. Truth in this realm had, perforce, to rely on observation, intuition, and empathy. Which is one reason why the portraits vary so much in their intensity of expression: much depended on the exact degree of Eakins's sympathetic interest in his subject. There was never any question of flattering the sitter. Nothing further from the suave, glittering embellishments of Sargent or Boldini could be imagined. And nothing is determined, as it so often is in Whistler's portraits, by considerations of design. In this respect, Eakins's portraits cannot be said to be in the least "inventive," and they are never stylish. They aim for a sort of Tolstoyan transparency in their depiction of character, and this can only be achieved when the painter is impelled by some inward identification with his subject to go beyond mere appearance. His strongest portraits, not surprisingly, are therefore usually confined to family and friends—to subjects he knew best—and of these it is usually the women who yield him the most memorable results.

Lloyd Goodrich, who began his studies of the painter more than half a century ago, was able to interview many of the women who sat for Eakins, and it is amusing to learn how persistent Eakins was—and how consistently he failed—in attempting to get them to take off their clothes and pose in the nude for him. (Many of these interviews are summarized in Mr. Goodrich's monograph.) Interestingly, several of these women in their old age expressed some disappointment with themselves for not having acceded to Eakins's wishes. But this is not a disappointment we are likely to share. For neither then nor now could nudity be said to be an inducement to disinterested character study, and it was this, after all, that was Eakins's forte in portraiture. The few examples of the female nude he left us do not make us pine for any further examples of the genre. Nudity in art was something that Eakins tended to associate with allegory and myth—with some vague notion of the "Greek" past. It thus had the paradoxical effect of removing his

subjects from life. It was only when they posed for him in their clothes that they acquired the requisite degree of reality for him.

Throughout the entire history of realism in the nineteenth century one finds many similar attempts to universalize subjects drawn from contemporary life by attaching them to some mythological theme. It was as if the realists themselves recognized that something was missing, after all, in the way they conceived of their work—an aspect of the heroic that had been lost to art when painters turned away from literary, mythological, historical, and religious themes in order to concentrate on the observation of life here and now. It is certainly interesting that even as dedicated a realist as Eakins felt this urge to emulate the past, to attach his art to culture rather than to life. But, fortunately for his art, he did not really have a sensibility for allegorizing or mythologizing his materials.

Eakins was, perhaps, a narrower artist than he is commonly thought to be. In what Mr. Goodrich says about Eakins's teaching there is a judgment that may also be applied to his art—though this is not, I think, Mr. Goodrich's view.

> The strengths of Eakins's teaching [he writes] were bounded by its limitations. It was deep but not broad. Its concentration on naturalistic truths excluded many other elements of the work of art. There was not attention to the role of form, line, and color in creating design. There was little study of great art, past or present. The artists of the past whom he held up as examples (aside from the Greeks) were almost exclusively the seventeenth-century naturalists, particularly those of Spain. In nineteenth-century art his commendation, with some exceptions, was for the academics. He showed little awareness of current European trends; in any case, he would probably have opposed them. And his observations on other art were confined mostly to technical matters. His students were given a thoroughgoing naturalistic education; what they made of it was up to them. Most of them, as was inevitable, absorbed the naturalistic truths, but missed the qualities of form and design that made his own art vital, but which he did not formulate—perhaps even to himself.

The only thing missing from this account is the moral imperative that was so decisive in shaping Eakins's art, and it is this, I think, that offers us a clue to the isolation that the artist suffered in his lifetime and that continues to haunt his art down to the present day. The truth is, Eakins aspired to an integration of art and life that we no longer find persuasive. We are less suspicious of art than Eakins was, and more skeptical, perhaps, about the kinds of "truth" it may be capable

of rendering. Our impulse is to back away from moral imperatives in art, and to take a larger and an easier view of its functions. And it may be that this is the reason why Eakins—at least the Eakins of the great portraits—has had no successors in American art.

SEPTEMBER 1982

8. Gorky Revised

Time has altered our perspective on Arshile Gorky. This much-revered painter, who died a suicide in 1948 at the age of forty-four, has long been acknowledged to be one of the pivotal figures in the formation of the New York School—an artist who forged a crucial link between the modernist art of the School of Paris (Cézanne, Picasso, Miró, et al.) and the beginnings of the Abstract Expressionist movement that transformed American painting in the 1940s. His importance in this regard has been amply confirmed in the big retrospective exhibition, organized by Diane Waldman, that is currently on view at the Solomon R. Guggenheim Museum in New York.

Yet despite his honored status, or perhaps because of it, we have been slow in attempting to get at the meaning of Gorky's art. In making him a hero of art history—*our* art history—we seem to have neglected something about his art that was decisive for Gorky himself, something that formed the very armature of his pictorial imagination. This was the subject matter, or content, of Gorky's art. The reasons for this neglect are interesting, and tell us something significant about the art—and the art criticism—of the past few decades.

That Gorky's art—especially the paintings and drawings of the forties that brought it to a climactic achievement—harbored a very personal imagery (or "poetic content," as critics often described it), was never exactly denied. Very often, indeed, it was openly alluded to, if only to be discounted. But no systematic attempt was made to explore this imagery. That would have violated the widely shared assumption among champions of the New York School that what really mattered in

Gorky's art was that it was abstract, and abstract in a particular way—
that it was based, in other words, on automatist methods. The aesthetic
prestige of the whole movement seemed at times to depend on an inter-
pretation of Gorky's paintings that gave absolute priority to their
purely abstract qualities, and it was as an abstract painter—albeit one
who had made certain detours into explicit representation—that
Gorky was ushered into the history of modern art. If there was any-
thing systematic in the Gorky literature, it was the suppression of any
inquiry into the nature of the "poetic content" that virtually everyone
recognized was there.

Thus, for the late Harold Rosenberg—in his book *Arshile Gorky: the
Man, the Time, the Idea* (Sheep Meadow Press/Flying Point Books)—the
case was clear. "Gorky was a pioneer in discovering the primary prin-
ciples of America's new abstract art," he wrote. Lest anyone assume
that there might be something more than a strictly abstract idiom lurk-
ing in this painting, Rosenberg insisted that for Gorky "the canvas was
not a surface upon which to present an image"—an astonishing state-
ment when we really ponder it. Rosenberg cautioned us against the
folly of any close analysis of the work. "Attempts to 'read' Gorky's pic-
ture for disclosures concerning the pathos of the flesh or the destiny of
man seem ill advised," he wrote. "Not in his metaphors but in the
action of his hand in fastening them within their painting-concept lies
the meaning of his work."

This admonitory note was sounded again by Irving Sandler when
he came to write the first comprehensive history of the New York
School—*The Triumph of American Painting*, published in 1970. "Gorky's
abstractions did not illustrate any particular scene or autobiographical
event," Mr. Sandler declared. What counted for Mr. Sandler—what
was thought to guarantee Gorky his stellar position among the elders of
the New York School—was the painter's success in making "a grand
style of automatism."

And so it has usually gone. In a popular college textbook, *American
Art*, the author concerned with the history of the New York School—
Professor Sam Hunter of Princeton University—assured his readers
that in Gorky's painting "abstract and anti-illusionistic shapes . . .
had their impact principally through paint marks and material sur-
face." The "vaguely erotic mood" that Professor Hunter detected in
Gorky's work was attributed to a residual, imperfectly exorcised—and
certainly not to be admired—attachment to Surrealism.

One has to have some sense of this protracted history of high-minded evasion and voluntary blindness in the Gorky literature in order to appreciate the immense importance of Harry Rand's new book on the artist. For in writing *Arshile Gorky: The Implications of Symbols* (Allanheld & Schram), Mr. Rand—who is curator of twentieth-century painting and sculpture at the National Museum of American Art in Washington—has broken with all the assumptions governing this entrenched view of Gorky as a hero of abstraction. He has given us instead a very persuasive, well-documented, and movingly written account of an artist for whom a certain subject matter was of absolutely crucial artistic importance. Now for the first time, the so-called poetic content of Gorky's art is closely examined and definitively explained. The result is a book that not only alters—and alters profoundly—our whole understanding of Gorky's painting, including precisely those parts of it that have seemed most "abstract," but also raises many questions about the way we have "read" the work of his contemporaries. It clearly inaugurates a distinctly new phase in the study of the New York School and, when placed beside recent studies of Kandinsky, Picasso, and others, can be seen as part of a historic revision in the interpretation of modern art itself.

"What emerges from this study," Mr. Rand writes, "is a picture of the artist quite as remarkable as previous studies have supposed, but different in every regard from the critical biases of the last thirty years. Gorky stands revealed as that rarest of creatures, a modern history painter; it was his own history that he painted." This is a large and heretical claim, but Mr. Rand supports it with an amazing succession of highly detailed analyses of almost every major work in the Gorky oeuvre. We read these studies with mounting excitement as in one painting and drawing after another what Mr. Rand calls "the hidden agenda of [Gorky's] mature art" is revealed to us.

To understand this "hidden agenda," one needs, of course, to know something about the melancholy life that formed the very substance of Gorky's art. It was certainly an extraordinary life, even among the artists of his time, and it was made all the more bizarre by what Mr. Rand describes as "Gorky's penchant for dissembling." About his life, Gorky—to be blunt about it—lied a great deal, and about the art that recorded his life he also lied, deliberately obscuring the sources that were essential to its creation. For that was what modernist art at the highest levels seemed to him to require, and Gorky—

no less than his admirers—was determined to have his art perceived as something wholly free of the intensely personal materials to which it was inseparably bound.

He was born Vosdanik Manoog Adoian in 1904 in the village of Kharkom on the Dzore River in Turkish Armenia, and passed his early years in the "climate of terror," as Mr. Rand correctly describes it, that resulted from the wholesale slaughter of the Armenian population by their Turkish rulers during World War I. Gorky's father had already left Armenia for America in 1908, in order to escape conscription into the Turkish army; and his beloved mother, to whom he was very close, died of starvation in 1919 at the age of thirty-nine. One of Gorky's sisters recalled that he did not begin to speak until the age of five or six. "His first word," Mr. Rand writes, "was a a nonsense word that later became the title of a painting: 'Alkoura.' "

Gorky and his younger sister, Vartoosh, came to America in 1920, and lived for a time in Watertown, Massachusetts, with their older sister, Akabe, who had preceded them here. He settled in New York in 1925, at the age of twenty, and it was then that he took the name Arshile Gorky. Arshile is a variant of Achilles, and Gorky—meaning in Russian "the bitter one"—was already a famous name. In one of the many myths that the painter began to weave about his past, he claimed to be Maxim Gorky's cousin. He also later claimed to have studied with Kandinsky in Russia. (The truth seems to be that he was largely self-taught.) From the outset he was eager for celebrity and distinction and never hesitated about associating himself with exalted names.

His talent was recognized straightaway. When, upon arriving in New York, Gorky enrolled in the Grand Central School of Art, its director—Edmund Graecen—promptly put him to work teaching a sketch class. Yet his life as an artist had scarcely begun when the Wall Street crash of 1929 reduced him to the direst poverty. For several years he lacked money to buy paints and produced only drawings. A place in the Mural Division of the Federal Art Project gave him more of a foothold in 1935, and he actually produced a mural entitled *Aviation: Evolution of Forms Under Aerodynamic Limitations* that was once installed in Newark Airport. He sold his first picture to a museum—the Whitney in New York—in 1937.

By that time he was already part of the growing movement in New York to create a modernist art that could stand beside its counterpart in Europe, but he was still very far from achieving this himself. Gorky's self-imposed apprenticeship to the great European modern-

ists—first Cézanne, then Picasso, then Miró and others—was so pro-
tracted, and the mature development of his own art so long deferred,
that he seemed to many observers at the time to be an artist perma-
nently fated to imitate the work of others. It wasn't until the 1940s that
he produced a body of work recognizably his own. His first one-man
show did not take place until 1945, only three years before his death.

The traumas of Gorky's childhood and the hardships of the Depres-
sion era turned out to be but a prologue, however, to the misfortunes
that beset his final years—the very years, oddly enough, when he was
producing the pictures that have won him a permanent place in the his-
tory of art. These misfortunes mounted to a tragic climax in the series
of catastrophes that swamped him in the last two years of his life. In
February 1946, a fire in his Connecticut studio destroyed much of his
recent work. Three weeks later, Gorky was discovered to have cancer.
A colostomy was performed, and since the artist still had little money,
it had to be paid for by friends, and the surgeon took two paintings for
his services.

As if all this weren't enough to destroy the man, his marriage—
which had earlier been a source of considerable happiness to him—
began to disintegrate. Then in February 1948 Gorky was in an auto
crash that resulted in a broken neck. When he returned from months
in the hospital, he found that his right arm—his painting arm—was
numb. In desperation he attempted to learn to draw with his left hand.
At this point his wife left him, taking their children with her. It was fi-
nally too much for him. "On 21 July 1948," Mr. Rand writes,
"Arshile Gorky hanged himself in a woodshed near his house in Sher-
man. Written on the wall near him was the message: 'Goodby My
Loveds.'" Malcolm Cowley and Peter Blume, who were friends and
neighbors of the painter in Connecticut, found the body.

This, then, was the life that Mr. Rand finds recorded in a plethora
of eloquent and imaginative detail in the very paintings and drawings
that so many earlier critics have insisted were abstractions. The key to
his analysis is to be found in an observation made by Frederick Kiesler,
the architect and sculptor, who wrote the first magazine article on
Gorky in 1935. Kiesler was writing about the Newark Airport murals
when he remarked of Gorky's art: "It isn't abstract, but it looks like an
abstraction," and this is the principle that Mr. Rand has found to ob-
tain in all of the painter's so called abstractions. Even the alleged au-
tomatism of Gorky's late pictures is found to contain veiled references
to specific figures, episodes, and locales.

"The hoarded intimacy of Gorky's pictures," Mr. Rand declares, "came to resemble a diary, but also in their sequential flow paralleling and commenting on his life, they were a secretive editorialism. All was judged and painted from his particular moral stance. When his family was with him, he painted *The Calendars*; to commemorate his father's death he painted *The Orators*; in 1946-47, his cancer operation curtailing his marital sex life but not his sexuality, his marriage strained, he painted *The Betrothal*." The congruence of image and experience is traced with breathtaking precision.

Since the analyses that support Mr. Rand's brilliant reading of these and other paintings are far too lengthy and detailed to be quoted here, let one example suffice—an example that Mr. Rand knows very well is shocking in its implications. In the first of the paintings called *Agony* (1947), he identifies the central figure as "the pitiful suspended corpse" of Gorky himself. The picture is thus taken to be an agonized meditation on the prospect of the artist's own suicide. "Of all the figures in *Agony*," he writes, "only this one was developed in separate studies, which shows special concern. . . . Gorky frequently returned to this figure, adjusting the smallest details, altering tiny aspects for the best possible exposition. In each of the three sketches the figure's feet are placed differently, yielding different silhouettes and varying amounts of space between the feet. As we have seen, Gorky lavished effort when depicting a figure close to his heart." Even though Mr. Rand is clearly dismayed at his own discovery, which suggests that the artist contemplated suicide long before the event, he points out that "with the exception of his mother's face, no other motif element received such care" from Gorky's hand.

We may disagree with this interpretation of *Agony*, of course; but once we have examined the visual detail marshaled in Mr. Rand's analysis, we are obliged to offer an alternative reading of the painting. To regard the picture as being primarily an abstraction is clearly absurd. And this, in turn, obliges us to revise our notions about the role of automatism in Gorky's painting. For an imagery so carefully prepared and so specifically executed, for a pictorial narrative so consciously worked out in advance, automatism—as that term is generally understood—was hardly an appropriate method of composition. The truth is, Gorky carefully simulated the effects of automatist painting in a style that was at all times under total control and tethered to a particular iconography. Automatism was, in a sense, another of the many "lies" he was willing to let his admirers believe in.

So sweeping is Mr. Rand's interpretation of Gorky's oeuvre, and so convincing his argument on its behalf, that it instantly makes virtually all other commentaries on the artist obsolete. I am afraid that the book Diane Waldman has produced to accompany the current exhibition at the Guggenheim (*Arshile Gorky 1904–1948*, Abrams) is no exception. It is valuable, to be sure, for its plates and its documentation; but its main text is little more than a skillful summary of the view of Gorky's art that Mr. Rand has now so successfully discredited. It is a book most unfortunate in its timing.

The Many Worlds of Arshile Gorky (Gilgamesh Press) is a curiosity of another sort. Karlen Mooradian is Gorky's nephew, and his devotion to his uncle's life and work has prompted him to collect family letters and to interview many of the artists who knew Gorky. The materials he has gathered in this volume will therefore be of some value to Gorky's future biographers, but Mr. Mooradian is not himself a writer equal to the task of placing these materials in any sort of meaningful perspective. As for Harold Rosenberg's little study of Gorky, its only interest now lies in the fact that Rosenberg wrote it. It is, in other words, an item for the Rosenberg bibliography, not the Gorky bibliography. For an understanding of Gorky and his art, Harry Rand's book is now the indispensable work.

JUNE 21, 1981

9. Rediscovering Stanley Spencer

The big exhibition in London this fall is the Stanley Spencer retrospective at the Royal Academy. The papers have been full of it, touting Spencer as a major figure, and the crowds filling the Academy's capacious galleries display an unmistakable relish for the personal saga so vividly revealed in the 280 paintings and drawings jammed into every available inch of wall space. The appeal of the show seems somehow more folkloric than aesthetic—rather as if it offered some last magical access to a world now swiftly receding into the mists of memory and

myth—and no doubt because of this appeal, its reception has had some of the characteristics of a national celebration.

This may be an enviable fate for an artist, but it is not one that is usually achieved on aesthetic grounds alone. In the case of Stanley Spencer (1891–1959), the purely aesthetic factor is certainly not the one that looms largest. "He was never an avant-garde painter," writes Andrew Causey in the catalogue of the exhibition; and this is a considerable understatement. Although he made his debut, oddly enough, in the Second Post-Impressionist Exhibition organized by Roger Fry in 1912, Spencer lived and worked for roughly half a century following that event as if the entire modern movement had never occurred.

He looked, rather, to Victorian and Pre-Raphaelite painting and to the early Italian masters for inspiration in creating the kind of symbolical narrative art, all teeming figures and dramatic incident, that dominated his prodigious output. This is what the English modernists found so hard to forgive in Spencer's art. But it was what endeared him to the Establishment of his day, and it is what endears him to an even larger public today when modernist orthodoxy is losing whatever power it may once have had in influencing taste.

It hasn't exactly hurt Spencer's reputation, either, that the materials of his art were extremely local, its outlook on life very insular, and his own personality that of a provincial eccentric with a remarkable flair for dramatizing his religious and erotic obsessions. All his life Spencer retained an almost mystical attachment to the life of his native village of Cookham, in Berkshire, which he made the scene of mural-size religious paintings unlike any other produced in this century. Many of these are vast visionary evocations of the Crucifixion, the Resurrection, and other biblical events reenacted in homely village settings by the artist's Cookham friends and neighbors in poses and gestures that suggest the dramaturgy of a provincial pantomime.

As religious paintings they ought to be laughable—and in truth, more than a few of them are. But there is something in the best of them (which tend to be the earliest of them)—a vein of feeling so obviously innocent and authentic—that inhibits ridicule even when failing to elicit admiration. We are never in any doubt that, for Spencer at least, the commonplace features of village life in Cookham really did have a mystical significance. And if he failed to find a pictorial rhetoric altogether appropriate to such an exalted subject—and fail he surely did in these religious paintings—well, so did every other artist of his time

who attempted to give us a genuinely religious art based on narrative conventions.

What remains engaging in these paintings today is not, in any case, their religious content but the loving account of village life that is glimpsed in them. And it is this, I suspect, that accounts in large part for Spencer's immense popularity today. The conditions of contemporary urban life have everywhere created a vast appetite for the fantasies of village pastoral, and Spencer's art ministers to this appetite with a conviction so absolute—so innocent of faked emotion or ulterior sentiment—that it cannot be mistaken as anything but sincere.

But there is another—and I think a stronger—side to Spencer's art that has lately acquired an interest it did not quite have in his lifetime, and that is his realism. The symbolical and narrative conventions of the religious paintings inevitably entail a certain allegorical quality that, however rooted in the actualities of village life, tends to place them at a certain remove from immediate experience. In certain portraits and self-portraits, however, Spencer broke free of this dreamlike, allegorical atmosphere and painted with a power and a candor that are astonishing.

The best of these are the self-portraits and the portraits of women he painted in the period beginning in 1929 and lasting little more than a decade—though in the case of Spencer's self-portraits, the paintings are spread over a much longer period, from 1914 to the very last self-portrait painted in the year of his death. In painting himself, early and late, Spencer seems always to have mustered the requisite courage and candor.

The most startling of the portraits are what came to be called, not inappropriately, the ''sex pictures''—the very frank nude portraits of Spencer's second wife, Patricia Preece. In one of these, called *The Leg of Mutton Nude* (1937), Spencer also placed a frontal, squatting portrait of himself in the nude, hovering over the figure of his wife. This painting now often hangs in the permanent collection of the Tate Gallery, and could scarcely be expected to shock anyone familiar, say, with the figure paintings of Philip Pearlstein—to whose work, as a matter of fact, it bears a certain resemblance. Because of the prevailing puritanism, however, it could not be publicly exhibited in its day, and this was something that baffled and embittered the artist. Conjecture on such matters is probably useless, yet one is nonetheless moved to wonder what a more receptive response to pictures of this type might

have meant to Spencer's development in the last two decades of his life—especially since it is unquestionably the strongest painting of his maturity.

As it was, this powerful realist vein in Spencer's painting always remained a minor aspect of his oeuvre. He never really developed it, and it occupies a very small place in the retrospective. Yet it generates a heat out of all proportion to the number of pictures it can claim in this very large exhibition. From everything we know about Spencer's life, moreover, the realist paintings appear to derive from the most painful experiences of his life. The so-called sex pictures of Patricia Preece, for example, are not at all the memorials to married love they may seem to be but, on the contrary, are known to be extreme expressions of frustration and despair. The second Mrs. Spencer, after deliberately destroying the artist's first marriage and taking him for whatever he had in the way of money and worldly goods, refused to have any physical relations with him, and took off with a girlfriend when it came time for the honeymoon. The ''sex pictures'' were painted in lieu of a marriage that was never consummated.

The last self-portrait from 1959—one of Spencer's finest—was likewise born of the pain of his final illness when he knew he was dying. (He always began with the eyes, and these remained the emotional center of the painting.) When it was finished, he died. It may have been that realism at this level of personal pain and intensity was not something that Spencer could ever have sustained, whatever the public response to it might have been. Though he acquired a somewhat kinky posthumous reputation, based for the most part on a misunderstanding of what had occurred in his two marriages, Spencer was not a very worldly character. He was an innocent who desperately needed religious allegory and all those loving evocations of village life as a defense against the outrageous fortune of his own experience. When he turned to realism, it was an involuntary cry of despair.

The passage of time has given us a changed perspective on Spencer's troubled accomplishment. In the heyday of modernist orthodoxy, Stanley Spencer seemed hopelessly provincial and out-of-date. But now, with realism acquiring a new international vogue, his work is beginning to take its place in an alternative tradition. Later this season, the Pompidou Center in Paris will be mounting a large international exhibition devoted to realist painting between the two world wars, and I should be very surprised if Spencer was not accorded a place of honor in this survey. Certain English critics have already begun comparing

his work in this respect to that of Hopper and Balthus, and in the United States, too, the writer Guy Davenport compares Spencer very favorably with Balthus in an article that is just out in the autumn number of *Antaeus*. I must confess to finding the comparison a little bizarre, for Balthus seems so much the larger talent and the better painter. Yet, for all of Spencer's obvious failings, I found far more to admire in this retrospective than I would have thought possible a decade ago. This, I suppose, is one of the things we mean when we say that the age of modernism is over.

NOVEMBER 2, 1980

10. The Return of the Nativist: Grant Wood

Of the many attempts that have lately been made to revive the defunct reputations of provincial American talents and restore them to their former position as revered national classics, none has proved to be more forthright in its intention or more lugubrious in its realization than the Grant Wood exhibition which opened this summer at the Whitney Museum in New York.[1] Organized by Wanda M. Corn for the Minneapolis Institute of Arts and accompanied by a catalogue/monograph published by the Yale University Press, "Grant Wood: The Regionalist Vision" is clearly the kind of exhibition that is designed to strike a blow on behalf of a cause. What it sets out to achieve is nothing less than a major revision in the historiography of twentieth-century American art. This, indeed, is not only the most interesting thing about the exhibition; it is almost the only interesting thing about it. The art itself is pretty feeble stuff where it is not simply ludicrous.

For some time now the pressure has been building, both in academic circles and in the art market, for the readmission of certain "re-

[1] "Grant Wood: The Regionalist Vision" was exhibited at the Whitney Museum of American Art in New York, the Minneapolis Institute of Arts, the Institute of Chicago, and the M. H. De Young Memorial Museum, San Francisco.

gional'' painters to the canon of accepted masterworks—the canon upon which the study as well as the exhibition of American art is based—and this exhibition obviously owes its origin to this impulse. It would therefore be a mistake to regard it as just another undirected episode in the waxing and waning of individual reputations. Something else seems to be involved here—something that goes to the heart of our recent cultural history. I doubt if an event like the Grant Wood exhibition can even begin to be understood, in fact, except as part of some larger attempt to reverse the course of that history and render it more amenable to the influence of certain extra-artistic standards. The revenge of the philistines has taken many forms in recent years, and in this instance we are given a particularly vivid glimpse of what its deleterious consequences can sometimes be.

Fifty years ago, at a time when our modernists were an isolated and embattled minority, the self-proclaimed Regionalists of the American Scene movement enjoyed a position of great prominence among the painters who dominated the American art world. Regionalism was widely considered to be both a good thing in itself—perhaps, in the view of many, the only good thing in American art there was—and a more authentic mode of American expression than the ''alien'' styles of the modernists. This was a view commonly upheld not only in the Midwest, where the Regionalist movement originated, but even in New York, where institutional opinion still tended, two decades after the Armory Show, to dismiss much of modernist art as a hoax or a fad if not an outright conspiracy of malevolent outsiders. No doubt this was one reason why the Museum of Modern Art, founded in 1929 to advance a very different view of the modern epoch, exercised such extreme caution in exhibiting nonrepresentational art in the first years of the museum's existence. When the Federal Art Project commenced its operations as a means of providing artists with jobs during the Depression, Regionalism was given a tremendous boost, acquiring a kind of semiofficial status as a government-approved style. The antimodernist prejudice of the Regionalist school could draw support, moreover, from a wide spectrum of social and political opinion. It was something—perhaps the only thing—that the Chamber of Commerce, the Communist Party, the New Deal bureaucracy, and the board of the Metropolitan Museum of Art could all agree on. The fact that a more virulent version of this antimodernist position was already official government policy in Stalin's Russia and Hitler's Germany seemed to bother no one—except, of course, the lonely band of modernists struggling for survival.

Because of the immense esteem and influence the Regionalist school enjoyed in the thirties, its fall from critical favor in the forties constituted a momentous event in American cultural life. Henceforth the outlook of American art would become increasingly cosmopolitan, and provincialism would not automatically be regarded as a virtue. Not only were a great many individual reputations shattered in the process—and Grant Wood's was certainly among them—but an entire attitude toward art and culture was suddenly stripped of its authority. Nativism (as this attitude can best be described) turned out to have been peculiarly dependent upon the isolationist ethos that more or less collapsed with America's entry into the Second World War. In the more internationalist perspective that emerged from the war effort, Regionalism in art lost its aura of authenticity, and without government programs to support it, it also lost its principal patron and a large part of its public, if not indeed its raison d'être. At the same time, the growth of the New York School during the war and postwar periods was rapidly making the ideas of the Regionalists look parochial and insipid. By the fifties the international success of the New York School was so complete and the taste for modernist art which it brought in its wake so widespread that the art of the Regionalist painters could confidently be regarded as a dead issue for everyone but a handful of diehard provincials nursing their grievances against a cosmopolitan culture they could neither appreciate nor ignore. It seemed most unlikely that their star would ever rise again.

But in art, no less than in politics, every victory brings its share of unintended consequences, and the success of the New York School has by no means been exempt from this inexorable law of history. By the very act of bringing an unprecedented prestige to the accomplishments of American art, the New York School opened the way for the wholesale revaluation of our entire artistic heritage. An earlier generation of modernists was the first group to benefit from this altered perspective on American art, but eventually the revaluation process reached into every corner of American art history, lavishing a rosy critical glow— and thereby conferring a new price tag—on everything from the humblest artifacts of anonymous folk artists to the most ambitious productions of forgotten academicians. Thus, by a curious twist of fate, it was the $2,000,000-plus sum paid for Jackson Pollock's *Blue Poles* that led to the six- and seven-figure prices subsequently paid for certain nineteenth-century American landscape paintings, just as it was the exhibitions called ''Modern Art in the United States'' and ''The New American Painting,'' which the Museum of Modern Art sent to Europe in

the fifties, that led the way to "A New World: Masterpieces of American Painting, 1760–1910," which the Museum of Fine Arts in Boston will be sending to the Corcoran Gallery in Washington and to the Louvre.

Sooner or later this revisionist impulse, which in the course of time has often degenerated into a smug and uncritical belief in the excellence of just about anything produced in the name of art in the United States, was bound to turn its attention to the Regionalist school. Yet this development was remarkably slow in coming to fruition. The revisionist juggernaut plied its merry way through some pretty remote and unpromising terrain before it got around to a serious revival of the Regionalists, and one naturally wonders why. It would be nice to think that the sheer mediocrity of the great bulk of Regionalist painting was itself an inhibiting factor, but that is probably too optimistic a view of the matter. (After all, mediocrity has proved to be anything but an obstacle to the revival of a great many minor nineteenth-century American painters and sculptors.) Other factors seem to have played a role.

What was needed, I think, before the revival of Regionalism could really take hold and attract the kind of patronage and scholarship that such revisionist enterprises require for their success was a whole combination of changes in both our outlook on art and the way we support it. A growing disenchantment with modernism—or the feeling, at least, that the modernist movement may have run its course—accompanied by a return to realism in contemporary art and a renewed admiration for the kind of academic and Salon painting that flourished in the nineteenth century: all of this certainly has played a role in preparing the way for the revival of the Regionalists. So, too, has the elevation of American folk art to a position very close to parity with the finest achievements of fine art. The success of the Pop art movement must also be counted as an influence in this development, if only because of the degree to which it legitimized a certain vein of jokey commercial iconography as a museum experience. For the appeal of Regionalist painting, such as it is, is the appeal of academic art pretending to be folk art and calling upon the devices of commercial illustration to deliver its simplistic and sentimental "messages." And make no mistake about it: Regionalist painting is, above all, an art of "messages."

Even so, the revival of the Regionalist school would probably not have materialized on anything like its present scale without the intervention of a support system that makes it all but mandatory for the

"provinces" to be accorded a place on the national art scene that their actual creative accomplishments can only very rarely be expected to justify. At the heart of this support system are the various agencies of the federal government which not only provide large sums of money for scholarly research and for the organization and circulation of exhibitions but which also, whether intentionally or otherwise, exert tremendous influence on the way private patrons (corporations, individual collectors, etc.) dispense their favors. In this respect, we seem to have come full circle since the thirties. It was the government art programs of that decade that elevated the Regionalist school to its semiofficial status, and it is the government art programs of our own day—in their ethos as much as in their specific policies—that have proved to be an indispensable factor in the revival of this school.

Given these developments, it was surely inevitable that Grant Wood would at some point be selected to play a key role in the effort to revise the history of American art at the expense of the modernists who have been in the ascendant since the forties. At least two of Wood's paintings—*American Gothic* (1930) and *Daughters of Revolution* (1932)—have come to enjoy a firm place in the folklore of the American imagination. If this is not quite the same thing as being accepted as artistic masterpieces—and it most assuredly is not—it has nonetheless earned for the artist a special status in American cultural history. This is a great advantage, of course, in any attempt to rehabilitate an artistic reputation and revive a school of painting; and it is by no means the only advantage that the champions of Grant Wood can nowadays call upon in their drive to reestablish his eminence. Wood went to considerable pains to make himself a certain kind of emblematic figure—a midwestern Regionalist and chauvinist, shameless in extolling native virtue (whether real or imaginary) and ruthless in rejecting anything that smacked of "alien" (which is to say, foreign or cosmopolitan) tastes and influences. He is therefore a handy instrument for anyone wishing to turn back the cultural clock to the so-called good old days when the experience of art was perceived to be no more problematical than a church supper or a corn-husking bee.

Or he would be if only both the man and his art were not so abysmally phony in almost every important respect. To the extent that Grant Wood can be said to be a distinctive or representative cultural figure, it is this very spuriousness that makes him so. And the best place to begin to understand the pervasive fakery of the art as well as of the man who produced it is in the pictorial imagery that Wood placed

at the center of his work: all those vacant wholesome faces that look like nothing so much as painted toys in a children's game called "Iowa Farm," and all those immaculate marzipan landscapes in which no farmer could ever soil his hands and where the only disaster likely to occur is a stomach ache from too many sweets. This imagery, far from reflecting the artist's midwestern "roots" as an Iowa farm boy (which is the usual claim), was a calculated lie from start to finish—the fantasy of an emotionally retarded adolescent sensibility desperately seeking refuge from the realities of life in a dreamworld of his own invention. That the depiction of this dreamworld proved to have a large public appeal is scarcely surprising, for it is in the nature of such cultural anodynes to be popular. This, after all, is what they are primarily created to be, and lying is essential to their purpose. Truth—truth about life or truth about art—can never be counted on to be quite so comfortable or comforting.

Wanda M. Corn gives us an important clue to the fantasy element in Wood's painting when she observes: "It would be his peculiar mark as a Regionalist, in fact, to paint very little of the 1930s life taking place outside his Cedar Rapids window." Again, in describing the prose autobiography that Wood left unfinished at the time of his death, Corn writes: "Like his Regionalist paintings, the memoir renders a rosy, mythical account of boyhood on a midwestern farm." And further: "Writing in the 1930s as a city artist, not a farmer, Wood looked back at his childhood through a veil of fond memories and sentimentalized the adventures of rural boyhood." This is a theme to which Corn frequently returns in her discussion of the life and art of Grant Wood. Whatever her failures may be as a critical guide to the artist's work— and I am afraid they are fairly grave—Corn has been extremely candid in giving us an account of his life and its relation to the work. Alas, she doesn't quite seem to grasp the fact that much of what she tells us belongs more properly to the realm of psychopathology than to the realm of aesthetics. The truth is, Grant Wood's compulsive need to invent an idealized childhood dreamworld rendered him utterly incapable of dealing with the life of the "region" whose painter laureate he set out to be, and no account of his painting—or, for that matter, of the whole school of Regionalist painting—can ever be expected to make much critical sense until this peculiar psychological deformation is given its due. Among much else, it serves to remind us that Regionalist painting, while wholly dependent upon the techniques of representation, has absolutely nothing to do with the aesthetics of realism.

Though he was born on a farm near Anamosa, Iowa, in 1891, Grant Wood was never a farmer himself. Even as a child, apparently, he performed few chores on the family farm. His father was the farmer, and Wood never got on with him. "His relations with his father were tense, unresolved," writes Wanda Corn; "for his mother he had a tender, adoring love." When the father suddenly died in 1901, Wood's widowed mother moved the family to the city of Cedar Rapids, and the protracted Oedipal idyll that was the dominant emotional experience of the artist's life unfolded without further conflict. It was in Cedar Rapids that Wood lived much of his life thereafter, remaining closely attached to his mother and acquiring patrons—for mostly straight-out commercial hack work—among the local businessmen. It was not until he was faced with the prospect of his mother's imminent death that he married a woman older than himself (a grandmother, in fact) at the age of forty-four, but the marriage was not a success. One has the impression that women were never much in Grant Wood's line. When he got to be famous as an artist, however, he liked to dress up as his father, so to speak, always donning farmers' overalls whenever it came time to play the Regionalist painter in public. With Grant Wood, it is sometimes hard to know where the family romance ends and the calculations of the shrewd careerist take over.

He seems never to have been interested in anything but art, and he lacked neither talent and training for his chosen vocation nor opportunity to practice it. He went right from high school in Cedar Rapids to the Minneapolis School of Design, then the University of Iowa, then the Art Institute of Chicago, never staying anywhere for very long but determined, all the same, to become an artist of some sort. For a time his life was divided between teaching school in Iowa and studying art and traveling in Europe, and it was then—in the twenties—that Wood produced most of his few credible paintings—brushy landscapes in a late nineteenth-century French style that suggest a talent waiting to be developed. It never was developed. For at the same time Wood was also producing ghastly confections like *Cedar Rapids, or Adoration of the Home* (1921–22), a panel painting that looks, as Wanda Corn remarks, "like an altarpiece of a Madonna and child surrounded by saints," but was actually a celebration of small-town family life, complete with a cow, a horse, and the requisite toy figures in farmers' overalls, commissioned by a Cedar Rapids realtor's office to promote the sales of houses. No doubt Wood needed the money that hack work of this kind brought in, but there is no sign that he suffered any conflict in producing it. On the

contrary. In the work of his so-called maturity he found a way to make kitschy subjects of this sort more universally appealing by giving his pictures a folksier look and more workmanlike surface. The promise we glimpse in the French-style landscapes of the twenties simply evaporated in the miasma of boosterism and commercialism to which Wood signed over his talents as soon as the folks at the Cedar Rapids Chamber of Commerce proved willing to pay for them.

None of this would be worth recalling if Grant Wood had not become a celebrated figure in the annals of American art. His neuroses were not unusual, after all, and he was neither the first nor the last of our talents to sell out to an easy market and a provincial standard. But celebrated he became—and influential, too—and this makes his case a particularly painful one for the student of American art history, or indeed for anyone attempting to come to terms with American cultural life of the twenties and thirties. For how could this childish, trashy, dreamworld "vision" have come to be embraced as a representative expression of American life? The answer most certainly does not lie in the fact that Wood somehow touched an archetypal vein of midwestern rural experience. He never got near it, and actually seems to have known little or nothing about it. He glossed over its every difficulty—not to mention the difficulty that a more serious artist might have faced in coming to terms with the real thing. Finally, it is this, I suppose, that accounts both for Wood's initial success on his own home ground—not among the farmers, of course, but among the boosters of Cedar Rapids—and his subsequent celebrity as a representative of the Regionalist school: he told the country exactly what it wanted to hear about a way of life and a vein of experience it preferred not to look into too closely. It was perfectly appropriate, then, that it was in the thirties—when the real life of the midwestern farming communities suffered the worst crisis in their history—that this fantasy version of their existence enjoyed its greatest popularity the country over.

That we should now once again be invited—by several of our major art museums, a major university press, and the two national endowments—to look upon this shallow, hapless artist as some sort of American classic worthy of reconsideration is a sure sign of the collapse in standards that is more and more apparent with every passing season. The bulk of Grant Wood's art is not of museum quality, and should therefore not be presented to the museumgoing public as if it were. Even the two pictures for which he is best known occupy a place in our minds that is not exactly determined by our interest in art. Just about

everybody now finds *American Gothic* and *Daughters of Revolution* pretty funny; but it is doubtful if the former was ever intended to be so; and both pictures, in any case, now enter our experience as examples of Camp. We are amused by them, we are made to feel superior to them, we think they are "good" just because they are so "bad," etc. But this tends to be true of a great deal that we see in the Grant Wood exhibition. It simply cannot be taken seriously as painting, so we are obliged to look for another way of encompassing it. Wanda Corn solves this problem by treating both the Wood oeuvre and the whole Regionalist school as an historical phenomenon calling for some sort of vindication. But this, too, is part of the Camp phenomenon that afflicts our museums: the academics take the trash seriously, the cognoscenti are pleased to laugh over it, and the public is deprived of any useful guidance in determining artistic quality.

Actually, the only really absorbing section to be found in the Grant Wood exhibition—the only part of it where one finds some real evidence of serious *thought*—is in the gallery devoted to the political cartoons that over the years have been produced as parodies of or takeoffs on *American Gothic*. Here at least, we feel, there is something that touches real life, that moves beyond the boundaries of provincial boyhood fantasy and enters the world as we know it. But on reflection, of course, we come to realize that these cartoons, amusing and instructive as they are, do not belong in an *art* museum, either. All in all, if "Grant Wood: The Regionalist Vision" is an augury of exhibitions to come in the remainder of the eighties, we are in for some dark times.

OCTOBER 1983

II. Modernists in Retrospect

EUROPEANS

1. Late Cézanne

For the large public nowadays interested in modern painting, there is one name above all that reverberates with a special power—one name that sounds with an almost religious resonance—and that is the name of Paul Cézanne (1839–1906). In the classroom and in the museum, among both specialists and amateurs, and in the hearts and minds of innumerable living artists, Cézanne's is the art that seems to stand at the center of everything. What Matisse once said of him—that "he was the father of us all"—posterity has eagerly and abundantly confirmed in each subsequent generation.

Within the copious Cézanne canon, moreover, the work of one period in particular—the art produced in the artist's last decade—has long been regarded as a legend in itself. Like the last plays of Shakespeare and the late quartets of Beethoven, the paintings and watercolors of Cézanne's final years are felt to represent an achievement apart, at once a summation of everything formerly attempted and a transcendent leap into a new realm of the creative imagination.

Yet, like most such legends of artistic achievement, that of Cézanne's late works has more often been taken as an article of faith than absorbed firsthand as a fact of experience. It is with a very special emotion, then, that we now at last come face to face with so many of these pictures—more than one hundred oils and watercolors—in the magnificent exhibition "Cézanne: The Late Work" at the Museum of Modern Art.

This is the kind of artistic experience that comes once in a lifetime. And even as we stand in the presence of these pictures, overwhelmed by their beauty, and attempt to encompass their myriad nuances and come to terms with the spiritual odyssey that is enacted in their every detail, we weep a little at the thought that we are unlikely to see anything quite like this exhibition ever again.

For in it are brought together for the first time a comprehensive survey of all the great pictorial themes that occupied Cézanne in his final years—among them the somber portraits of aging men and women, the luminous landscapes of Mont Ste.-Victoire, the bold evocations of the Bibemus Quarry and the Château Noir, the monumental still lifes of skulls and apples, and the classical theme of bathers in a landscape. We see these themes in a multitude of variations as the exhibition retraces the arduous course the painter followed in returning, again and again, to the same motifs and wresting from each new assault a fresh idea, an individual conception, and a daring realization.

There are, for example, some twenty versions of the Mont Ste.-Victoire motif—pictures that we know from American collections, and some known only to a few specialists, now joined with others even less familiar from collections abroad. This group alone would constitute a major exhibition. Its theme—the mountain terrain in the artist's native Provence—is one of the most famous and familiar in modern painting, a textbook image that is virtually a cliché. Yet we are now made to feel that we are seeing it for the first time, as Cézanne makes and remakes his infinitely inventive structures of color and light.

Some of these pictures are dense, monumental tapestries of color, whereas others—especially the watercolors, and the oils inspired by the watercolors—are pictures constructed out of the most delicate transparency. And the range of expression that we see in the Mont Ste.-Victoire pictures is something we confront over and over again, at every turn in the exhibition, as Cézanne shifts from bold sculptural effects to a sublime lightness and airiness, from inspired modeling to a daring and almost ''abstract'' flatness, from densities of pure color and dark-on-dark silhouettes to pictures that seem to invade the white space of canvas or paper with the minimum number of touches of color needed to bring its essential luminousness to vivid pictorial life.

This range of expression, in which we see Cézanne both radically remaking the art of painting and at the same time confirming his affinities with the Old Masters, creating a grammar of modernist form, and yet reforging his links with the traditions he adored, is one of the prin-

cipal revelations of this great exhibition. It reminds us, indeed, that there is no single "late style" but a whole spectrum of styles and possibilities of style, some of which he brought to triumphant completion in his own work and some that he bequeathed to painters of later generations.

The watercolors are, of course, one of the special joys of this show, and we shall never see a greater array of masterpieces in this medium than have been assembled here. But in the great portrait and figure paintings, Cézanne attains, I think, an even more profound level of expression. To follow the course of the artist's vision and feeling, as we do in this show, from the portrait of Gustave Geffroy (1895)—the first picture we see as we enter the exhibition—and that of Ambroise Vollard (1899) to the last room, containing the two paintings *The Gardener Vallier* and *The Sailor* (1905-6), is one of the most moving experiences the art of painting can offer us. The artist who set out to re-form Impressionism and in one of his aspects prepared the way for Fauvism and Cubism and abstract art, reaches in these final portraits something akin to the tragic art of Rembrandt.

But this is an exhibition in which we are bound to make further discoveries with each visit.

It has been organized by three outstanding scholars—William Rubin, director of the museum's department of painting and sculpture; John Rewald, professor of art history in the Graduate School of the City University of New York; and Theodore Reff, professor of art history at Columbia University. Mr. Rubin also edited the 416-page book that acompanies the exhibition and that, with its nine substantial essays and 427 illustrations, will certainly be the definitive study of late Cézanne for generations to come.

OCTOBER 7, 1977

2. The Public and the Private Rodin

There are reputations in art that soar so high that, if only for a genera-
tion or two, they scarcely seem to be reputations in the ordinary sense
at all. They acquire instead the status of some eternal verity, and it
hardly seems possible that a time might come when the bright light of a
renown that is universal in scope will grow dim and even flicker out.
The fortunes of art—everything we feel about its permanence and its
destiny—seem for the moment so closely bound to the prosperity of
these reputations that the very thought of their extinction is unimagin-
able.

The last sculptor in the history of Western civilization to enjoy a
reputation on this order was Auguste Rodin (1840–1917). Like other
modern artists, Rodin was often imperfectly understood. Certain of
his works were condemned. Others were overlooked or undervalued.
He caused controversy, consternation, even scandal. Yet none of this
mattered. He swept everything before him, triumphing on a scale that
none of his successors has either equaled or attempted.

So great was the force exerted by Rodin upon his contemporaries
that it seemed to them at times not be be confined to the realm of art or
culture but to emanate from nature itself. This, to be sure, was an illu-
sion. Rodin was very much a man of culture—an artist for whom po-
etry, history, ideas, and the traditions of high art were as essential as
clay or plaster or bronze. Yet it is one of the tributes that culture pays
to nature to attribute such power to the latter rather than to itself, and
Rodin greatly benefited from this tendency.

At a time, moreover, when high art was widely perceived to be sep-
arating itself from the authority of nature, Rodin's seemed to entrench
itself in nature with a phenomenal energy and conviction. No wonder,
then, that he was worshipped—by artists and public alike—as some-
thing very like a god. In a world rapidly coming apart, Rodin's art was
taken to be exemplary in its solidity, its harmony, and its wholeness.
Against all the claims of modernist disintegration and disarray, it reaf-
firmed the heroic mode.

Yet like other mighty reputations before and since, Rodin's de-
clined precipitously after his death. Even while he lived, the sculptors
who looked upon his achievements with awe nonetheless recoiled from
his influence, and were busily preparing the ground upon which Ro-

din's fame would wither. When he died, it was therefore left to official opinion to celebrate his genius, and official opinion was proving to be a feeble ballast against the mounting power of an avant-garde that defined its interests as inimical to everything that Rodin had appeared to represent.

That his death coincided with the horrors of the Great War, as it was called, also contributed something important to the demise of Rodin's reputation. For the heroic mode that had won the sculptor so much adulation and acclaim in his heyday, the generation that emerged from the war felt only a seething contempt. In the postwar atmosphere of disillusion and revolt, little attention was paid to the many qualities and interests that Rodin actually had in common with his detractors—above all, the note of anxiety and inquietude that is constantly sounded in his work, and the recourse to a restless and unappeasable eroticism that is one of its governing motifs. In the rhetoric he employed, in the traditions he invoked, and in the very scale of his visionary ambition, Rodin seemed for the moment to belong to a world that had come to an end in the carnage of the war. Thus began the long descent of a reputation that had once held the whole of the Western world in thrall.

Of the many and varied attempts that have been made since that time to revive our interest in Rodin's art and restore it to something like its former place in the pantheon of modern masters, none has been more ambitious or more comprehensive than the mammoth exhibition that has now been mounted at the National Gallery of Art under the title "Rodin Rediscovered." It is hard to believe that Rodin will ever be more vividly presented to us than he is in this exhibition, which includes nearly four hundred sculptures—some of them never before exhibited or published, by the way—and a great many drawings and photographs. Not since the Museum of Modern Art organized its Rodin exhibition in 1963 has anything like this show been attempted in this country, and the present survey is not only conceived on a far grander scale than the Modern's but it draws upon a great many works not hitherto available for exhibition. It also benefits, of course, from two additional decades of intensive scholarly research into Rodin's life and work.

That the exhibition resulting from all this effort is immensely impressive almost goes without saying. Rodin's was, among much else, one of the most theatrical talents ever to devote itself to the sculptor's art. And he peoples his "stage"—as one often comes to think of it—

with a greater variety of gesture, action, and character than it some-
times seems possible for any single artist to encompass in a lifetime.
There are, moreover, no petty emotions in his work, no niggling iro-
nies, no blank responses or blank digressions—nothing that diverts the
sculptor's energies or the spectator's attention from the Niagara-like
flow of high feeling and headlong fantasy. The atmosphere created by
this teeming imagination is at once intoxicating and magisterial, and
the vision it discloses is so capacious that nothing in the realm of
worldly experience or mythical invention appears to have been omitted
or overlooked. We no longer wonder that the world once looked upon
the creator of this vision as a godlike figure.

Yet when we emerge from the epic theater of Rodin's imagination,
we find ourselves more exhausted than moved, more troubled by our
lack of a consistent and sympathetic response than genuinely engaged
by the unflagging feat of depiction and invention that has surrounded
us at every turn. I speak for myself, of course, but I wonder if I have
been entirely alone in finding much that one encounters in this huge
exhibition to be, at best, so highly problematical and, at worst, so ut-
terly wearisome.

Take, for example, *The Gates of Hell* and the many sculptures related
to it. This immense and complicated work, for which a new bronze
casting—standing 24½ feet high and encompassing some 186 fig-
ures—was especially authorized for the present exhibition, is in many
ways the central focus of "Rodin Rediscovered." Professor Albert E.
Elsen, who headed the team of distinguished scholars in charge of orga-
nizing this exhibition, declares it to be "one of the greatest imaginative
works of art in history," and this, I believe, is now the accepted view.
Yet it struck me, alas—and it saddens me to say it—as an almost unen-
durable sculptural dinosaur. There is no denying the grandeur of its
initial conception, but its realization is something else—full of fustian
effects, inflated rhetoric, and ranting emotion—and it finally collapses
in the mind under the weight of its own incoherence and chaos.

There is, moreover—dare one say it?—something ugly and unruly
in Rodin's conception of the human organism, an unappeased sexual
turmoil that constantly subverts and distorts his attempt to elevate
every emotion to the heroic mode. In no other artist of the modern
era—except, perhaps, in Picasso—does the libido wage such fierce
warfare against the super-ego; yet in Rodin's public sculpture this con-
flict is seldom, if ever, openly engaged. Wrapping itself in the mantle of

a universal mythology, this public art speaks to us in an idiom of ostentatious euphemism. In this respect, at least, Rodin remained securely tethered to the academic tradition he is so often said to have challenged and transformed.

Where he does directly engage the sexual turmoil that lies at the core of his inner vision—which is in the "private" sculpture and in the erotic drawings that are often related to it—Rodin emerges as a very different artist indeed. It is for this reason that the high point of "Rodin Rediscovered" is, for this observer, the gallery devoted to the unpublished plaster sculptures that are exhibited here for the first time. It is not only because the plaster "sketch" so often gives us a more direct expression of feeling than the sculptor could ever allow himself in his public, finished work. It is because the plaster sculpture is so often and so avowedly addressed to the eroticism and grotesquery of the flesh— the very themes that obsessed Rodin and for which he devised so many high cultural euphemisms and evasions in his public art. Many of the plasters—and many of the drawings, too—are wild and wayward in their emotions, and for that very reason they have the effect of mocking the more public aspect of Rodin's art and stripping it of some of its ponderous dignity.

There are many reasons, I suppose, why it has proved impossible to restore Rodin to his former position of unquestioned glory, but one of them, surely, is precisely this division we now sense at the very heart of his imagination—this division between the public Rodin, so highminded in the grandeur of his conceptions, and the private Rodin, so totally in thrall to emotions that remain at odds with his worldly program. Once that fateful division has been glimpsed and pondered, as it is now possible to do in this giant exhibition, the godlike figure of the past dissolves into an artist far more human in scale and distinctly more flawed in his achievement.

JULY 5, 1981

3. Picasso's Rage

The historic Picasso exhibition at the Museum of Modern Art is clearly intended to overwhelm us, and—no question about it—it does. The legendary force, momentum, and multiplicity of Picasso's gifts have not been exaggerated, after all. They are truly prodigious; and the art that resulted from this extraordinary endowment is, as promised, presented to us in this exhibition on a scale and with a discrimination never before lavished on Picasso or any other modern artist. That his art proves to be fully equal to this outsize scale—that, indeed, it requires this scale to be fully seen and understood—is but one of the many revelations this exhibition discloses to us for the first time.

Thus, though Picasso has long been the most famous of modern artists, and in New York one of the most frequently exhibited, this show nonetheless gives us a new measure of his achievement. Henceforth, Picasso will live for us as the artist we will have studied and lived with—and argued about and, at times, even been a little sickened by— in this exhibition.

The artist who emerges from an initial contact with this immense survey of nearly one thousand objects is, then, in some respects quite different from the artist we may have expected to see on our arrival— different, that is, from the artist we have carried around in our heads as a familiar fiction on the basis of many previous exhibitions and the words beyond number that have been written and spoken about him. He is at once larger and smaller than the Picasso of our dreams. His powers seem preternatural, his imagination gargantuan, and his energy absolutely demonic; but his character, the character that is at first slowly but then more and more insistently disclosed to us in this immense oeuvre, looks—how is one to put it?—deficient in many human qualities, and even at times positively frightening and malevolent. It may shock the pious to hear this said, but it is worth remembering that Wagner—to choose but one example from many—presents us with a similar problem, and I think we shall fail to take this momentous exhibition, and the great artist it apotheosizes, with the seriousness they deserve if we do not face up to the implications of what it is we are actually looking at in this show.

Nietzsche said of Wagner, whom he greatly admired and greatly feared, that he was "by no means good-natured," and even spoke of

Wagner's music—which affected Nietzsche so profoundly—as "a poison." This may now strike us as a characteristic example of Nietzschean hyperbole, but there is this to be said for it. It has the virtue of acknowledging what the rosy sentiments of our own culture tend so often to deny when it comes to judging aesthetic achievement: that even the greatest art may sometimes exert a spiritual force that is by no means uniformly beneficent or benign. It therefore behooves us to bear this possibility in mind in approaching an artist as central to the spirit of our culture as Picasso.

It is, in any case, in the very nature of Picasso's work to direct our attention to the man himself, for he is the most autobiographical of the great modern artists. From the bawdy drawings in which he recorded his youthful escapades in the brothels of Barcelona at the turn of the century to the geriatric rage of *The Kiss* of 1969 and the sardonic self-aggrandizement of the 1970 engraving called *Picasso's Stage*—one of the last and most revealing of the many self-analytical images we observe in this show—Picasso placed his life at the very center of his art. The point is so obvious that it would scarcely need saying were it not for the fact that our preoccupation with "style" in Picasso—and in modernist art generally—has led us at times to discount, if not actually to dismiss, the expressive functions implicit in every nuance of style.

A keen appreciation of the well-known shifts of style—the celebrated "periods" into which Picasso's work divides itself—is absolutely essential, of course, to our understanding of his art; and it is one of the special glories of the present exhibition that it documents this amazing succession of styles with a clarity and precision never before equaled. One of the salutary effects of the very abundance of the exhibition, moreover, and of the care that has been taken to keep this abundance firmly focused on the main lines of development in Picasso's work, is that it takes us—to the extent that any single exhibition can—virtually inside the artist's mind, where year by year and sometimes even month by month, we are able to observe its decisions, and the emotions and ideas governing those decisions, with an intimacy rarely accorded to outsiders.

Yet in any attempt to penetrate to the inner substance of Picasso's art—to search out its "soul," so to speak—the appreciation of style so vividly given us in this exhibition is little more than a beginning. This is one important reason why the exhibition needs to be seen more than once. Our first view may serve, then, as a form of reconnaissance, allowing us to chart the vast terrain of this art and identify its principal

points of entry. When this vast terrain has been even provisionally encompassed, however, its salient features begin to acquire a unity of interest that is no longer usefully divisible into discrete "periods" or styles. For persisting throughout all these shifts of style is an attitude—a *Weltanschauung*, if you will—that is far more consistent and fundamental to Picasso's vision than the individual styles that give it voice. It is only when we have grasped what remains unchanging—almost fixed—in the sometimes frantic, sometimes serene, but always searching metamorphosis of style that we begin to feel ourselves in touch with the inner life of the art itself.

Simply stated, this inner life of Picasso's art—the very crux of the spirit animating it through every change of form—centers on two all-consuming and, for Picasso, closely connected passions: making art and making love. The world that exists beyond the boundaries of the artist's studio and his bedroom, or seraglio, is quite conspicuously lacking in what philosophers call ontology. It lacks, in other words, reality or being. Picasso's world is thus largely confined to the aesthetic and the erotic—which, in his case, are all but inseparable—and with the scenarios of power and dominance that are endemic to these self-centered and self-glorifying interests when they acquire the force—as they so obviously did for him—of a transcendent, self-defining obsession.

This is not to deny that there are pictures and objects in this show—and beyond it, in the oeuvre as a whole—exploring other themes. Picasso lived a long time; he was a compulsive, curious, and tireless worker; and his attention was often easily diverted by a great many transitory interests—some serious, but many not—especially in the long period following his association with the Ballets Russes during World War I when, let us remember, he still had more than half his life to live out. With few exceptions, however, most of these are little more than diversions—delightful, perhaps, but often trivial, too—from the central course of his work.

The towering exception is, of course, *Guernica*, the painting that Picasso produced at breakneck speed in May and June of 1937 as a memorial to the victims on the Republican side of the Spanish Civil War. Yet even this extraordinary painting, which for many people has long enjoyed a special status—and not only among the artist's confirmed admirers but for those, too, who otherwise feel nothing but disgust for modernist painting and yet tend to exempt *Guernica* from their usual

strictures because of its manifest political content—even this painting emerges in a somewhat altered perspective in the present exhibition.

At least it does for me. The element of rage that is such a palpable and powerful constituent of this work—and that is traditionally taken to be so transparently political in its inspiration—turns out to have been well-established as one of the dominant sexual motifs in Picasso's work years before either the bombing of Guernica, or the Civil War itself, loomed on the artist's horizon.

It makes its explosive debut in a ferociously erotic picture called *The Embrace*, painted in the summer of 1925. (This is one of the many works here from the artist's estate and now in the collection of the new Picasso Museum in Paris.) Thereafter it is never for very long absent from Picasso's work until the end of his life but, on the contrary, grows to absorb more and more of his creative energy. From the late twenties onward, this theme of erotic rage is central to his art and assumes more and more violent forms. From this time, certainly, and rising to a crescendo in the thirties, women are the special object of this rage (as they had, in earlier years, been the special object of his tenderness and *tristesse*); but it attaches itself to a great many other objects and motifs, too.

The "Crucifixion" drawings after Grünewald in 1932, for example, are consumed with it, and so are a great many works devoted to the themes of Bathers, The Minotaur and The Bullfight, which, like the "Crucifixion" series, now look quite unmistakably like surrogate scenarios for episodes of erotic combat.

In this altered context, the force of *Guernica* as a painting is not diminished, but its meaning emerges as somewhat changed. It is no longer quite as convincing as the strictly political avowal it has traditionally been taken to be. Its force is the force of something more personal and primitive. Its anger now seems to address its fury to human life itself—to the spectacle of all those unappeased and unappeasable appetites of the flesh and the spirit that, for want of other means of fulfillment or resolution, end in grotesque acts of violence.

Because of the placement of *Guernica* in the present exhibition, however, its exact relation to this theme of erotic violence in Picasso's work of the thirties is by no means easy to grasp the first time around. The immense size of the painting required, apparently, that it remain in place in the first gallery of the museum's third floor, where it interrupts the chronological order so rigorously observed elsewhere in the

exhibition. It therefore makes more sense, if the visitor can possibly negotiate such backtracking amid the crowds attending this show, to study the painting after the earlier works of the thirties have been seen.

The reputation earned by *Guernica* as the most celebrated political painting of the twentieth century has given us, I think, a distorted view of Picasso's true interests, which were only marginally and intermittently social. His fractional career as a political artist is no cause for celebration, in any case. The organizers of the present exhibition have prudently spared us his ingratiating peace doves, which won Picasso great popularity on the political Left during the Cold War, and the benign portrait of Stalin he produced for the Communist Party on the occasion of the tyrant's death isn't here either (though the latter is reproduced in the catalogue). Only the *Massacre in Korea* that he obligingly turned out as a propaganda painting for the Communists in 1951 is here to represent this dishonorable episode when he betrayed his position as one of the leaders of the free culture of the West and lent his immense prestige to the support of a regime far worse than Franco's.

There is nothing more striking in this exhibition than the gulf of feeling that separates the rage and mockery—including some notable examples of self-mockery—of the later work from the almost serene absorption in matters of pure aesthetic analysis that we observe in the earlier years (from 1909, say, to 1915) when Picasso was producing the incredible succession of Cubist masterworks which remain unrivaled in his oeuvre as his greatest achievement.

Picasso was thirty years old in 1909, and had already accomplished a great deal—enough, certainly, to assure him a permanent place in art history if he had done nothing more. But the leap that occurs in his work at that time, when the audacities already broached in *Les Demoiselles d'Avignon* are so painstakingly reexamined and so subtly and delicately developed into the classical language of Cubism, places his art on another level altogether.

For the first time in Picasso's work we are made to feel that all worldly distraction is in abeyance and the pressures and inspiration of mind—of pure thought—are firmly in control. Cleverness has been eschewed, facility resisted, and sensual impulse held in check. The hammering ego that creates such a din in the later work is not yet unleashed to wreak its havoc. An inspired detachment, wielding extraordinary powers of analysis, exerts a magisterial authority; and for a few magical years, Picasso sustains his art on a plateau of apollonian emo-

tion that is like nothing else he had ever achieved before or would ever achieve again.

This, surely, was one of the sublime accomplishments of the human spirit, and for this reason those first three or four galleries on the second floor of the exhibition that contain such an astonishing number of these great Cubist paintings, drawings, collages, and sculptures afford one of the most incomparable experiences that art can offer us. The beauty and power that are sustained in these works remains so breathtaking that familiarity breeds only a deeper admiration, and we return to them with a gratitude that it is not quite possible to feel to the same degree in any other section of this vast exhibition.

Had Picasso ended his career in 1915, he would therefore still count as one of the greatest artists of his time—less versatile and less prodigious perhaps, and certainly less overbearing than we now know him to have been, but unquestionably great all the same and probably more appealing. But greatness in art comes in many forms and in many degrees, and Picasso's—even after the experience of this unprecedented exhibition—is by no means easy to place. If he does not finally, even in the face of this immense accomplishment, seem quite the equal of Cézanne—to go no farther back in art history than that—it is unquestionably because of the character and spirit that his art reveals to us in the long aftermath of that early Cubist achievement. Cézanne leaves us with nothing like the awful sense of spiritual debacle that we feel at the end of Picasso's career. The disarray of those last years remains terrifying to contemplate, and sends us hurrying back to the halcyon years of Cubist splendor for a renewal of our faith in his genius and integrity.

JUNE 1, 1980

4. "The Essential Cubism" in London

"It is a curious fact," writes Alan Bowness, "that there has never before been a major Cubist exhibition in London." Mr. Bowness, the director of the Tate Gallery, has lately set out to rectify this astonishing situation by inviting Douglas Cooper and Gary Tinterow to mount a major exhibition. The result is "The Essential Cubism: Braque, Picasso and Their Friends, 1907–1920." This is in many ways a splendid exhibition and in some ways a peculiar one, but nothing in or about it is quite as peculiar as the "curious fact"—what an understatement!—that it has been so long in coming. Before turning to this interesting, if belated, exhibition, it might therefore be useful to place it in some historical perspective—though this is, admittedly, a little like attempting to trace the history of a void.

It is worth recalling in this connection that Alfred H. Barr, Jr., organized an exhibition of "Cubism and Abstract Art" at the Museum of Modern Art in New York as long ago as 1936—roughly a quarter of a century after Alfred Stieglitz first introduced the work of Picasso and Braque to the American avant-garde at the 291 gallery and the Armory Show brought Cubism and other modernist styles to the attention of the public at large. These exhibitions exerted an immense influence on American art and on American taste, prompting not only artists but dealers, collectors, and critics to take a serious interest in the new European art. This in turn led to the formation of modernist collections that in many cases account for our remarkable museum holdings in this field today. These, in turn, have played a decisive role in shaping the course of American art over the last four or five decades. A similarly prompt response, especially to Cubism, can be traced among artists, collectors, and dealers in Germany and Russia—and the artistic results of this response proved to be of even greater consequence in the latter countries than in the United States.

The situation in England was very different, particularly where Cubism was concerned. The only events in English art history that form an approximate parallel to the Stieglitz exhibitions or the Armory Show are the two Postimpressionism exhibitions that Roger Fry organized in London in 1910 and 1912. The first of these included but a single Cubist painting—Picasso's 1909 portrait of Clovis Sagot, now

in the collection of the Hamburger Kunsthalle. In the second Postim-
pressionism exhibition there were fifteen Picassos—but it was Matisse
whose work dominated the exhibition with more than double this num-
ber, and the derision that Picasso's work met with on that occasion was
never really engaged even by the sponsors of the show. (Frances Spal-
ding tells the whole story in her recent biography of Fry.) One has the
impression that Fry never cared much for Cubism even though by
1914 he had acquired two Cubist collages—a Picasso and a Juan
Gris—for his own collection. He certainly never became a critical
champion of the movement, and no one else in Britain did either. The
dealers shunned it, the collectors ignored it, and what passed for an
avant-garde in England satisfied itself with a second-rate substitute
called Vorticism.

Oddly enough, Fry's enthusiasm, shared by many of his Blooms-
bury friends, was largely reserved for the more decorative aspects of
Cubism. These he eagerly adopted as design elements in the furniture
and textiles produced by the Omega Workshops he organized in 1913.
Yet far from advancing any real understanding of the Cubist aesthetic,
this cozy, decorative use of its more superficial devices only served to
blur its artistic importance. The Omega style—so typically Blooms-
bury in the way it diluted and distorted modernism in the interests of
aesthetic sociability—made Cubism look homey and insipid, while
Vorticism made it look like little more than literary bluster. Together
they effectively buried Cubism before it had a chance to win any vital
following in England.

The consequences for modernist art in Britain were immense and
almost wholly negative. It condemned painting to an insularity that
punished originality and warped judgment—and, by no means inci-
dentally, deprived England of a great many works of art that its own
artists needed for their creative growth. (This is something to remem-
ber the next time you hear the whole world of adventurous dealers, col-
lectors, museum curators, and critics ridiculed as nothing but a com-
mercial racket.) In the twenties, as Mr. Cooper points out in one of his
essays for the catalogue of this exhibition, "Augustus John was still
more highly valued than Matisse and Picacco," and this tradition,
though nowadays somewhat chastened and certainly no longer as viru-
lent or as smug as it once was, has not exactly run its course—as we can
see in the preposterous overrating of a talent like David Hockney's, for
example. But that, of course, is not solely an English problem.

Still, the situation in Britain is not what it was. In 1959 a gifted art historian and painter, John Golding, produced the first solid study of Cubist painting in *Cubism: A History and an Analysis 1907-1914*, and a whole generation of scholars and writers has rallied to provide an intelligent and well-informed literature on the European modernism that England largely missed out on during the course of its development. Mr. Bowness belongs to this generation, and under his direction the Tate Gallery is hastening at last to fulfill its obligation to serve as a genuine museum of modern art. For this purpose no exhibition was more important for the Tate to undertake than a major Cubism exhibition, for it is only in relation to Cubism that much else in the history of modernist art can be understood. Cubism was the great watershed in the art of the modern era—so much so that even those styles that have sought to reject it or somehow circumvent its influence have tended to define themselves in relation to it. Without a comprehensive knowledge of its history and its achievements, we are simply adrift, without compass or moorings, in the art of the century in which we live. This, more or less, has been the condition in which the British art public has often found itself.

It was a brilliant stroke, moreover—though also something of a gamble—for Mr. Bowness to invite Douglas Cooper to organize this exhibition. Mr. Cooper, I think it is fair to say, is not one of those figures who is universally beloved in the British art world. Wealthy, erudite, independent, outspoken, and more than a little cantankerous, he has never attempted to disguise his contempt for the critical opinions of his compatriots or for the provinciality (as he saw it) of their taste. Over a long career as a collector, writer, connoisseur, and organizer of exhibitions—he is now in his seventies—he has managed to leave a great many important people feeling somewhat bruised and ill-treated. Yet on certain subjects—and Cubism is one of them—he speaks with an unquestioned authority. Fifty years ago he set out to form his own collection in this field, and he had the money, the eye, and the sensibility and determination to make a resounding success of this endeavor. In the course of his activities, he got to know the major surviving artists—particularly Braque, Picasso, and Léger—and he produced a series of important scholarly works on their achievements, among them *Fernand Léger et le nouvel espace* (1949), *Letters of Juan Gris* (1956), *Picasso Theatre* (1968), and *Juan Gris, Catalogue raisonné de l'oeuvre peint* (1977). No doubt a younger generation of scholars will find much to add to

these works—this is inevitable in any field of art-historical research—but Mr. Cooper will always have to be regarded as one of the pioneer scholars of Cubism. And by inviting Gary Tinterow to collaborate on this exhibition—Mr. Tinterow, an American art historian many years his junior, published an impressive catalogue of *Master Drawings by Picasso* for the Fogg Art Museum at Harvard in 1981—Mr. Cooper could be assured that his own catalogue for "The Essential Cubism" would avail itself of the most up-to-date research.[1]

As its title suggests, "The Essential Cubism" is an exhibition with a mission to fulfill. It seeks to concentrate upon and isolate the original impulses governing the creation of Cubism, and to separate the results from the many imitations and offshoots that almost immediately followed in the wake of its initial realization. This is not the simple task it may seem, for Cubism was one of those styles that had a lightning effect on virtually everything that surrounded it. It proved to be perilously easy to mimic—and to misunderstand—and it wasn't only in artistic backwaters like London that its essential quality was misperceived. At the same time, its influence was sometimes so hermetic that even now it goes largely undetected, or at least undiscussed. (Certain paintings that Matisse produced in the years immediately before the First World War, for example, would have been inconceivable without the prior development of Cubism, yet Matisse is rarely discussed in this connection.) Even where the influence of Cubism is obvious and unquestioned, there is the problem of distinguishing artistically significant consequences from abject dependency and superficial mimicry. Léger, for instance, made his entry into Cubism as something of an imitator, yet who would deny that he quickly made something authentic and original on his own? But where is one to draw the line on this authenticity—at Gleizes or Herbin or Klee or Feininger?—before the subject becomes unwieldy and meaningless? Then there is the knotty problem of so-called late Cubism, which for some writers has at one time or another been thought to include just about everything that modernist artists have produced in the last sixty years or so.

[1] *The Essential Cubism: Braque, Picasso and Their Friends, 1907–1920* by Douglas Cooper and Gary Tinterow, The Tate Gallery. Every work in the exhibition is illustrated and given a detailed provenance. Mr. Cooper's essay on "Early Purchasers of True Cubist Art" traces the history of the dealers and collectors who took an interest in Cubist painting during the first two decades of its existence.

Twelve years ago Mr. Cooper undertook to explore this matter in an exhibition which he organized for the Los Angeles County Museum of Art and the Metropolitan Museum of Art. It was called "The Cubist Epoch," and it was not a success. His primary sympathies were clearly reserved for what he called "true Cubism"—the subject he has returned to in "The Essential Cubism"—and he proved to be an uncertain and sometimes confused guide wherever he was called upon to make judgments beyond the boundaries of the materials he knew best. It was absurd, for example, to have excluded Julio González from the section devoted to Cubist sculpture while at the same time including the work of a minor figure like Otto Gutfreund. And in the whole uncharted realm of "late" Cubism, more often than not Mr. Cooper succumbed to the usual temptation—which is to admit the artists one knows and prefers while consigning all others to oblivion. For these and other reasons, "The Cubist Epoch" was rather a mess—a model of how *not* to organize a major historical exhibition.

Some of the problems that afflicted "The Cubist Epoch" are not entirely absent from "The Essential Cubism," as we shall see, but the bulk of the exhibition avoids them by concentrating on Braque, Picasso, Gris, and Léger, and giving us an almost step-by-step, picture-by-picture account of Cubist painting from its inception in 1907-8 in the work of Braque and Picasso through the ensuing stages of its evolution, refinement, and elaboration in the pictures of all four masters and in the early sculptures of Picasso, Laurens, and Lipchitz. Not every key work in the history that is traced here is included, alas. Picasso's *Les Desmoiselles d'Avignon* (1906-7) from the Museum of Modern Art is the most conspicuous omission, and there are no loans from the great Russian collections. But the selection, numbering in all some 233 items, is remarkably comprehensive, all the same, and certainly adequate to the task of providing us with a profound experience of what it was that these artists achieved.

The very heart of this experience lies in the work of Braque and Picasso, of course, and not only in the earliest years of the Cubist initiative but right through to the eve of the First World War, and it is their art that is properly given priority in this exhibition. Messrs. Cooper and Tinterow are surely correct in insisting that "the central episode in the evolutionary history of Cubism is entirely dominated by Braque and Picasso, who together progressively perfected and consolidated their new manner of pictorial representation, and eventually (1911) shifted from a perceptual to a conceptual approach to reality." It is

worth pausing over and emphasizing this reference to "pictorial *representation*," I think, for it is now so easy to overlook its significance. Nearly three-quarters of a century of abstraction—the kind of abstraction, moreover, that owes its origins quite specifically to the conceptual aspects of Cubism—have tended to blur our understanding of the degree to which Cubism was indeed a radical mode of representation from its very inception, and also the degree to which it remained a mode of representation for its original creators right to the end of their careers. Much of the high drama that we experience in following the creation of this style and its evolving vision from painting to painting derives from the tension and conflict that we see enacted in the struggle of these artists to retain some residual contact with the representational function of art while feeling more and more compelled to give a fuller and more intense expression to the more formal, abstracting elements of their own discoveries. To counterbalance the driving force of this abstracting impulse, they introduced ingenious tokens of "reality"— hence the invention of the *papier collé*—almost as if they were seeking to avoid some fateful precipice. None of this could have been anticipated or programmed in advance. There were no theories or manifestos, no politics or ideology, no scientific reasoning or philosphical doctrines. Cubism was all a matter of disinterested discovery and inspiration, and it is the particular virtue of this exhibition that it so vividly restores to us precisely this sense of the artistic and intellectual discoveries that guided its course.

This is what finally separates the "essential" Cubism from its many peripheral off-shoots—this sense of discovery that we are made to feel in the work of the masters. It is there in abundance in the work of Gris (who is especially well represented in the exhibition) and in Léger (who is not), and it isn't there at all in the work of Gleizes, Metzinger, Marcoussis, or Villon, and we feel the difference keenly. The latter occupy only a peripheral role in this exhibition, but even so, they don't belong in an exhibition called "The Essential Cubism," and it is almost cruel to their work to include it—they are so obviously outclassed. Otherwise, Messrs. Cooper and Tinterow have given London an exhibition that fully lives up to its name. Now it will be interesting to see what London finally makes of this belated effort to apprise it of the most important event in the art of the twentieth century.

JUNE 1983

5. Bonnard

That's not painting, what he does.

—Picasso on Bonnard

The great art event in Paris this spring has been the resplendent Bonnard exhibition at Beaubourg.[1] Though not an exhibition on the grand scale—it does not even attempt to give us a comprehensive account of the artist's oeuvre—it has nonetheless proved to be one of those events that stay in the mind as a major experience, continuing to reverberate in the memory as something unexpectedly weighty and profound.

Bonnard profound? Is it possible? It was not the way one was used to thinking of him. One went to this exhibition, as one had always gone to Bonnard's work, expecting pleasure; and pleasure it certainly afforded in ample measure. But added to this expected pleasure was something else—a sense of the artist's power, conviction, and authority which, for this observer at least, was something quite new. It was as if one were seeing the artist's true originality for the first time.

It was no surprise, of course, to find that Bonnard had been a wonderful painter. One hardly expected to be disappointed in this respect. Bonnard had always been pleasing to the taste, and his ability to please remained undiminished. Yet it is one of the oddities of modern cultural life that the artists who give us some prompt and unalloyed pleasure are not usually the artists who loom largest on our artistic horizon. They tend to be taken for granted. By the standards that had come to be applied to modern painting, there was thus something suspicious in

[1]"Bonnard," directed by Gérard Régnier, is currently on view at the Musée nationale d'art moderne at the Pompidou Center (Beaubourg) in Paris and will then travel to the Phillips Collection in Washington and the Dallas Museum of Art, co-organizers of the exhibition. The exhibition catalogue, *Bonnard*, published in the lavish format of the Pompidou Center's "Classiques du XXᵉ siécle" series, contains an introduction by John Russell and essays by Jean Clair, Steven A. Nash, Margrit Hahnloser-Ingold, and Jean-François Chevrier, in addition to Antoine Terrasse's chronology of the artist's life, excerpts from Bonnard's notebooks, reproductions of his photographs, and extensive notes on the individual paintings.

Bonnard's unfailing ability to please—something that suggested timidity, perhaps, or a lack of intellectual initiative. Had he actually done anything new, or was he—as was sometimes said—only a latter-day Impressionist clinging to a moribund tradition?

Even among Bonnard's admirers there had often persisted an element of uncertainty about these matters, and thus about the size and scope of his achievement—even, perhaps, about the nature of his achievement. However much one loved his work—and something like love was what Bonnard's work usually inspired in those drawn to it—there was, all the same, a certain hesitancy about placing it right up there in the front rank of the art of his time. There always remained some doubt as to whether Bonnard was really "big" enough to take his place beside the largest and most commanding talents. Too accomplished to be considered minor and yet not sufficiently imposing to be regarded as one of the greatest, Bonnard seemed to be permanently lodged in a sort of limbo of indeterminacy where our affection for his work stood guard against whatever doubts our critical faculties might be inclined to bring to it.

If the passage of time has now altered our perspective on Bonnard—as I believe it has—this undoubtedly owes much to the fact that our increasing distance from the great days of the School of Paris has had the effect of casting *all* of its myriad achievements in a new historical light. No longer are we as inclined as we once were to look upon the radical innovations of the School of Paris as constituting its most distinctive contribution to the art of the modern era. Important as these innovations were, they now look in retrospect less like ends in themselves than a means of sustaining an artistic tradition whose last glorious chapter has turned out to be the School of Paris itself.

This applies even to Cubism, the most radical of all the innovations spawned by the School of Paris—at least to Cubism as it evolved in the work of Picasso, Braque, Gris, and Léger, its originators. Far from providing an alternative to the Western pictorial tradition or a liberation from its authority—which was what Cubism did lead to when certain of its ideas were appropriated and radically transformed by the Russian avant-garde and other groups intent upon a more far-reaching revolution in art—Cubism in its classic School of Paris modality remained, on the contrary, a highly inventive means of giving that tradition another lease on life.

But such leases are, by their very nature, impermanent, and this

one certainly proved to be. The tradition to which Cubism had given new life was not something that could be handed on, as it turned out, and it wasn't. It could only degenerate into a variety of *pompier* parodies of itself. In the art that succeeded its demise—whether Dubuffet's in Paris or that of the Abstract Expressionists in New York—this tradition could still play a fugitive role, to be sure, serving as foil or irritant, as something to be resisted, ransacked, or transcended; but it could no longer offer direct sustenance. Which, incidentally, is one reason why Balthus has come to loom so large in our thinking about the School of Paris and the pictorial tradition it embraced and embodied. For in the work of no other painter of his generation has the will to resist the death of this tradition so completely shaped the scale of the artist's ambition and determined the quality of his oeuvre. Yet, however we may judge Balthus's achievement, it is hard to think of it as anything but a grand—or, depending on one's view of its success, only grandiose—epilogue to the great tradition it celebrates.

Difficult as it may be for us to think about the School of Paris in such terms—not, that is, as an avant-garde renaissance heralding the birth of a new era (which is pretty much the way we have all been brought up to see it), but as the glorious twilight of an epoch drawing to a close—this, I believe, is the way it is going to look to future generations. And this, in turn, is going to entail some drastic revisions in the way the history of modern painting will be written by, and for, those future generations. Already the existing textbook histories of the subject have begun to look obsolete, for they are based not on our current experience of the art in question but on an attempt to elucidate its intentions. Praiseworthy and even necessary as this task of elucidating intentions undoubtedly is, the result—more often than not—is the kind of partisan history that tells us a good deal more about what artists hoped to achieve (and therefore, all too often, are assumed to have achieved) than about what they actually did achieve. And being at the same time wholly governed by a suspension of disbelief in the efficacy of the various avant-garde ideologies that are thought to have determined the artists' goals, this history looks more and more like a species of intellectual fiction designed to guarantee a denouement that is at once foregone and unexamined. The least that can be said about such history is that it no longer accords with our experience of the art it is intended to explain. The worst that can be said of it is that it obscures the kinds of distinctions that loom largest in our experience of art and make it so precious to us.

It will be self-evident to anyone who has pondered these matters that certain artists have greatly benefitted from this state of affairs while certain others have suffered. It is ideally suited to the interests, for example, of a figure like Marcel Duchamp, whose actual accomplishment is so slender as to border at times on the non-existent, but it could not be anything but severely damaging to an artist like Bonnard, whose work cannot be made to accommodate the requisite categories and classifications without injury to the very quality of its existence. The priority given to ideas in Duchamp guarantees him a high position in any scenario that favors ideas at the expense of artistic realization. By contrast, Bonnard is an artist who seems to have had no "ideas" at all—except, of course, those that could be articulated by his paintbrush. Yet can anyone really doubt that Bonnard is the superior artist?

Alas, such doubt—never argued, to be sure, but simply assumed—has been a commonplace in the cultural life of the last quarter-century. And in the judgment implicit in this adverse comparison we can still hear the echoes, perhaps, of that curious attack on Bonnard which appeared in the pages of no less a journal than *Cahiers d'Art* in 1947, the year of the artist's death at the age of seventy-nine. That article was very likely inspired by Picasso, for whom *Cahiers d'Art* served as a kind of house organ and whose own ferociously critical view of Bonnard was subsequently reported in detail by Françoise Gilot in her memoir, *Life with Picasso*. The title of the article asked the question: "Pierre Bonnard—est-il un grand peintre?" And the conclusion of the article gave the following answer: "It is evident that this reverence [for Bonnard] is shared only by people who know nothing about the grave difficulties of art and cling above all to what is facile and agreeable."[2] Some version of this judgment will always, I suppose, be the view of professional avant-gardists in every generation, and it is for this reason that Bonnard has survived as a kind of displaced person in the art of his time.

Not the least of the many amazing things about the current exhibition at Beaubourg is the way it instantly sweeps aside all these questions and equivocations—including those that one has carried on one's own head for years—to reveal an artist of overwhelming power and intensity. An artist, moreover, of great originality who, though something of a slow starter, showed a remarkable tenacity and independence

[2]This episode was discussed by James Thrall Soby in his introduction to *Bonnard and His Environment* (Museum of Modern Art, 1964).

in perfecting his own highly individual vision over the course of a long career.

It was a wise decision, I think, to accord Bonnard's work of the nineties little more than a token representation in this exhibition in order to concentrate on the paintings of his maturity. (Of the sixty-three paintings in the exhibition, fifty are drawn from the years 1920–1947.) For the Bonnard we associate with *la belle époque*, while an artist of enormous charm, intelligence, and vivacity, was above all a public artist, obliged to compete in the marketplace for a living. This he managed to do with distinction, producing a dazzling array of posters, illustrations, stage décors, and the like—many of which are familiar to us as classic examples of Art Nouveau design. But we do not encounter the real power of the artist until we meet with what, by contrast, had better be called the "private" Bonnard—a painter of Baudelaireian sensuality who fashioned out of the most "unpromising" materials, namely the abandoned remnants of late Impressionist and Postimpressionist picture-making which the Cubists had nominated for oblivion, a style of uncompromising rigor.

The earliest of the paintings in which this private Bonnard reveals himself is the sleeping nude called *La Sieste* (1900). This is a painting with an illustrious history, having first been collected by Leo and Gertrude Stein and subsequently by Kenneth Clark. (It now reposes in the collection of the National Gallery of Victoria in Melbourne, Australia.) With its forthright depiction of a sleeping female nude on a rumpled bed, it strikes us straightaway as an archetypal image of *fin de siécle* eroticism, and we can hardly doubt that it commemorates a personal experience. Yet, as with so much that we encounter in the private Bonnard, what appears to be the most candid avowal of personal experience is subsumed in an artistic strategy of considerable complexity and one that tends, if not quite to deny this element of the personal, at least to relegate it to a secondary order of importance. Though not as audacious in either its structure or its angle of vision as Bonnard's pictures would shortly become, *La Sieste* nonetheless gives us a first glimpse of that luminous, soft-edge geometry—scaffoldings of vertical and horizontal bands and blocks of color as deftly deployed in relation to the shape of the support as anything in a Mondrian or a Noland—which evolved into one of the hallmarks of his style. The formal effect of this luminous scaffolding is to delimit radically the space which the painting comprehends in such a way that the eye is made to feel itself in an

immediate and irresistible retinal contact with every visible atom of the picture surface. Later, especially in the great paintings of the thirties, when Bonnard gave greater priority to close-valued color of the most extraordinary intensities and could therefore abandon the kind of chiaroscuro he still replied upon in *La Sieste*, he made this pictorial idea the principal basis of his art. And on that basis he became a colorist whose only rival among his contemporaries was Matisse (if, in the thirties, even Matisse could really be said to be his rival).

In *La Sieste* we are given only a first glimpse of this development. It remains in some respects a nineteenth-century painting, closer to Degas than to Matisse, not only in its subject matter but in the way it is conceived. For like Degas, Bonnard was an artist who painted with the art of the museums in his head. Thus, while the nude figure in *La Sieste* may very well have its origin in the painter's personal experience, we now know that that was by no means its only source, and was probably not even its primary one. For as Sasha Newman points out in a note for the catalogue of the exhibition, the image of the sleeping figure is based, right down to the way the left foot rests on the calf of the right leg, on a Roman copy of a Greek sculpture in the Louvre. What looks so intensely personal in Bonnard is rarely quite as personal, in the anecdotal sense, as it seems. Even in the most erotic paintings, the sexual emotion remains a coefficient of the pictorial idea.

The private Bonnard is, in fact, a far more mysterious and elusive figure than he is generally thought to be. In many of his greatest pictures—paintings of the breakfast or luncheon table, the bedroom, and the bath—the *mise en scène* is drawn from the most intimate moments of the artist's domestic life, which was itself a conundrum to Bonnard's friends. In the nineties the artist entered into a liason with a very young woman ("then still a child," his friend Thadée Natanson said) who went by the name of Marthe de Méligny. Some thirty years later—in 1925—she and Bonnard were married; and it was only then that Bonnard discovered her real name, which was Maria Boursin. Even at that late date he seems to have known little or nothing about her, yet she remained something of an obsession in his life and one of the central motifs of his art until her death in 1942.

Because of the ubiquitous figure of the legendary Marthe—bathing, breakfasting, etc.—in Bonnard's major paintings, they often give us the impression of being as diaristic as Picasso's. Yet are they? This is undoubtedly an important connection between the intimacy of

Bonnard's subjects and the style of his art—for even his landscapes partake of this intimacy—but his paintings are, all the same, as removed from the diaristic as paintings drawn from life motifs can be. For one thing, the figure of Marthe never ages. She remains a timeless apparition of youthful sensuality—an idea or an archetype even more than a presence. In Bonnard's paintings of her—or, for that matter, of himself—there is no trace of posturing or boasting. There are no displays of virility or emotional violence. What we are made to feel most intensely is the artist's total absorption in what he sees and what he makes of what he sees, and this turns out to be something *we* had never before seen in a painting.

In these paintings drawn from the scenes of his intimate domestic life, I think we are given an important clue to Bonnard's overriding aesthetic interests, and the reason why they remained so tenaciously tethered to the remnants of late Impressionist and Postimpressionist picture-making. For what matters most to Bonnard—in life, we are tempted to say, as much as in his art—is the accretion and analysis of sensation. Bonnard was never a realist in the sense that Courbet or even Degas, in certain phases of his work, could be said to be; but in some fundamental aspect of his painting he was certainly a subtle and fanatical, if also a highly idiosyncratic, naturalist. He was a naturalist in the sense that Monet was a naturalist—a naturalist of the eye, concentrating more and more intently as he developed his art on the precision of his perceptions and on the vexing problem of creating an exact pictorial correlative for their faithful representation.

It is no idle paradox to suggest that naturalism of this sort—a naturalism so intensely absorbed in analyzing and refining the most minute particles of perception—must inevitably find its pictorial resolution in a kind of abstraction. That is the course traced in the late paintings of Monet, and we find something akin to this tendency in Bonnard as well. Perceptual naturalism carried to this radical extreme tends, by its very nature, to be boundless and anarchic, and must therefore invoke some countervailing principle if it is not to dissipate the sensations it has garnered in a formless miasma of atomized observation.

Bonnard had such a principle ready to hand, as it were, in the pictorial conventions of the Nabi style on which he was nurtured as a young artist. Derived from Gauguin and the Pont Aven school, these

conventions placed great emphasis on "flat," unbroken planes of highly saturated color, and constituted one of the definitive modalities of Postimpressionist painting. In opposition to the naturalistic component of Impressionism, the Nabi style offered itself as a more "abstract" or Symbolist alternative, and Bonnard retained a strong attachment to its formalist outlook throughout his career. Yet at the same time, like his friend Vuillard, who probably influenced Bonnard a good deal in this regard, particularly in the creation of his mature style, he found the austerity and abstraction of the Nabi style insufficient for his increasingly complex purposes—insufficient, we may say, for his increasingly complex sensibility. There was no place in it for registering those accretions of sensation that became more and more essential to his temperament as an artist—and, we may infer, as a man.

To accommodate that compelling appetite for sensation, Bonnard was obliged to turn back to certain elements in the Impressionism which the Nabi painters had categorically disavowed—and which, in fact, continued to be disavowed by virtually every generation of avant-garde painters until the time came when the Abstract Expressionists rehabilitated Monet. The Impressionist element remained but one term in the dialectic of Bonnard's style, but it was a crucially important term—for it was the means by which the private Bonnard continued to supply his painting with extraordinary reserves of lyric emotion. It was also crucially important in inspiring the kind of disapproval that Bonnard sometimes met with. The truth is, Bonnard's decision to "return" to Impressionism was an act of great artistic daring in the art life of his time. It was one of those radical aesthetic initiatives—radical, at least, in refusing to conform to the reigning avant-garde imperatives of the moment—that are taken to be conservative and even reactionary only because they are mistaken as efforts to return to something safe and settled. Bonnard—who was almost alone among twentieth-century masters in this respect—understood that in the abandoned remnants of the old Impressionism there remained some unfinished artistic business of great creative value, and he pursued his intuition—no doubt because it offered him a vein that exactly suited his private world of feeling—with an uncommon tenacity. When Picasso dismissed Bonnard by saying "That's not painting, what he does," he was only, after all, saying that Bonnard had never succumbed to the influence of Cubism, and it was probably inevitable that we would have to wait until

Cubism and its many offshoots and by-products had quit the cultural stage before Bonnard would come to be recognized as the master he is. That moment seems at last to have arrived.

May 1984

6. De Stijl

For the large public that nowadays takes a keen interest in the history of modern art, the most important event currently occurring in this country is the definitive exhibition called "De Stijl: 1917–1931, Visions of Utopia," which has just opened at the Walker Art Center. It has been thirty years since the late Alfred H. Barr, Jr., devoted an exhibition to this Dutch avant-garde movement at the Museum of Modern Art in New York. In the interim, much new information on the movement has come to light, and an even greater significance has come to be ascribed to its achievements. Clearly, the time had come to take a fresh look at these achievements, and this is what the Walker has now done, both in the exhibition organized by Mildred Friedman, the museum's curator of design, and in the accompanying book that Mrs. Friedman has edited for the occasion and that will long serve as a standard work of reference on the subject. The result is a major contribution not only to our understanding of De Stijl itself but to our appreciation of the entire European avant-garde in the period between the two world wars.

Alas, as often seems to be the case these days, this exhibition will not be coming to New York. Arrangements could not be worked out with any of the appropriate museums. The show is on view in Minneapolis and will then be seen at the Hirshhorn Museum in Washington. It will then travel to The Netherlands, where many of the crucial loans to the exhibition originated and where it will be divided between two museums: the Stedelijk in Amsterdam and the Kroller-Muller in Otterloo.

"Of all the movements of the 20th century," wrote George Heard Hamilton in his Pelican history of modern European art, "De Stijl has seemed the most doctrinaire and at first glance the least accessible, yet ultimately and paradoxically it may have been the most influential." Like certain other avant-garde movements of the period, De Stijl— which in Dutch means, simply, The Style—reached beyond painting and sculpture to embrace architecture, furniture, typography, and the design of everyday objects. It even attempted at times to include literature and music in its program. Its aim was nothing less than—in the words of the Dutch art historian Hans L. C. Jaffé— "the formation of a new style of life."

This, of course, De Stijl did *not* achieve. When new styles of life came to Europe in the thirties and thereafter, they came as the result of social and political forces that lay far beyond the power of De Stijl, or indeed of any other art movement, to either initiate or forestall. Yet De Stijl did succeed in exerting an enormous influence, all the same. Mr. Hamilton was certainly not wrong about that. It profoundly altered the way we think about art and about the entire realm of visual culture in advanced industrial societies.

The governing ideas of De Stijl may have been doctrinaire—it is, after all, in the nature of utopian ideologies to be inhospitable to alternative modes of thought—and at times even hermetic. But this has not prevented these ideas from having an enduring appeal. More than half a century after the dissolution of De Stijl as a cohesive movement, there is still no shortage of painters and sculptors, architects and designers and planners, and critics and theorists who look to De Stijl as a source of wisdom and inspiration. Even the larger public that remains ignorant of its doctrines has proved to be remarkably susceptible to its standards of taste.

If, for example, we now find it perfectly natural—and even inevitable—for painters and sculptors to base their work on pure geometrical form, for architects to design buildings based on the principles of geometrical modular construction and devoid of extraneous ornament, and for designers to employ white and grays and unmixed primary colors in the decoration of our houses and places of business and in the manufacture of household objects and office equipment, then we may be said to have assimilated a good deal of the thought and taste that De Stijl introduced into the modern world.

De Stijl's ambitions were grander and more metaphysical, to be sure, than ours are likely to be today. For in its headier moments, De

Stijl set out to achieve a dream of utopian perfection that would transform earthly life into a model of spiritual harmony and order. This is something that few of us nowadays entertain any illusions about and even fewer look to painting or architecture to achieve for us. But we have nonetheless found much to use, even if for more modest purposes, in the visual program that De Stijl created to implement its utopian ideal.

Like other groups of its kind, De Stijl was initially composed of individual artists—painters, architects, and designers—who differed much among themselves. Its greatest talent was Piet Mondrian, a painter of genius whose interests were more metaphysical than social. Its principal animating force, however, was Theo van Doesburg, a painter, designer, and writer who was the very archetype of the avant-garde promoter and publicist. It was van Doesburg who conceived of the magazine that gave De Stijl its name, who enlisted artists from other countries—among them, El Lissitzky and Hans Richter—to join in its activities, and whose death in 1931 marked the end of the group's existence.

Among the others allied with Mondrian and van Doesburg in varying degrees of commitment were Gerrit Rietveld, the designer of the so-called Rietveld-Schroder House in Utrecht, which survives as the principal classic of De Stijl architecture, and the creator of the painted modular furniture that remains the movement's main contribution to that branch of design; the architects Jan Wils, Robert van't Hoff, and J. J. P. Oud, who proved to be early defectors from the movement; Bart van der Leck, a painter of remarkable gifts who defected even earlier; Vilmos Huszar, a painter and designer who is certain to be one of the major "rediscoveries" of this exhibition; Georges Vantongerloo, the Belgian painter and sculptor who participated in the founding of De Stijl and proved to be yet another early defector; and Piet Zwart, another of the gifted designers to be associated with the group.

The work of all of these and other participants in De Stijl's many-sided activities is traced in this exhibition with a scope and an attention to detail that has never before been equaled. If only for its comprehensive representation of paintings by Mondrian, van Doesburg, van der Leck, and Huszar, this exhibition would have to be considered a major event. (We are able to see for the first time, for example, both the figurative and the abstract versions of van Doesburg's 1916–17 *Card Players* paintings— a key moment in the evolution of De Stijl's pictorial style.)

But architecture, interior design, furniture, and typography are also accorded their full share of attention. The Rietveld-Schroder House is particularly well documented, and so is Mondrian's Paris studio in the twenties—an interior designed according to the strictest De Stijl principles. (Even Mondrian's white easel has been included.) And there are several splendid architectural reconstructions in this exhibition, the most important being the interior of the Café Aubette in Strasbourg for which van Doesburg enlisted the collaboration of Sophie Taeuber-Arp and her husband Jean Arp.

By the time the interior of the original Café Aubette came to be created in 1926, the De Stijl movement could scarcely be said to exist as anything but an idea in van Doesburg's mind. But its influence was already widespread, and in the years to come it would grow even stronger. The radical program of purification it originally set for itself—its insistence on strict geometrical forms and on primary colors as the only permissible vehicles for a truly "spiritual" and "universal" vision—would be modified and even abandoned. Yet, the essential ethos of the movement, which postulated an ideal relationship between our visual environment and our ethical standards, would continue to inspire a great many talents that had nothing to do with De Stijl itself.

To understand the impulse that set this movement on its course and kept it going for more than a decade, despite profound disagreements among its members and the defections of some of its leading talents, it has to be remembered that, like Dada and certain other avant-garde groups of the period, it originally emerged as an expression of moral recoil from the horrors of World War I. It was the cataclysm of the war that inspired De Stijl's utopian aspirations and the disillusionments of the postwar period that sustained its ambition to create, as it were, an alternative world.

De Stijl was never really political, however. Although its first manifesto consigned "the individual" to the past and upheld "the universal" as the basis for a new culture, this was essentially an aesthetic and even mystical program rather than a political idea. Not the least of its many appeals, indeed, was the faith that De Stijl placed in art as a medium of social and spiritual redemption. In the end, of course, it asked much more of art than art alone can ever give us. Yet, in a century that has been riddled with poisonous ideologies and repugnant visions, what a clean, sweet smell this particular movement has left behind even for those who remain skeptical of its claims.

And what a splendid monument this movement has been given in the Walker's extraordinary show. In every detail of its selection and installation, "De Stijl: 1917–1931, Visions of Utopia" is an exemplary exhibition and will certainly be looked upon for a long time to come as the event that gave us an essential account of the movement and its diverse roster of artists and visionaries.

<div align="right">February 7, 1982</div>

7. Vantongerloo

Who was Georges Vantongerloo? The name rolls off the tongue like a musical phrase or a line from some half-remembered verse; but for anyone acquainted with the career it signifies, it is a name all but lost beneath the debris of rebarbative associations that have accumulated around it. Vantongerloo made a speciality of being a crank, and seems to have lavished as much energy on cultivating a sense of his own martyrdom as he did on perfecting his work. Even when, late in his life, he had become something of a cult figure himself—a guru surrounded by true believers—he complained of "boycotts" and denounced the "cheats" and "usurpers" whom he imagined were out to destroy him. In the short *Intimate Biography* of himself that he wrote in 1961, he proudly announced, "I never belonged to any 'school,' to any 'ism,' I am alone and have nothing in common with anybody"—which, if true (it wasn't, of course), would have made him unique in the annals of human culture.

As a result of all this paranoid feuding, Vantongerloo—whose dates are 1889–1965—has remained a shadowy figure, even at a time when many of his contemporaries in the modernist movement in Europe, some of them artists not notably less hermetic in their work than he was, have acquired a more secure visibility. One sometimes wonders if Vantongerloo's isolation might actually have had less to do with outside plots and boycotts than with some obscure sense of failure on the part of the artist himself.

Whatever the cause of this unappetizing posture, it contributed lit-
tle to an understanding of Vantongerloo's art in his lifetime, and the
cult that has continued to be made of his work since his death has not
added much in the way of clarification, either. It is therefore good news
that we are at last in a position to have an unclouded look at a sizable
portion of the work itself. The Vantongerloo exhibition that has now
come to the Corcoran Gallery of Art is the first museum retrospective
to be devoted to him. Most of the objects in it come directly from the
artist's estate, which is now in the possession of the Swiss artist Max
Bill, and have never before been seen in the United States.

Vantongerloo belonged to the generation of European artists that
produced the first abstract paintings and sculptures. This is his princi-
pal and enduring claim to fame. He was born and educated in Ant-
werp, yet because he entered modern art history as a founding mem-
ber (along with Mondrian and van Doesburg) of the Dutch avant-garde
group known as De Stijl, he has often been mistakenly described as
Dutch himself. (This—probably innocent—mistake was a great boon
to his incipient paranoia, of course.) The exact circumstances under
which he broke with the group remain obscure. Given Vantongerloo's
temperament, one suspects that the disagreements, whatever they were
later claimed to be, were probably more personal than intellectual.
Was there a woman involved? The whole story, including the role of
Mrs. van Doesburg, is yet to be told.

Certainly the De Stijl aesthetic, with its doctrinaire rejection of
"nature" and its missionary embrace of geometric form, exactly
suited Vantongerloo's own search for a more reductionist, more theo-
retical and abstract art than could be found in other "advanced" styles
of the time. The De Stijl interest in extending this aesthetic vision to ar-
chitecture and applied art likewise paralleled, if it did not actually in-
fluence, Vantongerloo's radical outlook.

The paintings that he produced in the years 1917–19 are very much
in the geometrical De Stijl mode, and the pictures of the 1920s and
even into the '30s continued to ring variations—sometimes quite elab-
orate variations—on this geometrical theme. The early abstract sculp-
ture follows a similar course, sometimes employing color but more
often not. It is claimed that Vantongerloo created the very first
abstract-geometric sculpture based on mathematical reasoning. (This
would be his *Construction in a Sphere* made in several versions in 1917.) I
am not in a position to dispute this claim, but I am not convinced of the

importance attributed to it. Mathematical equations seemed to have functions for Vantongerloo rather as the theosophical doctrines of Madame Blavatsky functioned for Mondrian—they were a metaphysical device used for surmounting the claims traditionally made by "nature" on the imagery of art. They do not make Vantongerloo's sculpture any more or less "scientific" than Tatlin's or Gabo's or, for that matter, Rodin's.

The more interesting question is how this early abstract sculpture stands up beside the work of the other pioneer abstractionists of the period. My own impression is that, compared to the early constructions of Tatlin, Gabo, Rodchenko, and others, Vantongerloo's sculpture is pretty paltry. He talked to a great deal about "space," but he never fully developed a way of incorporating it into the internal structure of his sculpture. This was what the Russian modernists did with such extraordinary success. Vantongerloo's most original sculptural idea is to be found in his use of the cantilevered horizontal, but even this he did not develop into a fully realized style. He was actually a far stronger and more developed artist in his paintings.

Sometime in the 1930s he introduced curved lines into his paintings—a momentous event for an abstract artist so strongly attached to a rigid rectangularity. (Did his move to Paris have something to do with this change? In the late twenties he settled permanently in the French capital, and in the early thirties he was a founding member of the Abstraction-Creation group that promoted the interests of certain forms of abstract art in Paris—a very odd attachment, by the way, for an artist who believed he had "nothing in common with anybody.") The curved-line paintings, which consist of a very few arcs of color on a white ground, are lighter and more "open" than the paintings based on right-angled forms. They are the most original paintings that Vantongerloo produced. They are the immaculate classics of a vein of Minimal art that has scarcely, if ever, been significantly improved upon.

Earlier on, at the outset of his career, Vantongerloo had made some unremarkable sculpture in a figurative idiom common to aspiring European artists at the turn of the century. He had also painted some fine figurative pictures in a delicate version of the then-dominant Postimpressionist manner. (From the start, he was a better painter than a sculptor.) What is interesting in the last phase of his work—the paintings he produced in the fifties—is that he returns to the palette and to the delicate, yet highly legible touch of this early painting style. The

forms are now resolutely abstract, of course, consisting of curved and coiled shapes rendered in an almost pointillist accretion of touches; but the sensibility is recognizably the same sensibility that we see in the pre-De Stijl paintings of 1915–16. They give us a last glimpse of the lyricism that lay buried in Vantongerloo's work for decades on end.

Unfortunately, he continued to experiment with sculpture in these later years, too, working in coils and swirls of plexiglass to which he at times attached random bits of color. This sculpture was not a success and confirms one's impression that Vantongerloo's was an essentially pictorial talent. This, in a way, is one of the major revelations of the current exhibition. One comes to it expecting to see the work of a great pioneer sculptor, but one leaves it feeling that one has seen the work of an unappreciated painter. On this score, at least, the textbooks are going to have to be revised.

Was Vantongerloo a major artist? I doubt it. If an achievement of this sort is to be regarded as major, then we are desperately in need of another term to describe the accomplishments of Mondrian or Brancusi—not to mention Picasso and Matisse. (Let's not even think about the Old Masters.) His work does have an obvious topical interest, of course. He was a pioneer in creating the conventions of the kind of Minimal art that continues to command a large following among living artists. In this sense, certainly, the timing of the exhibition is propitious. But in the severe limits that we everywhere observe in Vantongerloo's art there may be found a cautionary tale that is also timely.

Whatever the shortcomings of Vantongerloo's art, however, this exhibition gives us as full a view of it as one could ever want to have, and it has been beautifully installed in the grand second-floor galleries at the Corcoran—just the kind of "traditional" space that Vantongerloo probably hated.

May 4, 1980

8. Max Ernst

Paul Valéry, reflecting on the nature of painting, once spoke of the "plurality" essential to its existence. The painter, he observed, "has brought together, accumulated and assimilated by means of the physical materials of his art, a host of desires, intentions, and conditions coming from all the regions of his mind and being. Sometimes he was thinking of his model, sometimes of the mixing of his pigments, his tone, his oils; sometimes of the flesh itself and sometimes of the absorbent canvas. But, though independent, these objects of his attention coalesced, inevitably, in the act of painting when all the discrete, scattered moments, followed up, caught on the wing, suspended or elusive, were in process of becoming the *picture* on his easel."

Valéry's notion of the plurality of the pictorial enterprise no longer, perhaps, has quite the universal application it once had. Certainly we have all seen a good many paintings in recent years in which "all the regions of . . . mind and being" seem to have been effectively displaced by a restricted list of arid precepts. But there are some painters whose work is all but impossible to encompass without this sense of the multiform activity of the mind that conceived it, and one of these, surely, is Max Ernst.

In Mr. Ernst's copious and engrossing oeuvre, we are indeed made aware of the "host of desires, intentions, and conditions" governing the artist's mind; and the mind we see at work in a multiplicity of mediums and circumstance is an extremely interesting one. It is a mind that has been deeply engaged by both experience and ideas, a mind deeply responsive to history—the terrible history of civilization in crisis and collapse—and yet resolute in preserving its own poetic prerogatives. Despite the well-known role that its author has played in some of the pivotal episodes of the modern movement, the art that such a mind produces is not easily categorized under any of the familiar rubrics of art history. It seems to live a life independent of everything but its own inspired insights into the dislocations of the world it inhabits.

The exhibition of Mr. Ernst's work that Diane Waldman has now organized at the Guggenheim Museum is the largest ever to be devoted to this artist. It numbers more than three hundred items, and fills all but the topmost ramp of the museum. Yet it never seems too large for its purpose and, at times, seems even to fall a little short of what we

would like to see. It is rare, even in these days of large-scale retrospectives, to be given so generous a view of a single artist's work and rarer still for an artist to withstand such exhaustive treatment without damage to his reputation. Mr. Ernst passes this test easily enough, and he does so—in large part, anyway—because the art he practices stands at so great a distance from what we have come to expect of so "modern" a master. He is, in some crucial respects, a very old-fashioned artist, absorbed in tasks of illustration and commemoration, a visionary for whom "the medium"—though handled with immense virtuosity and daring—is always less important than the vision it comprises.

We all know the story of the great part Mr. Ernst took in the founding of the Dada movement in Germany after the First World War and in the formation of the Surrealist *cénacle* in Paris in the twenties. His legendary contributions to these historic movements—his use of photo-collage and *frottage* (a form of rubbing), especially—are among his most original achievements, and they constitute some of the signal pleasures of this exhibition. But much that we see at the Guggenheim is the work of a German Romantic. It is work that takes its place in a tradition that can be traced to Altdorfer, Friedrich, and Böcklin—the tradition of visionary landscape in which the fantastic inventions of the mind are never clearly distinguished from the actualities of earthly observation.

In Mr. Ernst's version of this symbolic landscape, the anxiety quotient is given a fiercer, more psychological dimension. The element of menace, at once primordial and historical, is amplified to a fever pitch. The imperatives of Surrealism, with its evocation of erotic appetite and the energies of the unconscious, are joined to the leitmotifs of German Romanticism to produce a landscape of nightmare. In paintings such as *Europe After the Rain II* and *Day and Night*, both produced at the beginning of the Second World War, Mr. Ernst is very far from the Cologne revolutionary who helped to form a Dada group called *Zentrale W/3 Stupidia.* In the midst of the gravest crisis in his own life, fleeing to America as the Nazis were occupying France, he turned to the resources of the German Romantic tradition for an imagery equal to the horrors that had overtaken all of Europe.

Yet even in that early Dada period, he was drawn to a vision that also encompassed, albeit ironically, the resources of a venerable tradition. It was on a visit to Munich in 1919 that Max Ernst first glimpsed some reproductions of the paintings of Giorgio de Chirico in a magazine, and de Chirico was to be a model—in some ways, the primary model—for many years to come. Some of Ernst's most powerful paint-

ings of the twenties—*The Elephant of the Celebes, Oedipus Rex, Histoire Naturelle, The Equivocal Woman,* and others—were derived from de Chirico's dreamlike vision of haunted urban spaces painstakingly depicted in the most graphic detail. Into these spaces Mr. Ernst insinuated an even more mysterious imagery, crowded with private symbols that yet spoke with the force of archetypes.

The point is not that this artist was ever a closet academician—he was not—but that the particular kind of ambition and sensibility he brought to painting required for its realization a good deal more of painting's traditional language than the *révoltés* of Cologne or Paris could ever bring themselves to acknowledge. A mind like Max Ernst's, so fertile in symbolic intuitions of what was happening to the European psyche in its plunge from one war to another, and of what mysteries the human psyche harbored in its very essence, needed a certain space in which to elaborate its visionary scenarios, and that space, which was slowly but unmistakably being sealed off by "advanced" painting from the expression of anything but its own absoluteness, had to be snatched from the academic enemy.

In taking possession of this "academic space"—the illusionist space that had been the hallmark of Western painting since the Renaissance—the Surrealists produced much that justified the painterly avant-garde's horror of its revival. The truth is, many of the Surrealist painters who were most shameless in their exploitation of academic devices had very uninteresting minds, and thus had very little more to disclose to us than their own muddled narcissism. Mr. Ernst's pictorial oeuvre stands apart from all that. It is the oeuvre of a gifted and troubled intellectual who is, at the same time, a poet of unflagging energy and invention. To see this large exhibition is, indeed, very like reading through the collected works of a great and difficult writer. We may not respond with equal enthusiasm to every page, but we want to have it all; and we are grateful at last to have it.

FEBRUARY 23, 1975

9. Miró and His Critics

Joan Miró, who will observe his eighty-seventh birthday on April 20 and whose work is currently the subject of exhibitions in Washington and St. Louis, has enjoyed one of the longest and most distinguished careers in the annals of twentieth-century art. There can be little question but that he stands today as the greatest of living artists. He is an artist, moreover, whose work has long exerted an especially strong appeal in the United States. Our curators and collectors have acquired it in significant quantities and with an impressive sense of discrimination. Our critics and historians have written about it with immense seriousness, sensitivity, and devotion. And our artists have found it a source of profound inspiration. Much of the history of the New York School, for example, is unimaginable without it.

Yet, as familiar, as influential, and as beloved as Miró's art undoubtedly is on this side of the Atlantic, it continues to resist any settled view of its meaning or significance. Its protean character and its restless energy and invention place it beyond the reach of both easy summary and the kind of sectarian reductionism that is so much favored by certain schools of contemporary criticism, but this does not discourage attempts to enlist it in the service of partisan causes or narrow ideologies. Miró's art thus remains something of an intellectual battleground for the critics even as it delights an ever-growing public that cares little or nothing about the debate that surrounds it.

What the essentials of this debate come down to is this: there is a formalist view that persists in reducing Miró's many-sided art to its most easily comprehended syntactical attributes. This is a view that, in more than one sense, confines itself to the surface of his painting. And then there is a visionary view that gives priority to the many nonformal elements—especially the literary, folkloric, and erotic elements—that have entered into the creation of this art and that decisively shape our experience of it. The formalist view, first given powerful expression in Clement Greenberg's 1948 monograph on the artist, assumes that Miró is to be seen primarily as an abstract artist. (This, incidentally, is something that Miró himself has denied.) The visionary view, promulgated in the writings of André Breton from the late twenties onward, assumes that Miró is primarily a visual poet. The formalist view tends to restrict its attention to the aesthetics of painting, whereas the vision-

ary view exults in the whole wayward range of the artist's production—
in the bizarre constructions, collages, and sculptural objects as well as
the paintings and drawings—and attaches a special value to the iconog-
raphy that is so conspicuous a feature of their development.

That these highly divergent views of Miró's achievement remain
adamantly in effect is clearly demonstrated for us yet again in two cur-
rent exhibitions of his work and in the "arguments" offered in the cat-
alogue texts that accompany them. In Washington, a splendid exhibi-
tion of "Selected Paintings" has been organized at the Hirshhorn
Museum by its chief curator, Charles W. Millard. It consists of forty-
four works drawn entirely from American collections. In St. Louis, an
exhibition also drawn from American collections—and, oddly enough,
also consisting of forty-four works—has been organized at the Wash-
ington University Gallery of Art by Professor Sidra Stich. The latter
show, called "Joan Miró: The Development of a Sign Language,"
moves beyond painting, however, to include works in other media as
well. I haven't seen the St. Louis show, but I know a good many of the
works that are in it, and I think it is safe to say that both exhibitions
address themselves to the central core of Miró's oeuvre, though neither
is large enough to encompass it completely.

But what a world of difference separates the thinking that has gone
into these exhibitions! For Mr. Millard, Miró is first and last the classic
modern painter who "shares both Matisse's French fluency and Picas-
so's Spanish expressionism, and stands easily alongside the best of
both." Of these two strains in Miró's painting—the French and the
Spanish—the former is said by Mr. Millard to correspond "to the dec-
orative tendency toward simplicity, the latter to the expressionist tend-
ency toward multiplicity." The very language of this discussion delib-
erately dampens whatever interest we may have in Miró's visionary
iconography, which for Mr. Millard can scarcely be said to exist.

As for the influence of Surrealism on Miró's art, Mr. Millard is far
too intelligent to discount it, but he does not really approve of it, and it
is not, in any case, of compelling interest to him. In painting, he
writes, it led to pictures that "maintain the flat, horizontally divided
background of the landscapes, but impose on them a bewildering vari-
ety of shapes. Those shapes, generally biomorphic and referring to hu-
man and animal forms, are rendered in fairly saturated colors applied
without inflection and relieved by large areas of white." Again, the
language is revealing. The reference to "a bewildering variety of
shapes" is particularly precious, I think. Who could guess, from this

sanitized account of Miró's painting in the late twenties, at the wild vein of fantasy and mayhem that enters his art in this period and remains a steady—not to say obsessive—component of it until very recent times?

"A longer-range effect of Surrealism on Miró," writes Mr. Millard, "was a fragmentation in his art." Which is to say that under the pressure of Surrealist influence, Miró often abandoned painting for less orthodox, mixed-media pursuits—something that formalist criticism does not easily forgive. The exhibition that we see at the Hirshhorn Museum therefore effectively shields us from the aberrations (as they must be thought to be from this point of view) that resulted from this so-called fragmentation.

But if Mr. Millard does not give us a very complete account of Miró in this show, he does give us a marvelous view of what interests him. Miró *is* one of the major painters of the century, and this exhibition is a superb anthology of some of his outstanding achievements in this medium. It is especially rich in early pictures and very shrewd in its selection of the later work. Mr. Millard's eye is a lot better than his ideas. We thus leave this exhibition with a very keenly perceived appreciation of Miró's painterly gifts, whatever we may think of the exhibition's governing principles.

With Professor Stich's more ambitious and much lengthier catalogue essay, we are in a very different realm of discourse. Its very first sentence—"The art of Joan Miró heralds a deep grasp of the marvelous"—returns us to the visionary discourse of André Breton and to the whole adventure of the Surrealist imagination. We move beyond the syntax of pictorial surfaces into the world of symbols and their meanings.

I hasten to add, however, that Professor Stich—despite occasional flights of rhetoric that might lead one to suppose otherwise—is no visionary *manqué* herself. She is a serious scholar who has undertaken to ferret out some of the sources of Miró's visionary iconography. Far from finding the shapes in his art bewildering, she sets out to tell us exactly where they came from, what they mean (or were intended to mean), and how they were developed. This may not be the kind of information that helps anyone to discriminate between a good painting and a bad one—Mr. Millard is a much better guide on that question—but it is nonetheless wonderfully illuminating about an imagination like Miró's, which often functions like that of a Symbolist poet.

What Professor Stich dwells on is the Surrealist interest in primi-

tive thought, and especially the account of the primitive mind to be found in the writings of Lucien Lévy-Bruhl and his contemporaries. "Miró's art draws extensively from contemporary conceptions of primitive mentality," she writes, and her extensive researches—all scrupulously documented—certainly persuade us that this is indeed the case. The role of prehistoric culture in Miró's artistic thinking is set down with a concreteness that leaves our understanding of his art significantly enlarged. Many earlier writers have spoken in a general way of Miró's debt to primitivism, of course, but Professor Stich is one of the first to tell us in any detail what this debt entailed.

She has not stopped short with describing the relevant source material either. She carries the discussion into some very detailed accounts of particular works. There is a fine analysis, for example, of the "Constellations" series that occupied Miró during the early years of World War II; and we are left in no doubt about the relation of the imagery to the prehistoric sources that the artist studied with some avidity. Mr. Millard's discussion of the "Constellations"—which are represented in the Washington show—is pretty thin by comparison, for he cannot really bring himself to acknowledge the importance of the subject matter. He thus makes do with a passing reference to "fanciful figures and faces."

In the end, it is this question of subject matter—the whole question of the importance of content in art—that separates the formalist view of Miró from the visionary view of his achievement. And it is not only the art of Miró, of course, that is at stake in this argument. It may very well be that this hoary problem of the relation of form to content in art—for so long so blithely dismissed in formalist criticism—is going to be an important item on the intellectual agenda of the 1980s. And if that is the case, the entire history of modern art—and not only Miró's—is likely to be rewritten in some interesting ways.

MARCH 30, 1980

10. Sonia Delaunay

At the time of her death on December 5, 1979, at the age of ninety-four, Sonia Delaunay was described in *The New York Times* as "one of the foremost painters of her day and one of the last survivors of the Parisian art world before 1914." This she most certainly was, yet on this side of the Atlantic—where we sometimes have the mistaken impression that virtually every aspect of the School of Paris has been exhaustively studied—she had remained very little known as an artist. For most of us, it was the paintings produced by her husband, Robert, that the name Delaunay had long brought instantly to mind, at least until we encountered some of her major works at the National Museum of Modern Art in Paris. The question of the exact relation of his work to hers was not one that had been much explored; and Sonia Delaunay herself rarely, if ever, made heavy weather of the question.

In the 1970s, to be sure, we had begun to see some fragmentary exhibitions of her work, and some publications about it—the most notable being the monograph, written by Arthur A. Cohen, that Abrams brought out in 1975. But for a sound appreciation of her contribution to modern art, what was needed—more than argument or advocacy—was a full-scale retrospective of the oeuvre itself, which spanned nearly eight decades and embraced a remarkable variety of artistic activity.

This, happily, is the show that we have now been given in "Sonia Delaunay: A Retrospective Exhibition" at the Albright-Knox Art Gallery in Buffalo. Organized by Robert T. Buck, Jr., the director at Albright-Knox, and Sherry Ann Buckberrough of the University of Hartford, the exhibition brings together more than two hundred works. The earliest is a student drawing dating from 1901; the latest were produced in the last year of the artist's life. The organizers enjoyed the close collaboration of the artist herself over a three-year period, and she personally loaned many important works to the show.

As a result, almost every important aspect of the Sonia Delaunay oeuvre is well represented—and not only in paintings and works on paper, but also in works drawn from the many branches of the applied arts (books, fabric design, ceramics, advertising art, commercial decoration, needlework, theatrical costume and décor, women's fashions, etc.) to which the artist devoted so much of her career. One of the remarkable things about this career is, indeed, the artist's versatility. The

painter who, at a moment that was crucial to the fortunes of the Parisian avant-garde, produced some of the very first color abstractions also found it possible—ten years later—to enter the very different world of high fashion with designs that had a decisive impact on the taste of time.

We sometimes tend to forget that the pre-World War I Parisian avant-garde was not made up entirely of impoverished bohemians. Mme Delaunay, who was Russian by birth and education, came from a very different background, having been raised in the St. Petersburg home of a wealthy, cultivated uncle who encouraged an interest in the arts. (Until the 1917 revolution, which she welcomed, she derived a comfortable income from family real-estate interests in St. Petersburg.) She grew up speaking French, German, and English, and went to Germany as an art student while still in her teens.

She was twenty when she arrived in Paris in 1905, and only twenty-three when she had her first solo exhibition of paintings there. This was held at the Galerie Notre-Dame-des-Champs, whose enlightened owner—the German art dealer Wilhelm Uhde—Sonia Terk (as she then was) married a year later in London. This alliance she always described as a marriage of convenience, entered into to satisfy the demands of her family. She and Uhde were amicably divorced a year later when she fell in love with Robert Delaunay. She and Robert were married in 1910, and remained together until his death in 1941.

It was a characteristic of the Russian avant-garde painters of Mme Delaunay's generation to respond to every innovation in French modernist art with a demand for something even more radical and a determination to achieve it. Mme Delaunay's was very much a sensibility of this sort. Her *Yellow Nude* of 1908, for example, obviously owes much to Matisse and the Fauves, and to their sources in Gauguin and Van Gogh, but at the same time plays havoc with these influences by heating up the color with a very Russian, almost Byzantine glow. What dominates all the Fauve-derived figure paintings is intense expression rather than nuances of form, a determination to invest the painting with more emotion than the French sense of *mesure* ever quite allowed.

Was it the influence of Robert Delaunay, a far more intellectual painter than Sonia, that tempered this quality in her work? Or was it the normal process of artistic maturity? We shall probably never know. What we do know is that after 1910 her work grew more abstract and deliberate in design. She remained, in some respects, a warmer, more emotional, more intense artist that Robert, but she also achieved a

kind of control we do not find in the Fauve paintings. And whatever the causes, by 1913 she had produced in the *Bal Bullier* painting a pure abstraction of color and light that must be counted among the minor masterpieces of that astonishing period.

We would have an even better sense of Mme Delaunay's powers in this period if it had been possible to secure the huge painting, measuring eight feet square, called *Electric Prisms* (1914) from the National Museum of Modern Art in Paris. That painting represents the grand summation of everything she aspired to achieve at that time, and remains her major statement. But the French authorities would not release it for the exhibition, and we must make due with a wall label that calls this achievement to our attention.

What this early section of the exhibition does boast, however, are two needlework pictures of exceptional interest. The *Embroidery of Foliage* (1909), in earth colors akin to Henri Rousseau's, is in many respects a more radical picture than anything the artist achieved in painting at that time, and the famous *Blanket* (1911)—a hand-sewn cloth mosaic of irregular rectangles and triangles of pure color—itself became the basis of a good deal of the abstract art that followed, and not only the Delaunays'. (Mr. Cohen suggests that it influenced Paul Klee's later color-square paintings.) The *Blanket*, which Mme Delaunay made for her infant son Charles, was based on her memories of Russian folk art—and thus belongs, in a sense, more to the "school" of Russian abstraction that derives from folk sources than to the School of Paris.

From this time on, Mme Delaunay's work divides itself into fine art, on the one hand, and applied art, on the other. I know it is now the fashion to declare that these really come to the same thing; that an artist of Mme Delaunay's gifts invested even her commercial work with an aesthetic interest and integrity that is not to be distinguished from her purely artistic work. But I am not myself convinced that this is always the case, even though I recognize that she often achieved remarkable results as a designer. So long as she was committing her ideas to paper, moreover, she remained an artist of remarkable energy and invention, and some of the most beautiful works in the show are the small studies for posters, which often use figures and even letters with a stunning originality. But the room devoted to her fabrics is, as they say, something else. And I doubt if I am alone in remaining quite unmoved by the ceramics, the tapestries, and the other commercial stuff.

I am not suggesting that all of the nonpictorial work is to be dis-

missed, however. Far from it. The *Blanket* is, as I have already indicated, a powerful work. The painted *Box* of 1913 is likewise a little gem. The cutout paper covers and bindings Mme Delaunay made for her favorite books of poetry around 1913 are not only beautiful in themselves but mark an important advance in the art of collage—and, incidentally, anticipate something of the spirit of Arp's later reliefs and Matisse's later color cutout pictures. But these were not, of course, part of her commercial work.

Still, it is in the paintings and the small pictorial studies on paper that we feel the real energy and drive of this exhibition. "Energy" is the key word, perhaps. Mme Delaunay belonged to the generation that found in electricity, the automobile, and the whole new urban scene they created a powerful artistic inspiration. To capture the rhythms of this new urban civilization, to distill its essential spirit in a new poetry of design, was the heady ambition of that generation, and she herself never abandoned her loyalty to it nor, apparently, ceased to derive a certain joy from it.

The so-called art of simultaneity that this vision inspired cannot have the appeal for us that it had for Mme Delaunay and her generation; we have been obliged to live with too many of the destructive consequences of the urban dynamics that are exalted in it. But it remained for her a powerful stimulus, and there is something very moving about the unflagging pursuit of this vision in the "Rhythm" paintings of the later decades of her life. If the ideas in some of these paintings now look a little too codified for us, the sheer visual attack is still remarkably fresh. Not the least remarkable thing about this amazing artist is the degree to which she remained—and I mean in her painting—the same optimist who greeted a bright new dawn in the years before World War I. That was no little achievement in itself.

FEBRUARY 17, 1980

11. Giacometti's Moral Heroism

Alberto Giacometti died on January 11, 1966, at the age of sixty-four. To mark the tenth anniversary of that event, the Sidney Janis Gallery has organized an excellent exhibition of his work—over fifty sculptures, paintings, and drawings selected from the copious oeuvre the artist produced during the last twenty years of his life, the period of his return to "tradition" after the "Babylonian captivity," as he called it, of his alliance with the Surrealists. Its principal purpose, of course, is to honor an extraordinary artist and to call our attention once again to the special quality of his work, but this show also has the incidental merit of reminding us of the many splendid Giacometti exhibitions that were to be seen in this gallery in recent years. To Mr. Janis, as to Pierre Matisse, we owe some of our most memorable encounters with the artist's work.

At the time of Giacometti's death, I had occasion to observe that he was an artist who left no heirs. Perhaps I may be forgiven for quoting the relevant paragraph, for it bears on our understanding of Giacometti's place in the art of his time. "Both in utterance and appearance," I wrote, "Giacometti seemed the very embodiment of the archetypal avant-garde figure, resisting an easy accommodation with the status quo. Yet his art, measured against the more radical innovation of his contemporaries, grew more conservative as he grew older. At his death, his fame was at its height, but his influence—which, only a few years ago, was considerable—was scarcely any longer visible in the work of younger artists here or abroad."

These observations, I afterward discovered, were regarded in some quarters as constituting a virtual attack on, perhaps even a dismissal of, Giacometti's accomplishment. This was so far from being the case—so much, indeed, the opposite of what was intended and articulated—that I naturally wondered what issue lurked in this willful misperception of a clearly stated admiration. In the perspective of the decade that has elapsed since Giacometti's death, this issue is now, perhaps, more clearly seen. Briefly stated, it is simply this: Ideologues of avant-garde doctrine found it impossible to reconcile their respect for and response to Giacometti's art with the artist's own rejection of everything that had come to be identified with the avant-garde position

in the last decades of his life. In order to sustain their high opinion of the artist, these partisans of vanguard doctrine were obliged to dismiss the notion that Giacometti had, in fact, repudiated the ground they stood on.

It was with more than ordinary interest, then, that I read the following passage in the introduction to the catalogue of the current show written by James Lord, who has been at work for some years on Giacometti's biography. "He foresaw with melancholy clairvoyance," Mr. Lord writes, "that he stood at the extreme end of a tradition. 'After me,' he said, 'there will be no one to try to do what I'm trying to do.'" Giacometti was a singularly honest and intelligent man and not given to easy illusions. "Art interests me very much," Mr. Lord quotes him as saying, "but truth interests me infinitely more." This, for those willing to face the ambiguities of art as honestly as Giacometti did, is a fitting epitaph for both the man and his work.

It was entirely characteristic of Giacometti that he spoke of "what I'm trying to do" rather than dwell on what he had actually accomplished. For he conceived of the artistic task in those last years as a labor foredoomed to failure. Every mark of his pencil, every touch of his brush, every effort to shape a figure or a head from his scrutiny of the model who sat before him, was felt to be an "impossible" assault on an objective guaranteed to elude his grasp. At a time when so many artists discovered how easy it was to make a work of art that would instantly win the world's esteem, Giacometti rediscovered how difficult it was to create something that could satisfy his sense of the authentic.

This "difficulty" was the moral center of his art, the very fulcrum of his style. To it we owe that nervous, spidery line of the drawings—so quick, so attentive, yet so despairing—that alerts us to the elusiveness of the subject at the same time that it perseveres in the attempt to render it. We see this same combination of elation and despair, the same drive to capture something that remains forever beyond one's reach, in the gray, shadowy densities of the paintings. These paintings suggest a kind of groping in the dark, a quest for something palpable and concrete in a realm where light is fugitive and space a changing and uncertain medium. In Giacometti's universe, all relations are assumed to be unfixed and problematical. The object never rests secure in the space it occupies; the act of observation is never a reliable measure of what it scrutinizes.

There is thus in all of Giacometti's late work a large element of autocriticism that questions and elucidates the creative process. Nothing, we are meant to feel, may be taken for granted—neither the world "out there," which alters its every aspect as soon as we attempt to study it, nor the artist's own medium, a fictional medium that distorts and obscures as much as it reveals. This attitude—an attitude of profound moral skepticism held in delicate balance with a no less profound will to succeed in achieving the impossible—posed tremendous problems for the sculptor. Sculpture is, after all, the art of making an object, and it was the very ontology of the object that Giacometti had come to question. He felt obliged to begin again from the beginning, which, in his case, working as a sculptor, meant the point at which the figure is joined to the mass that supports it. We saw this more clearly, perhaps, in those minuscule sculptures of boxy masses supporting figures scarcely larger than the size of a pin that were shown at the Guggenheim Museum two years ago and not, unfortunately, included in the Janis exhibition. But it is there, all the same, if we care to see it, in the tall, slender figure sculptures that dominate this exhibition.

Notice, especially, the massive feet that are characteristically given to even the most slender and attenuated of these figures. For a long time I found it difficult to understand the swollen exaggeration of these feet that join the figure, like something held down with a lead weight, to the blocklike "earth" it occupies. They were clearly not meant to be a merely symbolic distortion in the facile Surrealist manner, for Giacometti had abandoned all such devices as false to experience. Only now have I come to understand, I think, what these feet signified for Giacometti's sculpture. They affirm a principle of gravity that, for the maker of sculptural objects, is perhaps the only perfectly knowable thing about the enterprise on which he is engaged, everything else being hostage to the subversive vagaries of the subjective mind. The place where the figure meets the earth was, for Giacometti, the only still point in a turning world; and it was at that point that sculpture—as he understood it—was required to begin again and again and again.

To build upon that isolated point of fixity was what Giacometti was "trying to do," and it was this self-assigned task, so distant in spirit and in result from the freewheeling belief in the autonomy of art that mesmerized his contemporaries, that made him a "conservative" in the art of his time. For Giacometti, art enjoyed no such autonomy but

was, on the contrary, doomed to be tethered to the life of the earth. It was in the way he confronted the implications of this lonely position that his moral heroism was made magnificently manifest.

January 18, 1976

AMERICANS

1. Marsden Hartley

Of the painters who made up the first generation of American modernists, Marsden Hartley (1877–1943) was surely the greatest. The Hartley retrospective that Barbara Haskell has organized at the Whitney Museum of American Art must therefore be counted one of the capital events of the season. We have had to wait an awfully long time to see a major show devoted to this extraordinary artist; and while the present exhibition is anything but flawless in its every detail, it is a beautiful show all the same—quite the strongest and most comprehensive we have yet had.

In addition to which—and it is no small matter, either—Miss Haskell's catalogue gives us something approaching a complete account of Hartley's life for the first time. It had long been known, of course, that Hartley's was a very difficult life. But attempts to tell this unhappy story have met with a great many obstacles in the past. (Miss Haskell describes a bit of that story, too.) It will some day require the gifts of a first-rate biographical writer to give us the definitive "Life" the subject cries out for, but for the moment we are at least—and at last—in possession of the basic outlines.

It is one of the many ironies of Hartley's career that he would probably have enjoyed a grander reputation much earlier on in our history if he had chanced to die at an earlier age—say, in 1917, when he was forty. For at that time he was undoubtedly the most accomplished

avant-garde painter in America. He had already won the admiration and support of Alfred Stieglitz in New York and Gertrude Stein in Paris. He had been accepted into the Blue Rider circle of Wassily Kandinsky and Franz Marc in Munich, and Herwath Walden had hung his work alongside that of Kandinsky and Henri Rousseau at a major exhibition in Berlin.

In Europe, in the halcyon period of the pre-World War I avant-garde (which for Hartley, who cared nothing about politics, extended right into the early years of the war), he was painting some of the most audacious pictures of the day. These were the so-called military abstractions, with their high color and bold design, in which Hartley effectively combined his deepest aesthetic and personal passions. Aesthetically the military abstractions can be shown to derive from the innovations of Picasso, Matisse, Kandinsky, and Robert Delaunay that were then decisively altering the art of painting throughout Europe. This in itself guarantees Hartley a place in the forefront of the modernist movement in its heyday.

But the special intensity of the military abstractions owes much, too, to the artist's personal affairs at the time. In the public life of Imperial Berlin, where Hartley then lived, he adored the elaborate displays of military pageantry. He was also drawn to the city's large homosexual subculture. And these were all the more important to him—and to his painting—because he was deeply in love with a young German officer he had first met in Paris. This romantic attachment—probably the most important in Hartley's life—came to an abrupt end when his beloved officer was killed at the front. Some of the finest of the military abstractions are believed to have been painted as memorials to this lost love.

When the progress of the war finally forced Hartley to quit Berlin, he returned to America and continued—but for a very short time, alas—to produce some extraordinary abstract paintings. Once in New York, however, he found it necessary for political reasons to eliminate all trace of the German military symbolism that had been so important to the paintings of the Berlin period. As a result, he turned to a more "spiritual" mode of abstraction, creating an art that was purer in form and more delicate in color. They are among the most beautiful abstract paintings of the period, but they proved to be Hartley's last. In 1917—isolated from the European avant-garde and very discouraged by the dismal reception accorded these wonderful pictures even by his closest friends and supporters in America—he began to make his way back to pictorial representation.

Ultimately, as we know, this turn—which represented a deep personal crisis for Hartley—proved to be the basis of some of his greatest and most authentic work. I mean the landscape, still life, and figure paintings of his last, lonely years in his native Maine. But this "late" achievement was slow in coming. The artist who set off on a new course in 1917 was, in many respects, a broken man suffering a failure of nerve. He was heartbroken, certainly, without financial resources, and no longer either young or very confident about his artistic mission. It took him years to rebuild his painting on a new, more "objective" basis, and he fell into a good deal of confusion along the way.

As often happens when an artist faces a crisis of this sort, he took a step backward in the hope of rooting and restructuring his art on a sounder, less subjective foundation. For Hartley in the twenties, this effort came down to a total (if mercifully temporary) immersion in the art of Cézanne. He even went to Aix and devoted himself to painting the most famous of Cézanne's motifs—the landscape of Mont Ste-Victoire. In some ways, it was an act of artistic self-immolation— an attempt to purge himself of his aesthetic transgressions.

This search for roots, and not only artistic roots, involved Hartley in a dizzying course of peregrinations. He had always been something of a wanderer, without even the semblance of a permanent home. Miss Haskell speaks of "itinerancy" as the dominant characteristic of his life. ("Hartley as an adult," she writes, "never occupied the same rooms for more than ten months.") But in the twenties and early thirties, this inveterate itinerancy acquired a more and more desperate urgency as he wandered from place to place, always short of money and acutely conscious of his accelerating loss of artistic status.

It is yet another of the many ironies of Hartley's career that his return to Maine, where in the end he painted some of his best pictures, involved a certain element of sham. In the cultural atmosphere of the thirties, he felt his survival depended upon dispelling his reputation as a cosmopolitan artist and establishing his "native" credentials. Persistent failure in the marketplace inspired a genuine hatred and suspicion of the New York art scene; yet he never really looked upon his final years in Maine as anything but an enforced exile. If it suited his painting—and it clearly did—it nonetheless exacerbated his spirit, and condemned him to a terrible loneliness and isolation.

His final hope of any personal happiness was destroyed when the last of his lovers—a young man with whom he was planning to establish a household in Nova Scotia—was drowned in a storm at sea. This occurred in 1936. The next year he had his last show with Stieglitz, who

had turned against him and was openly mocking his work. All this time, however, and right to the end, he was painting some of the greatest pictures he ever produced. There is nothing stronger in all of Hartley's oeuvre than the brilliant succession of landscapes and seascapes he painted in these final years, and several of the figure paintings of this late period—some of them memorials to his last lost love—achieve a power of expression that at times surpasses even the paintings of his Berlin period.

The culminating irony for Hartley was his late success—which came too late, of course, to change anything. ''His financial troubles and the haunting threat of hunger subsided in his last two years,'' Miss Haskell writes, ''but even belated success never altered his meager living habits or calmed his fears. At the time of his death, he had $500 in cash and $10,000 in savings.'' Which was quite a lot of money in 1943.

The great strength of the present Hartley retrospective lies in its generous representation of the paintings of the Berlin period and the American abstractions that immediately followed them. We have never before seen these pictures in such number, and they constitute a glorious exhibition in themselves. The late paintings—both the landscapes and the figure paintings—are also fairly well represented, though not nearly as comprehensively as one might wish.

The outstanding weakness of the exhibition, however, is in the selection of the paintings that fall between these two peak periods in Hartley's development. The choices confronting the curator in these transitional years are admittedly difficult. Should every twist and turn of style be documented, or should the selection be based entirely on aesthetic quality? Miss Haskell leaves one with the impression that she has often settled for documenting the artist's career, whatever the quality of the painting.

Still, this is a marvelous exhibition, and a very moving one. Whatever its weaknesses, it fully restores Hartley to his preeminent place in the first generation of American modernists.

MARCH 23, 1980

2. Florine Stettheimer

The American painter Florine Stettheimer died in New York on May 11, 1944, at the age of seventy-two. Two years later, the Museum of Modern Art mounted a retrospective exhibition of her work. Marcel Duchamp selected the pictures, and Henry McBride wrote the catalogue. The show later traveled to San Francisco and Chicago. Although never considered a "mainstream" talent, however the mainstream was defined at one or another moment in the history of her career, Stettheimer nonetheless commanded the admiration of some of the keenest aesthetic minds of her time.

Yet, a dozen years after the MoMA retrospective, hers was a name scarcely known to the New York art world. An entire generation of curators and critics came of age without paying the slightest attention to her work. In the heyday of the New York School, it would have looked hopelessly eccentric and out-of-date, in any case—a bizarre throwback to the spirit of Beardsley, Bakst, and Ronald Firbank. If Stettheimer was remembered at all, it was because she had designed the famous production of the Virgil Thomson–Gertrude Stein opera, *Four Saints in Three Acts*, in 1932.

On this, as on many other matters of art and culture, our perspective has now once again been significantly altered. No longer, in 1980, do we worship at the shrine of mainstream modernism with quite the old sense of dedication, exclusivity, and intolerance. We rather hunger, in fact, for a certain variety of style and vision, and art that is odd and personal, even a little strange, is not automatically abjured. One result of the more pluralistic attitudes governing the present situation in art, certainly, has been a more open attitude toward some of the "lost" art of the recent past.

Florine Stettheimer—now the subject of a delightful exhibition at the Institute of Contemporary Art in Boston—is but one of a number of artists who can be expected to benefit from this reversal, and an important one. She was an artist with a narrow but powerful imagination. She had a distinctive outlook on the world, and she gave it vivid expression in her work. A revival of her art has been long overdue. I am glad to say that with the present exhibition, organized by Elizabeth Sussman and called "Florine Stettheimer: Still Lifes, Portraits, and Pageants, 1910-1942," the rehabilitation of this interesting, offbeat painter is off to a good start.

Stettheimer was an unusual woman, and her paintings, too, are un-
like anyone else's. She is therefore easily misunderstood. Because she
was rich and once presided over a salon that was famous in its day,
there is an obvious temptation to regard her as some sort of amateur.
And because her mature style bears so little resemblance to the official
"schools" of modern art, there is a parallel temptation to regard her
painting as "naïve." Both approaches are woefully mistaken.

Stettheimer was a complete professional. In the 1890s, she studied
with Kenyon Cox—a leading academic painter—at the Art Students
League in New York. Later on, she continued her studies in Berlin,
Munich, and Stuttgart. Her first solo exhibition took place at
Knoedler's in 1916, and she worked at her art with unremitting seri-
ousness until her final illness in the 1940s.

The style that resulted from this effort is anything but naïve. It is a
highly individual and consciously achieved creation, combining ele-
ments of satire, elegy, reminiscence, lyric fancy, and a wit that is very
sharp. It is studded with brilliant observation and a wonderful gift for
parody. It is very shrewd in depicting character, and often hilarious as
well as mordant in its account of both art and society. Even where it is
most affectionate—in the portraits of family and friends—it remains
hardheaded and precise. Its extreme ornamental elements and its dazz-
lingly theatrical color may give to Stettheimer's painting a beguiling air
of foppery and burlesque, yet within the boundaries of what often
seems a breezy and insouciant harlequinade there is a social vision that
is a good deal more penetrating—and often a lot funnier, too—than the
one we find in some of the more highly touted realist painting of the
time.

Consider, for example, the painting called *Spring Sale (at the Dress-
maker's)* (1921). Women shoppers were a commonplace subject for our
realist painters in the twenties. Kenneth Hayes Miller virtually
founded a school devoted to this theme, and pretty dour it was. Stet-
theimer turns this material into a fantastic balletic comedy, all vivid
color—hot reds, pinks, and gold—and frenzied action. More than two
dozen figures, each enacting its own self-absorbed scenario, are
adroitly placed in an antic tableau that has something of the quality of a
Marx Brothers romp.

The crowded social tableau, later developed into a more ceremo-
nial pictorial pageantry, was something of a specialty with Stettheimer.
It was one of her most original creations. The canvas is divided into

zones of separate but simultaneous activity rather like the rings in which circus entertainers traditionally perform. The figures are deployed in groups, as diminutive and as colorful as an army of toy soldiers; yet each of these myriad figures is given a very concrete identity.

In the earlier paintings of this type, the themes are often drawn from family parties and country house weekends—wonderful chronicles, incidentally, of a certain side of New York art life at the time. In *Sunday Afternoon in the Country* (1917), for example, we are given, among much else, a glimpse of Edward Steichen photographing Duchamp in the foreground while Stettheimer herself is off at the margin working at her easel in the open air.

Later, in the more public social pageants of which there are two fine examples in the present show—*Cathedrals of Wall Street* (1939) and *Cathedrals of Art* (1942)—there is a much more ambitious program of satire attempted. The setting of *Cathedrals of Art*—the artist's last painting—is the grand stairway of the Metropolitan Museum of Art, and the atmosphere is distinctly comic. (Indeed, it is comic opera.) Among its many recognizable figures is that of the then-director of the museum, Francis Henry Taylor, as well as Alfred H. Barr, Jr., the founding director of the Museum of Modern Art, who is shown in his own zone in the painting contemplating the work of Picasso and Mondrian while reposing in a chair of modern design. Dealers are shown promoting their artists, and the whole scene is one of shameless hustling and posturing. It is a prophetic as well as a delightful painting.

Some of the individual portraits, especially those of McBride and Duchamp, give us a close-up look at some of the same figures and employ a similar montage-like form. McBride, the most highly regarded critic of the twenties, is shown wearing a black coat over a tennis costume. There is a tournament in progress (in the lower left of the picture), McBride is keeping score, and there is a distinct suggestion that for the critic, art, too, resembles a tournament of a kind. In this picture, also, there are amusing evocations of the art of John Marin and Gaston Lachaise—two of the critic's favorites at the time. Stettheimer and McBride were great friends, but the caustic undercurrent in the portrait is unmistakable.

From what sources did she draw the elements of the extraordinary style that could encompass such material with so much wit, elegance, and theatrical power? It is important, I think, to recall that Stettheimer was, in some respects, an offspring of the nineties. The elongated fig-

ures can be traced to Beardsley, I suppose, and the ubiquitous serpentine line, the stylized flowers, etc., must owe something to the Jugendstil aesthetic—the German equivalent of Art Nouveau—that was flourishing in Central Europe in the days when Stettheimer was studying there. Her amazing color, however, and what might be called the choreography of her painting, are directly traceable, I think, to Diaghilev's Ballets Russes, which she saw for the first time in Paris in 1912. Through Bakst, who designed some of the ballet productions she saw at the time, she acquired the basis of that Byzantine-Russian palette—hot reds and purples, magenta pinks, often set in brilliant, icy white light and embellished with yellow and gold—that she proceeded to develop in a very individual manner. In the end she made out of this feat of chromatic artifice a perfect instrument for dealing with a certain area of American social experience.

MARCH 16, 1980

3. Elie Nadelman

We have been waiting a long time for an exhibition that would do justice to the splendor of Elie Nadelman's achievement as a sculptor and draftsman, and at last we have one in the show that John I. H. Baur has organized at the Whitney Museum of American Art. Few exhibitions in recent memory have been as beautiful as this one, and those who see it will cherish the experience for a lifetime.

Nadelman is an unusual figure, and his work requires a certain adjustment for eyes jaded by the stripped and astringent forms so prevalent in modern sculpture. There is a quality of mandarin taste in his work and an impulse toward idealized utterance unlike anything we find in the art of his contemporaries. There is also a passion for the past—a passion combined with a rare intelligence and discrimination—that he was unconcerned to disguise. Nadelman was, like so many modernists, a dedicated purist in his sense of form, contour, and finish, but he differed from other sculptors of this persuasion in con-

sciously aligning his purist inventions with unmistakable evocations of adored precedents, which are reconstituted in his work with an extraordinary delicacy of imagination. In the history of Western sculpture since Rodin, he stands alone among artists of the first rank by virtue of his visible intimacy with "tradition."

Nadelman's "tradition," however, is a highly personal amalgam. One can name some of the diverse elements that contributed to it—Rodin and Beardsley, Houdon and Michelangelo, Hellenistic sculpture and Art Nouveau, Italian mannerism and American folk art—but Nadelman's sources never quite prepare us for the experience of the work itself. His early work especially—the grand oeuvre produced in the decade (1904–14) he spent in Paris and in his first years in New York (1914–16)—is as full of quotations and paraphrases as *The Waste Land* or the *Cantos*, and like them, it effectively absorbs, modifies, and transforms what it remembers in a rhythm and accent that is new. The example of poets like Eliot and Pound is, indeed, worth keeping in mind in thinking about Nadelman, for he too was a polyglot expatriate and cosmopolite of great cultivation and sensibility, a scholar of the traditions he sought to invest with a new vitality who found in the alien terrain of the modern world a rich store of material for a style at once contemporary and timeless.

Their careers traced a very different geographical route, however, and encompassed a very different experience. They crossed the Atlantic in different directions, each finding the other's promised land insufficient for his purposes. Whereas Pound and Eliot felt obliged to quit America in order to realize their highest artistic aspirations—aspirations closely linked to the romance of European culture—Nadelman, after an ecstatic immersion in that culture, found his most original impetus here. All three were assiduous "collectors" of the past, shoring up precious fragments of lost cultures in their quest for a meaningful modern statement and canny in perceiving the ways in which the primitive and the folkloristic might illuminate that quest. It was Nadelman's distinction to discover one of his richest veins of inspiration in a corner of the American past carelessly abandoned by the natives.

He was born in Warsaw, then a province of the Russian Empire, in 1882, into a family of cultivated and prosperous Polish Jews, attended the Warsaw Art Academy, served in the Imperial Russian Army, and by 1904 had made his way to Munich, where he spent six months, before settling in Paris. The decade that Nadelman passed in Paris saw

one of the greatest flowerings of creative genius known to Western art; and he was part of it, making his influence felt where it counted, but always, it seems, at a certain distance. He showed in the Salons frequented by the avant-garde, and the drawings he produced in those years—there is a dazzling group of them in the Whitney show—tend to support his claim of having played a role, generally unacknowledged, in the creation of Cubism. It is known that in 1908 Leo Stein took Picasso to Nadelman's studio, and the bronze Cubist *Head* Picasso produced in 1909—the first of his Cubist sculptures—is thought to have been influenced by this encounter.

Nadelman's first one-man show, at the Galerie Druet in 1909, was a great success; and by 1910, he was sufficiently established to be invited by Alfred Stieglitz to publish a statement about his art in *Camera Work*, the principal avant-garde journal in New York. But Nadelman was already an anomaly among the *révoltés* of the Paris avant-garde. His sense of the past was different from theirs, more pious perhaps, but also more knowing and intimate and alive. The past, for him, was a source of energy and ideas rather than a threat or an obstacle to fulfillment. He was, in every sense, "above" repudiating it. He could no more bring himself to spurn the classical sculpture of the Greeks—he was, at that very moment, putting it to splendid use in his own sculpture—than Pound or Eliot could spurn Dante. In this respect, his fight in 1912 with Marinetti, the leader of the Futurists, was emblematic of his whole position. For Nadelman, a speeding motorcar was certainly not more beautiful than the *Victory of Samothrace*.

There is, then, nothing of the academic, nothing merely conventional and unexamined, in the elegant heads and figures Nadelman produced in his Paris period. The sharp silhouettes of the sculptures, the exquisite curvature of their masses, and the "ideal" harmonies that obtain among their beautifully realized forms, are as fresh and forthright as the diction of Pound's early lyrics. Like those lyrics, they are at the same time a form of homage to their sources and a statement of contemporary feeling, and in the handsome installation that Arthur Clark has given them at the Whitney, they still speak to us with a vivid and lofty eloquence.

Nadelman continued to work in this classical vein during his first years in New York—the *Female Nude* (circa 1916–20), in bronze, and the white marble *Goddess* (circa 1916), at the Whitney, certainly show there was no falling off in quality or ambition—but he also turned to other tasks. Among them were some commissioned portraits, and

these—to judge by the *Portrait of a Little Girl (Marie Scott)* (1916) and the *Portrait of Hélène Irwin Fagan* (1917)—prompted Nadelman to produce works of a kind of incurious banality. Later on, too, he was always at his worst, always simply not *there*, in his commissioned portraits. The poet of the ideal head was apparently stymied in having to render a less than ideal likeness.

In the United States, however, he discovered a whole new area of inspiration—new to him, and new to the American art of his time. This was American folk art of the eighteenth and nineteenth centuries, then entirely overlooked by aesthetes and connoisseurs and virtually forgotten by everyone but a few antiquarians and amateurs. For Nadelman, it was a newfound land of the imagination, and he immediately set about collecting it in large quantities—he soon had enough to establish his own folk art museum—and adjusting his own most serious sculptural efforts to the lessons to be learned from it. The result is one of the most original bodies of work ever produced by a sculptor on the American continent.

Nadelman had always been a master carver, and now he turned to woodcarving, creating forms of an elegant simplicity and wit that spoke directly to contemporary experience. These forms he painted in the manner of the folk art he cherished but with that unerring sense of refinement and detached humor that separates his work from the naïve practice of the authentic folk artist. He drew his themes from the life around him—dancers and singers, society hostesses and circus performers, orchestra conductors and men in top hats and derbies, capturing their gestures with a flawless sense of kinesthetic precision that was always a powerful component of his art, and elevating them to a new level of poetic archetypes without in any way diminishing their worldly identity. Nadelman's discovery of American folk art allowed him to carry his vision of "ideal" forms into a new realm of expression. It was characteristic of his elegant, complex mind that he used something out of the past to illuminate the present and created something dazzlingly new in the process.

The north wall of the Whitney's third-floor gallery, where Nadelman's painted wood figures are lined up like members of the chorus in one of the musicals he so adored, affords an experience like no other in the history of modern sculpture. In these works, the real and the ideal live on easy and affectionate and humorous terms; and sculpture once again assumes an exalted task of poetic mimesis. It is all an astonishing achievement, and the wonder—not to say the scandal—of it is in

the way it was for so long allowed to remain obscured. It says something about the sectarian taste and narrow doctrinaire aesthetics that have dominated the art scene in recent decades that an accomplishment as fine as Nadelman's was so consistently overlooked and devalued and maligned, while so many minuscule talents burrowing in ever tinier reaches of the mind were upheld in high places as the exemplary figures of our time.

We can be grateful, anyway, that Nadelman's exile is now over. This exhibition, with its 103 sculptures and 41 drawings, triumphantly restores his achievement to the canon of modern art, and future histories of the subject and future exhibitions are unlikely to ignore it ever again. It is pleasant, too, to be able to say that the Whitney Museum has risen to the occasion by mounting this exhibition with exemplary taste.

OCTOBER 5, 1975

4. Edward Hopper

The paintings of Edward Hopper (1882–1967) have long occupied a special place in the history of American taste. He is the one realist in whose work almost everyone—whether radical or conservative or merely fashionable—has found something to love. Long before there was a Whitney Museum, the old Whitney Studio Club gave him a one-man show. (That was sixty years ago, in 1920.) Soon after the Museum of Modern Art opened its doors in 1929, Hopper's *House by the Railroad* (painted in 1925) was the very first painting acquired for its permanent collection. That was before the Modern owned a single Picasso.

When the Abstract Expressionist movement was taking New York by storm in the 1950s, the late Parker Tyler wrote a remarkable article for the *Art News Annual* in which Hopper was favorably compared to Jackson Pollock, and when Pop art was all the rage in the sixties, Hopper was proclaimed a precursor of that movement. And now, in 1980, when more and more painters are turning to realism as a viable artistic

course, Hopper's work is again the focus of new interest. He has proved to be a formidable survivor.

The Hopper retrospective that has now been organized by Gail Levin at the Whitney Museum is certain to increase the artist's great popularity further. For one thing, it is a big show—consisting of more than 170 paintings, 35 watercolors, and 175 drawings—and big shows are now the vogue. And for another, it is a show that gives us a closer look at Hopper's life and career—even at his marriage—than we have ever had in the past. It thus breaches the privacy that Hopper insisted upon preserving in his lifetime, and this, too, will add to the show's appeal. I think that Hopper himself would have hated this aspect of the exhibition—but this is speculation, of course. Given Hopper's disabused view of the world in which he functioned, he would hardly have been surprised by this, in any case.

The great surprise of the show for many people will be the early pictures Hopper painted in France in the first decade of the century. The Hopper we know so well—the Hopper that emerged in the 1920s with a style all his own—is a painter so dry and austere, so "American" in texture and feeling, that this "French" Hopper comes as something of a shock. We hardly expect painting so lush and brushy from "our" Hopper—painting so filled with the emotions of youth and so much in love with its Parisian subjects.

Yet among these "French" paintings there are more than a few that alert us to the themes—especially the theme of light—that later emerged as the staples of Hopper's art. The sunlight reflected on the exteriors of the buildings in *Le Quai des Grands Augustins* and *Le Pavillon de Flore* (both 1909) may not yet have attained the formal power that Hopper would achieve with his American subjects, but it nevertheless represents the same impulse. And in one superb picture from these early years—*Le Parc de St. Cloud* (1907)—we are suddenly introduced not only to a brilliant structure of light but also to a space that abounds in prophecies of the artist's future work. *Le Parc de St. Cloud* has the additional interest of bearing an uncanny resemblance to certain later—much later—pictures of Richard Diebenkorn.

But if there are pictures from the early period that anticipate later themes, there are others that show us attitudes and emotions that Hopper quickly abandoned. The finest of these is the remarkable *Soir Bleu*, a compelling figure composition painted in the United States in 1914. It is a wonderful picture for its date and unusual in Hopper's oeuvre both for the number of figures it contains and for the air of sweet and

worldly melancholy it sustains. (Melancholy would remain one of Hopper's abiding themes, but it would never again be quite as sociable and romantic as it is in *Soir Bleu*.) Hopper never again painted anything like it, for it was not a success when he showed it in New York.

Compared with *Soir Bleu* and the early Paris paintings, the work Hopper produced in Gloucester, Massachusetts, and Ogunquit, Maine, in 1914 looks pretty routine—provincial, in fact. For a decade or more after Hopper returned from France in the summer of 1910, he was clearly an artist in crisis. It wasn't until well into the twenties that he found his way.

It was probably the pressure exerted by the milieu he was closest to at the time—the antimodernist milieu of the original Whitney Studio Club—that led Hopper to create a style of his own. The pressure to create something authentically American in painting elicited from Hopper an original response. He had always been a keen observer, and in turning to his American material in the twenties, he now saw everything with a fresh vision. It wasn't the speed or energy or material prosperity of American life that attracted his interest, but the emptiness and isolation, the dull routines and lost hopes, that this fast-paced civilization left in its wake.

For this dour subject matter Hopper began in the twenties to develop a style, at once highly documentary and yet depopulated and very austerely structured, that is itself an emblem of the emptiness and isolation it expresses. There is almost nothing as lonely in all of modern painting as an interior or a landscape in a Hopper. Even the buildings in Hopper's paintings—and what a marvelous painter of architecture he was!—tend to look depopulated. In the theater or the movie house or the restaurant, the crowd has either just left or not yet arrived. The urban interior is often as vacant of social intercourse as a country road.

Yet within the space left vacant by social intercourse—which Hopper seems never to have had much taste or talent for—the painter created the drama that clearly interested him more than anything else in the world. This was the drama of pictorial form, with its immaculate structure of light and shadow. And as this formal interest came more and more to dominate his sensibility, the documentary aspect of his art grew correspondingly slighter and less important. The final irony of Hopper's art is that it looks happiest—most serene and philosophical—when there are no longer any human figures present to cast a melancholy shadow on the pure space of his invention.

He was a remarkable artist and a more original artist than many of his contemporaries quite realized. But is he big enough and various enough an artist to sustain an exhibition on this scale? I frankly doubt it. The show, which occupies two full floors of the museum and even spills over into a third, seems to me to be far too big for its subject—and too unselective, especially in the drawings and watercolors, which are rarely, if ever, as good as the paintings. A smaller exhibition would very likely have a greater impact.

SEPTEMBER 26, 1980

5. Morton L. Schamberg

A retrospective exhibition devoted to the work of an immensely gifted artist who died at an early age is bound to be an experience of special poignancy. The more we admire the work, the more likely we are to be haunted by thoughts of what the artist might have accomplished in the course of a normal life span. For in the perspective of his foreshortened career, his every solid achievement acquires a sort of double existence for us. There is the work itself, in all of its manifest quality, and there is also the penumbra of unrealized possibility that accompanies it. To the extent that such artists make a difference in the art of their time, we seem to suffer their loss anew at each encounter with their best efforts.

In the case of Morton Livingston Schamberg, whose work is currently the subject of a traveling retrospective exhibition,[1] there is the additional factor of the artist's historical situation. Schamberg belonged to the first generation of American modernists, and he shared a

[1]The Morton Livingston Schamberg retrospective was organized by the Salander-O'Reilly Galleries, Inc., in New York. It then traveled to the Columbus Museum of Art and is currently on view in Philadelphia at the Peale House Galleries of the Pennsylvania Academy of the Fine Arts. It will later be seen at the Milwaukee Art Museum and the Arts Club of Chicago.

good many of the difficulties faced by that generation in its effort to come to grips with the innovations of the European avant-garde. He was remarkably quick to grasp the importance of those innovations, and he proved to have the requisite gifts—including the gift of intelligence—for effectively adapting them to the lineaments of his own experience. At the same time, Schamberg felt very keenly the isolation that was the common fate of the modernist painter in his time and knew from the outset that it was more or less out of the question for him to win a sympathetic public for the kind of art that most interested him or, indeed, to make a living from producing it. Yet none of this seems to have impeded his artistic progress once he had determined his course. His resoluteness in this respect would have been remarkable enough for an American artist in the early years of the century working in Paris or even New York. In the far more provincial atmosphere of Schamberg's native Philadelphia, to which he remained firmly attached despite his contacts with Paris and New York, it entailed an exceptional exertion of will and independence. Only in the last years of his life—Schamberg died in 1918 two days before his thirty-seventh birthday—did the artist's spirit falter. Yet even this change, when it occurred, had more to do with the historical enormity (as he saw it) of the First World War and its implications for his art than with any bitterness or disillusionment caused by resistance to the art itself.

He was born in Philadelphia in 1881, the youngest child in a German Jewish family that William C. Agee, in his essay for the catalogue accompanying the current retrospective, described as "prosperous and conservative."[2] From what we know of them, the Schambergs were not a family much given to encouraging either artistic pursuits or unconventional behavior of any sort.[3] The father was a dealer in cattle, the mother died when Schamberg was a child. All the same, Schamberg seems to have been treated with a good deal of consideration, and his family ties remained close. He was given an extensive artistic

[2]The illustrated catalogue of the Schamberg exhibition, with a text by William C. Agee and a checklist by Pamela Ellison, is published by the Salander-O'Reilly Galleries, Inc. Mr. Agee's essay gives us the best account of Schamberg's artistic development that we have.

[3]Ben Wolf's sketchy monograph, *Morton Livingston Schamberg* (University of Pennsylvania Press, 1963), is the principal published source of biographical information on the artist. Neither as biography nor as art history can it be confidently relied upon, however.

education—first at the School of Fine Arts of the University of Pennsylvania, from which he was graduated as a Bachelor of Architecture in 1903, and then at the Pennsylvania Academy of the FIne Arts, where he concentrated on painting for three years. (The friendships he made with Charles Sheeler and Walter Pach, who were fellow students at the academy, date from this period; they appear to be the only close attachments Schamberg made outside of his immediate family.) While studying at the academy under William Merritt Chase, he was treated to his first trips abroad. He was given a year in Paris upon the completion of his studies in 1906, and he journeyed to Europe again in 1908. All of this, as far as we know, was at the expense of the artist's disapproving father. At the time of Schamberg's death in 1918, both father and son resided at the same hotel in downtown Philadelphia. In quick succession both were victims of the influenza epidemic that swept the world in the last year of the war.

The earliest painting that we see in the current retrospective is *The Regatta*, which is signed and dated 1907. Exactly where this brilliant little picture was painted is not known—it depicts decorated sailboats observed from the shore and was very likely executed during a summer visit to Gloucester, Massachusetts—but both its outdoor subject and its luminous, painterly style clearly reflect an admiring knowledge of the French Impressionists. Traces of this Impressionist manner persist for a time, but by 1909 it gives way to the various Postimpressionist strategies that give a radical priority to structure over sensation. Mr. Agee suggests that during his last stay in Europe, where he was joined for a time by Sheeler, Schamberg came under the influence of Leo Stein (whom he met through Pach). It was probably Stein who sent the two Philadelphians to Italy to study the Old Masters, for Stein had worked out an elaborate theory relating Italian quattrocento painting to the innovations of Cézanne and Matisse. It was at this time, in any case, that Schamberg produced his remarkable copies of Piero della Francesca's *Duchess of Urbino* and Lorenzo di Credi's *Venus*—both are included in the current exhibition—and at this time, too, that he got to know the work of Matisse, with its highly original concentration on color and structure. Mr. Agee is no doubt right when he observes that "the intensity of this experience in 1909 was fundamental to the evolution of [Schamberg's] art."

Oddly enough, it wasn't until he encountered it in the Armory Show in New York in 1913 that Cubism, which was to play a decisive

role in his most original work, first made a very deep impression on Schamberg's pictorial thought. (One wonders if Leo Stein, who was turning against Cubism, might have had something to do with this, too.) Perhaps he wasn't ready to make use of Cubist form before 1913, for Schamberg was never an abject imitator or stylemonger. In the period following his return to Philadelphia, he worked his way through the ideas he had acquired in Europe, and these turned mainly on assimilating the work of Cézanne and Matisse. Even when he adopted Cubist form in 1913, he used it as a means of organizing his pictures into Cézannesque structures of color. Cubism gave Schamberg a way of geometrizing his subjects. The subjects might not remain discernible, but whether or not they could be discerned, the effect was to relegate them to a subsidiary role and thus permit painting to enter the realm of abstraction. In the years 1913–15 Schamberg's art remained poised on the shifting frontiers of the new abstract art, never quite taking possession of this unfamiliar terrain and never entirely withdrawing from it. Not that there is anything diffident in the pictures of this period. Far from it. We are made to feel a distinct acceleration in the scale of the artist's ambition. The Armory Show seems to have renewed Schamberg's confidence in his artistic mission, and it certainly encouraged a greater degree of audacity in his art. He was himself represented in this historic exhibition, and it spurred him into acting for the first time as a public spokesman for the cause of modernism. He was even responsible for bringing a smaller version of the exhibition to Philadelphia. It is in the pictures of this period that we see Schamberg emerging from isolation to produce his most distinctive work.

It has long been recognized, of course, that it is in the machine paintings of the war years that Schamberg's most original work is to be found. Historians have hitherto been a little too eager, perhaps, to assume that these paintings were created under the direct influence of Picabia, Duchamp, and other avant-garde eminences of the day. The effect of this has been to blur our understanding of Schamberg's own work and its role in sparking the development of the Precisionist movement in American painting—a movement essentially different in spirit and style from the variety of Dadaism that flourished in New York in this period. The whole subject is admittedly a tangled one. Schamberg *was* closely involved with the New York Dada group, and undoubtedly drew some sustenance from them. Yet his own interest in machine forms seems to have predated theirs, and his paintings based on tele-

phones and other machines show not the slightest trace of that peculiar amalgam of irony, mockery, comical eroticism, and cheerful nihilism we have come to recognize as the hallmark of their art. The note that is sounded in Schamberg's machine paintings is, on the contrary, unmistakably one of admiration and lyric celebration, and is thus very much at odds with the Dada attitude. It was precisely because of his celebratory outlook, in fact, that Schamberg suffered a severe crisis over this work at the very moment when he was, as Mr. Agee says, "at the peak of his powers." Appalled by the carnage of the war in Europe, he could no longer sustain his optimistic and somewhat innocent vision of machine civilization. "We may speculate," writes Mr. Agee, "that Schamberg could not [reconcile] the lucid, ideal order of his machine paintings with the death and destruction that the machine was causing in the war." Sometime in 1916, after creating an uninterrupted succession of brilliant pictures, he abruptly abandoned the machine paintings, and thus unwittingly brought his oeuvre to an end.

Before he died, however, Schamberg produced two works that may be taken as emblems of his divided outlook at the end, for they point in very different directions. One was the construction of a plumbing fixture mounted on a box that was mockingly entitled *God* (1917–18). This was Schamberg's only authentic Dada creation, and Mr. Agee is surely correct in describing it as "a bitter anti-war statement." The other was a serene *Bowl of Flowers* (1918), an exquisitely realistic watercolor that is the artist's last known work. From such a stark contrast of bitterness and serenity we are offered no very definite clues to the direction Schamberg's art might have taken had he survived. All that we can be certain of is that his death marked an important loss for American art—more important than we have heretofore realized.

Of the nearly seventy works that make up the current retrospective, the most amazing—not only for their remarkable quality but because they have never before been published or exhibited—are a series of small pastels of machine images executed, it is believed, in 1916. There are nearly twenty works on paper in this series, which was only recently discovered in Philadelphia, and they are unquestionably among Schamberg's most beautiful pictures. Based on the forms of a Champion wire-stitching machine used by printers and bookbinders, these pastel *Compositions*, as they are called, are pictures of the most extraordinary delicacy—shimmering evocations of light and color that transform their given motifs into images of a flowerlike tenderness. Neither

wholly abstract nor exactly representational, they are Schamberg's most poetic works—and they remind us, incidentally, of how much remains to be discovered, and rediscovered, in the American art of his time.

APRIL 1983

6. Precisionism Revised

More than twenty years ago—in the fall of 1960—Martin L. Friedman organized an exhibition at the Walker Art Center in Minneapolis that significantly altered our perspective on American art between the two world wars. It was called "The Precisionist View in American Art"; and it consisted of paintings by, among others, George Ault, Ralston Crawford, Stuart Davis, Charles Demuth, Elsie Driggs, Louis Guglielmi, Louis Lozowick, Georgia O'Keeffe, Morton L. Schamberg, Charles Sheeler, and Niles Spencer. Some of these artists had long been highly regarded, of course, A few were established classics. Others— George Ault and Elsie Driggs, for example—Mr. Friedman had rescued from an undeserved obscurity. Whatever their degree of fame or obscurity, however, most of the painters represented in the "Precisionist View" exhibition were no longer very much discussed by critics, curators, and historians caught up in the more immediate excitements of the New York School. Avant-garde opinion tended to dismiss them as irrelevant, and academic opinion in those days paid scant attention to any aspect of American modernist art that could not be regarded as part of the direct ancestry of the New York School. Mr. Friedman had thus performed an important service in restoring these painters to our attention and in reminding us of their special qualities—qualities that contrasted sharply not only with the tastes and practices then dominating the contemporary art scene but with the spirit that governed it as well.

Precisionist painting was not, for one thing, a mode of abstraction. It was deeply attached to a particular subject matter. As the Precision-

ists saw it—and they were not alone in this respect—theirs was a very American subject matter. For the imagery of Precisionist painting was largely derived from the artifacts of American industrialism. Skyscrapers, steel bridges, modern factories and water towers, ocean liners, automobiles, locomotives, airplanes, traffic lights, all the machines and structures that by the twenties had come to shape and define the very life and spirit of the American metropolis—these exerted a tremendous appeal for artists of the Precisionist school. It was in the artifacts of twentieth-century industrialism, indeed—in their forms, in their speed, in their materials and textures, and in the modality of their production—that the quintessential spirit of the modern age was seen by the Precisionists to reside. Industrial production was looked upon as marking a decisive break with the past, and its forms were regarded as the idiom of the future. They were seen to constitute the distinctively modern element in modern life. It was for this reason, too, that so many European artists and writers took New York City to be preeminent as a model of modernity. As early as 1913, Francis Picabia characterized New York as "the Cubist, the Futurist city." "It expresses in its architecture, its life, its spirit, the modern thought," Picabia declared on his first visit to New York. "You have passed through all the old schools, and are Futurists in word and deed and thought." What to Picabia in 1913 had looked exotic and avant-garde, even revolutionary perhaps, was soon embraced by the artists of the Precisionist school as the central impulse of their native civilization.

The subject matter of Precisionism was important to these painters in another respect as well. It played a decisive role in determining their pictorial vocabulary. In strictly formal terms, of course, Precisionism derived from Cubism. It was Cubism, particularly in its early, "analytical" phase, that gave Precisionist painting its fundamental syntax. In the radical way that Cubism altered the depiction of objects in space by reducing their visual constituents to a highly simplified, quasi-geometrical structure of plane surfaces, Precisionist painting found the key to its own style. Yet strictly formal terms, while they have much to tell us about the spirit as well as the substance of Precisionist painting, do not finally account for its peculiar vision. For it needs to be understood that Cubism was, for the Precisionists, a means rather than an end in itself. It was in large part their special subject matter—and their attitude toward this subject matter: an attitude that was aesthetic, impersonal, and curiously romantic—that led them to adopt and modify the Cubist vocabulary. Cubism gave the Precisionists a way of encom-

passing the experience of the new industrial environment as an aes-
thetic phenomenon.

There was nothing in the way of social analysis or social criticism in
the Precisionist outlook. Precisionism was not a documentary style. It
took no interest in the minute observation of urban life. It did not con-
cern itself with the social or economic implications of industrialism. It
was not an art of social consciousness. It looked upon the world of sky-
scrapers and smokestacks as something especially beautiful—a new
beauty that was uniquely the product of the machine age. From this
beauty, moreover, it drew its models and its program, which was to
produce an art that was as sleek, as hard, as streamlined and immacu-
late, and as monumental as the industrial objects and structures that
inspired it. Charles Demuth said it all when he gave to the finest of his
industrial-motif paintings of the twenties the title *My Egypt*. Clearly the
comparison he wished to invoke was that of the pyramids. In the
smokestacks and factory towers of his native Lancaster, Pennsylvania,
Demuth felt that he had found the closest thing to an object of grandeur
the modern world had to offer. Being a dandy and an aesthete, he no
doubt harbored mixed feelings in the matter. Yet there is nothing satiri-
cal in the art itself. However tinged with irony the comparison of con-
temporary Lancaster with ancient Egypt may have been for Demuth,
irony plays no role in his painting of industrial subjects. On the con-
trary, he treats them with a kind of exalted lucidity—with an emotion
akin to religious awe. Charles Sheeler was even more explicit about the
"religious" parallel. "Our factories are our substitute for religious ex-
pression," he once observed, soon after completing a series of stunning
photographs of Chartres Cathedral. (What he clearly had in mind was
his own earlier project in photographing the Ford Company's River
Rouge plant.) We are thus reminded that the Precisionists were often
quite consciously involved in elevating the iconography of industrial
technology to a realm that invited comparison with the mythic monu-
ments of antiquity and the Middle Ages.

The Precisionists were, in other words, turning the iconography of
industrialism into a species of myth and romance. The pictorial world
of Precisionism is a timeless world. There is no history in it. Its imag-
ery tends to be archetypal and axiomatic. Nothing in it moves or
changes. Its universe is a universe of stability and stillness. All sense of
menace and risk has been removed from it. The dynamism of the in-
dustrial machine is banished, too. In his essay for the catalogue of the
"Precisionist View" exhibition, Mr. Friedman had pointed out that

the artists of the Precisionist school applied the methods of analytical still-life painting to their outdoor subjects, and this observation remains a key to our understanding of the Precisionist aesthetic. It reminds us that Precisionist painting is devoid of people and events. Above all, it cautions us not to expect from Precisionist art an account of the historical world from which its imagery is drawn.

It was inevitable, I suppose, that the passage of time would sooner or later alter our perspective on the Precisionist school, and it is indeed a very different perspective that is given us in the exhibition called "Images of America: Precisionist Painting and Modern Photography" that Karen Tsujimoto has organized for the San Francisco Museum of Modern Art.[1] The past two decades have brought us a great many publications and exhibitions in this field, and Miss Tsujimoto, the associate curator at San Francisco, is thus in the happy position of being able to bring to the organization of this exhibition a far more comprehensive knowledge of the principal figures of the Precisionist movement than has been possible hitherto. More important than any new information about individual figures, however, has been a development that lies outside the realm of painting itself. This is the enormous interest in the history of photography that, beginning in the sixties, has quickly won for that discipline a position of parity in certain fields of art-historical study. Miss Tsujimoto has taken full advantage of this development in organizing the "Images of America" exhibition. She may even have overdone it. There are more than a few photographs in the show that have, at best, only a tangential relation to the subject under review. And the disproportionately large number of photographs in the exhibition—out of a total of 161 works in this show, 87 are photographs—threatens at times to make painting and drawing appear to have served as a mere appendage to an artistic phenomenon primarily photographic in its interests.

This is not to say that the whole subject of Precisionism does not warrant an ample representation of photographic art. The Precisionist aesthetic unquestionably exerted a tremendous influence on American photography in the period between the two world wars. Precisionist painting was itself, in turn, deeply influenced by photographic images. Some of the outstanding painters in the movement were themselves

[1]"Images of America: Precisionist Painting and Modern Photography" was shown at San Francisco Museum of Modern Art. It is currently on view at the Saint Louis Art Museum, and will then travel to the Baltimore Museum of Art, the Des Moines Art Center, and the Cleveland Museum of Art.

photographers of distinction, and about Sheeler—the most important among them—it might even be said that, despite his considerable renown as a painter, it is in photography that his most enduring achievements are likely to be found. Certainly on the evidence of this exhibition, which gives us an opportunity to study certain of Sheeler's paintings along with the photographs on which they were based, it tends to be in the photographs that we find the most vital images. By comparison, the paintings of the same subjects tend to have a bland, illustrational quality that is entirely missing from the photographs. In this instance, at least—and there are others, too—Miss Tsujimoto has added something important to our knowledge of Precisionism by including photographs that are an integral part of its aesthetic history.

All the same, there is definitely something askew in the way the exhibition has been selected. We are constantly made to feel that there were interests being served in the selection that have little or nothing to do with the principal theme of the exhibition. No doubt one of these interests has to do with the size of the show. It would probably have proved to be impossible to mount an exhibition on this scale if photography had not been somewhat indiscriminately used to fill out the requisite bulk. Important paintings are far more difficult to acquire for large, traveling loan exhibitions than photographs are. (Demuth's *My Egypt*, for example, one of the stellar attractions in Mr. Friedman's "Precisionist View" exhibition, could not be secured for the "Images of America" show.) A smaller exhibition, no matter what its merits might be, would run into difficulty in attracting both the necessary funds and the collaboration of other museums on the lookout for a "major" loan exhibition. Nowadays small exhibitions are not, in any case, good box office; and box office has become a compelling concern in the museum world. In this case, as in many others, photography has proved to be a godsend.

But the scale of the "Images of America" exhibition is by no means the only consideration that contributed to its curiosity distorted selection. There was undoubtedly an element of regional chauvinism involved. Precisionist painting was, by and large, an East Coast movement. It was centered mainly in New York. One can easily understand why this fact might prove to be a problem for a curator in San Francisco. Might it not suggest that in the heyday of the Precisionist movement San Francisco—and the West Coast generally—was something of an artistic backwater? In this respect, too, photography has come to Miss Tsujimoto's rescue. While the West Coast contributed little

to Precisionist painting, it has given us an impressive roster of photographers—among them, Ansel Adams, Imogen Cunningham, John Paul Edwards, Alma Lavenson, Sonya Noskowiak, Peter Stackpole, Henry Swift, Willard Van Dyke, Brett Weston, and Edward Weston—who might, with a little adjustment, be claimed for the movement. This is indeed the claim made by Miss Tsujimoto in the "Images of America" exhibition. Not only is photography thus elevated to a place of parity with painting, but the West Coast is made to seem to be a force equal to—and maybe, at times, even a little more than equal to—that of the East Coast in its contributions to the Precisionist movement.

Even this, however, does not exhaust the list of pressures that have been brought to bear on the selection of the exhibition. There is also what can only be called the "affirmative action" question in regard to some of the women represented in the "Images of America" show. In most instances, this is not a question easily separated from the representation of photography, for most of the women in the exhibition are photographers—and this suggests yet another reason why photography is given so large a role in the show. But in one case, certainly, Miss Tsujimoto appears to have made yet another adjustment in her view of Precisionism in order to include a painting—as it happens, a very good painting—for extra-artistic reasons. The painting in question is Helen Torr's *Windows and a Door* (1926–35). This is a wonderful little painting, but it has nothing to do with Precisionism. Everything about this picture marks it as belonging to another order of sensibility. I daresay that if it had been painted by a man, it would never have been included in this exhibition. But Helen Torr is an artist we are only just now rediscovering, so a special allowance had to be made. She was the wife of the more famous Arthur Dove, and *Windows and a Door* happens to be far closer in spirit and method to Dove's work—which is not, and should not be, represented in the "Images of America" show—than anything to be found in the history of Precisionism.[2] Clearly the decision to include this work was not a disinterested one.

It is not only in the selection of works that are included in the exhibition, moreover, that Miss Tsujimoto has given us a revisionist view of the Precisionist movement. In the book-length catalogue she has produced to accompany the exhibition, she has attempted—not altogether

[2] For my views on Helen Torr as an artist, see my article "Art: Rediscovering Helen Torr's Work" in *The New York Times* for April 4, 1980.

successfully, I am glad to say—to give us a sociological interpretation of the movement that is often at considerable variance with the spirit of the pictures we see on the museum's walls.[3] Miss Tsujimoto is clearly impatient with, and discomfited by, the purely aesthetic interest that many of the Precisionists took in the spectacle of industrial technology. She does not quite know what to do with their tendency to turn it into a species of myth and romance. She seems to yearn for a degree of social consciousness, even social protest, that is just not to be found in the pictures. If anything, the pictures tend to celebrate the beauty and energy of industrial production, not to denigrate it or protest against it. She therefore has a difficult time coming to terms with what the Precisionists actually achieved. Reading the text that she has written for *Images of America*, one sometimes has the impression that she would be more at home in writing about a different subject—the W.P.A. mural movement, say, or the social-protest art of the thirties.

Consider, for example, the opening paragraph of this catalogue text:

> America at the turn of the century was basically an agrarian society, divided between the extremely wealthy and the very poor. The wealth of America was concentrated in the East within the hands of relatively few, among them J. Pierpont Morgan, head of the mightiest banking house in the world; Andrew Carnegie, whose personal income in 1900 was over $23 million with no income tax to pay; John D. Rockefeller and Cornelius Vanderbilt. There were, in contrast, thousands of citizens for whom life, especially in the city, was not pleasant or easy. Particularly in New York, but in other cities and industrial towns as well, many American families were living in a state of poverty.

Lest anyone assume that Miss Tsujimoto has conjured up this picture of the Robber Barons in order to confront a paradox—namely, that the Precisionists should have become so enamored of the industrialized world that these figures did so much to bring into being—I must hasten to inform you otherwise. More than anything else, she seems to want to make it known at the outset that her heart is in the right place. She is not much of a social historian, in any case. The only work cited to support her rather simpleminded view of American history at the turn of the century is, alas, Frederick Lewis Allen's *The Big Change:*

[3] *Images of America: Precisionist Painting and Modern Photography* by Karen Tsujimoto. University of Washington Press.

America Transforms Itself, 1900-1950, which appeared thirty years ago and was not exactly, even then, a very weighty account of American society in the twentieth century. But this, I am afraid, is altogether characteristic of what passes for social history in the texts of museum exhibition catalogues.

It would be pleasant to report that Miss Tsujimoto shows a firmer grasp of the history of art and architecture in this text, but this is not altogether the case, either. Further along on the first page of the *Images of America* text, we are treated to the following account of American architecture:

> In its architecture, America looked to the past, emulating Europe and the Greek classics. As Merle Armitage recalled, ''The architecture of our houses was monotonously hideous, and cornice-conscious red brick stores were everywhere. Carnegie Libraries in the form of aborted Greek temples were being erected throughout the land, and the prevalent concept of a state or county building was a compromised replica of St. Peter's in Rome.'' Although Louis Sullivan was in mid-career, it was not until several years later that America began to be conscious of simplicity and function in its buildings. Modern architecture, as far as America is concerned, did not really begin to define itself until the mid-Twenties.

It would be difficult to know where to start in attempting to untangle this mess, and it would not be terribly rewarding, in any case. But several things in it are worth commenting on. The most obvious, perhaps, is the fact that the skyscrapers, bridges, and factories that the Precisionists painted and photographed with so much feeling in the twenties were already in place when they came to them. These were not imaginary structures. There are, for example, two paintings by Louis Lozowick depicting skyscraper architecture in the ''Images of America'' show. One is called *Pittsburgh* (1922-23), the other *Chicago* (1923). Both are reproduced in color in the catalogue, but one wonders how closely Miss Tsujimoto had looked at them in preparing her essay. For both their subjects and their dates make hash of everything she has to say about American architecture in the passage I have quoted. As for those ''cornice-conscious red brick stores'' that so offended Merle Armitage, moreover, hasn't Miss Tsujimoto ever noticed—in her researches into the period—how beloved they were by the painters and photographers of the twenties? For that matter, if she takes a good look around her native San Francisco, she will find that those ''monotonously hid-

eous" houses are today among the most desired habitations in the city. She is, I am afraid, merely mouthing ideas that have long been discredited and out of date.

This is not an approach that takes us very far in attempting to understand the Precisionist movement—or, indeed, anything else in our cultural history. It is one thing to express some dissatisfaction with the formalist view of art history, and to want to act on it in preparing an exhibition of this sort—which cries out for some illumination of its social dimension. Obviously, Miss Tsujimoto is recoiling from the sectarian interpretations of modernist art that formalist criticism had long imposed upon it, and there are certainly good and ample reasons to resist such a narrow reading of art history. But all that she has to offer in its place is a confused amalgam of dated avant-garde shibboleths and radical tags that in the end serves only to elucidate the assumptions that govern it. The task of writing the social history of American art is going to require a good deal more in the way of study and of thought than Miss Tsujimoto imagines. A few facile references to Frederick Lewis Allen and Merle Armitage will not do.

The sad fact is that an important opportunity has been missed in the "Images of America" exhibition. Interest in the Precisionists is very high at the moment. New exhibitions and publications devoted to individual artists in the movement follow in a steady stream. What we have needed is a large exhibition and a comprehensive study that examine this movement with a fresh eye and new ideas, and this was what we had every reason to expect to find in "Images of America." Now it is unlikely to be done for another generation.

DECEMBER 1982

7. Morris Kantor

The American painter Morris Kantor died on January 31, at the age of seventy-seven. His death was not unexpected. For two years he had been seriously ill; and during that time, he often spoke of his imminent death, in conversation with friends, with the same kind of intensely

sardonic humor that he lavished on other subjects that absorbed him—painting, above all; for painting remained his consuming passion, but also the world in which painting struggles for realization and survival. His own struggle as an artist had been faithfully pursued for nearly sixty years, and he continued to paint during the very last weeks of his life, despite his weakened condition, several of the finest canvases of his career. It was an extraordinary example of the artistic will triumphing over physical circumstance.

Some forty years ago Kantor had been very much in the limelight, winning many prizes, sitting on exhibition juries, and showing his work wherever American painting was taken seriously. (Duncan Phillips once organized an exhibition of American painting called "From Eakins to Kantor.") He lived long enough to see himself written into and then out of the histories of American art, and he could be caustic—and sometimes hilarious—on the subject. He was indeed a shrewd observer of both success and failure, having tasted a good deal of both in his long career, but his observations were private and disinterested. Against the politics and commercialism of the art world, which he thoroughly understood and detested, the door to his studio was firmly closed.

In his youth—the youth of an immigrant who came to the United States from Russia at the age of fifteen—he had studied with Robert Henri and Homer Boss, and was thus one of our last living links with the period that saw American realism challenged and then swamped by the strengths of European modernism. By the early twenties, he was himself a complete convert to the modernist position. He produced a series of abstract Cubist paintings and drawings at that time that are still too little known, but I have no doubt they will be better known in the future. In the National Collection of Fine Arts in Washington the other day, I saw once again his large and powerful *Synthetic Arrangement* (1923), freshly cleaned and dazzling, which now hangs in the recently refurbished Lincoln Gallery. It was a great comfort to see this picture restored to its rightful place in the history of American painting.

In the thirties, Kantor turned to a more romantic representational style in which poetic evocations of the American past—early American houses together with the lives and the objects that occupied them—are combined with direct observation and autobiography. The juxtaposition of past and present, of the imaginary and the concrete, sometimes earned him a reputation as a surrealist, and the structure of certain of these "Americana" paintings (as they are often called) may indeed

owe something to Surrealism. But they owe even more, I think, to the artist's marriage, in 1928, to Martha Ryther, herself a painter and a New Englander, who probably opened his eyes to this "American" world for the first time. The paintings of this period are, in any case, a poignant exploration of native imagery by an outsider profoundly sensitive to its visual and poetic properties. Upon the best of these pictures Kantor lavished all his virtuosity as a painter, and they, too, will one day be rediscovered and cherished.

From the war years onward, he embarked on another kind of search. It took the form of a return to a more abstract, analytical style—a return, in fact, to the Cubism of the twenties. Only now the subject, whether observed or imaginary, was transmuted into something more hermetic and mysterious. The earliest of these paintings, mainly abstract seascapes of Maine, are extremely austere, almost diagrammatic. In the fifties, however, he reintroduced the figure into these paintings, and, with it, a subtler, more sensuous use of color, and this became the dominating interest of his last paintings.

They are paintings of astonishing visual delicacy and emotional intensity. The exact subject is often elusive—usually it is one or more figures situated in a space that shifts from interior to landscape—but the realized image is a brilliant construction of diaphanous color. They abound in marvelous pictorial detail—subtle transitions of light and shade and sudden shifts of intensity. They represent, I think, a remarkable integration of the romantic and the analytical elements of his sensibility, and bring his art to a high level of lyrical expression.

Until the onslaught of his final illness, Kantor had also functioned for many years as a teacher of painting—at the Art Students League and Cooper Union in New York and at many schools elsewhere. He was, in the opinion of most of his students and colleagues, a magnificant teacher, genuinely committed to the talent and aspiration of the individual student. He imposed no dogma or system and therefore had little to say about art in general; it was the concrete example that interested him, and it was to that that he addressed himself. He was modest and even shy, but about the artist's vocation he held strong opinions, and he often expressed them.

Starting in the fifties, he was much in demand as a teacher in the big university art departments of the Midwest, and he served them well. Yet he never felt at home in those big departments, where the artist's sacred vocation was often sacrificed to what he considered irrelevant and damaging considerations (both practical and ideological). He

became more and more appalled, on his visits to these universities, at the extent to which the art journals published in New York—and the more aggressive critics who contributed to them—held the minds of his students (and those of his younger colleagues) in thrall. He remained loyal to the old atelier system and was deeply suspicious of the new academic arrangements that encouraged art students to work at "ideas" rather than at developing their individual vision.

He was a remarkable man, and he will be missed. I was lucky to have known him as a friend for nearly twenty years, and I never had a conversation with him from which I did not gain some valuable insight or understanding. The first time I called on him at his old studio in Union Square, sometime in the fifties, he had been reading Plutarch, and we spent most of that afternoon talking about the *Lives*. He could be very funny, recounting and embellishing Plutarch's tales in his broad Yiddish accent, but he was always serious.

"It's good reading for an artist," he said. "After all, the politics, the cheating, all the rest of it—it's just like the art world. Nothing much has changed."

Encountering one of his finest paintings of the twenties in the National Collection the other day—it was, as it happened, the day before he died—I was suddenly encouraged to think that Morris Kantor's real accomplishments would someday be given their due.

FEBRUARY 10, 1974

8. "Abstract Expressionism: The Formative Years"

The writing of the history of art, especially the history of art recent enough to remain subject to the correction (or, as is sometimes the case, the falsification) of living witnesses, is a conundrum of considerable size. So much depends upon the perspectives and prejudices of the moment, and so many of these depend upon those networks of personal and political association—and business connections, too—that are an

inevitable part of the lives of the artists who produce the art, of the dealers and museum curators who select it for exhibition, and of the writers who set down the history of both. The wonder is not that distortions occur in the writing of such art history but that anything remotely resembling a coherent and persuasive chronicle ever sees the light of day. Everybody knows that a friendship or a love affair or a divorce, a move to the country or a decision not to, an altercation with a dealer or an affront to a critic or curator, can sometimes determine an artist's place in written history; yet the history is written as if it were a completely "objective" account of objects and their attributes. The myth of "objectivity" is, I suppose, one of the fictions essential to the writing of such history, but it remains a myth all the same.

Take the history of the Abstract Expressionist painters of the New York School, for example. How is it to be written? Who is to be included? When the Museum of Modern Art organized a major exhibition called " The New American Painting" in the late 1950s, one of the painters omitted was Hans Hofmann. Yet Hofmann was clearly regarded as an artist of considerable importance by both Clement Greenberg and Harold Rosenberg, two critics who disagreed about much else. When Thomas B. Hess wrote his pioneering study *Abstract Painting: Background and American Phase*, published in 1951, the section he devoted to the New York painters included reproductions of work by Hyman Bloom, Lee Gatch, Jack Tworkov, Balcomb Greene, and Esteban Vicente, among many others, but nothing of Barnett Newman's. For Mr. Hess in 1951, Newman was clearly a minor figure at best. Yet since then Mr. Hess has written two monographs on Newman that accord this artist a primary place in the movement. When Irving Sandler's *The Triumph of American Painting* appeared in 1970, it carried on its jacket a famous group photograph of the New York School in which only one woman is to be seen among the fifteen painters represented: Hedda Sterne. Yet Miss Sterne's name is not even listed in the book's index. And so it goes with much of the historical writing on this subject. Perspectives shift, prestige waxes and wanes for reasons seldom elucidated, and the works of art nominated for historical consideration appear and disappear as if by magic.

It is against this background that the exhibition called "Abstract Expressionism: The Formative Years," organized by Robert Carleton Hobbs and Gail Levin at Cornell University's Herbert F. Johnson Museum of Art in Ithaca, New York, assumes a special interest. The focus of this exhibition, though it includes among its more than one hundred

works a few pictures from the late 1930s and a few executed as late as 1949, is primarily on the war years and their immediate aftermath. It thus recalls us to the important fact that this period—the period of World War II—was the crucible in which the art of the New York School was formed; a fact that the Tenth Street myths of the 1950s tended to obscure. It also has the effect of separating the pioneers of the school from those others—some of them estimable artists, to be sure— who joined the movement later.

In "Abstract Expressionism: The Formative Years," there are thus no paintings by Franz Kline or Philip Guston or James Brooks, for example, and Barnett Newman barely squeaks in with a small watercolor said to have been painted circa 1945. On the other hand, there are seven pictures by Lee Krasner, who until recently was denied any sort of serious place in this history except as the wife of Jackson Pollock. Is this a case of an historical injustice finally being set right—both the quality and the dates of the pictures would suggest that it is—or does it represent a surrender to the feminist politics that are now influencing the writing of art history, or both? There are also in this exhibition five major paintings by Richard Pousette-Dart that effectively reestablish his place in the first rank of the artists who were at work in the crucial war years—a place that historians of the New York School, often basing their work on the very different "scene" of the fifties, have tended to deny him.

Yet the motive of his exhibition is clearly not revisionist, and the majority of the names represented in it are the expected ones: Baziotes, de Kooning, Gorky, Gottlieb, Hofmann, Motherwell, Pollock, Reinhardt, Rothko, Stamos, Still, and Tomlin. The work is too heterogeneous in style and too mixed in quality to lend itself to easy summary or generalization; yet, in one respect at least, it can claim a certain unity that sets it apart from much of the art of the later years. This is in its distance from any sort of slick and glamorous look. For the most part the paintings in this exhibition are untouched by—what shall one call it?—the look of money or success. They are not "pretty" and easy in the way so much abstract painting—and not only abstract painting—has since become. There is something about the physical quality of the paintings, too—is it, perhaps, the absence of that bright, dead look we have become inured to since the advent of acrylics and other plastic pigments?—that is almost poignant in itself. The atmosphere of struggle is palpable and affecting.

This is, moreover, art that is very close to its European sources.

Perhaps that, too, sets it apart from some of the later work. (This is a point well made in Gail Levin's catalogue essay "Miró, Kandinsky, and the Genesis of Abstract Expressionism.") What is particularly interesting about this aspect of the exhibition is not the obvious dependency of this or that artist on one or more European masters but the spirit in which the European masters are struggled with. There is very little attempt here to reduce the heritage of European modernism to a series of formalist strategies. That, too, came later. The imperative interest lies in the discovery or creation of some personal archetype or myth—in symbolism that employs the painted surface of the canvas for some avowal of the spirit beyond the merely aesthetic.

In part, of course, this was a reflection of the Surrealist ethos that played so crucial a role in the formation of the New York School, but one feels it even in a painter like Clyfford Still, who seems to have been very little touched by that ethos. It probably had something to do with the war, and it certainly had a lot to do with the reaction then in progress against the discredited clichés of 1930s radicalism in politics. Freud and Jung tended to supplant Marx as intellectual deities; the radical aspiration was turned inward, with painters concentrating on "the discovery of the unknown within themselves," as Mr. Hobbs puts it in his essay for the catalogue. The search for "meaning" was still a burning issue, and not easily come by. Painting had not yet become so dazzlingly and dispiritingly efficient in finding its eye-pleasing forms. The language of this search for "meaning" was still governed to a very large extent by the conventions of Cubism and Surrealism, but they were already in process of dissolution. It was the beginning of the end of modern painting.

I have never myself seen an exhibition that made the essential spirit of American painting in the war years so vivid, so naked to the eye and to the mind. Removed from the world of glamour and money and success that afterwards overtook the New York School, the paintings that have been gathered in "Abstract Expressionism: The Formative Years" offer a fresh start for anyone attempting to come to terms with the art history of the last four decades.

APRIL 16, 1978

9. The Rothko Retrospective

After the noxious experience of the legal battles that did so much to make the name of Mark Rothko famous for all the wrong reasons, it is an immense relief to be able to return at last to the paintings that are, despite suicide and financial scandal, the first and last reasons for our interest in this difficult and still very enigmatic artist. The exhibition that Diane Waldman has organized at the Guggenheim Museum— "Mark Rothko, 1903–1970: A Retrospective"—is the most complete survey of the man's work anyone has yet given us. In addition, the Pace Gallery has simultaneously mounted an exhibition, "The 1958–1959 Murals," which have never before been shown as a group. These exhibitions by no means exhaust the entire Rothko oeuvre, but they do give us a very ample basis on which to come to terms with the artist's accomplishment. Future shows may amplify or modify our understanding of one or another aspect of that accomplishment, but the fundamental experience of Rothko's art has now been laid before us. For anyone with an interest in the art of our time, it is an experience not to be missed.

Almost the first thing one notices in the show at the Guggenheim— and I say this on the basis of several visits—is that the public attending this exhibition is strangely subdued. There is, if not exactly a hush, then certainly an atmosphere of piety and wonder. People tend to linger, moreover, often turning away from the paintings in front of them in order to look across the great open space of the Guggenheim spiral at paintings in the distance. More than at most exhibitions of contemporary painting, the public at the Rothko show looks somewhat awestruck and transfixed. Whether this is because of the way Rothko's work affects them, or because of the way it fails to affect them, or—as I suspect—because of some combination of the two, who can say with any certainty? One nonetheless has the impression of witnessing a curious search—of seeing people looking for something as well as at something.

The exhibition fills almost the entire museum, and the special feeling I speak of does not begin to make itself felt until we reach the paintings of 1947 and after—the paintings in which color and the scale necessary to sustain its power are given an audacious priority over every other pictorial consideration. The last traces of symbolic figuration are

gone, and from this point on there is an atmosphere of visual magic in the exhibition. The eye is more and more ravished by an experience of color unlike anything to be found in the work of other painters—even today, amazingly, when so many of the big abstract paintings that we see have followed and enlarged upon Rothko's influence in establishing color as the artist's all-consuming interest.

So seductive is the quality of Rothko's color, and so complete is its hold on our attention, that we experience its later descent into the shadows as a very emphatic and concrete emotion. The experience of color in painting is an experience of light, and when we find ourselves staring into the darkness of a painting called *Black on Dark Maroon* (1968)—which rivals the later work of Ad Reinhardt in approaching the unseeable in painting—we are made to feel that it is not only something in art but something in life that is being terminated. The experience of color in Rothko's paintings thus begins, in the late forties, on a note of sensual affirmation, even joy, and ends in the late sixties in an atmosphere of despair. Even if we were ignorant of the artist's biography, knowing nothing of his decision to end his own life, the implications of this visual scenario would not be very difficult to fathom. Commencing with the paintings of the late forties, we are never in any doubt that we are witnessing a deeply subjective drama of the self.

The small early paintings in the Guggenheim show stand at a great distance from this drama of the self. The earliest date from the late twenties; and even the paintings of the 1930s are, for the most part, without distinction. There is a notable self-portrait, painted in 1936, and some interesting pictures of figures in New York subway stations from 1936–38—interesting, that is, because of the way their division of space seems to foreshadow the simplified forms of Rothko's later painting. But the truth is, the early Rothko is a pretty banal painter. Even when he attempts to emulate the style of Milton Avery—a friend and mentor of that period—he cannot yet make creative use of Avery's gift for color. This he was only to do later on when he turned to complete abstraction.

The turn to abstraction did not immediately take the form of an interest in color, however. What absorbed Rothko from the late thirties until that moment after the war when he found in color the key to all the emotions he wished to impart to his painting was the symbolic world of ritual and myth, especially as it could be gleaned in the "primitive" forms of archaic art. Klee and Miró and Max Ernst, and indeed the whole culture of Surrealism—which more or less trans-

planted itself to New York during World War II—were more important to this phase of Rothko's development than Avery or any other painter with a specialized interest in color. Important, too, was a more general shift then occurring in American culture—away from the social concerns of the thirties, and toward that interest in psychoanalysis which, from that time onward, has held so many American artists and intellectuals in thrall.

The paintings that Rothko produced in this Surrealist, or mythic, phase have titles like *The Omen, Phalanx of the Mind, Archaic Phantasy, Ritual*, and *Totem Sign*. One is called *Vessels of Magic*, and it was as a kind of vessel of magic that Rothko now conceived painting to be. The observable vicissitudes of earthly life are suppressed in favor of an imaginary iconography of the mind. At times these strange pictures look like fantastic evocations of marine biology. But the drawing in them—tethered, as it still is, to the conventions of Surrealism—is their weakest constituent, and the balance of expressive power is already shifting to the representation of atmosphere and light. It was not until Rothko eliminated surrealist drawing from his painting and harnessed that interest in light to a more audacious use of color for its expression that he was able to produce something entirely his own. Color itself was now to be the vessel of magic.

And it is color—soft, luminous, almost cloudlike—that lends an air of enchantment to the exhibition, and captivates the eye. Yet Rothko himself was adamant in insisting that his art went "beyond" color—that its fundamental purpose was religious and spiritual. In a famous statement he once declared: "There is no such thing as good painting about nothing. We assert that the subject is crucial and only that subject matter is valid which is tragic and timeless," and it was no secret that this was precisely how he regarded his own work—as a statement of the "tragic and timeless." His painting therefore raises in the most extreme form the whole question of exactly how a purely abstract art may be construed as having—or as expressing—a subject matter that somehow exists beyond the visual boundaries of the object itself.

So much nonsense has already been written about this aspect of Rothko's art that one is reluctant to go into it yet again. Yet the nonsense persists, and it is important that we understand it for what it is. There are now whole phalanxes of critics and curators who, when they hear the word "Rothko," reach for their Sophocles or Buber or whatever, in order to read us Existentialist sermons on the tragic nature of the universe. Robert Goldwater made the definitive comment on this

sort of thing when, writing about Rothko in 1961, he remarked: "Such literary fancies are program notes that relax the visual hold of these canvases, filter their immediacy, and push away their enigmatic, gripping presence."

Yet these many years later the game is still being played. Thomas M. Messer, the director of the Guggenheim, at least varies the scenario a bit when, in an introductory note to Mrs. Waldman's catalogue, he invokes the names of Schubert and Brahms and the whole "era of German Romanticism." But the fact is, Schubert's name—not to mention the vast roster of minds conjured up by this reference to German Romanticism—tells us exactly nothing about the experience of Rothko's painting.

Still, the question of "meaning" in Rothko's art—for this is what all these "literary fancies" are really about—cannot be avoided, if only because Rothko himself made such a point of it. An artist who insists that "the subject is crucial" in painting, and then denies that the one most dominant visual element in his painting—in Rothko's case, color—is the subject, is presenting not only us with a paradox but presenting himself with one as well. Rothko was clearly uneasy, indeed extremely anxious, about this paradox, and he had every reason to be. He had carried painting to a point of extreme reduction, and had made something extraordinary out of what remained, and yet he still yearned for the world of meaning that painting had jettisoned on its way to colonizing its extreme position.

What he was left with—and what we are left with in his art—is precisely this struggle between the artist and his aesthetic materials. It adds to the paradox of Rothko's art that this struggle resulted in images of such apparent serenity, but the drama of the self makes itself felt all the same, and it is made all the more poignant by the fact that the only language available to the painter for its expression is the language of an extreme aestheticism.

If there is a religious dimension to Rothko's art, is it not to be found precisely in this aestheticism—in the religion the artist made of art itself? That, I suspect, is what accounts for the atmosphere of piety and wonder in this exhibition—the sense it gives us of art itself being made into a substitute religious faith. This, I think, helps to explain both the power of the art and its capacity to leave us with a sense of bafflement.

NOVEMBER 12, 1978

10. The Singularity of Clyfford Still

Clyfford Still, who died on June 23 at the age of seventy-five, was in many respects the oddest, the most singular, and the most intransigent artist of his generation—the Abstract Expressionist generation, which made its embattled public debut in the 1940s and which has since acquired a worldwide renown rivaling that of the School of Paris. He was also one of the most original. Like Willem de Kooning—in so many other ways his polar opposite—he became for a time the object of a cult, so admired and beloved by a circle of younger painters that the work of other living artists all but ceased to have any meaning for them.

One of the things that made him so odd was his wholesale rejection of the art of others. All artists tend to take a sectarian view of the past as well as of the work of their contemporaries, elevating what is immediately usable to a special status and consigning everything else to oblivion. Often these rejections prove to be temporary—remember T. S. Eliot's rejection of John Milton?—and are later recanted when they no longer serve a useful creative purpose. For artists tend as a rule to venerate their own tradition. In Still's case, however, the rejective impulse remained absolute. Toward the art of his immediate contemporaries he harbored an attitude of suspicion and contempt that was not easily distinguished from paranoia, and toward the art of the more distant past he was similarly negative and adamant.

Something of the spirit with which he viewed the whole prior history of modern culture may be gleaned in a letter that Still wrote in 1959 to Gordon Smith, the director of the Albright Art Gallery (as it was then called), and that was used as an introductory statement for the retrospective exhibition of Still's work mounted that year in Buffalo. Reflecting on the 1920s and attempting to explain his own purposes ("It was never a problem in aesthetics," he said), Still wrote:

> Self-appointed spokesmen and self-styled intellectuals with the lust of immaturity for leadership invoked all the Gods of Apology and hung them around our necks with compulsive and sadistic fervor. Hegel, Kierkegaard, Cézanne, Freud, Picasso, Kandinsky, Plato, Marx, Aquinas, Spengler, Einstein, Bell, Croce, Monet—the list grows monotonous. But that ultimate in irony—the Armory Show of 1913—had dumped upon us the combined and sterile conclusions of Western European decadence. For

nearly a quarter of a century we groped and stumbled through the nightmare of its labyrinthine evasions. And even yet its banalities and trivia are welcomed and exploited by many who find the aura of death more reassuring than their impotence or fears. No one was permitted to escape its fatalistic rituals—yet I, for one, refuse to accept its ultimatums.

Rejecting what he called "intellectual suicide," which he identified with "the collectivist rationale of our culture," Still described the course of his own career "as a journey that one must make, walking straight and alone." Clearly he regarded his life as an artist as a kind of Pilgrim's Progress, and spoke of it in a language that reminds one of the hell-fire sermons of certain Calvinist divines. "One's will had to hold against every challenge of triumph, or failure, or the praise of Vanity Fair. Until one had crossed the darkened and wasted valleys and come at last into clear air and could stand on a high and limitless plain."

Never one to take a modest view of his own powers, Still concluded the statement with a warning: "Let no man undervalue the implications of this work or its power for life—or for death, if it is misused." Even in a period when raging megalomania was not exactly unknown among artists, Still's confidence in the power and uniqueness of his achievement was unparalleled. But so was the depth of his alienation from the culture in which he functioned—the very same culture, let us remember, that soon came to regard him, precisely because of the intensity of his alienation, as a hero. For there is nothing that our culture so much admires as an artist who vociferously denounces it—and thus, overtly or otherwise, places his own work above it.

Yet the culture of one's times is more easily denounced than escaped, and Still was not quite as immune to its conditions or temptations as he liked to aver. He was simply more adroit than many of his contemporaries in manipulating its machinery for his own purposes. He was determined that his work be accorded not only high visibility but a kind of sacred preferment, and he was expert at attaining both. Scorning the company of his contemporaries, he wanted to be regarded as singular and incomparable—for so he regarded himself—and he knew exactly how to arrange it.

East and west, at museums in Buffalo and San Francisco, he contrived to establish sizable collections of his own work that he clearly envisioned as objects of pilgrimage for generations to come. Meanwhile, though practiced in the ways of keeping an army of eager curators and collectors at bay, he allowed a happy few just enough access to his work

to permit them to feel supremely privileged even to glimpse it. And when he finally consented to an exhibition at the Metropolitan Museum of Art last year, it had naturally to be the largest exhibition ever devoted to the work of a living artist at that institution. And it was Still, of course, who selected the show, which came mostly out of his own storerooms; and it was he who wrote his own catalogue and otherwise acted as his own curator. Such favor is never won on the basis of aesthetic merit alone. No doubt his often-professed detestation of the ways of the art world was genuine, but Still played upon the susceptibilities of that world like a Horowitz at the keyboard. In the end the art world had nothing to teach him about getting ahead.

Given this megalomaniac attitude, it was a mercy, of course, that the work was as good as it was. Still really was an original—an abstract painter who seemed to owe nothing to anyone else, and who created something genuinely new in his art. (To say that he owed nothing to anyone else may be overstating the case, however. Exactly what he knew of the work of Augustus V. Tack, a visionary landscapist whose paintings bear a distinct if distant resemblance to Still's, remains a mystery not yet fully explored.) The sense of space that Still achieved in his work, whatever it may or may not have owed to Tack, was a genuine pictorial invention. The illusion it created of a cosmic boundlessness affords an experience not easily forgotten. It suggests something unearthly and immense, a world infinite in dimension and implication—a world, too, of loneliness and isolation. At times it may acquire the look of a vast, uninhabited landscape, or seem to be miming the space of the very heavens, but mainly it resists any facile reading from "nature." It was, I suppose, an attempt to create an image of space—which is to say, an image of spirit—that could be taken as primordial, stripped bare of all cultural or historical association.

All art remains bound to the culture and history of its time, however, and Still's art is no less bound to its moment than any other. It was essentially a creation of the forties. It came out of the isolation and turmoil and opportunity of the war years and shared with so much of the culture of that period the tendency to turn inward—to reject the world that existed beyond the private boundaries of the individual psyche and to find salvation in the realm of spirit. It was to this yearning—and to the sense of unfettered individualism that was its natural concomitant—that Still gave such eloquent expression.

In Still's case, it was not a mode of expression that allowed for very much in the way of development, however. Once he had perfected his

style in the forties, it had nowhere to go. The artist's dialogue with the world had been completed. And from the fifties onward—right to the end—it tended, therefore, to be a rehearsal of familiar, well-established premises. The color might be altered and the work grow lighter, and its physical dimensions might be enlarged. But fundamental growth was foreclosed. The artist had made himself immune to further artistic thought.

It was in this sense that the crank element so evident in Still's public personality in later years—and so vividly spelled out in the curious catalogue of the Met show—insinuated itself into his art, and placed a severe limitation upon it. This, in any event, was the impression that many visitors to that gigantic show at the Met came away with—an impression of a gifted, original artist who had long before sealed himself off from any vital intercourse with the world or the culture he inhabited.

JULY 6, 1980

III. Contemporary Art: The Anatomy of Pluralism

1. Fairfield Porter: An American Classic

Not the least of the many extraordinary things about the Fairfield Por-
ter retrospective, which Kenworth Moffett recently organized at the
Museum of Fine Arts in Boston, was the way it resulted—overnight, as
it were—in a sweeping transformation of the artist's reputation and
status.[1] It is one of the functions of a retrospective exhibition, of
course, to enlarge our understanding of an artist's work, and this often
leads to some modification in our estimate of his achievement. But it is
rare, all the same, for such exhibitions to produce the kind of prompt
and categorical change in critical opinion that greeted this show. Por-
ter, who died in 1975 at the age of sixty-eight, did not lack for serious
admirers in his lifetime. Among certain painters and poets, as among
certain critics and collectors, his work had for years commanded an al-
most abject loyalty. Yet beyond this circle of devotees he continued to
be regarded as a minor and somewhat eccentric figure, and the public
at large was hardly acquainted with his name. It is not exactly a secret
that in New York, where Porter was well known in art circles both as a
painter and as a critic, no museum would undertake to organize an ex-
hibition of his work. Even the Whitney Museum, famous for its eclec-

[1]An abridged version of "Fairfield Porter (1907–1975): Realist Painter in an Age of
Abstraction" is currently on view at the Greenville County Museum of Art, Green-
ville, South Carolina, and will then travel to the Cleveland Museum of Art, the Mu-
seum of Art at the Carnegie Institute in Pittsburgh, and the Whitney Museum of
American Art in New York.

tic taste and flexible standards, had to be coerced into accepting even
an abridged version of the Boston show.

It is no exaggeration, then, to say that it is only with this retrospec-
tive that Porter has emerged for the first time as an American classic—
and an immensely popular one, too. In Boston the Porter show proved
to be something of a sensation, bringing in some eighty-five thousand
visitors in a period of two months—an astonishing number for an exhi-
bition devoted to a little-known contemporary artist. In the national
press, too, the show was treated as a major art event. Even journals
that are normally content to act as if contemporary art does not exist—
I think particularly of *The New Republic* and *The New York Review of
Books*—felt obliged to make an exception in this case and pay the Porter
exhibition some sort of critical attention. The former invited no less a
literary personage than John Updike to review the show—presumably
on the grounds that it takes a WASP to understand a WASP, and that
only a professional observer of American middle-class manners could
be expected to come to terms with the world depicted in Porter's
paintings—while the latter simply reprinted John Ashbery's affection-
ate little essay for the exhibition catalogue. (Like many things written
about Porter by his friends, this paid a handsome tribute to the man
but had virtually nothing to say about the paintings.) At *The New
Yorker*, the assignment to cover the exhibition for "The Art World"
column did not go to the magazine's regular art critic—a specialist in
the antics of Andy Warhol, John Cage, and Robert Rauschenberg—
but to Whitney Balliett, the resident jazz critic and sometime reviewer
of novels who happens to be the fortunate owner of one of the best pic-
tures in the exhibition and may thus be presumed to be a passionate
admirer of Porter's work. What is remarkable about all this is not,
alas, the critical content of the articles in question—Mr. Balliett's was
by far the best, if only for its quotations from Anne Porter, the artist's
widow—but just the fact of their publication. Nothing quite like the
press coverage of the Porter show had been seen hereabouts since the
great Picasso retrospective in 1977; and in that case, of course, it was
Picasso's legend that determined the attention. With Porter, it was the
exhibition and its coverage that contributed to the creation of a legend.

How are we to account for this response, from both the public and
the press, to an artist whose name could scarcely have meant much of
anything to either only a short time before? It is usually the case, I
think, that such questions, even when answerable, tell us little or noth-
ing about the art that occasions them. But in regard to the Porter exhi-

bition I believe the question goes to something central in the art itself. For Porter's painting seems to elicit in its public a response, a sense of connection and integration, very much akin to the impulse that moved the artist to create it in the first place. We are given a glimpse of what that impulse was in a particularly illuminating passage in Mr. Moffett's essay for the catalogue of the exhibition. (Mr. Moffett's penetrating essay "The Art of Fairfield Porter" is by far the best thing ever written on Porter's paintings.[2]) In this passage Mr. Moffett is speaking of Porter's special admiration for the paintings of Vuillard and Velázquez, and he draws from this a compelling insight into Porter's own work:

> Porter saw in both Vuillard and Velázquez sovereign artistic personalities who were able to balance their love of the medium and their love of visual reality in such a way as to respect the inherent individuality of both. Here is Porter's ideal. . . . It explains why he liked Vuillard better than Bonnard. For Bonnard's wayward and equivocal brushing imposes itself, however passively, on the structure of reality. Porter didn't like deliberate distortions, which he called "affectation," just as he didn't like bravura, which he called "performance." . . . He felt that it was Vuillard, not Cézanne, who had "made of Impressionism something solid and durable like the art of of the museums." "Vuillard organized Impressionist discoveries about color and pigments into a coherent whole." Or Vuillard was more "coherent and orderly" than Monet. Now it can be said that more than Cézanne or Bonnard or Monet, Vuillard, especially the later Vuillard, kept to traditional perspective and drawing. He was innovative, fresh, personal, mostly in his handling of paint and in his unusual sense of color. Something like this could be said about Porter, too; he experienced what we think of as Vuillard's conservatism, a respect for the wholeness, uniqueness, and presence of the world.

It was upon such a hard-won effort to combine his "love of the medium" and his "love of visual reality" that Porter based his own painting from the 1950s onward. Of that, I think, there can be no doubt. And it is in his unusual success in achieving this synthesis of "medium" and "reality" in his painting that the key to his immense appeal at the present time is to be found. For in this painting what Mr. Moffett aptly describes as the "presence of the world" is restored to a

[2]*Fairfield Porter (1907–1975): Realist Painter in an Age of Abstraction.* Essays by John Ashbery and Kenworth Moffett. Contributions by John Bernard Myers, Paul Cummings, Prescott D. Schutz, Rackstraw Downes, and Louise Hamlin. Museum of Fine Arts, Boston, and Little, Brown.

place of high importance in pictorial experience, yet this is accomplished without any forfeiture of that priority given to the medium that Porter himself recognized as one of the hallmarks of modernist sensibility. It is precisely this ability to bring together in a unified vision what had more and more come to be divided and codified into separate artistic impulses that distinguishes Porter's work. This is what some of the younger painters of the fifties and the sixties were moved to emulate in their own work—and the reason, incidentally, why they looked upon Porter as a hero and an inspiration—and it is what the public has now responded to with so much pleasure and satisfaction. What is involved in this response is not so much a rejection of modernism—for Porter remains an unmistakably modernist painter—as a revisionist view of what modernism in painting entails. What *is* rejected in this revisionist view, if only by implication, is the notion that the only viable modernist art in our time is to be found in the more reductionist modes of abstraction.

Given the appetite for representational imagery that persisted at one or another level of taste, even so-called advanced taste, through all the years that abstraction was establishing its reputation as the dominant mode of contemporary art, it may seem surprising that recognition of Porter's quality was so long in coming. After all, the subject matter of his pictures, with its affectionate concentration on family and friends, on fine houses and flowers and agreeable landscapes, should not in itself have been problematic for conventional tastes; and his handling of these subjects gained significantly in fluency, vitality, and confidence as the artist grew older. All the same, Porter's art proved to be difficult to grasp. It looked too conventional to be avant-garde, yet it was insufficiently "reactionary" in outlook or method to satisfy the philistine standards of the time.

If Porter failed to win the kind of approbation that now seems appropriate to his achievement, it was not simply because his paintings were representational, however. To believe this, as many partisans of representational painting apparently do, betrays a serious misunderstanding of the art history of the last thirty years. In the fifties, when Porter began exhibiting his work regularly for the first time, there was in fact a distinct prejudice in favor of certain representational styles—and not only among critics writing in the mass media, who for the most part were utterly hostile to the emergence of abstract art, but even among such champions of the avant-garde as *Art News* and the Museum

of Modern Art. It is worth recalling, in this connection, that it was in the fifties that Larry Rivers and other "second-generation" figurative painters of the New York School achieved a swift success, and in the sixties, too, the widespread attention and acclaim that greeted Pop art on its initial appearance can hardly be taken as evidence of a dogmatic resistance to representation as such. What met with resistance wasn't representation, then, but Porter's particular use of it—and the revisionist "reading" of the modernist enterprise that was implied in that use. It was this that made Porter an isolated figure in the fifites, and it probably accounts as well for the resistance that his painting continued to meet for a long time thereafter. If this resistance has now abated, as I believe it has, it may be that more orthodox interpretations of modernism have had to run their course and more clearly exhibit their exhaustion before this "conservative" view could be given its due.

In the subtitle that he has given to the Boston retrospective— "Realist Painter in an Age of Abstraction"—Mr. Moffett alludes to Porter's isolated position, while at the same time affirming his own belief in abstraction as the dominant style of the age. This in turn suggests that Porter was something of an anomaly in the art of his time— which, in some respects, he certainly was. Yet he nonetheless had something in common with the abstract painters of his generation, and I don't mean only his often professed debt to Willem de Kooning. I think it sheds an interesting light on Porter's development if we see what that common ground was. But in order to understand what it was that he shared with those painters, it must first be understood that it was to the Abstract Expressionist generation that Porter himself belonged—a fact that has been obscured by the history of his reputation. His first solo exhibition took place at the Tibor de Nagy Gallery in 1951, and his work from this period marks the beginning of the oeuvre that Mr. Moffett has brought together in the current retrospective. (The very few earlier works in the exhibition have, at best, a documentary rather than an artistic interest.) This would seem to place Porter in the generation of Larry Rivers, Helen Frankenthaler, Grace Hartigan, Jane Freilicher, and Robert Goodnough—the so-called second generation of the New York School. But it is not to this chronological generation that Porter belongs. In 1951 he was forty-four years old— only three years younger than de Kooning, but actually a few years older than Jackson Pollock, Franz Kline, Robert Motherwell, and Ad Reinhardt. What he shared with some of the older members of this first

generation was a protracted and no doubt painful period of uncertainty that effectively postponed the development of an independent style until the brink of middle age.[3]

To what may we ascribe this phenomenon of delayed development in artists who subsequently displayed not only conspicuous talent in many cases but a real gift for invention and originality? Surely there were important personal factors involved, but exactly what these were we are unlikely to know in any concrete detail until a time comes when the biographies of these painters can be written without the restrictions that are inevitably imposed by their heirs and beneficiaries. Yet I doubt if purely personal circumstances will even then account for a phenomenon so widespread in a generation as diverse as this one. We must look, rather, for some larger shaping factor in the history of the period, and my own view is that we are more likely to find it in the cultural imperatives of the thirties than in the biographies of individual artists.

In any reckoning of these imperatives, especially as they affected Porter's artistic development (but not his alone), there are three that strike me as particularly salient. The first is the immense influence exerted by Marxism and the ethos of the radical movement. Notwithstanding his private income and the leisure and independence this guaranteed him, Porter was more deeply affected by this political current than is nowadays generally recognized. (Not until Rackstraw Downes produced his excellent edition of Porter's critical writings in 1979 was this aspect of the artist's intellectual outlook first documented for us.[4]) He had gone to the Soviet Union as early as 1927, his junior year at Harvard, and is said to have made a sketch of Trotsky at that time. From the thirties onward, Porter seems to have remained some sort of unaffiliated radical, and as late as 1962 he wrote an essay, "Class Content in American Abstract Painting" for *Art News*. For much of his adult life, it seems, Porter was haunted by the need to rec-

[3]Within this first generation of the New York School, there is a division to be noted between certain of the older and the younger members. Among the younger painters, Motherwell, Pollock, Reinhardt, Pousette-Dart, and Stamos appear to have experienced much less difficulty than some of the older artists in getting started. Some of the latter—especially Rothko, Still, and Newman—did not hit their stride, or in certain cases even begin their stride, until the period following the end of the Second World War. Strictly in terms of the chronology of this artistic development, Porter belongs with this older group, however much he differed from them in his artistic outlook.

[4]*Fairfield Porter: Art in Its Own Terms: Selected Criticism 1935-1975*, edited by Rackstraw Downes (Taplinger). See especially the essay "The Purpose of Socialism," written around 1940.

oncile art—not only his own, but any art that really meant something to him—with his political and social interests. I think it is this need, not always acknowledged as such, that gives to some of his criticism its special moral fervor.

The second of the cultural imperatives I have in mind—the modernist of Europe, especially as it was shaping American art in the thirties—was more directly aesthetic. Yet for Porter this aesthetic imperative proved to be almost as difficult to come to terms with as his political interests. He seems not to have been able to make up his mind about it. He neither embraced it nor rejected it but remained a little outside its appeals. In the thirties he got to know de Kooning and bought his work, and in 1938 he saw an exhibition of Bonnard and Vuillard at the Art Institute of Chicago that made an enduring impression on his artistic thought. But the affinity he felt for both de Kooning and Vuillard in the thirties did not bring Porter any closer to the more radical impulses of modernist painting. This may sound paradoxical, but it isn't. For in the thirties, de Kooning's painting was not yet as "advanced" as it afterwards became, and Vuillard could certainly not be counted as an avatar of the avant-garde.

In the thirties, then, Porter could fairly be characterized as a political radical and an artistic conservative. This was not, by the way, at all an uncommon combination of cultural loyalties at the time. One finds something similar in artists as different from each other—and from Porter—as Thomas Hart Benton and Arshile Gorky, even though Benton was more of a reactionary in his attitude toward modernism and Gorky more of an acolyte. (It is a matter of interest, of course, that Porter studied with Benton at the Art Students League.) For Porter, however, more than for many artists of his generation, there was a third imperative that exacerbated his relation to modernist art and contributed to his diffidence. This was his early and enduring admiration for and knowledge of the Old Masters. Mr. Moffett speaks of the role played in the formation of his art by Porter's "early experiences with Old Master painting and his training at Harvard's Fogg Museum, which was then permeated by Renaissance ideals and classical aesthetics." "When studying with Arthur Pope or reading Bernard Berenson's books," Mr. Moffett writes, "Porter's taste for traditional structure and pictorial decorum was probably first confirmed," and Moffett suggests that this was reinforced by Benton's teaching. Porter had met Berenson in Italy in 1931, and this venerable figure—so remote from the concerns of modernist art, yet so authoritative in his discrimi-

nation of aesthetic quality—remained for Porter a touchstone of criti-
cal wisdom to the end. It seems to me that there was little likelihood
that a mind so disposed could ever have brought itself to align its artis-
tic ambitions with the more *révolté* innovations of modernist art, and in
fact Porter never did.

It is in the light of these imperatives that we are obliged to consider
the most celebrated of the anecdotes connected with Porter's career—
the encounter with Clement Greenberg in de Kooning's studio in the
late forties. The story is told by Porter in a conversation he once re-
corded with Paul Cummings. (An excerpt is reprinted in the catalogue
of the exhibition.) Cummings asked Porter if he had ever been an ab-
stract painter, and Porter replied:

> No. One reason I never became an abstract painter is that I used to see
> Clement Greenberg regularly and we always argued, we always dis-
> agreed. Everything one of us said, the other would say no to. He told me I
> was very conceited. I thought my opinions were as good as his or better. I
> introduced him to de Kooning (Greenberg was publicizing Pollock at that
> time), and he said to de Kooning (who was painting the women), "You
> can't paint this way nowadays." And I thought: Who the hell is he to say
> that? He said, "You can't paint figuratively today." And I thought: If
> that's what he says, I think I will do just exactly what he says I can't do. I
> might have become an abstract painter except for that.

Porter then went on to say:

> Another reason I paint the way I do is that in 1938 at the Art Institute of
> Chicago there was an exhibition of Vuillard and Bonnard. I looked at the
> Vuillards and thought that maybe they were just a revelation of the obvi-
> ous, and why did one think of doing anything else when it was so natural
> to do that.

Now this is a very curious story, and is not, I think, to be taken at face
value. I am not persuaded that Porter "might have become an abstract
painter" under any circumstances, and I doubt if Porter really be-
lieved this himself. Everything we know about the artist and the man
makes it highly improbable that he would have based the most impor-
tant artistic decision of his life on such a facile gesture of intellectual
defiance. Yet I believe that this story nonetheless offers us an impor-
tant clue to the development of Porter's art—and, indeed, to the very
nature of his art.

The encounter in de Kooning's studio would have taken place in
1947 or 1948, approximately ten years after the Vuillard exhibition in

Chicago. We may thus wonder why, if Vuillard's "revelation of the obvious" struck Porter with such force in 1938, it took him the better part of a decade to act upon it in his own work. In 1938 Porter was thirty-one years old—still a "young" artist by the standards of the day, but not exactly an unformed youth. There were no economic obstacles to be overcome, and his sense of vocation seems to have been reasonably secure—as secure, anyway, as it can ever be in an artist who has not yet discovered his forte. He was gifted, intelligent, independent, and knowledgeable, and ambitious enough to be on the lookout for a viable point of entry into the art of his time. If he felt he had found it in Vuillard, how are we to account for this protracted delay in his development?

The truth is, I believe, that Porter found only part of what he was looking for in his experience of what Mr. Moffett describes as "Vuillard's conservatism, a respect for the wholeness, uniqueness, and presence of the world." This, to be sure, remained a necessary and indispensable term in the dialectic of Porter's mature style. But it wasn't enough to inspire that style. What Porter still lacked even after his discovery of Vuillard—and what it took him another decade to acquire—was a redefinition of the medium in which the "love of visual reality" that he shared with Vuillard could be effectively realized in unmistakably contemporary terms. It was precisely this that Porter discovered in de Kooning's paintings of the late forties, and why de Kooning always remained a sacred figure for him—a touchstone of the age. Abstract Expressionism, at least as it was practiced by de Kooning (and Kline too, probably) supplied Porter with the kind of contemporary redefinition of the painting medium that he needed as the other term in the dialectic of his style.

Abstract Expressionism thus served Porter's artistic interests very much as Impressionism had served Vuillard's. It gave him the means of producing an art that was modern as well as traditional—for producing an art that he could somehow regard as complete. Now that we have been able to take the measure of Porter's achievement in this retrospective exhibition, we can see more clearly than even before that what he, too, aspired to make was "something solid and durable like the art of the museums," and that it was of the relationship that he forged between Abstract Expressionism ("the love of the medium") and his own "love of visual reality" that he made it. He was not alone in this ambition, of course. Many of the "second-generation" figurative painters in the fifties shared the same kind of ambition. Yet Porter

succeeded in a way that most of them did not, and on a larger and more consistent scale too, not only because his dependence on de Kooning was notably less abject that theirs, but also—and more importantly—because he was equipped by training and experience to bring to bear on his painting a deeper and more comprehensive understanding of what "the art of the museums" actually consisted of. He was not dependent on de Kooning, as many of the younger painters were, for his notion of what that art was. His knowledge of it had long preceded his own ambition to produce it himself.

Oddly enough, it was Porter's independence—for he never belonged to the legion of de Kooning's imitators—that contributed to his isolation in the fifties. He could not be considered a part of the Abstract Expressionist movement, and he could not be entirely separated from it, either. He had to wait until Abstract Expressionism had itself become as historical as Impressionism before the splendor of his stubborn individualism could be fully grasped and appreciated. Now that it has been, or at least has begun to be, we may note a further irony in Porter's situation as an artist. During all the years that he was openly acknowledging his debt to de Kooning and (as a critic) elucidating what he saw as de Kooning's special quality, he was himself emerging as a painter superior to de Kooning in achievement. That, it seems to me, is one of the things we learn from this extraordinary exhibition. Porter himself would probably have been horrified by this judgment—or maybe not: he was a proud man—but it is a conclusion that strikes me as inescapable for anyone who studies this exhibition with careful attention. Only in the last gallery of the show did Porter seem, strangely, to lose his way occasionally, either by venturing toward an Avery-ish mode of abstraction for which he had no gift or by doing just the opposite—basing his pictures on a literalism that did not suit him. Otherwise, the exhibition moved from strength to strength with a consistency and eloquence that were overwhelming.

Make no mistake: After this exhibition, the history of American painting is going to have to be rewritten to give Fairfield Porter a larger place than he has heretofore been granted. He is going to have to be recognized as one of the classics of our art. For myself, though as a critic I had praised Porter's work on a number of occasions during the last twenty years and thought I knew it well, I found I was not really prepared for what I found in this exhibition, either. For a critic it is a very odd experience to praise an artist's work over a long period of

time and then discover, as I did in Boston, that I had actually under-rated it. For at least one visitor, that too made this exhibition a truly extraordinary event.

<div align="right">MAY 1983</div>

2. Noguchi

At the age of seventy-three, Isamu Noguchi can look back on what is probably the most varied and far-reaching career in the history of American sculpture. Indeed, no other sculptor of our time—American or otherwise—has extended the interests of modern sculpture into so many areas of public life while continuing to produce with a prodigal abundance and exquisite invention the kind of small-scale art object that, whether encountered in a museum, a gallery, or a private collection, affords an essentially "private" experience. Mr. Noguchi is at once one of the purest of living sculptors, having sustained and refined for half a century a commitment to the kind of absolute form first glimpsed in the work of his master, Brancusi, and one of the most socially oriented, exulting in the large public projects in which this world of ideal form is obliged to accommodate itself to the rude demands of daily use. He has designed parks and playgrounds, outdoor sculpture, gardens, fountains, and public plazas for some of the world's busiest cities. He has worked a good deal in the theater, especially in collaboration with Martha Graham; and with his series of "Akari" lamps, he has produced one of the classics of modern interior design. Earlier this year, his 36-foot-high sculpture, called *Portal*, was installed on the plaza of the Justice Center in Cleveland, and later this year an even more immense enterprise, the Civic Center Plaza occupying acres of downtown Detroit and crowned with a huge fountain, will be completed. At the same time, visitors to the new East Building of the National Gallery of Art in Washington will find one of his most severe and elegant stone carvings prominently placed in the high-domed great

hall, where it holds its own in the company of Calder, Miró, Caro, and other classics of modern art.

A career and an oeuvre as many-sided as Mr. Noguchi's is not easily encompassed in a conventional museum retrospective, yet to limit such an exhibition to objects of museum scale would clearly result in a very partial view of the artist's accomplishments. It would, in fact, drastically reduce our sense of the scope of his activities. Some combination that brings together a straight art exhibition with a more documentary approach to the architectural and theater projects is clearly in order, and this is precisely what the Walker Art Center has given us in the excellent show called "Noguchi's Imaginary Landscapes." Organized by Martin Friedman, the director of the Center, this exhibition supplements its extensive selection of sculpture—some of the simplest and most beautiful sculpture of the modern age—with an ample survey of models, plans, and photographs of the sort we find in architectural shows. It thus alternates between being very pure and very didactic.

Mr. Noguchi's work for the theater is also well represented for the first time. The haunting, symbolic objects created for Martha Graham's *Appalachian Spring, Herodiade, Cave of the Heart,* and *Judith* are here, and so are the masks and objects he created for George Balanchine's production of *Orpheus.* (The Graham material is further amplified with some videotapes of actual performances.) There is also an important section of the exhibition devoted to "Unrealized Projects"—among them some canceled architectural and playground projects in New York—that vividly brings home to us the disappointments endured by an artist attempting to bring an art of such refinement and imagination into the public sector in the years before this particular vision of public art won acceptance. Unifying this diverse range of materials is Mr. Friedman's account—both in the fine catalogue essay he has produced, and in the actual exhibition itself—of "Noguchi's Formal Vocabulary," which provides a kind of primer of the basic forms the artist has employed in all of his work. The result brings us closer to the artist's achievement—and to the way his sensibility functions in relation to such a wide range of challenges—than any other exhibition I have seen.

What, then, is the nature of this sensibility, which has moved in a wider world than that to which any other living sculptor has been admitted and which yet seems, despite its success in meeting the demands of an industrial age, to draw its essential spirit from some other realm of time or timelessness? Perhaps a clue is to be found in the sense of

primitive mystery—if I may borrow this term from Martha Graham— that seems to govern all of the objects and landscapes that Mr. Noguchi has created. His is an imagination of primitive archetypes—one reason, no doubt, why he proved to be the perfect collaborator for Martha Graham, whose dramaturgy gives us a glimpse of the way these archetypes inhabit the modern psyche. But whereas the Graham sensibility takes us on an inward journey, exploring an essentially subjective darkness, Mr. Noguchi's turns to light and celebration—to a more "objective" social space. His sense of ritual is more social and spiritual than psychological—there is a larger and more accommodating place in it for the ordinary experience of the world. Undaunted by the mechanization of the modern world, Mr. Noguchi's vision confers on it a sense of serenity and order derived from something more primitive than the actual world it serves.

The individual sculptures he has made—especially the stone carvings in which we see his art in its purest form—are invariably arresting in the sheer simplicity of their shapes. Visually, they are irresistibly seductive in their elegance and perfection, yet they have a power beyond the visual—the power to recall us to elementary experience. Again and again, they seem to represent the birth of the world, the beginning of things. Their very clarity has the effect of clearing the mind—of shutting out the noise of the quotidian, and inducing a more contemplative attitude toward experience.

Obviously it is easier for art to accomplish this end in a museum, especially in a museum filled with the stone carvings of Mr. Noguchi. No matter what their arrangement—and they are very beautifully installed at the Walker Art Center—they beckon us into a kind of paradise of the spirit where we are made to feel reborn.

In the bigger and more various world "out there," where Mr. Noguchi has placed so many of his public projects, this sense of serenity and order is not only harder to achieve but much more difficult to sustain. Society—especially modern industrial society, with its unappeasable appetites and conflicts—is not so easily seduced into aesthetic contemplation. It remains to be seen whether something like the Detroit project is workable in the terms Mr. Noguchi has conceived for it or whether it will become another urban folly—"primitive" in a more vicious sense than is usually dreamed of in the archetypal imagination of the artist. But there is this to be said for all of Mr. Noguchi's public designs: There is no suggestion in them of the authoritarian or the utopian. They do not impose a harsh authority or an arbitrary discipline.

They address themselves to the world as it is, an attempt to make it a lovelier, more playful, more imaginative place. They do not attempt to turn public space into museum space, either, though they are wonderfully attentive to the aesthetic spirit. Who else among us has even attempted a rapproachement between art and life on this scale?

MAY 21, 1978

3. Encountering Nevelson

Certain experiences in the realm of art remain forever associated in our minds with the places where the art was first fully revealed to us. Subsequent experience may augment our knowledge, alter our perspective, and deepen our understanding, but it can never quite eradicate the impression made upon us by the quality of that initial encounter. If only for that moment, something central to the spirit of the art seemed to belong to the very atmosphere that enclosed it. Thereafter, the art itself seems to us to carry the spirit of that atmosphere with it, no matter what the actual physical circumstance in which it is seen.

Anyone lucky enough to have seen the sculptures of Henry Moore reposing in the gray-green winter light of the cozy meadows surrounding the artist's studios in Herefordshire, for example, is unlikely ever again to conjure them up in his mind's eye in any other setting. Likewise, to have seen the constructions of David Smith arrayed like magic sentinels in the open fields of the Terminal Iron Works at Bolton Landing, above Lake George, or to have glimpsed the fugitive figures of Alberto Giacometti emerging from the crushed plaster and grisaille light of his cell-like Paris studio was to have experienced something essential to the inner life of the art itself. At such times we are made to realize that, whatever the nature of its material realization, there is a world of mind, feeling, and spirit at the core of every work of art that captures our imagination, and that world is often coextensive with the place where the art is created.

As a young man in the 1950s, when I was just beginning to write about the visual arts, the visits I made to the studios of Moore, Smith, and Giacometti were among the experiences that meant the most to me, and they remain today among my most precious memories of that very rich period. Yet in some respects the most extraordinary of all my encounters with artists and works of art in those days occurred on a sunny spring day when I paid a visit to a tall townhouse on East 30th Street in Manhattan. This house, which has since been torn down, was then the residence and workshop of Louise Nevelson—a sculptor virtually unknown to the art public, unexhibited in the museums, and scarcely ever written about by the critics.

From the street, the house hardly looked like the sort of place where an artist, especially a sculptor, might be engaged in serious work. For one thing, the neighborhood—though already a little rundown in anticipation of the wrecker's ball—was distinctly bourgeois. It was certainly far removed from the ambience of 10th Street and the Cedar Bar or, indeed, from any social milieu one associated with the art life of the time. The New York art scene was, it must be remembered, a very different place in those days. Among other things, it was smaller. There were fewer artists, fewer galleries, fewer collectors, fewer critics, and fewer museums that took an interest in the new art of the day. It was also less chic. And word of its activities reached the "outside" world—the world of money and the media—at a much slower rate of speed. Artists' lofts had not yet come to be featured in the home-decorating pages of our newspapers and magazines. For an artist to live in comfort and luxury seemed almost a contradiction in terms.

But there was also another reason why one did not expect to find a sculptor at work in a townhouse on East 30th Street. This was the heyday of welded sculpture, and there were many practical considerations that made a townhouse in midtown Manhattan an unsuitable environment for the welder's torch. In those days there was much talk—and with ample reason, too—about "The New Sculpture," and it was more or less assumed that this new sculpture would be welded sculpture. The new sculpture tended to be "open" in its forms. It was often spoken of as "drawing in space," and welding was deemed the most appropriate means of achieving its artistic objectives. No one, as far as I know, had laid down any laws to that effect; but it was a commonly held belief among those who were interested in new sculpture. Welded metal was therefore considered avant-garde. The use of wood—like the

use of stone and bronze in this respect—was identified with "tradition," despite the fact that many (indeed most) of the major modern sculptors had employed these materials. And "tradition," it will be remembered, was not in good odor in the fifties, especially among the sculptors who wished to be associated with the Abstract Expressionist movement in painting.

It was painting, moreover, that dominated the scene—dominated, indeed, our very notions of what art was, and what it might be. It was around this time, as I recall, that André Malraux observed that while painting was the art we had inherited, sculpture was an art the modern world had been obliged to reinvent. And although this project of reinvention had been launched decades earlier and achieved spectacular results, it had not yet met with the kind of acceptance and understanding that much of modern painting had already received. In the fifties, neither Paris nor New York had yet seen the bulk of the sculpture that Picasso had been producing for half a century, and it was not until the mid-fifties that New York saw its first museum retrospective of the work of Julio González. Even to devotees of modern art—still, in those days, a minority among those who took a serious interest in art—much of modern sculpture remained unknown, and was in any case looked upon as ancillary and marginal. It was painting that was assumed to represent the mainstream of creative endeavor. Those interested in new sculpture, especially abstract sculpture, thus constituted a minority within a minority.

I mention all this because it is essential to any understanding of the art of the fifties, to the place that sculpture occupied in the art of that period, and to the role that Louise Nevelson came to play in the evolution of that art. It may also help to explain why it was that my visit to the house on East 30th Street proved to be such an extraordinary experience.

Nothing that one had seen in the galleries or museums or, indeed, in other artists' studios could have prepared one for the experience that awaited a visitor to this strange house. It was certainly unlike anything one had ever seen or imagined. Its interior seemed to have been stripped of everything—not only furniture, rugs, and the common comforts of daily living, but of many mundane necessities—that might divert attention from the sculptures that crowded every space, occupied every wall, and at once filled and bewildered the eye wherever it turned. Divisions between the rooms seemed to dissolve in an endless sculptural environment. When one ascended the stairs, the walls of the

stairwell enclosed the visitor in this same unremitting spectacle. Not even the bathrooms were exempted from its reach. Where, I wondered, did one take a bath in this house? For the bathtubs, too, were filled with sculpture. Somewhere, I suppose, there were beds that the occupants of the house slept on, but I never saw them. There were, I remember, a plain table and some unremarkable chairs in the basement kitchen and a glass coffee table in the "living room," which was otherwise designed less for living than for the storage and display of the sculpture that was the overwhelming raison d'être of the whole interior.

Once inside this enchanted interior, one quite forgot that one had entered a townhouse in mid-Manhattan. One had entered a new world. It was a very mysterious world, too, very far removed from the sunshine and traffic of the street. Here one entered a world of shadows, and it required a certain adjustment in one's vision simply to see even a part of what there was to see. The separate sculptural objects were mostly painted a uniform matte black, and they seemed to absorb most of the available light. The light itself seemed to be a permanent and unrelieved twilight—gray, silvery, and shadowy, without color or sharp contrast. It was austere without being bleak. It was also, as one came afterwards to realize, intensely theatrical. Emerging from that house on this first occasion, I felt very much as I had felt as a child emerging from a Saturday afternoon movie. The feeling of shock and surprise upon discovering that the daylight world was still there, going about its business in the usual way, was similarly acute.

Yet there was another aspect to this experience that stood in sharp contrast to this feeling of poetic enchantment. This was the sense one had, whenever and wherever one paused to examine a particular object, of a mind that was extremely tenacious and remarkably fertile in its command of a certain mode of sculptural form. One was constantly being reminded that, in some odd and unexpected way, Nevelson's sculpture, however much it may have attached itself to the impulses of fantasy and however often it seemed to produce a private landscape of dreams, belonged nevertheless to the Constructivist tradition. While the rationalism and idealism of Constructivism, with its tendency to sublimate the passions in favor of an unearthly perfection, appear never to have interested her much, Nevelson nonetheless brought to each of her wood constructions the kind of clarity, precision, and order that Constructivism made an integral part of its aesthetic vision. One of the things that made her work so strange—even when seen in the cold light of a museum exhibition, and thus removed from the twilight at-

mosphere she favored for her sculpture—was the way she employed the syntax of Constructivism for expressive purposes that did not conform to Constructivist goals. Yet her employment of that syntax was never marginal or incidental to the work itself. It became an integral part of her vision as well—one term, but an absolutely essential term, in the dialectic that governed her art.

This became vividly apparent when Nevelson burst upon an unsuspecting world with the first of her full-scale sculptural walls. For without this Constructivist syntax, with its architectural rigor, the walls would scarcely have been imaginable. Consisting of stacked and extended modular enclosures, each containing a compressed, miniature variation on Nevelson's by then characteristic dream construction, the walls have surely been her most original contribution to modern sculpture. The first of the walls was conceived and executed in the house on East 30th Street, and it was there that I saw it soon after its completion. It was an unforgettable experience—a revelation not only of a new and powerful work of sculpture, but of a new way of thinking about sculpture and about the scale governing its conception. The Nevelson wall gave us, in fact, a new sculptural genre.

Only later did I come to realize that there was an important connection between the creation of this genre and the 30th Street house— between, that is, the original walls and what Nevelson had made of the interior of the house. For the experience afforded by the interior of the house, with its pell-mell profusion of forms, its architectural divisions of space, and its twilight atmosphere, served as both a model and a given—the content, as it were, for which the form of the walls had, perforce, to be created. The walls were, in other words, versions of the house itself. And so completely had the experience of the house been absorbed into the creation of the walls, and so profoundly transformed by that creation, that when Nevelson left East 30th Street and established herself in a taller, narrower house on Spring Street, where she has lived ever since, this new habitation became, in effect, not an attempt to recreate the 30th Street interior but quite simply another, ampler, more commodious and quintessential version of the wall itself.

As everyone knows, a great many elements—some consciously intended, some not—enter into the creation of a work of art, and it is an illusion to suppose we can ever identify all of them. It is also illusory to suppose that their identification somehow "explains" the work of art or accounts for its power. At the same time, it is always salutary in confronting a truly original work of art to remember that art belongs to the

realm of culture as well as to the realm of experience, that it may owe as much to precedent and convention as to the promptings of the individual psyche, that it is an artifact of history as well as an expression of feeling. If, indeed, we know anything about art, we know that it is in these collisions of convention and imagination, of tradition and the individual talent, that the most vital artistic events tend to occur. In the life of art, there are no virgin births.

How, then, are we to account for the art that emerged so unexpectedly in the fifties from that very strange house on East 30th Street?

If we attempt to answer this question strictly in terms of form and technique, the answer is not hard to come by. I have already mentioned Nevelson's debt to Constructivism. Beyond this lay a deeper and more comprehensive debt to Cubism, both to its general vocabulary of form and to the specific technical innovations of the collage medium and the kind of constructed sculpture that directly derived from the methods of collage. Nevelson has always acknowledged—in fact proclaimed—her debt to Cubism, and it is not to be doubted. Everything she has produced for the last forty years confirms it. For her, as for so many artists of her generation, Cubism marked the birth of the modern age, and it was upon its foundation that she based her style and her vision.

All of this is unquestionably true, and it tells us something important about her work. But as often happens with explanations of art based on matters of form and technique, it does not take us very far in accounting for what is most individual in the art in question. In Nevelson's case, for example, it does not account for either the scale of the art as it evolved in the creation of the great walls or the element of the theatrical that is so much a part of our experience of them. It does not account, either, for the psychological texture of the work—the curious quality of inwardness and subjectivity that lives on such easy terms with the formalities of its architectural structure. We must look elsewhere if we are to penetrate the mystery of what are some of the salient qualities of Nevelson's art.

Take the matter of scale. Historians of modern sculpture tend to ignore it. The fact is, it did not loom as a very compelling artistic issue in most of the sculpture—and I mean most of the best—that was produced in Europe and America in the first six decades of this century. (That it became an issue in the sixties and has remained one ever since must surely owe something to Nevelson's work of the late fifties.) It was a very big issue for painting, however, especially for the Abstract Expressionists. Whether Nevelson was directly influenced by the scale of

the "big picture" that came to dominate Abstract Expressionist paint-
ing in the fifties, I do not know. I rather think that she was. What we
know for certain is that she was the first sculptor of the period to pro-
duce something that could be compared to the scale of Abstract Expres-
sionist painting, and the result changed our whole notion of scale in
contemporary sculpture. This, incidentally, was but one of the reasons
why Nevelson was never in any danger of becoming a casualty of the
changes in sculptural taste that occurred in the sixties. She had already
anticipated these changes in her own work.

The scale she introduced into sculpture was a mural scale, and this
surely owed something to her experience as Diego Rivera's assistant in
the early thirties. The Mexican mural movement has long been ac-
knowledged to be one of the sources of the altered sense of scale to be
found in the painting of the Abstract Expressionists, and I think it must
be counted among Nevelson's sources as well. Like the Abstract Ex-
pressionists, she had to get rid of the figure—get rid of the whole mori-
bund tradition of explicit social commentary in art—before she could
do anything significant with this source. She had to find a way of wed-
ding it to the world of private feeling, to subjective emotion, to the
realm of myth and abstraction.

Crucial to this process, I believe, was Nevelson's encounter, in the
early fifties, with the ancient art and architecture of Mexico and Cen-
tral America. This was a world in which art and myth were one and
inseparable—a world of primitive mystery and heroic form. Impor-
tant, too, was the fact that it was a world of *sculptural* form projected on
an architectural scale. To say that she felt a profound affinity with this
world of primitive form, and with the subjective emotions it symbol-
ized for her, would be understating the case. It proved to be an inspira-
tion and a model for everything that followed. The myriad sculptures
that filled her house on East 30th Street in the late fifties, the sculp-
tures that she exhibited in those unforgettable exhibitions at the Grand
Central Moderns gallery in those years, were all, in a sense, an imagi-
native gloss on what she had seen in Yucatán and Guatemala. Like so
many modernists before her, Nevelson had found in the expressive
conventions of primitive sculpture and architecture a grammar of feel-
ing that answered to the world of her dreams. It is worth recalling that
the exhibition she mounted at Grand Central Moderns in 1955 was
called "Ancient Games and Ancient Places."

One of the things that struck the visitor to those exhibitions of the
fifties so forcefully—most especially the exhibition called "Moon Gar-

den + One'' in 1958—was their sheer theatricality. The entire gallery was turned into what we would now call an ''environment,'' and like the interior of that house on East 30th Street—which served as a prototype—it was a realm of enchantment. Not everybody liked it, of course. Art exhibitions tended in those days to be somewhat austere occasions, and the theatricality of the Nevelson shows violated the sense of solemnity then associated with the exhibition of serious art. Yet the impression that these ''environments'' made on the spectator proved to be irresistible and provided one of the keys to Nevelson's art.

Theater, dance, music, films—the whole world of theatricality had long been one of Nevelson's passionate interests. In the twenties she had studied drama and voice, and in the thirties—and for many years thereafter—she studied modern dance. It was to be expected, then, that she would sooner or later come to look upon exhibitions as a mode of performance and upon the gallery space as a stage. This was what she commenced to do in those exhibitions of the fifties. Interestingly, in this endeavor too she had to eliminate the figure in order to realize the idea. The ''drama'' she staged in these exhibitions was an interior drama—a drama of the psyche—but its metaphors were entirely visual. Yet the primitivist forms that governed this visual drama had certain affinities with actual performance—most especially with the dance-dramas of Martha Graham, with their obsessive exploration of dark emotions and primitive mysteries and with the radical priority they gave to the life of the psyche, in all its inwardness, over the demands of the workaday world. The psychological texture of Nevelson's work from the fifties onward has many obvious parallels with the psychological intensities we find in Graham's dramatic choreography and even in her technique. It has not been the least of Nevelson's achievements that she has been able to bring this mode of feeling into sculpture without recourse to the kind of symbolism that properly belongs to arts other than her own.

Sometime after Nevelson had moved from East 30th Street and established herself in the house on Spring Street—this was in the early sixties—I brought an English painter to see her. He was visiting from London, and was eager to meet her and see her work. She was now beginning to be famous, and people were beating a path to her door. She gave us a complete tour of the house, with its sculpture-filled rooms. She gave us drinks and talked at length about her life and her work. I could see that my English friend was in a state of excitement and bewilderment. I had seen people go through the whole thing before, and the

result was always the same. They hardly knew what to make of it all, for nothing that they saw or heard there seemed to conform to their notions of the way artists lived and produced their work—especially sculpture. And when we finally left the house and were riding uptown in a taxi, we sat in silence for a long time until my friend finally said: "You know, when I get back to London and tell people about this, no one is going to believe it. I don't blame them, really. I'm not sure I quite believe it myself."

Well, for a long time there were many people here, too, who could not quite believe their eyes when they came to the sculpture of Louise Nevelson. There was so much of it, and it was all so different from what everyone was doing. Yet once she emerged as a major figure in the late fifties, she could never again be ignored. She turned out to be one of those artists who changed the way we look at things.

1983

4. Jacob Lawrence's Chronicles of Black History

The painter who nowadays attempts to align his work with historical or narrative materials essential to its understanding finds himself in an odd situation. The history of art abounds in superlative examples of painting based on the representation of literary, historical, and mythological motifs, yet our experience of modern art predisposes us to regard the contemporary use of such "texts" with deep suspicion. Painting is no longer expected to traffic in narrative themes. It shuns a "story" like the proverbial plague, and the only history of compelling artistic interest to most contemporary painters is the recent history of their own medium.

Even the newer modes of realism are essentially "formalist" in their basic objectives. They are rarely concerned to dramatize a historical action or serve a narrative purpose. The great masterworks of his-

torical and narrative painting from the distant past are likewise "read" as if they were pure distillations of form—solutions to pictorial problems rather than interpretations of human experience. We have simply lost the habit of taking painting seriously as a medium in which significant human action can be directly represented.

The artist who sets himself in opposition to this development requires, more than anything else, a supreme conviction about the importance of his subject. He requires, in addition, a public—though not necessarily or even primarily what we normally think of as an "art public"—that shares this attitude toward his subject. For narrative painting on historical themes, if it is to be anything more than the expression of a subjective fiction, must enjoy a sense of communal utterance. The fate of something larger than the artist's own private consciousness must clearly be seen to be at stake in what he chooses to depict.

Forty years ago the most ambitious attempt to revive narrative painting in modern times took place in Mexico. In the wake of the Mexican revolution a whole generation of painters set about adorning the walls of mammoth public spaces with pictorial evocations of native history. Inevitably, the example of the Mexican mural movement affected the thinking of certain American painters. Yet the opportunities here were radically different. Despite the sponsorship of government programs, the mural projects executed by American artists in the 1930s rarely, if ever, attained that surpassing sense of communal impetus so dramatically evident in the work of the Mexicans. We were, perhaps, too big a country with too many diverse ethnic and regional traditions to accommodate the kind of art that could prosper only in the presence of a more restricted and more universally shared sense of the past.

What did emerge from this situation, however, were a great many smaller-scale attempts to make painting serve as a vehicle for the political myths of particular groups, mostly of a left-wing persuasion. Most of these efforts were short-lived; few survived the decade in which they were conceived. For most of the American artists who came of age in the 1930s, the community that came eventually to dominate their consciousness was the community of artists, and the only myths that counted were the myths of art history.

The art of Jacob Lawrence stands as a dramatic exception to this history. Early on in the career of this black artist, he conceived of his work as an expression of the community in which he found himself—

which was Harlem—and very quickly set about creating a mode of pic-
torial narrative capacious enough to deal with the difficult history of
black America. Mr. Lawrence was only twenty when, in 1937, he com-
menced work on the "Toussaint L'Ouverture" series, the first of the
serial pictures that were to become the distinctive feature of his copious
oeuvre. A year later, he began the "Frederick Douglass" series, which
proved to be far more ambitious. (Of the 163 pictures in the current
retrospective exhibition of his work at the Whitney Museum of Ameri-
can Art, 33 belong to the "Douglass" series.) And there followed over
the years similar series on the lives of Harriet Tubman and John
Brown, and on the more general themes: "Migration," "Harlem,"
"War," and "Struggle: From the History of the American People."

The scale as well as the style of these pictures denotes an enterprise
markedly different from both the mural art of the Mexicans and the ea-
sel art of Mr. Lawrence's American contemporaries. The pictures are
small—in the "Douglass" series, the size of each is roughly twelve by
eighteen inches—and are evidently intended to be "read" close up, yet
the scenarios they recount are conceived on an epic scale. Into each im-
age, executed in tempera, gouache, or watercolor, is distilled a dra-
matic episode or emotion of great simplicity, yet the crowded succes-
sion of such images traces a complex course. One is reminded at times
of the woodcut "novels" of the Belgian engraver Frans Masereel, for in
Mr. Lawrence's narratives, too, we move from intensity to intensity in
a headlong rhythm that never slackens its pace.

The style Mr. Lawrence created for this narrative mode is almost
more graphic than pictorial, and may best be described as conscious
primitivism. Drawing is reduced to the delineation of flat shapes and
easily read gestures. Figures are seen as the sum of their actions never
as individualized personalities. Color is generally somber, yet illumi-
nated by moments of gemlike intensity. There is an extraordinary ve-
locity in this style and an extraordinary empathy. It succeeds in creat-
ing a world, and it holds us in its grip.

There is a literary component to this art that should also not be
overlooked. Long before black history became an academic fashion,
Mr. Lawrence carried out his own research and wrote his own chroni-
cles of struggle and achievement. These, in the form of terse, dramatic
summaries, accompany each picture in the serial and are an essential
part of the serial conception. They are not a literary substitute for the
painted image but program notes that elucidate the action depicted.

Very few of the American artists who started out in the 1930s have sustained an accomplishment of such coherence and drive. In this respect, at least, Mr. Lawrence enjoyed the advantage of knowing what he wanted to do and how he wanted to do it. He was not obliged to reinvent his artistic personality with the dawn of each succeeding decade, for he was guided by a sense of mission that drew its energies and inspirations from something larger than the world of galleries and seasonal reputations. No doubt this cost him a certain isolation from that world, but it also entrenched his art more deeply in that sense of communal enterprise that is one of the sources of its strength. Such steadfastness of purpose is rarely, alas, so triumphantly vindicated.

MAY 26, 1974

5. Pousette-Dart: Odd Man Out

Richard Pousette-Dart is, in some respects, the odd man out of the New York School. Born in 1916, he is the youngest of the painters generally included among the first-generation Abstract Expressionists. (Robert Motherwell is one year his senior.) His first one-man show took place in 1941, when he was twenty-five, and his work was first shown at the Museum of Modern Art three years later. He was anything but a later starter.

There was, moreover, no suggestion of rebellion, nothing of the ethos of the *révolté*, in his choice of a vocation. Brought up in an atmosphere where art was regarded as the highest spiritual value—his father was a painter and a widely published writer on art; his mother, a poet—he came both to painting and to the frontiers of modernism as a natural inheritance. Few painters in the entire history of American art have entered upon a career with so little sense of trauma.

Since that precocious debut more than thirty years ago, Mr. Pousette-Dart has been enormously productive, and has shown his work with great frequency—and not in obscure places, but in the gal-

leries and museums where reputations are made and values (of every sort) computed. Yet there is a curious sense in which he remains, if not exactly an unknown artist, certainly an artist whose quality and special achievement have been difficult to keep in clear focus.

The writers who have produced the textbook histories of the period acknowledge the artist's presence, but have nothing to say about his work. (Barbara Rose, in *American Art Since 1900*, accords him a single line of comment and Sam Hunter, in the more recent and more voluminous *American Art of the 20th Century*, reproduces a picture but offers no discussion of it.) No critic has made a cult of his work, and the artist himself has not been adept at negotiating the mysteries of art-world politics and publicity. The winds of fashion have blown in other directions, and exhibitions designed to sum up the period in question tend to overlook him. (He was thus omitted from Henry Geldzahler's ill-fated extravaganza at the Met a few years ago.) It is entirely characteristic of the curious fate that has overtaken his work that the Museum of Modern Art organized a traveling show of his paintings in 1969–70 but never brought it to New York.

Only the Whitney Museum of American Art has paid Mr. Pousette-Dart any sort of consistent attention. Yet neither on the occasion of its retrospective exhibition in 1963 nor for the show currently installed in the museum's second-floor galleries has the Whitney undertaken to produce a comprehensive catalogue of his work. This failure cannot, I think, be attributed to a lack of interest. (It is unusual, to say the least, for a museum to mount two major exhibitions of an artist's work in little more than a decade.) What it does suggest is an attitude of uncertainty about the work itself—or, if not about the work, then about its relation to the established scenarios we have come to rely on in explaining the significance of the abstract painting of this period.

For the truth is, Mr. Pousette-Dart's work does not really conform to the specifications of these scenarios. The notion of "Action painting" will get you nowhere in coming to terms with his paintings, early or late; and some of the more arcane formalist theories are even more irrelevant. There is, to be sure, a rough congruence to be observed between the development of certain aspects of Mr. Pousette-Dart's work and that of certain of his contemporaries in the New York School. In the earlier paintings—well represented in the 1963 exhibition but unfortunately excluded from the present show—there is that preoccupation with myth and symbolism, expressed in terms of pictographic forms and totemic shapes, we easily recognize as one of the pictorial

leitmotifs of New York painting in the 1940s. (James K. Monte, the curator at the Whitney responsible for this exhibition, points out the parallels with the work of Pollock, Gottlieb, and Rothko.) In the later paintings, there is that extreme concentration on large areas of light and color familiar to us in a great deal of abstract painting from the late 1950s to the present day.

Similarities there are, then, but Mr. Pousette-Dart's paintings do not really resemble anyone else's. In the earlier paintings there is an almost Byzantine taste and ambition, a painstakingly elaborated hieratic imagery that separates them from the more improvisatory styles of his contemporaries. In the later paintings, especially the "Hieroglyph" and "Radiance" series, there is a sensuousness of surface combined with a vastness of image that, while not in the least representational in any ordinary sense, seems nonetheless to apostrophize the heavens as a sacred subject. This is painting at once intensely physical, executed with finical care for built-up surfaces and finely worked accretions of color increasingly rare in an age that favors thin washes and sprayed-to-order pigment, and intensely spiritual in its basic aspiration. Mr. Pousette-Dart is, indeed, something of a mystic, and the best of his paintings—the mural-size *Radiance* (1973–74), *Hieroglyph No. 1. Blue* (1973), and the exquisite *Presence by the Sea* (1967–68)—have that sensuous-spiritual appeal we associate with the poetry and prayers of the great mystics.

The exhibition Mr. Monte has arranged at the Whitney consists of thirty-one paintings produced since 1961, with the bulk of them dating from the last six years. They make a handsome exhibition, but the show will inevitably mean a good deal more to those who are familiar with the artist's earlier work—at least as shown in the 1963 retrospective—than to those who are not. Mr. Pousette-Dart's white paintings, for example, are among his finest accomplishments, but the pictures in the current exhibition really need to be seen in relation to some of his earlier work in this vein. (There is an excellent example in the permanent collection of the Museum of Modern Art.) And the situation is in no way helped by the decision to hang most of the newer white paintings on the yellow carpeted walls of the Whitney's smaller galleries—just about the worst environment imaginable for pictures of such extreme delicacy.

Still, Mr. Monte's exhibition is a salutary reminder of an achievement that stands at a certain distance from what we have sometimes been persuaded to think of as the mainstream of abstract painting in

our time. Mr. Pousette-Dart is an independent in every sense—independent of claques and coteries, and independent, too, in the integrity and beauty of his very personal vision. For many years now, he has followed a lonely course—something that the writers of textbook histories tend to honor more in principle than in practice, especially if the practice inconveniences their facile categories. We are still a long way from grasping the size and variety of Mr. Pousette-Dart's achievement, but the present exhibition moves us a little closer in that direction.

NOVEMBER 17, 1974

6. Richard Lindner: Artist of Two Worlds

The death of Richard Lindner on April 16 has come as something of a shock. As it happened, I had been with him at a very festive dinner party only a few nights before. While a recent and serious bout with flu had left him looking a little tired and drawn, he was otherwise as one had always known him—gentle, affable, amusing, and wonderfully intelligent, with the kind of easy and interesting talk, always delivered in a distinctive stage whisper, that Americans recognized as having been nurtured on the European café life of another era. As both an artist and a man, Lindner was a creature of two worlds and two periods—Europe in the period between the two world wars, and America, or rather New York, where in the last thirty years he had become the painter that we know and admire today. The exhibition of his work that only recently opened at the Sidney Janis Gallery shows him to be an artist at the top of his powers.

Death is unwelcome at any age, and Lindner was seventy-six. Yet the energy and audacity of his work were of a sort one associates with youth; and even in its very latest realizations, it was not the kind of "light" painting in which we feel a career being summarized or reexamined. It was the vigor of his art as much as one's affection and re-

gard for the man that made his sudden passing such a shock and left his friends and admirers feeling so saddened and diminished. We were unprepared for something that had been so much a part of us to come to such an abrupt end.

Yet the art remains—an art little understood and given small welcome in the early stages of its public career in New York and actually not much better understood, though it was now widely acclaimed, in the years of its acceptance and success. The masterpiece he painted in 1953, the picture called *The Meeting* that is nowadays often seen hanging in the main hall of the Museum of Modern Art, bore so little relation to the abstract art of the New York School that it seemed at the time of its composition to belong to another era—which, in a sense, it did. But so did the paintings of the sixties that brought this same artist his first fame—paintings widely misconstrued as emanating from the Pop art movement but really have nothing to do with that movement, which Lindner happened to admire but which he felt a great distance from as an artist. It was part of the comedy of his career—a comedy he savored with appropriate irony—that art history, after at first shunning him for what he was, then acclaimed him for something he was not.

Lindner was fifty-three years old when he had his first one-man show at the Betty Parsons Gallery in 1954. He had been living in New York since 1941, earning his living first as a commercial illustrator and then as a teacher of painting. As a German Jew, he had been twice a refugee, first in 1933 when he left Munich—where he was the art director of a large publishing house—on the day that Hitler came to power, and then again in 1941, when he emigrated to New York to escape the Nazi occupation of France. He was thus a man with considerable experience of the world and much of it very painful, of course, before he was able to settle down to the creation of his art. Life in New York gave him his opportunity—and gave him, too, some of the distinctive imagery he carried into his art, with its bizarre, exaggerated fantasy of urban menace and erotic display—but the art he produced in America was firmly based on the culture and experience of his "other" life. The slick forms and brassy color, symbols of street life and the sense of underworld power and glamour, may have given his art a superficial resemblance to certain modes of Pop art, but its essential scenario was derived from something personal and European, something closer to early Brecht and *The Blue Angel* than to anything discovered in New York.

The Meeting remains the most autobiographical of all Lindner's paintings and therefore the key to his oeuvre as a whole. It is a kind of Proustian synthesis of private reminiscence and symbolic evocation, at once a family romance and a chronicle of cultural change. The childhood of the artist is represented by the figure of the young boy in a sailor suit, and the artist's new life in New York by portraits of his artist friends, émigrés like himself—Saul Steinberg, the seated figure on the right; Hedda Sterne, upper right; and Evelyn Hofer, on the lower left. Into this private theater of past memories and present circumstance, a more mythical confrontation is introduced with the figures of the mad King Ludwig of Bavaria, representing European culture in all its gorgeous decadence and aesthetic extravagance, and the stout corseted temptress, representing the fatal woman we see in much of Lindner's subsequent work—the archetypal whore of the metropolis, symbol of the nexus of power, appetite, and money that haunts his work to the end.

Thereafter, we were never again to see a picture as explicitly autobiographical as this one; yet the whole fantastic cast of characters Lindner made familiar to us—the dreamy boys in uniform, innocent in their virtue and reluctant to awaken to the manhood that awaits them; the queening whores of the street, with their outrageous vitality and appeal; and the gangster figures supreme in their uncontested positions of power—are all traceable to this private scenario of memory, history, and human fate. Even the huge beautiful cat that we see in *The Meeting* is another of these archetypal characters in Lindner's psychodrama—representing the animal in our lives, and in us, stripped of all natural force and made vulnerable to more powerful desires than his own.

What was most obvious in Lindner's work—and no doubt the source of its popular appeal—was the sense of erotic menace it conveyed combined with the cool, brilliant surface employed in its depiction. But there was also, I think, a political dimension to this vision, though Lindner was never explicitly a political artist. The contest of power that we glimpse in his work—a contest in which the innocent are invariably the victims, and the victims collaborators in their own fall—may be stated in erotic terms, but the historical subtext implied in this imagery is unmistakable. Everything is stated in terms of erotic reverie; yet the sense of conflict and defeat, the sheer will to power, and the general aura of a merciless universe carry a meaning that cannot be accounted for in sexual terms alone. The echoes of Weimar and the

Hitler era are never insisted upon, but are always clearly there. Which makes the confusion about Lindner as some sort of Pop artist macabre as well as mistaken.

He was a marvelous artist, and a very sweet man. Only in the refuge of America could he have achieved what he did, and only in the horrible dislocations of European life could he have been formed as he was. And he remained to the end a man of two worlds, dividing his life between New York and Paris, at home in both and without illusions about either. We shall miss him.

APRIL 30, 1978

7. Saul Steinberg

Saul Steinberg, whose work is the subject of a major retrospective exhibition at the Whitney Museum of American Art in New York, is not like other artists who have museum shows. Is he, indeed, an "artist" in this museum sense at all? The answer to this question is by no means clear even today, when so many established notions about "art" and "artist" seem to be under permanent suspension. Once safely relegated to the ranks of the more sophisticated cartoonists, he has long since ceased to fit comfortably into that company, yet he is not easily located elsewhere. At times, Steinberg speaks of himself as a "journalist," and it is true that most people still know him best for his work in *The New Yorker*, to which he has been a regular contributor since the 1940s. He has also been known to describe himself as "a writer who draws," and when pressed, he will admit to thinking of himself as a kind of "novelist." But art museums, even with today's shifting and sometimes nonexistent standards, are not much inclined to give major exhibitions to cartoonists or journalists or novelists or writers who draw. Obviously, Steinberg is an anomaly.

The public that attends a Steinberg exhibition—for he has often exhibited in art galleries and museums—is also anomalous. It does not resemble the public at other exhibitions. It moves differently and be-

haves differently, for it does not *look* as much as it *reads*. It also smiles a lot. Its whole manner of absorption—and there is no question about its being absorbed—is quite different from that of people looking at painting or sculpture. A Steinberg exhibition arches the back and concentrates the mind. It is an intellectual puzzle as well as a visual entertainment. It abounds in ideas. It both embraces the world "out there" and yet obliterates it, turning everything the Steinberg mind touches into— what? A comedy of manners, certainly. But also a comedy about art and its processes of thought. And a comedy about the relation that obtains between the two.

In the Steinberg world, there is also a comedy about *us*, the public, studying this comedy and about Steinberg himself, creating it. Everything Steinberg does is an essay on style—both his and ours—and on the role of style in society and in the inner recesses of the mind. Central to the whole Steinberg enterprise is a vivid perception of the anxiety of style, and of the styles of our anxieties. Beyond the obvious comic delights of the work, it is probably this—the deep vein of anxiety that informs every curlicue and costume in the Steinberg oeuvre—that holds his public in thrall. In the Mozartian lightness and elaboration of the Steinberg "line," we recognize an imperative truth about the way we act and react in the modern world we share with this odd visionary of the drawing board.

There is little point, then, in trying to place Steinberg in some conventional artistic category, Highbrow illustrator? Metaphysical cartoonist? Novelist-draftsman-journalist-satirist? In a new book on Steinberg that also serves as the catalogue of the Whitney show, Harold Rosenberg speaks of him as "a writer of pictures, an architect of speech and sounds, a draftsman of philosophical reflections." All such descriptions apply, yet none quite captures Steinberg's variety or eccentricity—the oddness and surprise of his position and his vision. Rosenberg correctly speaks of him as a "frontiersman of genres," yet by now "a Steinberg" is virtually a genre in itself, as we can see from the army of imitators who go on shamelessly exploiting his every invention.

It does no good, either, to place Steinberg in his artistic generation—the generation that emerged during the war years of the forties in New York—for there, too, he eludes classification, being at once an insider and an outsider. The dates and locations of his early exhibitions place him at the center of the world of the Abstract Expressionist painters of the New York School. Betty Parsons showed him in 1943, Dorothy Miller included him in the "Fourteen Americans"

show at the Museum of Modern Art in 1946. By 1952, he was showing at both Betty Parsons and Sidney Janis—this was the milieu in which Jackson Pollock, Mark Rothko, Clyfford Still, et al. were setting a new pace and establishing a new tradition for abstract painting.

But what did the drawings of Saul Steinberg have to do with *their* art? In the struggle that was then being waged to win a place for the new American art beside that of the European avant-garde, where did Steinberg belong? Was he European or American? Was he avant-garde or its opposite? The truth, as is usually the case with Steinberg, is that he was neither and both, a hybrid that flowered in the space that divided these things from each other.

Perhaps one way to understand Steinberg's curious and paradoxical relation to his painter contemporaries in New York is to see that what for many of them was an urgent matter of *form*— the search for a form to be transmuted into yet newer, bigger and ever more personal forms—was for Steinberg a matter of *content*. The legacy of Dada and Surrealism, for example, was one of the paramount artistic issues for the painters of the New York School in the 1940s, whereas for Steinberg this legacy was less a matter of art than of life. His experience had already encompassed what the iconography and ideas and methods of Dada and Surrealism had distilled into pictures and objects. Dada was less a vision for him than an environment, Surrealism less a style than a personal memory. It was the extent to which they had entered into the fabric of our lives, not the manner in which they could be used for art, that affected the way they entered into the art he was himself beginning to create.

When he arrived in New York in July 1942, Steinberg was twenty-eight years old. He spoke little English, but he had already published drawings in *The New Yorker* and in the New York newspaper *PM*. He had grown up in Rumania, or rather, in "a certain small segment of Bucharest," as he says, which he still describes as pure Dada country. That was the beginning of The Education of Saul Steinberg. "Now, being born in a Turkish ex-colony," he observes, "you are born with an understanding of several levels of truth. Certain things have to really be learned early enough. One of the troubles with our world (I talk about a comfortable world) is that the early years are lost. . . . This is when the brain, the heart, everything understands. Quickly. It was the last remnants of a Byzantine society." Which may be something to remember in seeing the devious Byzantine line that is traced, as if in a dream, in so many of Steinberg's later drawings.

The next phase of this Education he regards as the Surrealist phase. At eighteen he went to Italy, to Milan, to study architecture. ("The study of architecture is a marvelous training for anything but architecture," Steinberg writes in the official chronology of his career. "The frightening thought that what you draw may become a building makes for reasoned lines.") This was in the Mussolini era. "It was a world that occasionally I see in Buñuel movies," Steinberg now recalls.

> I see streets that have real sidewalks with no cars parked—the slower-motion empty streets. This was the quality of both Italy, Surrealism, and the times of Fascism. Fascism brings Surrealism. Fear causes Surrealism—people stay home. Now, at night, our city looks Surrealist, illuminated like a modern kitchen—a brilliant alarming light, and nobody in the street, and whoever is in the street leaves three or four shadows going in several directions like in Futurist or Surrealist pictures. . . . This is how Milano was in those days. It had the quality of prison.

It was in this Surrealist "prison" that Steinberg turned to comic drawing as a profession, publishing cartoons in a bi-weekly magazine called *Bertoldo*. "In Fascist Italy, where the controlled press was predictable and extremely boring," Steinberg says, "the humor magazines were a way of knowing other aspects of life which, by the nature of humor itself, seemed subversive." For one of the first of his *Bertoldo* drawings, the caption reads: "Dammit, this isn't me. In the crowd I get lost." Which is both a veiled comment on the Fascist ethos and, as Steinberg himself points out, "in the avant-garde of the identity problem."

The identity problem: With all of its attendant masks and anxieties and assumed disguises, and its necessary dependence on the quick-sands of style, this is clearly one of Steinberg's most persistent themes. It turns up again and again—in his use of fingerprints and rubber stamps, in his anthologies of imaginary certificates and documents. It is the theme, above all, of the exile and cosmopolite negotiating a succession of voluntary and involuntary emigrations. Of his years in Italy, Steinberg says: "I became what I always wanted to be: fictitious." And then he adds: "That is what we all want to be."

In this, surely, is the key to every Steinberg character and situation. It is characteristic of the way his mind works—and of the way it works in the drawings—that he found in his own situation as an agile and adaptable exile and émigré one of the principles that informed all of modern experience, and based his art upon *that*. It is a common strat-

egy, of course, for novelists to use their experience in this way, and this is one of the respects in which Steinberg's method does indeed resemble that of a novelistic imagination.

He was soon to have ample opportunity to test his own gift for donning unlikely masks and assuming new identities. By the time he left Italy in 1941 to embark on the most important of his emigrations—to America—he was both a *Dottore* in *Architettura* and a contributor of cartoons and comic drawings to *Life* and *Harper's Bazaar*. By way of Lisbon he got to Ellis Island, only to find that he had to proceed to Santo Domingo to wait out his turn on the lists of refugee quotas. He entered the United States at Miami, taking a bus to New York—the first of the many bus trips around the country that have yielded him many of his finest images of places like Kansas, Nebraska, Las Vegas, and Los Angeles. Steinberg is particularly partial to bus travel and laments what has lately happened to it. "The view from the car is false, menacing," he observes. "One is seated too low, as if in a living-room chair watching TV in the middle of a highway. From the bus, one has a much better and nobler view, the view of the horseman. It is a pity that now they color the bus windows, and one sees only a sad, permanent twilight."

Almost immediately on entering the United States, he became another "fictitious" person. He entered the United States Navy. Still speaking little English, he was commissioned as an ensign, became an American citizen, and was promptly sent to India and China. "I expected this sort of thing to happen in America, an adventurous place," he says. It was in China, not New York, that he became American: a case of the émigré outwitting the refugee. "Instead of remaining here as a refugee from Europe—a thing I detested, because you become the victim of refugee-lovers—instead of this," he says of this period, "I was thrown in with all these fellows from Montana and Arizona, and I learned Navy English before I could learn any better English. It was easier for me to become an American in China or India than in Beekman Place. So when I came back, I had absolutely no desire to mix with refugees. It was a very fast indoctrination into the lowest clichés of America. Great stenography for me. So when I came back here, I was not too 'foreign' anymore."

Now when Steinberg speaks of "the lowest clichés of America," he is not voicing a criticism; he is identifying his material, the material of which he has studiously made himself a connoisseur. These clichés are his stock in trade, and he treasures them. His tours of Fourteenth

Street in New York, and other such haunts, for example, still yield him more than his visits to the museums. About the latter he tends to be morose. "Museums make me nervous," he says, "I go very fast through them. I look with the tail of my eye. I see a few things, and I leave exhausted." But about Fourteenth Street he can be eloquent: "I get involved in that sort of Mickey Mouse brutality that I see in the streets. And to me, it's hypnotizing, it's beautiful. . . . All these guys—six, seven feet tall, with Afros and high platform shoes watching filthy movies in stores. Fourteenth Street is the key to the City, the U.S., and the Western world. I make a tour of Fourteenth Street to see what's new all the way from east to west. It's the—what shall I call it?— it's like a cross section of the human body. You see all the organs."

It is out of this quirky, inspired perspective—untouched by either the pieties of American life or the conventional snobberies of European culture—that Steinberg had developed one of the most compelling aspects of his art: the travelogues and catalogues of the popular culture that for Steinberg is never a social abstraction but a universe of bizarre and fascinating images. In this world he is a master at the detection of the unsuspected affinity: The jukebox is shown to belong to the same species as the Chrysler Building, the Times Square whore is sister to the Hollywood starlet and the suburban schoolgirl, and the kitschiest product of cynical commerce and vulgar sentiment turns out to be the distant, disinherited offspring of a once exalted artistic style. Steinberg seems to know the aesthetic genealogy of every object and gesture and impulse in our culture. He has a wonderful grasp—at once comic, knowing, and disabused—of the relation of high and low culture and of the illicit intercourse that takes place between fastidious sensibility and the lowly objects it spurns.

No other artist of our time has such a precise perception of the unacknowledged connections that join the disparate, warring elements of our culture in a reluctant and hilarious unity. "He sees this kitsch," Harold Rosenberg writes, "as the legacy inherited by the modern world from the art of earlier centuries. Religious and romantic motifs—Madonnas, a lion attacking a mounted African warrior, a stag reflected in a lake—are made into low-priced designs. The French, he explains, have a word for this stuff: *bondieuserie*, which comes from *bon Dieu*." Steinberg takes these "gods" of a vital popular culture as seriously as an archaeologist studying the remains of a lost civilization, yet comedy—a comedy that remains cool and detached, the comedy of style—is the form that his seriousness takes.

Like an expert archaeologist—for the émigré, too, is a kind of archaeologist confronted with the task of decoding an unfamiliar culture—Steinberg is a connoisseur of forms and their hidden "content," the emotions and aspirations contained within the form. "You learn a new language," he says, "and when you suddenly savor the new syntax of the place, you see things that nobody had seen before. When I arrived here—this whole nation was involved in painting like Cézanne. Everything looked like Mont Ste.-Victoire. They had a real paradise—the most marvelous country. When I arrived here, I had such a joy to find these things that were untouched—the diners, the roads, the small towns—while the natives were painting like Rubens on Fourteenth Street and Rembrandt upstate." In this respect, Steinberg's closest affinities are, as he acknowledges, with "real immigrants—men like Bashevis Singer, Nabokov, de Kooning." Especially, I think, Nabokov, whose discovery of the American scene in *Lolita* reads at times as if it were a libretto written for a Steinberg score.

Like Nabokov, Steinberg, too, is a master of the double parody— the kind of parody in which it is not only the particular object or emotion that is mimicked, ridiculed, or otherwise rendered in a new and satirical light, but also the medium that is employed for this purpose. Nothing in Steinberg is given straight. Everything is refracted through a collation and collision of the styles deemed most appropriate to the subject. Steinberg has more than once averred that his drawings are, among much else, a form of art criticism, and he tends to see all of experience—it is perhaps the single most distinctive thing about his own "style," which is an amalgam of many styles—as a drama of conflicting art styles. In the Steinbergian world, there is no thing-in-itself, no "reality" independent of the modes of its perception. Nature, Fourteenth Street, his own drawing table—nothing is free to be itself, for everything is tethered to the forms that culture, high or low or some combination of the two, have imposed on it.

Speaking of his travels in Africa a few years ago, Steinberg reported that "I found out that while, let's say, the lion is a Baroque animal and some others—the hog, the fox—are maybe Gothic, the crocodile is Aztec. An extinct art. It has the rigidity of extinction, and it fits the discipline of the crocodile." His drawings are, in a sense, anthologies of art history. There are Cubist and rococo characters, Expressionist conversations, Renaissance objects, Gothic words, and Pointillist emotions. There is a kind of primitivism in all this, an animism, for everything in Steinberg—even the most inanimate object or ab-

stract thought—is teeming with feeling, aspiration, ambition, and portents. Numbers are erotic, words are predatory or faltering, a coiffure may be cerebral, or a boot didactic. Steinberg sees experience itself as a parody of experience, with "style" the only reliable clue to its mysterious gyrations. While most of the so-called advanced art of our time has systematically set out to drain style of its extra-artistic "meaning" and make something absolute of what remains—a pure aesthetic distillation—Steinberg has smuggled this world of "meaning" back into the realm of visual discourse. In this respect, too, he is at once the insider and the outsider—a connoisseur of forms who has made a specialty of harvesting their forbidden content.

"The *technique* of drawing," Steinberg told Grace Glueck of *The New York Times* a few years ago, "is not for me an aesthetic pursuit. . . . Drawing is a way of reasoning on paper." It also represents the unbroken thread of continuity in a life otherwise disrupted and divided into a succession of "fictitious" episodes. "I am among the few who continue to draw after childhood is ended, continuing and perfecting childhood drawing. . . . The continuous line of my drawing dates from childhood and is probably a way of writing from my illiterate days." The idea of drawing as a form of writing is never far from Steinberg's thoughts about himself as an artist and an émigré—the "peculiar condition," as Steinberg says, of his life—for the two are, of course, related. "I imagine if I had been born in a place with a good language, good vocabulary, I would have stayed there, I would probably have become a writer. This was my inclination. But being deprived of this thing, and having what I considered a modest talent, gave me from the beginning a métier. I transformed this métier into something much more complex and much more to my own needs."

"When I make a drawing," Steinberg says, "I'm just like a writer. I have a desk—a bigger desk, of course; I need more space." For this reason, the most poignant of all of Steinberg's works, and the gentlest in the emotions they invoke, are the drawings he has made of his own drawing table—his "desk"—and the actual fool-the-eye tables, with their arrays of fake pencils and pens and sketchbooks and other paraphernalia of the draftsman's art. These objects are carved ("whittled," Steinberg says) and constructed and painted to resemble the real thing. These are the "household gods" that minister to the mystery of his vocation. They, too, are a parody—for Steinberg does not exempt himself from the special vision he brings to all things—but they are a sweet parody, a parody of love.

What does it mean for an artist of this sort, an artist for whom art is not "an aesthetic pursuit," and for whom the museum is not a congenial atmosphere, to have a retrospective in an art museum? It is a question that weighs on Steinberg these days. "A retrospective is some sort of mistake," he says. "The retro itself is pejorative—retrograde, retroactive—looking back is a mistake, a taboo. The most famous example of a retrospective (looking back) victim is the wife of Lot (fleeing Sodom) who, by looking back, became a pillar of salt. The pillar of salt means your transformation into a monument. I know all the time this is not the wisest thing."

Yet he has found a way of coming to terms with this alien enterprise by regarding it as yet another of his "emigrations." "It's history," he says. "It forces you to save yourself from it by the most uncomfortable of situations—running uphill." And the image of Saul Steinberg running uphill to escape his own monument may in the end be the quintessential Steinberg parody.

MAY 16, 1978

8. Romare Bearden

The practice of combining collage with the art of storytelling, or with sundry other forms of "literary" expression, has an older history than is commonly supposed. In a huge study of the collage medium written some years ago, and mainly focused, of course, on the accomplishments of collage since Cubism—the late Herta Wescher gave us an interesting glimpse of some of these premodernist uses of collage. She cited examples from twelfth-century Japan, thirteenth-century Persia, and seventeenth-century Europe, and recalled that in the nineteenth century literary eminences on the order of Victor Hugo, Hans Christian Andersen, and Christian Morganstern turned to collage for artistic purposes.

It was true, as Herta Wescher said, that such efforts remained "on the sidelines" of art history until the Cubists elevated collage to the position it continues to enjoy today—a position of aesthetic parity with painting and drawing. Yet it is worth recalling this earlier "literary" use of collage, for it harbored a range of expressive possibilities not immediately apparent in the more formalistic uses of the medium.

One possibility not much explored in recent art is the use of collage for narrative or storytelling purposes. It is in this respect that the work of Romare Bearden sets itself apart from the more familiar conventions of collage. Cubism established collage as the fulcrum of a new pictorial structure, and variations on this structure were promptly put to use by Dada and Surrealism for all sorts of satirical, lyrical, and symbolic purposes. The sudden, unexplained juxtaposition of images that collage affords proved to be an ideal instrument both for the depiction of dreams and dreamlike experience and for the mockery of conventional sentiment and social observation. Through collage—and the kindred medium of photomontage—fantasy and satire, both separately and together, were given a new range of experience.

Although Mr. Bearden's work clearly derives from this rich tradition, and certainly owes much to the structural vocabulary of Cubism, it nonetheless stands apart, as I say, from common practice in being tethered to a narrative or anecdotal point of view. His new show at the Cordier & Ekstrom Gallery is at once the most personal and the most "literary" he has yet given us, yet it continues in the vein he has made very much his own.

What is remarkable about this vein is that it permits Mr. Bearden to do many of the things that modernist art is not supposed to do. He attaches his art to a story—in this case, the story of his own life. He is anecdotal. He is also affectionate—in fact, tender—in the attitude he takes toward his subject, and there is never any doubt that he does, indeed, *have* a subject, and that the subject is not art itself. He just gives an emphatic priority to experience—that is, to the recollection and transmutation of experience—over style. Yet the style is distinctly modernist, and it serves its subject well.

Mr. Bearden is black, and in the past many of his themes naturally have been drawn from the experience of blacks in America. (An earlier series of collages was called "Of the Blues.") In spirit, then, his work has always tended toward the autobiographical and now it is explicitly so. Called "Profile"—Mr. Bearden likes to give titles to his shows—

the new exhibition is the first of a projected series on the central experiences of his life. He begins here with pictures about the 1920s, when he was in his teens.

The story was recently given literary form in a profile of Mr. Bearden written by Calvin Tompkins—it appeared in *The New Yorker* on November 28, 1977—and the title of the show is obviously drawn from that. For the present occasion, the individual picture titles and their short, accompanying texts—written on the walls of the gallery and reproduced in the catalogue—represent a collaboration with another writer, Albert Murray. Mr. Bearden is not an artist averse to words.

The twenty-eight collages that make up this series are small, striking, and intricate. They are crowded with visual incident even where the anecdotal reference is quite simple. They are at once homey in feeling and ornamental in design. The settings are Mecklenberg County in North Carolina, and the city of Pittsburgh.

Each collage focuses on a single scene or episode—children being sent off to school, people at work in the cotton fields, revival meetings, memories of trains crossing the landscape, glimpses of brothels, mornings at home. Mr. Bearden uses photographs cut out of magazines, bits of paper and fabric, lots of paint—all the things artists now use in making collages. In his hands, these materials have a sensuous, haunting quality and a distinct sense of color. The countryside is green to an almost preternatural degree, and the interior light romantic as only memory can make it. There is an air of artifice and romance, but the emphasis throughout is on memory of intense social intercourse.

The style that serves this very personal iconography might best be described as patchwork Cubism. The folk-art conventions of the patchwork quilt have often been used by Mr. Bearden in the past, and they are again used here. Actual quilts, too, are depicted in appropriate settings. I think there is a key here to the special quality Mr. Bearden achieves in his collages. The patchwork quilt is, after all, a kind of primitive Cubism in itself, and its use allows the artist both a free play on personal memory and the discipline necessary for art. It evokes a certain vein of experience and association, and at the same time provides—because of its affinities with the Cubist origins of collage—a structure for the expression of that experience.

Will this stylistic device serve equally well when Mr. Bearden turns to dealing with his more mature experience? It will be interesting to see if it does. In every autobiography, it is the early years that are most viv-

idly recalled in a series of striking images, and Mr. Bearden has certainly found the means for making his own early experience vivid to us. The congruence of narrative and visual materials is complete. But can the more complex story of his life as an artist be effectively encompassed by such means? It will be the later years that will put Mr. Bearden's narrative art to its most severe test.

DECEMBER 3, 1978

9. Helen Frankenthaler in the Fifties

The Helen Frankenthaler exhibition that Carl Belz has organized at the Rose Art Museum on the campus of Brandeis University focuses entirely on the paintings of the 1950s. Which is to say, it is an exhibition devoted to the work of a young artist. The earliest pictures in the show are dated 1950, when Miss Frankenthaler was twenty-two years old. The latest are from 1959, when she had just turned thirty-one. Even in a generation—the so-called second generation of the New York School—that was noted for winning a place for itself in the limelight far more quickly than had been common for American artists in the past, the sheer velocity of Miss Frankenthaler's career was unusual. Her first solo exhibition took place in 1951; her first museum retrospective in 1960.

The 1950s was a period of high expectation and large ambition for young artists who knew what was going on in the New York School and were sympathetically attuned to its aesthetic momentum. (Such artists were not nearly as numerous in the early years of the decade as they got to be in the later, by the way. In 1950, the New York School was not yet the "success" it afterward became.) Few of these young artists were better informed or more keenly responsive, in this respect, than Miss Frankenthaler. Her friendship with the critic Clement Greenberg, whom she met in 1950, gave her immediate access to the leading painters and sculptors of the movement. It also shaped her thinking about

what they were doing. It was through Mr. Greenberg that she met Jackson Pollock, and it was under Pollock's influence that her own style was formed—and formed remarkably quickly. If her position was privileged in the special opportunities it offered her, it must be said that it was Miss Frankenthaler's uncommon gifts that enabled her to take such prompt artistic advantage of them.

Her period of apprenticeship appears to have been very brief, in any case. In the present exhibition, the watercolor of *Provincetown Harbor* (1950) is very close to Marin, and another work on paper from the same year is very close to Kandinsky. The painting called *Untitled (Tropical Landscape)* and dated December 1951 is a fairly typical but still better than average example of second-generation Abstract Expressionism. The paint surface is heavy, though cleanly articulated, and every area of color is firmly locked into a contour that is drawn in black or brown pigment.

Yet by 1952 Miss Frankenthaler was working in a manner distinctly her own, however much it may still have owed to certain aspects of Pollock or Gorky or Kandinsky. She had thinned out her paint to the consistency of a wash, which was poured directly onto the canvas. This was sometimes combined with pigment applied with a brush, and in some pictures—most famously in *Mountains and Sea* (1952)—it was also combined with drawing that provided the painting with a kind of armature on which to build its improvised structure of color. The look achieved by this method was closely akin to the fluency of watercolor. Soon the brush was eliminated from this process, and so was the underdrawing. The entire picture was created by means of pouring, or staining, these thin washes of color onto the canvas surface without the aid of any visible prior design. Even where the brush might still be applied, it no longer determined the course of the painting itself.

The pictorial images that resulted from this change in the artist's method bore a distinct resemblance, of course, to certain Abstract Expressionist paintings. The forms were gestural and improvised, however much thought about in advance; and there was a good deal of drip and splatter. Yet the visual weight of the painting had been radically reduced. It was as if Abstract Expressionism had been put on a diet. Certain features in the physiognomy of the painting remained recognizably Abstract Expressionist in origin, yet the whole effect was different—lighter, slimmer, and more quickly legible. Color achieved a greater degree of immediacy and transparency as it came to dominate the entire experience of the painting itself.

This change turned out to have a decisive influence on the course of Color-field abstraction as it developed in the late fifties and sixties, but at the time it looked to many partisans of the New York School like rank heterodoxy. The standards upheld as models for second-generation Abstract Expressionism derived from Willem de Kooning and Franz Kline, rather than from Pollock, and central to these standards was a sacred belief in the dense Expressionist surface. Despite the myths that were afterward spun around the phenomenon of the Abstract Expressionist "drip," this was something more honored as an embellishment to painting than as a method of composition. Miss Frankenthaler's washy surfaces did not therefore look weighty enough to sustain a place beside the masters of the movement.

Art history moves in mysterious ways, however. The painters most directly influenced by Miss Frankenthaler's style were Morris Louis and Kenneth Noland, who acknowledged *Mountains and Sea* as their principal source of inspiration in turning toward the kind of Color-field painting that is based on poured, thinned-out washes of color, and she is now widely acknowledged to have been the crucial link between the Abstract Expressionists and the Color-field movement. She has paid for this distinction by being consistently assigned a place in the latter movement, quite as if her paintings of the fifties did not actually belong to the period in which they were made. In his essay for the catalogue of the present exhibition, Mr. Belz argues—very persuasively, in my opinion—against this view, and he has obviously conceived of this exhibition as a means of restoring her work to its rightful place in the history of the fifties. I think he has succeeded.

Now that Abstract Expressionism and Color-field abstraction can both be placed in historical perspective, we can see that it is to the history of the former that Miss Frankenthaler's work of the period clearly belongs. Its every gesture, its animating energy, its whole attitude toward lyric improvisation—even its distant kinship with landscape painting—stand in vivid opposition to the more deliberate, more controlled, more rationalistically determined methods of the Color-field school. Hers is an art that remains Expressionist in everything but its facture. However much the Color-field painters may have gotten from her, she has certainly never followed them in adopting the hard edge or the eccentrically shaped support as the basis of her painting. She has remained loyal to a very different order of vision.

Mountains and Sea, which has long been on loan to the National Gallery in Washington, is not included in the present exhibition; and it

isn't really missed. The reputation it has acquired as a sort of *Des-moiselles d'Avignon* of the Color-field school has itself distorted our understanding of Miss Frankenthaler's work in the fifties, and it is rather a relief to be able to study that work in its absence. Certain other pictures—especially *10/29/52* (1952) *Open Wall* (1952–53), *Shatter* (1953), *Eden* (1957) and *Dawn After the Storm* (1957)—give us a more substantial account of her achievement in this decade, while still other paintings here—most conspicuously *The Facade* (1954)—give us a clearer view of her limitations.

In this exhibition we can see how firmly tethered to the Abstract Expressionist mode Miss Frankenthaler remained even after she had effected a break with so many of its painterly practices. There was always something that drew her back to the haste and improvisation of that mode; the energy and growth of her painting—its unremitting search for a fresh emotion and the form that will give it voice—has clearly depended on it. That she was very young when she launched herself on this course should no longer prevent us from recognizing what it was she accomplished—which was nothing less than a major revision of the dominant style of the time. If in some way she was a fresher and more powerful painter in 1952–53 than in 1959—as I believe this exhibition shows her to have been—that, too, tells us something about the fate of the Abstract Expressionist mode in the course of the decade that is traced in this exhibition.

JUNE 7, 1981

10. Morris Louis

The first thing to be said about the Morris Louis exhibition at the National Gallery of Art is this: it is a very beautiful show. The eye is ravished by an experience of color that, though subtle in design and carefully calculated in effect, is nonetheless simple, fresh, and direct. There is nothing "hidden" or mysterious in these paintings and nothing metaphysical in our experience of them. They capture the eye with an

easy immediacy and hold it by eliminating everything but a naked appeal to the kind of optical pleasure that color, and color alone, can offer. Color is what Louis's painting is "essentially about," writes E. A. Carmean, Jr., the curator at the National Gallery who organized this exhibition and wrote its catalogue—a judgment everywhere confirmed in the paintings on view.

The exhibition, which consists of only sixteen paintings, is small enough, too, to avoid that sense of monotony and narrow purpose that a larger number of Louis's paintings would almost certainly induce. Louis, a founder of the Washington Color School who died in 1962 at the age of forty-nine, was not, in my opinion, a "big" artist. He was an extremely gifted member of that class of painters who, searching for a way to go "beyond" what has immediately preceded them, settle on a strategy of attrition as a means of achieving the requisite "breakthrough." Louis concentrated his breakthrough on color, more or less rejecting all other considerations. The result, as I say, was often very beautiful, but also very limited, and not of a scope, I think, to justify Mr. Carmean's calling Louis (as he does in the current issue of *Arts Magazine*) "a great painter"—a judgment that would oblige us to find another way of describing Matisse and Cézanne.

A strategy of attrition, such as Louis pursued, requires both technical prowess—for what remains, after so much has been forfeited, must be made to support the entire pictorial enterprise—and great single-mindedness; and Louis was not lacking in either. It requires, too, a theory of the history of painting that reduces everything of importance to a succession of technical feats or innovations, each designed to reaffirm—but ever more insistently and unmistakably—the physical attributes of the medium, its flatness, its edges, its shape, etc. This theory, widely known as formalism, Louis also did not lack. Its foremost promulgator in our time is the critic Clement Greenberg, and it is Mr. Greenberg who served as Louis's guide and mentor—and Mr. Greenberg, too, who serves as the principal source of the ideas employed by Mr. Carmean in explaining Louis's work and the high esteem in which he holds it.

What we are being offered in this exhibition, then, is not only a selection of paintings by Morris Louis but also an "event" in the history of art. The first of these—the paintings themselves—are a delight. The second—the elevation of their creation to the status of a major milestone in the history of the modern movement—is a factitious irritation that burdens the paintings with claims they cannot support. Far from

clarifying the kind of experience that Louis's paintings actually afford, such claims only obscure its real nature.

As an "event," Louis's accomplishment is said to hinge on the conversion he underwent in the studio of Helen Frankenthaler in the spring of 1953. Louis was then forty years old, a painter struggling to find a way "out" of Abstract Expressionism. Visiting Miss Frankenthaler in the company of Mr. Greenberg and Kenneth Noland, he saw her painting *Mountains and Sea* (1952), and there—Eureka!—discovered the future course of Western painting. Miss Frankenthaler, Louis said, "was a bridge between Pollock and what was possible."

What was possible, in this case, was the technique of staining color into the raw canvas instead of applying it to a prepared surface with a brush or some other implement. Louis made of this technique the basis of everything he produced in the remaining years of his life. Miró had used it years before, of course, but Miró was insufficiently single-minded, perhaps, for the purpose at hand. He was obsessed with images, with poetry and puns, with objects and erotic scenarios and a sense of humor—with everything, one is tempted to say, that formalist theory rejected. *Mountains and Sea* provided a more direct and uncluttered access to the promised land.

Mr. Carmean leaves us in no doubt as to how we are to consider Louis's use of this technique. "Many examples of twentieth-century art reveal a new expressive ability or a new direction based on the use of a novel technique or material," he writes in the catalogue. "We can cite pasted newspaper in Braque and Picasso collages, painted paper in a Matisse *découpage*, the painterly poured line of Pollock's classic abstractions, or David Smith's welded stainless steel. For Morris Louis the staining technique was such a breakthrough."

One could devote a long essay to unraveling this list of precedents and placing them in their proper historical contexts, but the point is clear enough. The paintings that Louis produced in the last eight years of his life are to be taken as works of towering historical importance.

One result of this attitude is that the first painting we see, as we approach the Louis exhibition at the National Gallery, is Miss Frankenthaler's *Mountain and Sea,* the significance of which is duly explained. We thus enter the exhibition appropriately prepared for the revelations to come.

What we then see is the work of a delicate, almost fragile sensibility that acquired extraordinary control over a very small area of the art of painting. Louis often worked on a large physical scale—the painting

called *Beta Iota* (1960), on loan here from the Museum of Modern Art, measures more than twenty-three feet in width—but the conception governing his work is always a small one. He began by employing large, overlapping stains, or "veils," of liquid color that occupied most of the canvas. He then turned to something sparer, placing discrete irregular ribbons or rivulets of color in denser saturations that come in from the edges of the picture plane and leave a large central area a white void. He ended by laying in these dense saturations in stripes, which likewise left large areas of white space. Upon all these "themes" he produced numbers of variations—hence the title of this exhibition, which is called "Morris Louis: Major Themes and Variations"—and produced them all expertly, with an unfailing technical control.

And that, perhaps, is the crux of the experience we take away from these pictures—the experience of color, ravishing to the eye, as it is conceived by a mind in thrall to the very technique that yielded so many small perfections. Morris Louis was not the first modern artist to discover that by jettisoning a great many of the traditional resources of painting, something small and perfect might be achieved with what remained. But it *was* something small, and it is a mockery of great art— or a convenient amnesia—to claim otherwise.

SEPTEMBER 26, 1976

11. Kenneth Noland

For anyone whose attention may have wandered, in the last year or two, away from a close observation of developments in Color-field abstraction, the new paintings by Kenneth Noland at the André Emmerich Gallery will come as a slight shock. Mr. Noland has long been regarded as one of the leaders of the Color-field school, and the pictures he produced in the latter half of the sixties—pictures of enormous size consisting of unbroken horizontal stripes, or bands, of color— were, for many connoisseurs of advanced art, a standard for determin-

ing what was (and what was not) permissible and desirable so far as abstract painting was concerned. Many people spoke of this style as "masking-tape abstraction"—a reference to the technique the artist employed in separating one straight-edged band of color from another.

In the new paintings, straight-edged bands of color are still very much in evidence, but they no longer constitute the only visual incident to be found on the picture surface. They are now narrower, moreover, and are much diminished in visual impact. Confined to the edges of the large picture surface, these stripes now provide a kind of interior frame for a vast open space, and it is what transpires inside the "frame" that is remarkable. For this open space is filled with thin washes of pale color—color virtually devoid of shape, color that impinges on the eye as an almost undefined hazy glow. Along the edges of the picture, where the narrow stripes overlap these washes of color, the latter are given a slightly heavier saturation. The effect is of an irregular frame of light enclosing a nearly empty space.

Mr. Noland thus joins the growing number of younger and middle generation abstract painters who have turned away from the "hard" forms and no-hands look of the sixties in favor of something more romantic, amorphous, and informal. Whether this trend to lyrical abstraction, as it is called, represents an advance, a retreat, or neither will no doubt be a subject for debate in art circles for years to come; but the trend itself is unmistakable. Two younger painters who give every evidence of being extremely shrewd in their reading of the aesthetic climate—Dan Christensen and Walter Darby Bannard—have lately shown new paintings that seem to be compounded of equal parts of Clyfford Still and Hans Hofmann. A third—Larry Poons—had already gone all-out in shifting to a completely Expressionist surface, and many of the younger abstract painters in the Whitney Biennial this year showed a similar willingness to reconsider the Expressionist option.

Mr. Noland, even in his new pictures, is still very far from embracing this return to Expressionism, but he has nonetheless aligned his art with the new romanticism. He has done so, however, with a caution and a diffidence that signify—to this observer at least—a curious lack of conviction. These new paintings have the distinct air of being compromise solutions. At their edges, they are an unconvincing amalgam of Noland-Olitski; in the large open spaces framed by the edges, they are sheer evocations of late Turner (above the pale blue haze of *Twice Around*, there is even a "rainbow" of sorts). Despite certain beautiful

effects—I am myself a sucker for these Turneresque hazes—these pictures suggest the depletion rather than the prosperity of an impulse.

A sense of depletion is not, to be sure, necessarily fatal to art. Modernist painting has been guided—not to say compelled—by that particular sense into some of its most startling innovations. What was deemed essential to one generation of modernists was judged by another to be expendable, and the line of modernist development—the line to which Mr. Noland's art belongs—has made a virtual crusade out of celebrating each successive depletion as an aesthetic victory. And perhaps victory is not too strong a word to describe the way our modernists have been able to make so much out of so little. They have certainly established beyond dispute that it is possible to make a legitimate work of art of fewer essentials than our grandfathers ever dreamed of. I am not speaking of great works of art, only works that qualify as art—that can be experienced as art.

But the tendency to strip art of its essentials—to reduce it to some absolute minimum constituent—has acquired a history and a mythology that are now far richer than the new works of art created in their image. Separated from the conventions and the mystique that guarantee their aesthetic status, these works tend to be pathetic relics of a faith that no longer commands assent. They tend, in other words, to be academic.

What the new romanticism in abstract painting suggests—even in the case of Mr. Noland's halfhearted version of it—is a recoil from the sterilities of this academic position. The will to deplete art of its resources and make the most of what little remains—the reductionist orthodoxy—is being rejected, and not only by the artists who always hated the whole idea but, significantly, by artists who have been adherents of the faith. Interestingly, this recoil is taking the form of a revival. One has the sense these days of abstract painters looking back, of attempting to resume a line of development that is felt to be more resourceful than yet another push toward the absolute minimum. There is an evident attempt to bypass the art of the sixties in order to reestablish a creative and historical link with the fifties. And who knows if the search will end there. Once the past is reexamined for creative clues, anything can happen. On the present evidence, however, Mr. Noland's art shows only an acute awareness of this reversal. He is in the unfortunate position of belonging to the very thing that is being reversed.

MARCH 4, 1973

12. Frank Stella: Renewing Abstraction

When the paintings of Frank Stella were shown at New York's Museum of Modern Art for the first time just twenty years ago, the reaction of most people who saw them was instant consternation. These were paintings that hardly looked like paintings at all. Each was a big rectangle symmetrically subdivided into rigid, repetitious, right-angled patterns of vertical and horizontal black stripes. They looked cold and forbidding. They also seemed to many people a hoax. They caused a good deal of anger and a good deal of mirth. Almost nobody liked them. I certainly didn't.

That the paintings were completely abstract, without even a hint of some discreetly hidden subject, was not in itself the problem. By 1959, when Stella's pictures were shown at the Modern in an exhibition called "Sixteen Americans," painting in one or another mode of abstraction had been a regular feature of the international art scene for nearly half a century. Abstract art might still, in some respects, be puzzling and difficult and unpopular; but it was no longer unfamiliar. It was looked at in the museums and taught in the schools. It was discussed in the press, and it fetched high prices. The public was learning to take it in stride.

What caused consternation was not that Stella's paintings were abstract, but the particular way they were abstract. They were so cool, neat, and deliberate. They seemed so intent upon rejecting any invitation to feeling. And the impression they conveyed—of a monstrous detachment from what were then taken to be the normal emotions of art—was enhanced by a statement in the catalogue of the show made by sculptor Carl Andre. This read, in part: "Frank Stella is not interested in expression or sensitivity. He is interested in the necessities of painting." Overnight, it seemed, the necessities of painting had been sorely circumscribed.

This was in the heyday of Abstract Expressionism—the movement that brought American painting an influence and prestige it had never before enjoyed. One of the hallmarks of Abstract Expressionism—certainly the one that most impressed itself on the public imagination—was its tendency to exhibit, even to flaunt, the artist's emotions. Painterly gesture, the drip and splatter of pigment on canvas, was taken as a sign of high seriousness. The look (if not the reality) of improvisation was much admired. It was all but assumed, however mis-

takenly, that an abandonment of conscious control was a prerequisite to artistic success.

Stella's formidable display of control, the very straightness and deliberateness with which every black stripe was applied to the canvas, without any pretense of feeling or improvisation, had the effect of a provocation. Its very simplicity brought a sense of shock, but it also aroused the envy and admiration of other young artists who were thereby offered an alternative to the orthodoxies of Abstract Expressionism. One result was the Minimal art movement of the 1960s, a movement that by the mid-1970s had established a great many new orthodoxies of its own.

It is in this context, and out of this background, that Stella has once again emerged as a provocative figure—as the artist who is probably doing more than any other in the late 1970s to revise our sense of the possibilities of abstract art.

Of course, the provocation is not now as heated or controversial as it was twenty years ago. Stella is too secure in reputation to inspire the kind of jibes that were commonplace in 1959, and the public is now so thoroughly inured to artistic change of every sort that innovations likely to cause a scandal in an earlier generation are now more or less accepted as they come. Still, our insouciance is by no means complete, and Stella's new work—which, it is important to note, is not exactly painting—has caused some real excitement.

At first glance the new work looks like a total reversal of everything we had come to associate with Stella's art. It is as if the 1950s were being revisited and revived. Gone is the look of cool deliberation. The strict geometric module had been replaced by an arrangement of forms that harks back to (of all things!) the improvisatory shapes and textures of Abstract Expressionism that were so summarily dismissed twenty years ago. Forms that have the appearance—if not, as we shall see, the reality—of a free-form gesture now dominate the work, and color seems to be scumbled and scribbled on with an air of abandon. It almost looks as if feeling were back in style.

During the 1960s Stella had carried the original premise of his cool, detached style into some very complex developments. The rectangular picture surface gave way to a variety of irregular shapes, and the so-called shaped canvas, whether based on V-shapes, on irregular polygons, or on the half circle of the protractor series that climaxed his work of the 1960s, became his standard pictorial vehicle. Throughout the 1960s, too, color—often commercial in its quality and power—

came to play an increasingly important role in his painting. But even where the shape of the canvas looked most eccentric and color was unabashedly gaudy and fluorescent, a basic geometric regularity still governed the conception of every form.

This is what has lately been abandoned with an evident relish. Early in the 1970s Stella turned away from painting on a flat canvas surface to produce a series of low reliefs. Their forms retained a geometric, or at least a straight-edged, character; but color was applied to some of these forms in a way that was sometimes sketchy in texture. And with the exotic bird series of relief constructions in 1976–77, this sketchy texture blossomed into a display of expressionist gesture, not only in the application of color, but in the very forms to which color was applied. Geometric structure is now totally abandoned in favor of those labyrinthine orchestrations of color and form that will be forever associated with the passions of the Abstract Expressionists.

Gone, too, is the flat picture surface, for Stella's new work is a form of painted relief construction that seems to acquire, with each object that comes from his studio, a more and more sculptural quality. The latest works, made from corrugated aluminum, are constructed on elaborate armatures or scaffoldings that thrust the artist's forms out from the wall to occupy a kind of sculptural space. Yet we still tend to experience these objects as paintings—that is, pictorially—rather than as sculpture, and it is no doubt in the ambiguity of this experience, which mingles (as Stella's work often has in the past) the literal and the illusionary, that a good deal of the visual power of the work lies.

In the presence of all this intense color, scribbled texture, and expressionist form, we are given every obvious reason to believe that Stella has undergone some sort of aesthetic conversion. But this, I think, is not really the case. He remains a very methodical artist, deliberate and cool in every decision, even where, as in the new work, the visual materials he employs are so much hotter to the eye. For the new work is not a revival of Abstract Expressionism, but a reexamination—a kind of anatomization—of it. Forms heretofore thought to represent spontaneous gestures of feeling are arrested in flight, so to speak, and broken down into their constituent parts and then reassembled and elaborated in designs that are no more improvised than the black stripes of twenty years ago. And yet—such is the ambiguity of the new work—it has the look and feel of all that expressionism that Stella explicitly disavowed when he made his debut in the "Sixteen Americans" show.

In all of Stella's work there is a kind of dialogue with other art, and the focus of the present dialogue is on precisely those elements in visual art that he eschewed in the past—the elements of expressionist appeal we associate with the Abstract Expressionist style. The success of the Minimal art movement devalued all obvious appeal to feeling to a radical degree. Showy demonstrations of emotion in art were placed under a virtual ban, while the conscious statement of an idea was given a sort of absolute priority. And Minimal art turned to the kind of technology—the technology of fabrication—that seemed to safeguard this erasure of wayward emotion.

The paradox to be observed in Stella's new work is that it employs the impersonal methods and technology of the Minimalists as a means of restoring the lyric element to abstract art. Other, younger artists of the 1970s, have looked back on Abstract Expressionism with a certain longing for the kind of emotion it harbored, and the result has often been a shallow rehearsal of the painterly gestures that were already wearing pretty thin when Stella arrived on the scene in the late 1950s. This simple, sentimental revivalism is something he has avoided. Instead he has found a way to repersonalize the impersonal methods of the Minimalists and effect a synthesis of feeling and idea that is new, and not only to *his* art but to abstract art itself. In a sense, he had to abandon abstract painting in order to conserve and essentialize its very spirit. It is this accomplishment—so unexpected from the artist who once gave us those dour black stripes—that has made Stella the most interesting exponent of abstract art at the end of the 1970s and an augury, perhaps, of what the 1980s might bring.

APRIL–MAY 1979

13. Agnes Martin

The day will come, no doubt, when New York will see a proper retrospective exhibition of the art of Agnes Martin. The fine retrospective that Suzanne Delehanty organized at the Institute of Contemporary Art in Philadelphia three years ago never did make it to New York—a

fact more damaging to the reputation of our museums than to that of the artist. Miss Martin's is, to be sure, a sometimes difficult art. It does not "perform" for a crowd. It cannot be described as "brilliant." It is quiet, elusive, contemplative—most elusive, perhaps, where it seems most obvious. Yet any understanding of the vicissitudes of abstract painting in America over the last decade or more remains incomplete without some grasp of her work.

We are fortunate, then, that a happy coincidence of gallery schedules has now brought us two exhibitions of this work—new paintings at the Pace Gallery and a selection of earlier pictures from the years 1961–67 at the Elkon Gallery. They do not add up to a retrospective, but they contain a fair number of pictures that would have to be included in any definitive retrospective of the future.

The shows are very different, however; an innocent observer might easily mistake them for the work of quite separate artists. The pictures of the 1960s are based, for the most part, on modular grids. The new pictures abandon the grid for straight-edged vertical forms that sometimes (when narrow) have the effect of stripes and sometimes (when wider) of architectural columns. This might not sound like a momentous change, but within the terms of Miss Martin's art—where, as Mies said of his own, God is in the details—it is. Miss Martin's painting, still austere and closely calculated, still suggesting that the language of geometry is the perfect vehicle for unearthly contemplation, has clearly entered a new phase.

Color, too, has changed in the new pictures—but color is something one almost hesitates to speak of in Miss Martin's work. It is, in a sense, hardly there at all, and the very word—*color*—sounds too colorful and sensuous, too worldly and theatrical, too highly charged with attempts to importune the eye and swamp our emotions for what is there. In the peculiar chromatic experience that Miss Martin's use of color affords, color is almost drained of color. It is distilled to a minimal essence that we experience as light, as surface, as a vapor—as almost anything but color. Yet it is there, all the same, essential to the artist's enterprise, and in the new paintings, it is quite audacious. For Miss Martin has now turned to what might be called baby colors—pale pinks and blues and white—as the vehicle of her otherworldly contemplations, and not the least startling aspect of these new paintings is their success in assimilating color commonly associated with domestic felicity to the purposes of a kind of mystical pictorial architecture.

The pictures of the 1960s now look, by contrast, a little more earthbound than they used to. Color tends to be pale gray, pale yellow

and ocher. The straight lines of the grids, drawn in pencil on acrylic grounds, have a pale silvery presence that is ghostly, as if the picture surface were not so much articulated by its forms as haunted by them. What in reproduction may look like nothing more remarkable than a page of graph paper is, in actuality, a subtly executed field of light. Everything is fixed in a strong pattern, with every element of the design repeated many times and with an insistent regularity, yet the paintings are not themselves insistent. They strike us as passive, almost indifferent to our glance, secure in a mission that does not exclude us but that does not go out of its way to solicit our interest either.

There is indeed a kind of ghost to be seen in these paintings of the 1960s—the ghost of Constructivism, with its ideology of order and its faith in geometrical form as a paradigm of earthly perfection. Only in these paintings, this sense of perfection is stripped of its pride. There had always been a strong element of the metaphysical in Constructivist art, but it was usually combined with a sense of social purpose. As a result, not infrequently, the Constructivist aesthetic suggested something arrogant and authoritarian—a will to impose uniformity and order. Not infrequently, too, it seemed to aim at the elimination of everything that was lyrical and inward. There were times when one felt it might be necessary to defend oneself against this ideology of order.

From this Constructivist tradition, which has harbored so much arrogant assertion and militant perfection, Miss Martin wrested something gentler and more personal—an art of private spiritual avowals. We never feel, in her art, that something "universal" is being imposed on us, for everything has been tested and transformed in the crucible of her sensibility. The "universal" is, in a sense, made subjective, individual, a matter of personal faith and perception; and it lives on easy terms with a delicate lyricism. Her art has the quality of a religious utterance, almost a form of prayer.

At least this was true of the paintings of the 1960s that we see at the Elkon show. If the new paintings at Pace do not always strike us as having this religious quality, it may be that they will take some getting used to. They represent, as I say, the beginning of a new phase of the artist's work. Perhaps to compensate for the new "soft" color, the surface of these pictures is an unusually "hard" one for Miss Martin. She has never been one to offer us a sensuous surface, but in these pictures the pigment is applied in so dry and austere a manner that the canvas seems to harden before our eyes—to turn, at times, to stone.

But then, when we step back from a close examination of these surfaces, the gallery that houses them seems to be filled with an almost

heavenly light. The close-valued vertical panels of pink, blue, and white create an extraordinary atmosphere—a happy radiance that is not so different, after all, from our experience of the earlier pictures. Perhaps, too, there is something "southern" in the light of these paintings that looks a little odd, not only in a northern clime but in relation to the "northern" climate of the artist's earlier work. They are probably paintings we are going to have to live with a while before we know exactly how we feel about them.

But however we may feel about this new work, Miss Martin has already produced more than enough to win her a place among the most accomplished painters of her generation. Born in 1912, she was late in developing her most distinctive work, which was produced in the decade 1957–67, when she lived in New York. Since that time, she has lived mainly in New Mexico; and we feel this shift of place more emphatically than you might think, even in an art that eschews earthly specifications. This, too, is one of the things that gives her art its spiritual edge—the sense we have of looking into a private world.

MAY 16, 1976

14. Anthony Caro at MoMA

The name of the British sculptor Anthony Caro now stands so high in the firmament of artistic reputations that we should not be surprised, I suppose, to find that the exhibition of his work currently installed at the Museum of Modern Art has been conceived less as an occasion to catch up on the progress of a living and still fallible artist than as an event calling for our unconditional aesthetic surrender. It is no secret, of course, that the fifty-year-old Mr. Caro has been for some years—at least since the death of David Smith in 1965—the nominee of Clement Greenberg and the critical establishment over which his ideas preside for the post of Greatest Living Sculptor, and the museum has approached the task of presenting us with what it mistakenly calls a "retrospective" more or less in the spirit of this judgment.

The elaborate lecture series organized to coincide with the exhibition at the museum, like the book-length monograph written by William S. Rubin, director of the museum's Department of Painting and Sculpture, in lieu of a mere catalogue, seems to have been undertaken with the object of establishing Mr. Caro's work as the grand culmination of everything that is most creative and "advanced" in the history of modernist sculpture. We are being invited, in other words, to pay homage to a master, if not indeed to worship at a shrine, and one's response to this invitation will very largely depend, I imagine, on the way one feels about such acts of preemptory and premature beatification.

For myself, I think the "hard-sell" approach adopted by the museum for this exhibition is very much to be regretted—it is insulting to those who are in a position to decide these questions for themselves and extremely misleading for those who are not—but the actual exhibition is something else. It brings us what is indeed an important body of work, and it is interesting in a way few of us would have anticipated from the art Mr. Caro produced in the 1960s: it discloses a significant change in the way he has begun to envision the task of sculpture in the last two or three years.

Briefly stated, the change is twofold: color, which formerly assumed a major role in the way Mr. Caro's sculptures were conceived, or at least in the way they were experienced, has been abandoned; and an emphasis on frontality, which Mr. Caro's sculpture formerly eschewed, has effectively displaced the polyaxial or multiple-view orientation that was the basis of his earlier achievements. The shift to a more frontal sculptural image—to an image that, though still physically possible to see from many angles, reveals its essential visual character head-on rather as a painting does—places the artist's work in closer proximity to that of David Smith, whose constructed sculpture launched Mr. Caro on a new artistic course some fifteen years ago.

The abandonment of color would likewise seem to bear a certain relation to Smith's work. It is well known that Mr. Caro values Mr. Greenberg's counsel on all matters affecting the aesthetic resolution of his work—Mr. Rubin's monograph is admirably explicit about their closeness in this regard—and so one assumes that it is no mere coincidence that color disappeared from the living artist's constructions at the very moment when Mr. Greenberg, in his role as an executor of the Smith estate, was, on his own admission, removing the color from the deceased artist's constructions. The medium of Mr. Caro's new work is

described as "steel, rusted and varnished," which is exactly what certain of Smith's painted works have lately been turned into.

The point would scarcely be worth making if Mr. Caro's new constructions represented some earth-shaking breakthrough in sculptural thought, but I am afraid they do not. In speaking of the new work, Mr. Rubin makes a tactful reference to "what may be on Caro's part a quite unconscious renewed interest in the sculpture of the forties and fifties—Smith especially," but everything else he tells us about the milieu in which Mr. Caro lives and works, both here and abroad, suggest it would be highly unlikely for an "interest" of this sort to remain "unconscious" for twenty-four hours.

What is more likely is that the decision to abandon color—and the kind of open, laterally expansive, multiple-view image that color made visually possible—required a discreet retreat to the ground occupied by Smith in the forties and fifites. The results of this move are not especially happy, and I doubt if a *pompier* work like *Riviera* or a problematical one like *Durham Steel Flat*, which even Mr. Rubin describes as "reversing many of the premises of Caro's earlier mature work," would have found a way into the sculpture garden of the Museum of Modern Art with such alacrity if they had borne a less exalted signature.

The real glories of this exhibition are to be found among the sculptures produced between 1962 and 1970—in *Early One Morning* (1962), possibly the finest thing Mr. Caro has ever done, and in *Orangerie* (1969), *Sun Feast* (1969-70), the table piece called *The Deluge* (1969-70), and a few others of this period. *Early One Morning* remains even today, when we have all become a little jaded from having seen such a multitude of well-meaning imitations and dreadful travesties inspired by its form, a work of stunning grace, originality, and power. In opening up the Constructivist mode to the horizontal sweep of a low-lying open sculpture that evokes something of the scale and the multiplicity of incident of a panoramic landscape without actually describing anything but its own carefully modulated succession of shapes and gestures and of the visual relations obtaining among them, Mr. Caro added something genuinely new to the art of sculpture.

The syntax of Constructivism was enlarged in the direction of a sculptural experience that could be fully encompassed only by a reading of the work and the space it occupies from many different angles of vision. The unity of experience in *Early One Morning* is cumulative, and very much dependent on the use of color—in this case, bright red—

that carries us from one visual "episode" to another without disruption or intermission. Michael Fried once invoked the realm of dance to describe the experience Mr. Caro's work affords; Mr. Rubin speaks of "narrative." However we describe it, it is this sense of an ongoing experience unfolding in a fixed but capacious space that Mr. Caro brought to abstract sculpture with such lyrical finesse, and it is for this that posterity is likely to honor him.

There are some thirty works in the present exhibition, which Mr. Rubin has organized in collaboration with the Museum of Fine Arts in Boston, and for my taste, too many of them are drawn from the unpainted constructions of the seventies. I would have much preferred a fuller account of the sculptures of the sixties, which are amply represented in both museum and private collections in this country but are now not likely to be brought together in a major exhibition for many years to come. But this is, all the same, an important exhibition; no one hoping to understand the art of our time can afford to miss it. (It will travel to Minneapolis, Houston and Boston after its New York showing.) It is not, to be sure, a retrospective; Mr. Caro's figurative sculptures of the fifties—reproduced in the monograph—are omitted. It dates from Mr. Caro's 1960 "conversion" and has something of the intensity of the convert's ardor.

MAY 11, 1975

15. Christopher Wilmarth

The sculpture of Christopher Wilmarth, although still little known to the large art audience that depends on news of a "trend" for its acquaintance with contemporary reputations, has been a subject of fairly consistent serious interest to critics and curators since the artist's first one-man show in 1968. Now, with the exhibition called "Nine Clearings for a Standing Man" at the Wadsworth Atheneum, Mr. Wilmarth is likely to be more widely recognized as one of the leading sculptors of

his generation. (He is thirty-one.) This is a small exhibition and not one easily encompassed by the untutored eye, but it is something of an event all the same. It is the kind of exhibition that connoisseurs of contemporary sculpture will not want to miss.

Mr. Wilmarth is a Constructivist, but he brings something new to the established conventions of Constructivism—a sensibility that is closer, in some important respects, to painters like Rothko and Matisse than, say, to Constructivist sculptors like Gabo or Tatlin. He works in heavy industrial materials—large rectangular sheets of steel and etched glass, each measuring sixty by eighty inches, joined by wire cable—yet the visual effect he achieves is one of extreme delicacy. We are always conscious—and made conscious—of the sheer weightiness of these materials, yet our experience of the work is an experience of subtle, shifting modulations of light and shadow. Without subterfuge or disguise, with every element of their ingenious but essentially simple syntax clearly manifest, these constructions of steel and glass induce an extraordinary feeling of inwardness and intimacy. They are cast in the lyric mode—which is another measure of their distance from the familiar conventions of Constructivism.

As its title suggests, the present exhibition consists of nine works, together with a selection of preparatory drawings and watercolors, that are variations on a single theme. Their visual subtlety is such as to make their reproduction in a black-and-white photograph virtually impossible—and no description of their physical appearance can hope to do justice to that subtlety, which is the very essence of the power of these sculptures. Suffice it to say that in each work a plate of pale greenish glass, etched to achieve a frosty, brushy surface that preserves its translucency while at the same time dimming its transparency, is set against a dark, unpolished steel plate the same size, and both are joined to the wall and to each other by means of a taut wire cable that is threaded through a tiny opening in the glass panel to become a vertical or horizontal member of the construction. The differences or variations that give each work in the series a separate visual identity are to be found in the placing of the angles at which the steel plate is bent to admit light to the small enclosed area (never more than a few inches wide at its largest opening) dividing the steel from the glass.

The entire construction rests on the floor—or as the show is installed at the Atheneum, on a slightly raised stone platform—and thus has the look of a low relief placed against the wall. Except for the

brushy, painterly surface of the etched glass, the entire vocabulary here is that of geometrical abstraction. Every unit of the composition, from the bend in the steel to the line formed by the cable to the rectangular shape of the steel and glass plate, has a straight edge and observes a strict geometrical orthodoxy. Yet the image that meets the eye is one dominated by soft-edged tonalities. We are in a world of light and shadow—of tinted shadows just barely but perceptibly penetrated by "clearings" of light—at the same time that we are bounded by the highly rationalized syntax of geometrical construction.

I know of nothing quite like this in the history of modern sculpture. While fully satisfying the taste for a radically simplified and completely visualized structure—for doing away with "hidden" supports and disguised technical strategems—that Constructivism introduced into modern sculpture, Mr. Wilmarth has yet managed to create an imagery of remarkable resonance and romance.

I have already mentioned Matisse, and in his excellent essay for the catalogue of the exhibition Joseph Masheck makes a brief comparison between Mr. Wilmarth's *Clearings* and one of Matisse's great *Back* reliefs. But for myself, it is not Matisse's sculpture that Mr. Wilmarth's work calls to mind, but one of those astonishing "empty" paintings he produced in 1914—specifically, the *Porte-fenêtre à Collioure*, which the artist himself thought too daring to exhibit in his lifetime and which has been shown only a few times in recent years. The vertical panels of blue, green, and gray light that frame a central rectangular cavity of black shadow form an image that bears a close similarity to Mr. Wilmarth's basic theme, and both belong to a family of images in which Rothko's late black-and-gray paintings also have a place.

To employ the language and the technology of Constructivism for an imagery of such tonal delicacy requires not only immense technical skill but also something rarer—an audacious leap of the sculptural imagination. This is indeed what Mr. Wilmarth has achieved in these "Nine Clearings for a Standing Man." The result is an exhibition that permanently alters our understanding of the resources of sculpture— and permanently modifies, too, our previous notions about the limits of Constructivism. We have seen the art of sculpture undergo a great many changes in the last decade, but these have been changes either in the radical simplification of form or in the somewhat less radical inflation of scale. The introduction of color—color as an integral part of the sculptural conception—once promised much, but has yielded remarkably little. Often, indeed, the resources of sculpture were "extended"

only at the cost of abandoning sculpture altogether, as we have seen so often in the works of the Conceptual-Process school.

Mr. Wilmarth's work has been formed in this climate of swiftly changing definitions of sculptural form, and he has clearly kept his eyes open to what has been happening. His work owes something to the Minimalists, as it also seems to owe something to the Color-field painters. But he has made something enormously interesting out of his sources, whatever they may be, and something all his own. These ''Nine Clearings'' constitute a work of considerable beauty and originality, and I suspect we shall soon be seeing evidence of their influence on the work of his younger contemporaries.

Because they are rather subtle constructions of light, these sculptures require an exhibition area both ample in wall space and bathed in soft natural light. The Avery Court at the Wadsworth Atheneum, with light filtering through its glass ceiling, is just about perfect for work of this sort. One can scarcely imagine a more sympathetic setting. And the Atheneum is to be congratulated, in any case, for showing these nine works as a group.

DECEMBER 8, 1974

16. The Transformations of Lucas Samaras

One of the most interesting aspects of the current art scene, and yet one of the least remarked upon, is the virtual collapse of that absolute sense of art history—that monomaniacal belief in a single style dictated by historical circumstances—which has governed so many ''schools'' of modern art. This devotion to an absolute has been responsible for a great deal of what we most admire in the history of modern art. Artists as different as Mondrian and Duchamp would be unthinkable without it. Yet there was always an element of myth at the heart of this devotion to the absolute. There was always a voluntary surrender of intelligence in regard to the sheer plurality of styles that had proved themselves ar-

tistically viable. The very concept of a museum specializing in modern art implied, without ever openly acknowledging, an ecumenical attitude toward the many separate, contradictory absolutes contending for attention and influence.

Artists, of course, have not only the right, but the duty to be, in V. S. Pritchett's phrase, sectarians of their own vision. But the rest of us—critics, collectors, the museums, the public—have other rights and other duties, not to mention other pleasures; and one of these, surely, is the pleasure we take in diverse forms of art that take so little pleasure in each other. We may, at times, succumb to a fashion, but fashions are temporary by their very nature, and the great corrective to them is a vivid and open-minded sense of history. And it is this sense of history— this larger sense of the multiform possibilities it embraces at any given moment—which has effectively eroded our belief in the absolute as anything but a temporary means of achieving a limited objective.

The Lucas Samaras exhibition that has now come to the Whitney Museum of American Art is an interesting case in point. It is, from the point of view of almost any absolutist art-historical scenario, a throwback to an earlier period of modern art—specifically, to Surrealism, with its dominating interest in irrational images and its programmatic indifference to the purity of plastic form. For more than a decade—the decade of Minimal art, Color-field abstraction, and other such attempts to deepen and sustain the austerities of modernist expression— Mr. Samaras has been engaged in an energetic revival of all the old Surrealist strategies and ambitions, not the least of which was the ambition to create something shocking.

True, Mr. Samaras is not without some close connections with the art of the sixties. Both the general ethos of Pop art—the "anything goes" spirit it fostered in opposition to the puritan denials of abstract art—and its origins in the Neo-Dada revival of the late fifties have certainly contributed something essential to Mr. Samaras's work, if only the freedom to do what he pleases. But what it pleased him to do was not to follow in the path of Pop art, which was at all times a highly sociable form of visual entertainment, but to dwell on something more personal—a private world of dreams and fetishes. His art is thus a good deal closer in spirit to Dali's—the Dali of the thirties—than, say, to Claes Oldenburg's, however much the abiding obsession with transformed objects may remind us at times of Mr. Oldenburg's parallel concerns.

Like Dali, too, Mr. Samaras betrays in certain aspects of his work—I think especially of the delicate pastels of which there are abun-

dant examples in the present exhibition—an unmistakable nostalgia for the conventional. It is precisely this nostalgia that is at once outrageously violated and beautifully embellished in the large number of transformed objects that dominate the Whitney exhibition. The basic strategy behind these inspired transformations is itself a convention, of course—the convention of seizing upon something commonplace (a chair, say, or a pair of shoes or a self-portrait photograph) in order to violate all the expectations and associations we may bring to it.

If this strategy can scarcely be said to be new—to go no further back than the nineteenth century, we can find plenty of precedents for it in the imagery of Rimbaud and Lautreamont—Mr. Samaras nonetheless brings to its implementation the requisite sense of obsession and compulsion, that indispensable willingness to go "too far." Of course, this going "too far" is still another convention, a fiction we agree to honor while under the spell of the objects it has inspired, but Mr. Samaras is very adept at making this fiction stick. And he makes it stick by the very same means the Surrealists employed so successfully—by lavishing upon its realization an extravagant taste for the decorative, the literary, and the psychological. There is an enormous amount of brilliant visual invention in this work, but it is used as a means rather than as an end in itself. For the end in view is never a form as such but an episode in the psychology of perception and expectation.

What we are offered, then, is very largely an exhibition of dazzling mythological objects, poetic metaphors given a physical and fantastic form, which, owing largely to the current of sadomasochist eroticism that informs them, is intended to shock, or at least discomfort, us a little. There are certainly images here to make us cringe a bit, especially in the series of so-called "Autopolaroids," the embellished self-portrait photographs in which the artist depicts himself in a kind of trance of autoerotic and fetishistic excitation. This is indeed a case of going "too far," which, as a matter of fact, is only about a quarter of the distance already traversed by certain writers of the period.

The "Autopolaroids" occupy the last gallery in the exhibition, making explicit what is more or less implicit in the entire show—that Mr. Samaras's work is, in some sense, an autobiography. In this respect, too, it reminds me of Dali, who, in *The Secret Life of Salvador Dali*, gave us years ago what might be called the subtext of Mr. Samaras's obsessions.

Is it, then, all out-of-date, something over and done with, another of the phony revivals we are constantly plagued with? I don't think so. Or no more so, anyway, than Surrealism itself, which, from the point

of view, say, of the Cubists, was itself out-of-date, a throwback to something earlier and obsolete, at the very moment of its birth. Mr. Samaras's work stands in relation to the abstract art of the fifties and sixties very much as the Surrealists stood in relation to Cubism and Neo-Plasticism. His art dwells on everything that abstract art was determined to leave out. It is rude, but also extremely amusing, to be reminded of how much that was; and it is highly instructive, too. A strictly Freudian analysis of recent art history, using Mr. Samaras's work as evidence, would have much to tell us about the sublimations of abstraction. What a Freudian analysis of the Samaras oeuvre would reveal, I shudder to think.

NOVEMBER 26, 1972

17. Richard Diebenkorn

The Richard Diebenkorn retrospective, which opened this week at the Whitney Museum of American Art, is one of the happiest artistic events to come our way in a long time. Diebenkorn is not only a marvelous painter—he is probably the only major painter now at work in this country who is still often denied that status by the historians who are supposed to keep track of such matters. In the latest history of twentieth-century art to come off the press—*Modern Art: From Post Impressionism to the Present*, by Sam Hunter and John Jacobus (Abrams)—there is no mention of his name. Which is pretty funny, considering some of the names that *are* mentioned. But this exhibition, which was organized by Robert T. Buck, Jr., and Linda L. Cathcart at the Albright-Knox Art Gallery in Buffalo and has already been seen there as well as in Cincinnati and Washington, will change all that. Henceforth it will be impossible to write seriously about the arts of our time—and not only in America—without taking Diebenkorn's achievement into account.

It is an achievement quite unlike that of any other painter of his

generation—which is odd, in a way, because he has been in so many respects very much a part of his generation, the generation that took its cues from the Abstract Expressionist movement and then attempted to go beyond it, or at least outside it, for an essential statement of its own. Diebenkorn, who was born in 1922 and painted his first important picture in 1943—the Hopperesque *Palo Alto Circle*, the earliest work included in the current show—has been first a representational painter, then an abstract (indeed, an Abstract Expressionist) painter, then a representational painter again, and now yet again—and triumphantly—an abstract painter. Yet these shifts do not strike us as arbitrary or willful or confused, and they certainly have had nothing to do with the shifting winds of fashion. They are signs of the essential freedom the artist has observed in pursuing a very independent course: a freedom that is inseparable from an alert awareness of the traditions that are conjoined in his work.

In this, as in so many other aspects of his art, Diebenkorn recalls us, above all, to the example of Matisse. Writing about Matisse some years ago, I had occasion to observe that even at the peak of his accomplishments in the 1908-11 period—the period of *The Dance* and the *Red Studio*—"he was constantly drawing back, reconsidering his ground, casting a covetous eye on the conventions he was so effectively dissolving, and repairing his links with a tradition he had already seriously, if not irrevocably, undermined." Something like this zigzag progress can now be observed in the Diebenkorn retrospective, and it is all the more exhilarating, of course, because it reaches a conclusion—for the moment, anyway—in the great series of "Ocean Park" paintings that are among the finest pictures anyone anywhere has produced in the last ten years.

An artist as conscious as Diebenkorn of the traditions in which he works is bound to absorb a great many influences, and a good many of these—among them, Hopper's, Motherwell's, de Kooning's, Bonnard's, and Matisse's, as well as that of the California milieu in which he matured as an artist—are spelled out for us with uncommon intelligence in the excellent catalogue that accompanies the show. But it is, again, the example of Matisse that asserts its priority in this development, and one of the absorbing interests of this exhibition lies in the way it documents an American—indeed, a Californian—painter's success in creating in the "Ocean Park" paintings a very personal equivalent of that Baudelairean ideal of *luxe* and *calme* that was so much a part of Matisse's vision. As for *volupté*, the third Baudelairean element that

Matisse brought to his work, it is to be found, in Diebenkorn, more in his figure drawings and in the small representational still-life paintings than in the "Ocean Park" pictures, which give us a vision of art and nature—for these are very much abstractions of a landscape—beyond the reach of a personal sensuality.

The Matisse connection is everywhere in evidence in Diebenkorn's later work, but it is made explicit in the two paintings he produced as the result of seeing the Matisses in Leningrad and Moscow in 1964— *Recollections of a Visit to Leningrad* (1965) and *Large Still Life* (1966). Diebenkorn was then still painting in a representational mode—the "Ocean Park" series was not to commence until 1967. But in the *Recollections* painting, particularly, we are given not only a brilliant and moving *hommage* to a beloved master but a bold and original picture that foreshadows in its structure and color and whole sensibility the decisive turn about to take place in Diebenkorn's own work. There is enough of Matisse in it to do justice to the artist who is being honored, and there is more than enough of Diebenkorn in it to establish the basis—the independence—of his own vision. It is, for this observer, the key painting in this retrospective in the way it illuminates everything that has preceded it and everything that follows.

Perhaps the best way to understand an artist like Diebenkorn is to reread T. S. Eliot's essay, "Tradition and the Individual Talent." In that essay, it will be recalled, Eliot was concerned to refute the "tendency to insist, when we praise a poet, upon those aspects of his work in which he least resembles anyone else." Against this tendency, which has always been the hallmark of avant-garde ideology, Eliot suggested that "if we approach a poet without this prejudice we shall find that not only the best, but the most individual parts of his work may be those in which the dead poets, his ancestors, assert their immortality most vigorously. And I do not mean the impressionable period of adolescence, but the period of full maturity." It was this understanding of tradition, Eliot believed, that made "a writer most acutely conscious of his place in time, of his own contemporaneity."

This, I think, is how we have come to understand Matisse's relation to the traditions that nourished him, and it is the way we ought to approach Diebenkorn—as an artist consciously working in a great tradition and adding something of significance to it. In a minor way, he has done it even in the least of his drawings, and in a major way he has done it with real grandeur in the bold panels of light, color, and space in the "Ocean Park" paintings. After some of the more highly touted

but overrated retrospectives we have seen this season—after Rauschenberg, and after Noland—what a pleasure and illumination it is to encounter the real thing!

JUNE 12, 1977

18. Chuck Close

Of certain forms of realist art it can truly be said that they are very largely the continuation of abstraction by other means. No matter how dominant the depictive function may seem to be in such art, and no matter how proficient it may be in sustaining a persuasive illusionism, its fundamental interests lie elsewhere—in a conception that gives to form, and the methods by which it is realized, a radical priority over the "subject" or image that is used in its creation.

Realist art of this persuasion is therefore not, in its innermost essence, "about" anything but itself. That, at any rate, is what many artists and writers on art are determined to have us believe. But as soon as this claim is made, the voice of common sense interposes itself with some bothersome questions. To what extent does this alleged innermost essence actually govern our experience of the art? Isn't there, after all, a lot more to our experience of art—realist art, especially—than it is possible for its supposed innermost essence to direct and control? Surely no art that traffics in elaborate strategies of depiction and that makes the whole question of illusionistic representation central to the way we perceive it can be expected to address the eye or to reside in the mind as an uncompromised mode of abstraction. The matter would seem to involve a certain ambiguity.

In the Chuck Close retrospective that has now come to the Whitney Museum of American Art, it is precisely upon this tension between the claims of abstraction and the claims of representation that our attention tends to focus. The representational element in this art is certainly blatant. Yet from the very outset, from that first black-and-white self-portrait of 1968, we are made to feel that this is realism of a peculiar

kind—realism that owes a great deal to nonrealist modes of pictorial construction.

The immense head and neck that nearly fill up the nine-foot-high picture space in this self-portrait are magnified many times life-size, and although we are spared nothing in the way of ugly depictive detail and it is all this overscale and unflinching detail, in fact, that gives the picture its peculiar aura—the image itself is oddly disinterested and impersonal, a portrait divorced from the processes of observation. Much that has been traditionally associated with the realist impulse— direct observation, for example, and the kind of subjective analysis that follows from it—has been deliberately jettisoned. What we are given is realist execution without any trace of realist observation or analysis.

What has intervened between the painter and his subject is, of course, the camera. "The photographic origin of each Close painting is never in doubt," writes Martin Friedman in the catalogue of this exhibition. "In fact, his paintings are portraits of *photographs* of his subjects—never of the subjects themselves." Far from bringing us closer to his subjects, this use of photography tends to sever our interest in them. For the photographs that are selected to serve as the painter's pictorial *données* are programmatically banal. They are designed to discourage curiosity, and they mostly succeed in doing so. "A certain blandness of expression characterizes the subjects in all the photographs he chooses," Mr. Friedman observes. "Nor is there an effort to select a flattering view. The chosen photograph is usually the opposite—a prosaic shot of a believable person who might have some distinctive feature but hardly a face that stands out in a crowd either for its beauty or grotesqueness. In short, an I.D. photograph."

In the painting that results in this use of a banal mug shot, what we are directed to take an interest in is not the subject, then, but the means that Mr. Close employs in rendering its replication on the picture surface and the range of pictorial variations he devises for its realization. There is an obvious parallel here with Jasper Johns's overscale paintings of maps, flags, and targets and with Andy Warhol's overscale paintings of the Campbell Soup can; and there is no question, I think, that the whole conception of Mr. Close's style owes much to the ethos as well as to the aesthetics of the Pop art movement. But something else enters into the conception of the style, too. Pop art wasn't the only movement that shaped the sensibility of the sixties. That decade, in which the rudiments of Mr. Close's style were formed, also saw the tri-

umph of Minimal art, and its precepts, too, have played a role in the development of his painting.

In order to enlarge his photographic images to the scale of a canvas or sheet of paper many times the size of the original mug shot, Mr. Close found it convenient to make use of a grid—the system of vertical and horizontal lines that painters have long employed for the faithful transfer of small images to larger surfaces. Traditionally it was the fate of the grid to be concealed in the finished painting, and in the first of his overscaled portraits Mr. Close followed this traditional practice, so effectively covering his tracks that no trace of the grid was to be found in the completed picture. With the advent of Minimal art, however, the grid was elevated to a new pictorial status. Suddenly there were painters on the scene whose pictures consisted of little more than overscale variations on the grid structure. They quickly came to constitute a distinct subgenre of abstract art.

The effect of all this on the way Mr. Close developed his paintings in the seventies was crucial. The grid ceased to be used merely as a concealed device. It came out of the closet, as it were, and was now made visible—and increasingly dominant—as a governing principle. Every image still retained its attachment to a photographic *donnée*—it remained unmistakably a portrait image—but its depictive constituents were now made to share a certain parity with the elements of abstraction that gave the image its essential form. The realist impulse was by no means occluded, but the scope of its authority was radically diminished. The tension between abstraction and representation was resolved, so far as painting is concerned, in favor of abstraction.

In many of the works that Mr. Close created on paper in the 1970s this tilt toward abstraction was made abundantly manifest, and in the very latest of the paintings that we see in the present exhibition—the large version of the portrait called *Stanley*, completed only a few weeks ago—it can be seen to have taken a very interesting new direction. This, in my opinion, is quite the best painting that Mr. Close has yet produced. In the earlier works on paper, it could already be observed that as soon as the grid form was made explicitly visible in his work, Mr. Close used it as a way of introducing a softer, more painterly texture into what had formerly been a hard, impersonal surface. In the large version of *Stanley* that we see in this show, this tendency toward a very painterly mode of abstraction—complete with a grid framework, and in this case abetted by a more audacious use of color—has flowered into something that could scarcely have been foreseen in the early

mug-shot pictures. *Stanley*, too, remains recognizably a portrait image, but as a painting it has more in common with certain modes of painterly abstraction—the recent revival of which may indeed have influenced its development—than with the earlier Photo-Realist portraits that otherwise dominate this very large exhibition.

The marriage of painting and photography that we see in the earlier works in this retrospective have now clearly been dissolved in an amicable divorce. If, in the picture of *Stanley*, the painterly impulse can clearly be seen to have achieved a new independence, the artist's photographic interests have likewise been given a separate existence in the oversize Polaroid portraits that fill the last gallery of the present exhibition. Like many divorces, this one looks at times to be more technical than absolute. Traces of its photographic origins may still be detected, even in the creamy, polychrome surface of *Stanley*; and there is no shortage of pictorial artifice in the Polaroid portraits, either. The latter seem, in fact, to owe more to the artist's own paintings than to the mug shots from which they were derived. But absolute or not, a divorce of some sort has now separated the photographic from the painterly—and thus the representational from the abstract—in Mr. Close's oeuvre, and it is this separation that gives to this exhibition its unexpected and somewhat dramatic denouement.

"Close Portraits," as this exhibition is called, was originally organized by Lisa Lyons at the Walker Art Center in Minneapolis, and its accompanying catalogue—which gives us the best introduction to Mr. Close's work that we have—was written by Miss Lyons and Mr. Friedman. Because the latest works in the exhibition were completed after the show opened last fall in Minneapolis, the exhibition that is now installed in the fourth floor galleries at the Whitney is somewhat larger and, because of *Stanley*, more interesting than it was in the original version.

APRIL 19, 1981

19. Pearlstein's Portraits

The art of the portrait, though nowadays unsanctioned by either a significant body of aesthetic ideas or a movement of like-minded artists who specialize in its production, nonetheless persists as a thriving artistic enterprise. There is certainly nothing in the theories that dominate contemporary art that calls for it, yet the portrait continues to be painted and admired. Evidently for both the artist and his subject and for the public, too, it answers to a need greater than that of the purely aesthetic—a need for something in art that is "beyond" art.

The portrait provides us with a record, a concrete impression, a datum of time and personality and manners, and it is as a record—at least in the short run—that we value it. We expect certain things from it—a reasonable likeness, a suggestion of character and bearing, the summary of an identity—and we are disappointed when these remain unclear in the portrait of someone we know or someone we have at least heard something about. (We tend to have a purely aesthetic interest only in portraits of people we have no other interest in.) There is, you might say, a "gossip" quotient in portraiture that demands to be satisfied. All of which is highly paradoxical, of course, for in the long run it is primarily as art that portraits survive or fail to survive.

Among the painters who now lavish some of their best energies on the portrait, Philip Pearlstein is probably the most accomplished. His new exhibition at the Frumkin Gallery, though it includes the latest in his protracted series of paintings of nude models in the studio, is largely devoted to portraits from the years 1972–75. These pictures are quite unlike anything else in contemporary portraiture I have seen. I think we have to go back to certain Eakins portraits to find something comparable in American painting.

No more than Eakins's do Mr. Pearlstein's portraits seem designed to be especially likable. They, too, seem more interested in "truth" than in art, though the kind of truth they seek is, of course, something that can be realized only through the most sustained artistry. They do not engage in idle flattery, indulge in theatrical effect, or search out what is obviously beautiful. They are at once "tough" and detached, vivid in characterization, but without any evident bias on behalf of their subjects. (They are without any evident hostility, either.) Only in the two portraits of the artist's daughters does one detect a softening in the attitude of Olympian neutrality that is otherwise so striking in Mr.

Pearlstein's portraits, and I wonder if that may be the reason why these portraits of his daughters seem to me the weakest paintings in the show.

There are a number of single portraits in this exhibition, and some of them have the added interest of being portraits of subjects already familiar to us in the portraits of other artists. Ada Katz, so often a figure in the paintings of her husband, Alex, is seen here in a cropped "head shot"—remarkably cold and clinical—that is distant indeed from the engaging image we are used to, and the painter Raphael Soyer is likewise given an identity more worldly and "realistic" than any to be found in his own self-portraits. As for the critic John Perreault, who was once the subject of a particularly bad picture by Alice Neel, he is here given a dignity and solidity that his writing, so avuncular and haphazard, will be hard pressed to live up to. Mr. Pearlstein has the habit—it is not a quality guaranteed to endear him to everyone—of giving his sitters some chastening "lessons" in their own personalities.

By far the most impressive of his recent pictures, however, are the portraits of married couples, of which there are six in the current exhibition. This is a subject nowadays more frequently explored in novels or the movies than in painting, and one can easily see why. It normally requires an accretion of incident and implication, changes of circumstance and costume and emotional temperature, to make its special revelations felt, and narrative art is obviously more suited to such an enterprise than portraiture. Yet Mr. Pearlstein succeeds to an amazing degree, and the result is an unforgettable "picture" of modern married life.

It is, in his version, a picture of uneasy alliances of unequal powers. The men in these portraits tend to be a little more anxious and a little more spoiled, a little softer, than the women; the women, a little harder, a little more petulant, and a little more determined, than the men. Mr. Pearlstein is not an avowedly "psychological" painter—the complaint has often been made, indeed, that his paintings of the nude deny the subject its requisite psychological dimension—but his portraits of married couples are scarred all over with disclosures of personality.

Interestingly, these disclosures seem more the result of the painter's method than of his sensibility. His aim is objectivity, and to achieve it he places his subjects in the "objective" light of the studio. This harsh studio light—the bright, cold, even, artificial light that is an essential coefficient of the painter's studied neutrality—creates an atmosphere of unrelieved interrogation. It is a light that renders his subjects de-

fenseless; it neutralizes their charm and even their beauty and under-scores their vulnerability. No one, not even a babe in arms unmarked by the ravages of time, could possibly emerge from close and prolonged observation in this light as anything but a casualty of experience, and no one does.

The wonder, you might think, is that so many people willingly sub-mit to an interrogation guaranteed to place them—in more than one sense—in a harsh light. Similar questions used to be asked about Eakins's portraits. But time has only vindicated Eakins's taste for the "truth"; it has also, owing to such vindications, drastically altered the way portraiture is now perceived and valued. Enlightened taste is now deeply suspicious of the kind of facile flattery that was once the norm in the art of the portrait. (And that is still the norm in the general run of commercial portrait painting. See, as a particularly laughable exam-ple, the portrait of Robert Lehman that hangs at the entrance to the Lehman Collection of the Metropolitan Museum.) It is not that we are less vain than people used to be, but that our vanity assumes other forms; it is now complicated by this imperative need, which everything in our culture encourages, to be fully revealed whether or not the reve-lations in question are particularly happy ones. We are, in short, less interested in being flattered than in being authenticated, and this has inevitably altered the "psychology" as well as the aesthetics of the por-trait.

The great strength of Mr. Pearlstein's portraits—and the basis, I think, of their peculiar appeal—is precisely this remorseless articula-tion of the authentic. He has succeeded in eliminating from the por-trait all those ameliorating fictions we no longer believe in. It is a brave and original accomplishment that places the portrait at the center of our cultural life—a place it had not occupied for a long, long time.

FEBRUARY 15, 1976

20. Kitaj: The Vision of an Expatriate

Few artistic careers of the past two decades have been more distinctive than that of the American expatriate painter R. B. Kitaj, whose work is currently the subject of a retrospective exhibition at the Hirshhorn Museum. He was born Ronald Brooks in Cleveland, Ohio, in 1932, acquired the name Kitaj when his mother remarried in 1941, and spent his high-school years in Troy, New York. At the age of eighteen he went to sea, and for four years divided his time between traveling the world as a merchant seaman and studying art—first at the Cooper Union in New York under Sydney Delevante and then at the Academy in Vienna under Albert Paris von Gütersloh and Fritz Wotruba. After two years in the American army, spent mostly in France, he went to Oxford on the G.I. Bill, and then in 1960 he began two years of study at the Royal College of Art. It was at the Royal College in the early sixties that he became something of a celebrity in the London art world. David Hockney, among others, has testified to the influence that Kitaj exerted on his fellow students.

When the painter's first solo exhibition took place at the Marlborough New London Gallery in 1968—it was called "R. B. Kitaj: Pictures with Commentary, Pictures without Commentary"—he was acclaimed by the critics as a new master. The Tate Gallery promptly bought a picture called *Isaac Babel Riding with Budyonny.* Not since the arrival of T. S. Eliot, it was said, had London been favored with the presence of so important an American artist. "It is not unusual to begin a discussion of R. B. Kitaj's work with a mention of Eliot's; Kitaj himself has done so," writes John Ashbery in the catalogue of the Hirshhorn show, and Ashbery also follows established custom in invoking the additional parallels of Whistler and Ezra Pound. Except for occasional sojourns here—Kitaj has taught at Berkeley, U.C.L.A., and Dartmouth, and recently spent a year in New York—he has remained an expatriate, and now divides his time between residences in London and on the Catalan coast of Spain.

The work that Kitaj has produced since the late fifties—the Hirshhorn exhibition is drawn from the years 1958–80—is quite as distinctive as the career it adorns. What most distinguishes this work and sets it apart from that of his immediate contemporaries is its unabashed attempt to create a "major" pictorial style based on a combination of drawing and literature. Drawing—life drawing of a very tra-

ditional sort—is certainly an essential element in Kitaj's art, but so is the unabated stream of classy literary and historical reference that lends to his more elaborate productions a special aura—a suggestion that something deep and significant is being confided to us about our wayward culture and our common fate.

What that something is, however, we never quite discover in these works. The mysteries they traffic in are well kept. The symbols employed to evoke them remain hermetic, and the dramatis personae that appear in phantom roles in the pictures, even when identifiable (as they occasionally are), bring little in the way of definition or illumination.

Will we ever discover the identity of the girl with the yellow pigtails in the painting called *Walter Lippmann*, for example? Does it matter if we do or not? Is she more or less important than the multicolored, hard-edged scaffolding that gives the picture its rudimentary structure? And why is the picture called *Walter Lippmann*, anyway? Lippmann's face, partially concealed, appears in the lower right-hand portion of the picture, and his name is written on its surface, but he hardly dominates the very busy, montage-like composition. Perhaps we shall have the answers when the Phaidon Press produces Lawrence Gowing's forthcoming monograph on the artist. But will the answers make any difference? I frankly doubt it.

Walter Lippmann (1966) belongs to the series of pictures that Joe Shannon, the organizer of the exhibition, describes as having "epic" subjects. Others similar in their ambition and atmosphere are *The Ohio Gang* (1964), *The Autumn of Central Paris (After Walter Benjamin)* (1972–74), and *If Not, Not* (1975–76). If you detect a reference to Brecht's notion of "epic theater" in Shannon's description, you are probably right. As he notes in his catalogue commentary on *The Ohio Gang*: "We can almost hear strains of *The Threepenny Opera*." We sure can. Never mind, by the way, that Brecht's attempt at "epic theater" postdates *The Threepenny Opera*. The moral ambiance of Kitaj's "epic" paintings— and a good many of the drawings, too—does indeed resemble that of the early Brecht, but it is even closer in feeling to *In the Jungle of Cities* and the poems in *Manual of Piety* than to *Threepenny*.

To establish this moral parallel between the decadence of Germany in the Weimar period and that of our own civilization—which I take to be the essential purpose of the "epic" paintings—Kitaj employs a kind of pastiche of George Grosz's caricature drawing, combining this at times with what appear to be memories of old movie stills. The result is

a very dolorous, very literary style that is unlike anyone else's, to be sure, and it proved to be an inspired recipe for success in the special atmosphere of the 1960s.

Even more than Brecht's or Grosz's, however, the presiding spirit in these "epic" paintings is clearly that of Eliot in *The Waste Land* and Pound in *The Cantos*. It was his ambition, which he has never been shy about voicing, to save the art of painting from what were seen to be the timidities and trivialities of abstraction and make it a vehicle for a visionary art akin to Eliot's and Pound's that made Kitaj a kind of culture hero in the London art world of the sixties. Everything that Abstract Expressionism had denied to painting—explicit allusions to literature, history, politics, sex, and scenarios of social criticism—Kitaj grandly offered to restore, and in the face of such glittering promises it hardly seemed to matter that the painting produced in the service of this program never quite measured up to its announced objectives.

For Kitaj's "epic" style is everywhere afflicted by its hapless dependence on a pictorial syntax that owes more to the bright clichés of commercial graphic design—especially the kind that draws upon the language of Constructivist painting and Surrealist montage for its characteristic formats—than to the formal strategies of *The Waste Land*. The only thing that really lives in his painting—the only thing that articulates an emotion that is not shopworn and secondhand—is his drawing.

It is for this reason that it is in the drawings, and in the paintings that are essentially drawings of subjects he deeply cares about—the pictures that haven't been mortgaged to some portentous historical scenario and thus sidetracked into "literature"—that we are given a glimpse of a vital talent. One of the best of these "straight" pictures is the double portrait of the poets Robert Creeley and Robert Duncan called *A Visit to London* (1977). Fortunately, it is to drawing of this kind and to pastels of the same persuasion that the artist has lately devoted much of his energy—if we may judge from Joe Shannon's selection of the recent work—and so the exhibition closes on a rather more appealing note than the one that is sounded throughout much of the earlier work.

What we find in that earlier work—the oeuvre that won for Kitaj his amazing international acclaim—are the unexamined cultural pieties of an American intellectual of the *Partisan Review* period given a very facile graphic form. (He once did a series of prints—silkscreen, I believe—that consisted of nothing but oversized reproductions of old covers of *Partisan Review* from, if I remember correctly, the forties

and fifties.) He is too young to have known that world at first-hand, of course, but all its symbols and shibboleths—and most especially its fond illusions about the marriage of literary modernism and political radicalism that was going to usher in a new and happy life for our civilization—are lovingly evoked in the "epic" phase of his work. Distance, I suppose, lent enchantment to what turned out, in reality, to be a scene of intellectual disaster. Perhaps this is what people mean when they speak of the "mythic" element in Kitaj's work.

Still, certain illusions die hard, and now that there is an eager public on this side of the Atlantic for painting that spurns abstraction, addresses itself to "big" issues, and has an air of radical utterance about it, Kitaj's "epic" painting is likely to find a new generation of admirers. It is all a case, I suppose, of those who forget the past being condemned to repeat it.

SEPTEMBER 27, 1981

21. Maurice Sendak

It is one of the oddities of our cultural life that the Niagara of critical commentary, which nowadays pours forth from every quarter, shedding its mighty waters on everything from trashy movies to nitwit television shows to moldering old photo albums, can usually be found to evaporate somewhere in the vicinity of the books we urge upon children for their edification and delight.

There are, to be sure, the official custodians of children's books, who monitor social and moral attitudes and hand out prizes, and there are reviewers who keep up with the new titles. But where are the critics? And where is the cultural historian who can speak with authority about the place occupied by this vast branch of literature and art in the minds of the most receptive and most vulnerable segment of the population? If only because it is in children's books that many people in our society have their first—and who knows? maybe their last—important and really inward experience of storytelling, poetry, and pictorial art,

one would think this would be a subject likely to engage a great many serious minds. Yet just the opposite is true. Children's books are an art—and an industry—unattended, for the most part, by critical curiosity or cultural analysis.

Given this paucity of critical literature, Selma G. Lanes's new book on Maurice Sendak is something of an event, for it brings into happy conjunction the best writer on the subject and the work of the most accomplished writer-illustrator in the field. In *The Art of Maurice Sendak*, Mrs. Lanes has written a very intelligent and appealing book. She calls it a "picture biography"—an awkward but not inaccurate term to describe a study that combines the methods of art history with the conventions of literary biography. Its lavish format and handsome illustrations give the work the appearance of an art book, which of course it is. In this respect, it takes its place beside the long and distinguished list of titles that Abrams has devoted to the work of contemporary painters and sculptors. Yet its very readable text is closer in style and spirit to Margaret Lane's *The Tale of Beatrix Potter*, the only work I know with which it may be usefully compared.

The biographical material, though vivid with many personal and family details, tells a now familiar, even archetypal story—the story of a gifted youngster born of immigrant Jewish parents in the provinces, in this case the backwaters of Brooklyn, who yearns to escape to the enchanted island of Manhattan, and ultimately achieves fame and fortune there through the requisite combination of luck, talent, and ambition. There is the inevitable Jewish mother, and the succession of surrogate mothers and fathers who ease and assist the young antihero on the rocky course to success. The story is not so different from the one told in Alfred Kazin's autobiographical *A Walker in the City* and the many novels about the lives of Jews in America that followed in its wake.

It is a story that combines the elements of nostalgia, anxiety, and rebellion in about equal degrees. What gives this often-told tale a special interest in this case, of course, is the fact that Mr. Sendak has made these familiar materials the basis of a highly original mode of literary and pictorial fantasy. One of the best things about Mrs. Lanes's book is the way she uses this biographical background to illuminate the sources and sometimes even the spirit of Mr. Sendak's major works. Biographical criticism is a sometimes treacherous enterprise, and Mrs. Lanes does not always escape its pitfalls, but by and large she brings to it the necessary delicacy.

Still, there are problems for any biographer undertaking to write the life of a living author—problems of a sort that Margaret Lane was never obliged to face in writing *The Tale of Beatrix Potter*—and Mrs. Lanes cannot be said to have entirely surmounted them. Inevitably, the version of the life given in this book is the more or less "official" one sanctioned by its subject, who appears to have cooperated with Mrs. Lanes in supplying a great deal of information otherwise unobtainable. Such cooperation is certain to involve at least some degree of control. Much is therefore left unsaid, and the result is often a little too smooth, too utterly painless in fact, to be entirely believable.

The profound role played by psychoanalysis in both the life and the work, for example, is mentioned but not really explored. This is important, for the vision of childhood experience that is conjured up in Mr. Sendak's stories and drawings is deeply indebted to the psychoanalytical mode. Yet the curtain is drawn on any psychoanalytical revelations. How could it be otherwise without violating the privacy that the subject has every right to maintain? But this understandable reticence leaves a certain blur in the text. For how can the imagination that produced *Kenny's Window*, *Where the Wild Things Are*, *In the Night Kitchen*, and the Grimm illustrations be penetrated without a frank examination of their psychoanalytical origins?

The great appeal of Mr. Sendak's work lies precisely in his success in transforming this psychoanalytical vision of experience into fictional fantasies that have something of the quality and mystery of traditional folktales and fairy stories. His audacity in opening up the traditional children's story to the terrors, including the sexual terrors, that are disclosed to us in psychotherapy is the very mark of his originality. A criticism that is evasive on this score, even if prompted by the most generous of motives, cannot in the end be anything but incomplete.

When it comes to dealing with the evolution of Mr. Sendak's illustrational styles, however, Mrs. Lanes is generally on much firmer ground. Another of the many audacities to be found in his work is the way he has moved from emulating traditional models (Blake, Rowlandson, the Victorians, et al.) to using the materials of popular culture, and about this aspect of the work Mrs. Lanes is superb. Anyone who has ever wondered about (and been delighted by) the appearance of Oliver Hardy in *In the Night Kitchen*, or about Mr. Sendak's use of comic-book styles, Busby Berkeley movies, Art Deco design, and sundry other elements of popular culture, will find a definitive account of these and other such matters in this book.

Where *The Art of Maurice Sendak* again falls short, however, is in relating these important elements of style to the cultural history of their time. Something might have been said, for example, about the way Mr. Sendak's use of comic-book styles coincided with the heyday of the Pop art movement. And it might have been illuminating to compare those skyscraper-scale jars and milk bottles in *In the Night Kitchen* to similar comic devices initiated in the drawings of Saul Steinberg many years earlier. Criticism thrives on apt comparison, and there is not enough of it in this book.

Missing, too, is any attempt to place Mr. Sendak's work in the literary history of his time. In some important respects, the writer he often seems closest to is not any other author of children's books—far from it!—but Philip Roth. Isn't *In the Night Kitchen* the *Portnoy's Complaint* of children's books? Both the comedy and the anxiety are very similar, and so is their attitude toward family authority and sexual release. Both books belong to the cultural history of the sexual revolution. And a comparison with Mr. Roth might have suggested something else, too—the place occupied by Mr. Sendak's work in the recent development of American-Jewish writing.

As the first serious and comprehensive account of Maurice Sendak as writer and artist, Mrs. Lanes's book is pioneer work, and none of the criticisms made here is meant to diminish its importance, which is considerable. But it is a measure of the state of criticism in this field that even its best writer has been satisfied to settle for such a narrow view of the subject at hand. A writer as popular and as accomplished as Mr. Sendak deserves something more.

NOVEMBER 9, 1980

22. David Hockney

Few contemporary painting exhibitions are more entertaining than David Hockney's. What fun they are to see! They give us a world that can be instantly apprehended and enjoyed. The figures in them are obviously drawn from firsthand experience. The objects too—a vase of

red tulips, say, or a patterned bedspread or a modern folding chair—have a vivid up-to-date feeling. Even the light in them has the kind of turned-up synthetic clarity we recognize as the light of our time and no other—a light compounded, in about equal parts, of psychological candor and improved technology. And the painting itself is immensely clever and accomplished, glossy in fact, and its high technical finish carries an amusing undercurrent of comedy and wit.

Mr. Hockney, just turned forty, is showing his new work—paintings, drawings, photographs, and a suite of etchings based on Wallace Stevens's poem "The Man with the Blue Guitar"—at the André Emmerich Gallery. He is now one of the most successful and acclaimed artists of his generation, not only in his native England, but also wherever today's Western art finds a ready and eager public. He is versatile as well as prolific, and has lately been occupied with set designs for Glyndebourne opera productions—Stravinsky's *The Rake's Progress* in 1975, Mozart's *The Magic Flute* for 1978.

Inevitably, then, his new exhibition is something of an event. But what kind of event is it? The new pictures—mostly portraits and self-portraits—are as clever as anything Mr. Hockney has ever done, and there are things in the painting that are, if anything, even finer than what he has attempted in the past. The sheer technical virtuosity that has gone into certain passages of *Looking at Pictures on a Screen* and *Model with Unfinished Self-Portrait* is certainly impressive, and will win him many new admirers. His gift for a certain mode of pictorial theatricality—for setting a scene and effectively placing the actors and the props within it—is also very appealing. The people who come to see these pictures obviously take a great delight in them.

Why, then, do I find them—well, superficial and even reactionary? That their style, with its meticulously plotted illusionism, repudiates the rigors of modernism does not in itself bother me. Modernism, after all, is now an academic convention, and its doctrinaire sectarians find it difficult to be anything but ridiculous. No, it is not because Mr. Hockney's art repudiates this convention. It is rather because of the degree to which he still clings to it, and lives off it, that I find something hollow in his painting, despite its obvious appeals.

What we find in this painting—and this, I think, is finally the basis of its appeal—is a kind of nineteenth-century Salon art refurbished from the stockroom of modernism. This, of course, is no small accomplishment in itself, but it ought to be recognized for what it is and not mistaken for something it is not. Mr. Hockney's art, like the success it enjoys, marks the triumphant return of what might be called bourgeois

art, only in his case it is bourgeois art compounded out of the very materials that once challenged and offended bourgeois taste. This is indeed the true comedy of it, if we have the wit to see it.

The "Blue Guitar" etchings give us an interesting perspective on Mr. Hockney's art as a whole. They are said to be "inspired by Wallace Stevens who was inspired by Pablo Picasso," and there is a good deal of Picasso parody in them. This, too, is handled with much cleverness and invention; yet the more clever and entertaining the work becomes, the farther it removes us from the spirit and substance of Stevens's great poem. In the end, Mr. Hockney is too much of a lightweight to do justice to Stevens's imagination.

He is more successful in mocking the kind of public solemnity that now surrounds Picasso's art, but this, too, has the effect of removing us from Stevens's universe of discourse.

Mr. Hockney's own gifts are of a more sociable sort than Stevens's—or indeed, Picasso's—ever were. So long as he sticks to comedies of manners, and the comedy of taste that is their corollary, he can be brilliant. But Wallace Stevens reminds us that there is a spiritual quest at the heart of modernism that is alien to the very nature of Mr. Hockney's art. In choosing to illustrate "The Man with the Blue Guitar," Mr. Hockney has inadvertently defined the boundaries of his own imagination.

NOVEMBER 4, 1977

23. The Social Realism of Jack Beal

With the completion, three years ago, of the mammoth, four-panel mural painting called *The History of Labor in America*—commissioned by the General Services Administration for the Department of Labor Building in Washington—Jack Beal established himself as the most important Social Realist to have emerged in American painting since the 1930s. Given the generally low esteem—a disfavor bordering at times on contempt—that the Social Realist impulse has suffered in recent

decades, this is not a position likely to be a cause of envy among the vast majority of Mr. Beal's artist contemporaries. Not yet, anyway. Modernism may be widely felt to have run its course nowadays, but the painters who regard the conventions of Social Realism as a viable artistic alternative are still very few in number. Even among realists, the appeal of Social Realism remains very much a minority taste. And among the many painters who continue to work within the modernist tradition, Social Realism is pretty much what it has always been to artists of this persuasion—a throwback to something benighted and discredited.

This is clearly not the way Mr. Beal regards the matter. Sheer competence isn't everything in art—it can so easily be misplaced—but it is not something to be despised, either, and Mr. Beal obviously brings great reserves of it to the task he has set for himself. The *History of Labor* mural was carried through in a spirit of triumphant affirmation and audacity. Everything that its enemies most dislike in the Social Realist style—its corny subject matter, its flagrant use of illustration and anecdote, even its tendency to propagandize on behalf of the sunniest liberal platitudes—Mr. Beal embraced with an unashamed energy and appetite. And if the technical mastery necessary to the realization of this mural could not be said to be unfailing—it was quite uneven in this respect—it was certainly sufficient to keep the project from floundering.

The *History of Labor* mural might not, then, have constituted quite the turning point in contemporary painting that Mr. Beal envisioned, but it nonetheless succeeded in restoring the Social Realist option to the agenda of American painting. Considering the obstacles (both spiritual and technical) to be overcome, this was no small feat in itself. Whether this develops into a movement of some consequence or remains what it now is—an ambitious personal initiative—only the future can tell. Certainly the populist social sentiment necessary to such a development is there to be exploited, but the aversion to modernism—another prerequisite to the success of such a movement—may not really be deep enough to support it.

Meanwhile, in his current exhibition at the Allan Frumkin Gallery, Mr. Beal is showing two major paintings completed since the *History of Labor* mural—*The Farm* (1979) and *Harvest* (1979-80)—together with some preparatory studies. Though smaller than the *Labor* panels, these two are large paintings—*The Farm* measures seven by eight feet, and *Harvest* is eight feet square. Once again the dominant theme is—as it

was in the mural—labor seen in its relation to the natural environment. Only now this theme, which in the mural was transformed into a series of historical tableaux, is treated in a more openly autobiographical manner.

The setting is Mr. Beal's farm at Oneonta in upstate New York. The time is summer, the foliage is verdent, and the sky almost as unclouded as the sky in a picture postcard. The whole scene is, indeed, an environmentalist's dream—this is surely the cleanest air anyone has painted since Winslow Homer quit the coast of Maine. The action is likewise unremittingly wholesome. In each of these pictures we observe the residents of the farm at their normal round of outdoor work. In *The Farm* they are busy painting and drawing directly from nature, which in this case consists of a pigpen in rustic surroundings. In *Harvest* they are gathering in the vegetables. Nourishment for the soul and nourishment for the body in a happy harmony.

Healthy, attractive bodies and smiling faces serve as a perfect complement to the warmth of the dazzling sunlight that bathes the scene. In this pastoral idyll we are surely meant to draw a parallel, too, between the labor of art and the labor of agriculture—between, that is, the respective ways in which they are dependent upon nature and exalt it. In this sense, at least, the new paintings are as allegorical as anything to be found in the *History of Labor* mural, only now the allegory is more directly addressed to the life of art. We are invited to find a special virtue in art derived from the soil, so to speak—art that is close to nature in this special, rather literal sense. *The Farm* is thus a very moralistic painting about painting—Mr. Beal's "answer," perhaps, to the kind of art about art that his own art rejects—and *Harvest* shares in the same sentiment.

Well, it is not the purpose of such painting to be subtle, and Mr. Beal's isn't. Clearly, he has set out to celebrate a way of life and a way of making art—and he has never made any secret of his ambition to make that art as accessible as possible to a very wide public. I see nothing wrong in this ambition. There is even something refreshing in its attempt to reach beyond the jaded tastes of professional art circles in order to establish contact with a public more interested in art about life than in art about art. Surely we've had enough art about art—and enough of the criticism, too, that tells us that art is never really about anything but art—to last us a very long time.

Why, then, do I find myself more than a little divided in my response to these paintings? Their details are often wonderful, and Mr.

Beal grows more and more skillful in his ability to render them. Yet they seldom add up to a convincing whole for me. One admires them as isolated feats of representation, but as elements in a painting they tend to be still-born. I love painting that abounds in visual incident, and Mr. Beal supplies it with an abundance that rivals the richness of his crops. But it avails not; the painting, as painting, does not live for me. To my eye, there is more emotion in the little pastel, called *Cloud Study I,* than in the whole of *The Farm* and of *Harvest.*

Then, too, there is the paradox of Mr. Beal's subject matter. Even down on the farm, while the pigs fatten and the tomatoes ripen and God—or at least the weather—smiles upon the fecundity of nature, we are treated to an allegory on the life of art. To judge from the evidence of *The Farm,* the spiritual distance separating Oneonta from Manhattan isn't really as great as we are invited to believe. Even in this bucolic retreat, what emerges—after all—is still painting about painting.

Finally, there is the fallacy endemic (it seems) to the whole Social Realist enterprise—the fallacy of idealization. Everything in Mr. Beal's paintings, from the slenderest blade of grass and the tiniest eye of a potato to the radiant sky overhead, is given an idealized clarity and grandeur that is very much at odds with our experience of nature. The great failing of Social Realist painting—Mr. Beal's included—is its compulsion to elevate every object of observation to the realm of romance. Nature is turned into a fictional paradise. In the end it is simply too corny and too false to be believable. Who could ever guess, from Mr. Beal's paintings, that farming—and for that matter, painting—is often very dirty work? But in the ideal world of the Social Realist, there is no dirty work. Everything remains in a pristine state, and the pigs and potatoes are as clean and unblemished as the light in the sky.

It was the growing sense of the falseness of this idealized vision that earned our Social Realists a certain amount of discredit and derision the last time around, and I cannot see that Mr. Beal's new foray into this realm—despite its obvious strengths and audacities—entirely avoids the old pitfalls.

FEBRUARY 10, 1980

24. Milet Andrejevic

For anyone attempting to chart the course of contemporary realism, the paintings of Milet Andrejevic constitute something of a conundrum. He is clearly one of the most gifted painters of the contemporary realist school. He brings to his art an unusual sense of refinement—an eye calmly and exquisitely attuned to pictorial nuance. His best pictures achieve a purity of tone and a gravity of feeling unusual in the realist painting of any period and very different, certainly, from some of the more clamorous realist styles of our own day. His strongest affinities are obviously with painters of an earlier age, and while his subject matter is unquestionably contemporary—consisting, for the most part, of groups of figures disporting themselves in New York's Central Park—his attitude toward it is not. This, indeed, is the conundrum.

Mr. Andrejevic approaches his material as if from a great distance in time. His figures may be attired in running shoes, T-shirts, and other items of contemporary apparel, and the skyline often looming on the horizon of these outdoor pictures is most certainly the New York of our time. Yet the feeling conferred upon every scene is deliberately remote from the present. The atmosphere is Arcadian and mythic, and the attitude is allegorical. Figures are singularly lacking in personality—for personality is too earthbound a thing for this style—and the terrain they occupy is denuded of anything resembling history. They represent, rather, the abstractions of childhood, youth, and age—stages in the timeless cycle of life—rather than figures specifically of our time. This gives even their contemporary costumes an allegorical dimension, and thus removes them from the realm of earthly contingency. We are recalled to the world of antique friezes and to that modern exemplar of the frieze style, Puvis de Chavannes, which removes this painting from anything that's customarily associated with the realist aesthetic.

Puvis, whose dates are 1824–98 and whose work has lately been the subject of a major revival on both sides of the Atlantic, is surely the guiding light of Mr. Andrejevic's painting, and it says something about the latter's originality that he has chosen so difficult a model to follow. Puvis was once one of the most admired of modern painters, virtually a cult figure for Gauguin and Van Gogh and a considerable influence on the work of artists as different as Maurice Prendergast—whose own

paintings of Central Park invite comparison with Mr. Andrejevic's—and the young Picasso. No less a judge than Leo Stein placed Puvis's work beside that of Cézanne in the pantheon of modern masters.

In the 1920s, however, under the impact of more radical modernist styles, Puvis's influence waned, and his reputation suffered the eclipse from which it did not begin to recover until the seventies. (For some mysterious reason, the recovery has been more apparent in Canada and in France, where important exhibitions of Puvis's work were organized in the seventies, than in the United States. But his art was finally restored to something like its rightful place in this country last year when it was included in the installation of the André Meyer Galleries at the Met—nowadays the most accessible place for us to secure a glimpse of Puvis's work.) I doubt if Mr. Andrejevic is the only living painter to find inspiration in Puvis, but he has made a more inspired use of it than anyone else.

This will be apparent, I think, to anyone who studies Mr. Andrejevic's new exhibition at the Robert Schoelkopf Gallery and brings to it some sense of the tradition in which he has deliberatley chosen to work. There are nineteen paintings in this exhibition, most of them new and all produced since 1976. Two are still lifes, and a few others are Central Park landscapes without figures, but the bulk of the paintings here belong to the quasi-allegorical mode upon which Mr. Andrejevic has lavished his principal energies.

As some of the titles of these paintings clearly indicate, a sense of the mythic—and of the perspective on contemporary experience that is afforded us by the mythic mode—is absolutely central to the way Mr. Andrejevic views his material. Titles like *Hope* and *The Three Ages of Man* are straight out of Puvis, and others—*Diana and Acteon* and *West Side View with Fall of Icarus*—make explicit what is elsewhere only implied. In a pastoral idyll called *Scene in the Park* (1976), for example, we again glimpse the figure of Icarus falling earthward—a strange but poetic supernatural rupture in an otherwise peaceful and naturalistic tableau of open-air festivity.

Mr. Andrejevic scarcely needs either the titles or even the falling figure of Icarus, however, to establish the allegorical ambiance of his painting. The painting itself, its very mood and demeanor, is sufficient for the purpose. Its veil of gray-green light, with occasional glints of a similarly valued pink, unifies each surface with a visual quality—at once delicate and profound—that addresses the eye as something unearthly, a vision purified of the accidents of experience and transmuted

into pure poetry. Everything here is muted, modulated into the texture of a soft-focus reverie, and nothing is allowed to violate the uncanny calm—the preternatural silence—that gives the work the feeling of a beautifully composed daydream.

Yet this allegorical dreamscape is entirely recognizable as, in some sense, *our* Central Park—a somewhat idealized park of the mind, to be sure, but one that is nonetheless derived, however distantly, from the observable data of experience. It is anchored in something concrete and contemporary. Surprisingly, this double vision never jars, never looks preposterous or escapist or willful. On the contrary, it has a spiritual quality that is very affecting. It defines an emotion that is real, and powerful. And it recalls us to an idea of realism that is more complex, at least in its conception, than most realists can nowadays bring themselves to entertain.

We are more familiar with this conception of realism in literature than in painting. Writers as diverse in style and point of view as James Joyce (in *Ulysses*) and John Updike (in *The Centaur*) have employed it, endowing every concrete detail of their narratives with a mythical dimension that is never allowed to divert attention from the essential naturalism of the fictional surface. This is a conception of realism that is fundamentally modernist in spirit, and yet never shirks the traditional obligation of realism to give us a persuasive account of the concrete world "out there."

Something like this attempt to effect a fusion of the mythical and the real—the timeless and the timebound—is what gives to Mr. Andrejevic's paintings their special quality. In Puvis's otherworldly vision he discovered an effective instrument for joining the concrete and the archetypal in a shimmering, seamless image; and he has made wonderful use of it by shrewdly shifting the focus away from Puvis's fictional antiquity and rooting it firmly in a world we can acknowledge as our own.

If there is a fault to be found in the result, it has more to do with the scale of the work than with its quality or execution. The vision in Mr. Andrejevic's work is large—this, too, owes something to Puvis, who was a master muralist—but the paintings themselves are not. The logic of the work calls for something on the scale of a public mural—in a library, perhaps, since this is painting that calls for an atmosphere of silence—for only on that scale can its implied ambition be fully realized. But this, of course, is not something that the painter himself is ever in a position to control. Someday, perhaps, someone in a position

to effect commissions of that sort will have the wit to recognize that Mr. Andrejevic is a natural for such a large-scale undertaking. Meanwhile, on the smaller scale to which his painting is now confined, he remains a remarkable artist who can already boast of a distinctive achievement.

JANUARY 11, 1981

25. Roy Lichtenstein in the Seventies

The American artist Roy Lichtenstein earned immense international renown in the early days of the Pop art movement, in the 1960s, as the painter who specialized in turning comic-strip cartoons into paintings. But time passes, perspectives alter, and artists develop in unforeseen ways. In the 1970s, Mr. Lichtenstein set about the task of turning images of paintings—some very famous paintings by Picasso, Matisse, Léger and sundry other eminences of the modern movement—into cartoons. They, too, have quickly won a place among the classics of contemporary art, and a large exhibition devoted to this work of the seventies has now come to the Whitney Museum of American Art.

Organized by Jack Cowart, curator of nineteenth-century and twentieth-century art at the St. Louis Art Museum, where the exhibition was first seen last spring, "Roy Lichtenstein 1970–1980" consists of fifty paintings, nine sculptures, and fifty-three drawings. Many of the paintings are large, their forms easily legible at a distance, their colors—mostly primaries framed in bold black outlines—bright and cheerful. The whole atmosphere they create when brought together in this quantity is light, bouncy, high-spirited, and good-humored. It is less the kind of atmosphere we associate with the higher altitudes of the fine arts than, say, with that of a very slick and brassy Broadway musical. If Broadway were ever to mount a musical based on the masterworks of modern art—horrible thought!—its design would probably look a lot like this exhibition.

For most, but by no means all, of the paintings in the show are based on the kind of reproductions of modern masterworks that we

commonly encounter in books, postcards, exhibition catalogues, etc. From these mechanically printed images of familiar works of art, Mr. Lichtenstein has distilled, through a process of simplication and magnification, the forms and formats of his own paintings. What exist as integrated shapes, lines, positive and negative spaces, patches of color, fragments of images, even individual brushstrokes in the "originals"—that is, in the printed reproductions the artist is making use of—are torn from their contexts, reduced to an elementary design vocabulary, exaggerated in scale, and made to serve as the bases of new compositions that echo the original sources, and indeed parody them, without really repeating their pictorial strategies.

The result is not exactly art-about-art, however, though art is one of the subjects these paintings are about. But it is not so much art itself as the kind of counterfeit experience its reproduction is made to serve that is the central focus in Mr. Lichtenstein's paintings of the 1970s. It is assumed—correctly, I think—that the mechanical reproduction of art always produces, in one degree or another, a visual travesty of the original because of the radical changes in color, scale, texture, touch, material, etc., that are introduced into the fabricated image. Far from despising these travesties, Mr. Lichtenstein cheerfully accepts them and at times seems positively to adore them. He certainly emulates them in piling his own distortions on the ample distortions already there in the "originals." It is, in any case, upon the visual fictions to be found in the reproductions that he constructs his own pictorial imagery. In this respect, certainly, his "modern art" paintings continue the course begun in his early cartoon-strip paintings, for they, too, attempt to make significant art out of debased visual materials.

What we have, then, in Mr. Lichtenstein's paintings of the 1970s is art about the modern vulgarization of art, about the use that has been made of it in commerce, education, and the communications media since it acquired its present popularity—art, in other words, about certain aspects of art-world culture and popular culture. This is not an art of satire or social criticism, however—it does not ridicule or question the objects it focuses on. If anything, it takes a rather grateful and affectionate attitude toward them.

From a pictorial style so heavily indebted to these mechanical counterfeits of modern art, which it simulates with an evident empathetic relish, we cannot expect much in the way of nuance, delicacy, poetry, or personal expression—and we certainly don't find them in his work. All of Mr. Lichtenstein's paintings have a vivid, graphic, posterlike

power; and some of them positively assault the eye with their broad visual effects. Some of them are quite amusing, too. But as painting, it is pretty coarse stuff. Physically, the surfaces of the paintings offer little pleasure to the eye. The black outlines tend to be greasy and shiny, while the areas of color they contain are brittle and lifeless. Clearly, the paint has been applied with an attitude of indifference. Wherever one edge meets another, there is something ugly to be observed in the execution. This is definitely not an art in which God is in the details. It is an art designed—and designed it very much is—to be seen at a distance across the room.

Where this tendency toward design yields its most effective pictorial images, I think, is in the near-abstract paintings from the "Mirrors" and "Entablatures" series of the early seventies. What Mr. Lichtenstein has done in these interesting pictures is to combine the strategies of Pop art with those of Color-field abstraction. The imagery remains recognizable, but our experience of the painting is more akin to what we find in a purely abstract art. Here, too, there are terrible insensitivities in the execution, but viewed across a large open gallery, these paintings—especially the "Entablatures" that seem to owe something to the art of Kenneth Noland—attain a level of quality not readily discernible in the exhibition as a whole.

SEPTEMBER 25, 1981

26. Robert Smithson

Even before his death in 1973 at the age of thirty-five, the American sculptor Robert Smithson was well on his way to becoming something of a cult figure on the contemporary art scene. Since that time—he died in a plane crash in Texas while inspecting one of his costly "earthworks," which was then under construction on a ranch near Amarillo—Mr. Smithson has become an international legend. It is for this reason, no doubt, that the exhibition called "Robert Smithson: Sculpture," which has now come to the Whitney Museum of Ameri-

can Art, has been chosen to represent the United States at the Venice Biennale this year.

The exhibition was originally organized by Robert Hobbs, curator of the Herbert F. Johnson Museum of Art at Cornell University, and was first shown at the Johnson Museum in Ithaca, New York in 1980. Since then it has traveled to several American museums, and after its showing in Venice, the exhibition will travel on a similar tour of European museums. At the Whitney, where more of the exhibition can be seen than will be possible in Venice, the show has been installed in the spacious fourth-floor galleries by Patterson Sims, associate curator of the permanent collection.

Mr. Smithson's outsize reputation was very much a product of the cultural and political upheavals of the 1960's. The artist was seen by his admirers to represent everything that was most innovative and daring in the art of that tumultuous decade. Mr. Smithson's ambition was to break with the conventions of studio production and museum exhibitions in order to create an art that would stand in a more intimate and vital relationship to the world of nature and to the man-made social environment. In this, he represented a tendency that promised to have far-reaching social as well as aesthetic implications, and it struck a responsive chord in the anti-establishment sensibilities of the period.

It was Mr. Smithson's idea, as John Coplans writes in the book that serves as the catalogue for and bears the same title as this exhibition, "that the artist could become a functional worker within society, changing the socio-economic basis of art by restoring to it an everyday function within society; and making an art that restored to the common man his sense of place in the world." This was a very grand ambition, indeed, and we shall never know, of course, how close Mr. Smithson might have come to realizing it had he not met such an untimely death. Yet even so, there is reason to doubt that his artistic program would ever have amounted to more than a cultural sport—an innovation supported and sustained by a lavish expenditure of funds from the very same art-world establishment that, even today, it is often assumed to have repudiated.

The fact that we are seeing this exhibition in an art museum—and that it is only in a museum milieu that the bulk of the work has any real meaning—tells us all we need to know, I think, about Mr. Smithson's success in breaking with the conventions of the museum exhibition. Much of what we are actually given to look at in the show, moreover, will be familiar to anyone who has followed the progress of contempo-

rary art as it has been shown to us in galleries and museums since the sixties. I am afraid the interests of "the common man," unless they include a keen concern for the aesthetics of modernist sculpture, are not abundantly served in this exhibition.

Mr. Smithson, before he found the patronage that enabled him to pursue his vast outdoor earthworks projects, was very much a part of the Minimal sculpture movement that emerged in the sixties to challenge the Expressionist and Constructivist styles that had held sway until then. To explain the origin of the concrete arrangement of forms that Mr. Smithson devised for his Minimal sculptures, he often provided elaborate explanations and detailed diagrams that are said to derive from theoretical physics. Being mostly ignorant of physics myself, I cannot say whether these theoretical explanations bear any necessary relation to the forms Mr. Smithson created. But I doubt if it matters. We don't judge Mondrian on the basis of his theosophical beliefs, after all, and theoretical physics is probably as sound a basis as any for the creation of abstract art.

What matters, of course, is the artistic result, and Mr. Smithson did create a few Minimal sculptures that stand up very well—though not enough, perhaps, to win him a place among the major figures of the movement. His real innovations, in any case, are to be found in those works in which he abandoned the monolithic forms of pure Minimalism for a mode of improvised construction. His method, essentially, was to fill metal bins of various geometrical shapes and sizes with small stones or sand, or, alternatively, to spread these materials onto open, mirrored supports in a museum setting where they have the effect of evoking dismal landscape subjects.

It was those bins filled with stones and sand, and those mirrors (sometimes deliberately cracked) covered with carefully selected debris, that had a considerable influence on the art scene of the late sixties and early seventies. If, nowadays, when you walk into a contemporary museum and find something that looks a lot like abandoned refuse tucked away in a corner of one of the galleries, then you can be pretty sure it is a work of art—I am not saying it is a marvelous work of art—that owes its conception to Mr. Smithson's precedents.

Even more influential, of course—influential, at least, on critical opinion—were the earthworks that represented Mr. Smithson's ultimate artistic aspiration. The most famous of these was the *Spiral Jetty* that he created at enormous effort and expense out of mud, precipitated salt crystals, rocks, and water in Utah's Great Salt Lake. By now

it is one of the most famous works of the twentieth century. Pictures of it, usually in color, occupy a prominent place in almost every book devoted to the art of the last quarter century, and the work is, as we would expect, voluminously documented in the present exhibition.

I myself have never seen this work, and so I cannot offer a judgment on its artistic success. All that I have seen are the plans for it and the pictures of it, and neither the plans nor the pictures have persuaded me that it belongs among the marvels of the modern age. But the point is now, in every sense, academic. For the work no longer exists. The Great Salt Lake has risen up to bury the *Spiral Jetty* in a watery grave. Its bare outlines, I am told, can be made out from a plane flying over it, but that—plus the documentation—is all that now remains of the work.

Whether Mr. Smithson made a mistake in his engineering calculations or actually intended the work to sink as it has—all this is now a matter of some dispute. There are some aficionados of the *Spiral Jetty* who firmly believe that this is what Mr. Smithson intended. None of this is likely to diminish the mythic aura the work has achieved, however. Myths of this sort have a life of their own. After all, most of the writers who have extolled the beauties of this work and given it a place of honor in their books have never seen it either. They take its quality on faith. Which is more or less what the visitor to the Whitney exhibition is obliged to do.

"Robert Smithson: Sculpture," which has been supported by a grant from the National Endowment for the Arts, is a memorial exhibition in more than one sense. It is a memorial, first of all, to the work of an artist who was much admired in his lifetime and who died too early to complete his work. But it is also a memorial to some of the illusions spawned in the art world of the sixties. Where else but in an art museum could such illusions still be taken seriously today?

FEBRUARY 19, 1982

IV. The Prose and Poetry of Photography

1. Fox Talbot and the Invention of Photography

The Victorian visionaries were different from you and me. They had more time, more energy, more curiosity, and they commanded far greater powers of concentration. They were certainly better educated, and they worked harder and played less. Their minds were ampler than ours, their interests wider, their ability to master immense realms of knowledge and experience more prodigious. Above all, their belief in the power and prestige of mind was itself a conviction we no longer warrant—or indeed, can even quite imagine—in anything like the same degree. "To use one's intellect to its utmost extent," writes Gail Buckland in her important new book *Fox Talbot and the Invention of Photography* (Godine), "was a Victorian ideal." It is an ideal we seem to have lost.

William Henry Fox Talbot's was a Victorian mind on this outsize scale. If his principal claim on our attention today is his work in photography, it is only because this was the most fateful and far-reaching of his many accomplishments. His intellectual interests were, to say the least, diverse.

Like many upper-class Victorians of his generation—his dates are 1800–87—Talbot seems to have had no adolescence. (Was this the secret of their mental powers?) Between leaving Harrow School in 1815

and entering Cambridge three years later, he studied at home, receiving instruction, as Miss Buckland tells us, "in Latin, Greek, Hebrew, mathematics, astronomy, botany, chemistry, Italian, French, and the other subjects that constituted a proper education of a nineteenth-century gentleman."

He promptly made use of virtually all these fields of learning when he began to work on his own. At the age of twenty, he won a prize for his translation of *Macbeth* into Greek. At twenty-two, he published his first paper in mathematics—"On the Properties of a certain Curve derived from the Equilateral Hyperbola"—and was made a member of the Royal Astronomical Society. Three years later he worked with François Arago at the Paris Observatory. He did research in the chemistry of color, in optics, electricity, and oceanography, and altogether published more than fifty papers on scientific and mathematical subjects—not counting his writings on photography.

His first books were not concerned with the physical sciences, however. Moving in 1827 into Lacock Abbey, his family's ancestral home in Wilshire, he was prompted to investigate the folklore of the place and in 1830 published a collection based on this research called *Legendary Tales in Verse and Prose.* Etymology was another of his passionate interests, and in 1838—in the interval between his first experiments in photography in 1834 and his first announcement of them in 1839—he published the first part of his etymological studies in a volume called *Hermes—or Classical and Antiquarian Researches.* During this interval, too, he was awarded the Bakerian Prize of the Royal Society for two papers on the optical phenomenon of crystals and the same society's Royal Medal for his work in integral calculus.

Nor does this exhaust the range of Talbot's interests. "If today the name of William Henry Fox Talbot is mentioned in particular corridors of the British Museum or in certain learned societies," writes Miss Buckland, "recognition will come not as the inventor of photography, but as a brilliant Assyriologist. As a young man Talbot studied Hebrew and collected hieroglyphics but although he never devoted himself exclusively to this study, his accomplishments were of the highest order. . . . More than sixty of his translations from the Assyrian were published by the *Transactions of the Society of Biblical Archaeology, Journal of Sacred Literature, Journal of the Royal Asiatic Society*, etc., and in 1858 he was elected vice-president of the Royal Society of Literature." Incredibly, he also found time to stand for public office and serve as a

member of Parliament. No wonder that George Steiner once speculated that the Victorians never slept.

It was while he was sketching on the shores of Lake Como, in Italy, in the fall of 1833 that Talbot first conceived the "idea" of photography. "The idea came first," Miss Buckland writes, "and remained supreme to everything that followed." Dissatisfied with his drawings—Talbot was no draftsman and knew it—he thought about employing a camera obscura to improve them. He then began to reflect on the transitory images that this device would yield him—"fairy pictures, creations of a moment, and destined as rapidly to fade away," as he wrote—and thought about "how charming it would be if it were possible to cause these natural images to imprint themselves durably, and remain fixed upon the paper."

Immediately he made notes on the experiments that might be performed to achieve this result, and upon returning home in January 1834 he set about conducting them. By the following summer the results of these experiments in "the art of photogenic drawing," as Talbot called the new process, were such that he began sending examples to friends and relatives. Once launched on this pursuit, he moved from discovery to discovery. Experimenting with the chemical treatment of paper, he found a way to stabilize the imprinted image. He also discovered a primitive method of photocopying, using the so-called *cliché-verre*.

This involved a darkened sheet of glass written or drawn upon with a needle. "When this is placed over a sheet of prepared paper," Talbot wrote, "a very perfect copy is obtained; every line which the needle has traced being represented by a dark line upon the paper." Talbot called the results "photogenic etchings," and clearly envisioned their future use. "Another application of the same principle," he wrote, "is to make copies of any writing. This is so easy, and each copy takes so short a time in making, that I think it may prove very useful to persons who wish to circulate a few copies among their friends of anything which they have written. . . . The chief expense will be from the quantity of silver used, which is small; but no press being wanted, it cannot fail to be, on the whole, a very economical process."

The most consequential of his discoveries came in February 1835, however. Until that time, according to Miss Buckland, "all the photogenic drawings were negative, in other words, had their highlights and shadows reversed." The breakthrough came on February 28, 1835.

This is the entry from Talbot's notebook for that date: "In the Photogenic or Sciagraphic process, if the paper is transparent, the first drawing may serve as an object to produce a second drawing, in which the lights and shadows would be reversed."

This, as Miss Buckland writes, is "the first recorded reference ever to negative/positive photography," and she is absolutely correct in claiming: "From this technical milestone is derived modern photography." The practice of producing multiple "positive" prints from a single "negative," which remains the foundation of most photographic work today, dates from this momentous event. (Incidentally, it wasn't Talbot but his scientist-friend Sir John Herschel who coined the terms "positive" and "negative" to describe this process.)

Still, Talbot pressed on to make further discoveries. In 1840 came the invention of what he called the calotype (from the Greek *kalos*, meaning beautiful, but also good or useful). "This new technique," writes Miss Buckland, "allowed a short exposure to produce a latent image that could be brought out—developed—by the use of certain chemicals." With exposures now reduced from an hour or so to a few minutes, or even a few seconds, depending on the strength of the light, the photographic process was made not only faster but far more versatile, and the discovery of the so-called latent image radically extended the very concept of what photography might be.

Henceforth photographers would be alert to the fact that their negatives were likely to contain a good deal more than could be observed by the naked eye or even intended by the photographer himself. Taking a picture thus became but the first step in a process that would be fully realized only in the artful printing of it. Here again one of the fundamental *données* governing the medium was quickly established.

Then, in 1844, came Talbot's *The Pencil of Nature*, the first book to be illustrated by photographs and itself a meditation on the meaning of photography and printed images. Beaumont Newhall once compared its importance to that of the Gutenberg Bible. "In the history of photography and of publishing," writes Miss Buckland, "it is a seminal event. Even today, Talbot's words and pictures give anyone interested in modern visual communications much to reflect on. For Talbot was a genius and his ideas show a profound understanding of the power of mechanically produced images."

The implications of this historic venture into books containing mechanically reproduced images scarcely needs to be elaborated upon today, but Talbot, with his characteristic curiosity and zeal, carried his

discoveries still further by going on to establish the basis of halftone printing as we know it today. "Talbot's invention," writes Miss Buckland, "is the start of modern visual communications, of a new way of seeing and thinking about the world."

About every stage of this extraordinary history Gail Buckland, an American scholar and writer who was formerly curator of the Royal Photographic Society of Great Britain, writes with exemplary clarity and precision and with a keen sense, too, of the human drama that attended every aspect of its development. The book she has given us is at once learned, readable, and wise, and where appropriate—especially in the penetrating discussion of Talbot's own first photographs—it achieves an eloquence rarely to be found in a work containing so much original research.

For the story she has to tell us is even more dramatic than I have yet indicated. Talbot's discoveries—and his own technical and aesthetic development of them—were one thing. Their career, and the disappointments caused by his lack of haste in announcing them to the world, were quite another. Although he began his photographic experiments in 1834 and quickly established the viability of the new medium, he was in no hurry to publish or publicize his accomplishments in this field. He therefore missed by two weeks establishing his priority as the inventor of this new medium. Daguerre's process was announced in Paris on January 7, 1839, and it was not until January 25 that Talbot officially presented his work to the Royal Institution in London. It is for this reason that the world still regards Daguerre as the originator of a medium that Talbot first conceived six years earlier while sketching on the shores of Lake Como.

This was only the beginning of a series of disputes that later involved Talbot in feuds and legal battles over patents and licenses. In none of these was his primary interest ever that of money or profit. He remained to the end a scientist, a scholar, and an artist, and was never much good at business. But the results caused an understandable bitterness to cloud an otherwise charmed and happy life.

About all of this, too, Miss Buckland's book is scrupulous and wise. What is finally most impressive in her book, however, is the delicacy of her perception. Discussing Talbot's earliest pictures, for example, she writes:

> They do not pretend to be reality, only to deal with it. . . . They powerfully address the question of time. Shadows with soft edges fall on both

sides of a building while the sun moves from east to west. They are made with time, in time, and show respect for time. They address the question of viewpoint. . . . They address the question of the imposition of the frame. Trees are unnaturally confined and push out and up as they reach for the light. The deceit of photography becomes as obvious as its honesty.

To both the history of photography and the literature of modern culture this book makes an important contribution, and in both its text and its pictures it has itself been designed and produced in a style exquisitely appropriate to the genius that is its subject.

SEPTEMBER 17, 1980

2. Muybridge: The Stanford Years

The man who called himself Eadweard Muybridge—his original name was Edward James Muggeridge, and he is said to have used the name Muygridge before settling finally on Muybridge—was born on April 9, 1830, in the town of Kingston-upon-Thames. He died in this same English town in 1904. As a result of the photographic work he completed during his long residence in the United States, he achieved immense fame in his own lifetime as the man who radically altered both the scientific understanding and the pictorial depiction of animal locomotion.

He was yet another of those prodigious figures the nineteenth century produced in such astonishing abundance—a great photographer who was also a great inventor; a man who moved easily from the realm of artistic expression to the challenges of a new technology; a writer, traveler, and tireless public speaker who was also a shrewd businessman and a canny custodian of his own fame. Even his private life was lived on a Balzacian scale, for Muybridge, among other feats, managed to murder his wife's lover and get himself acquitted on grounds of justifiable homicide—an episode that seems scarcely to have caused a pause in his busy professional life.

Muybridge is still best known, of course, for his historic studies of animals and human figures in motion, but he was already a photographic artist of great distinction before undertaking his motion studies. Although he did not take up photography until he was in his thirties—he had come to San Francisco, at the age of twenty-five, as a bookseller—he enjoyed an almost instant success with his picturesque views of San Francisco and the West Coast. With his studies of clouds and trees and his subsequent panoramic scenes of the Yosemite Valley and Central America, Muybridge must be regarded as one of the great landscape photographers of the nineteenth century—a successor to the great Romantic landscape painters. One still marvels at the thought of Muybridge traversing the rugged terrain of Yosemite, with his heavy cameras and equipment, making his wet-plate glass negatives, the largest of them twenty by twenty-four inches, under nearly impossible conditions, and yet triumphantly producing some of the most glorious landscape images known to the medium, or indeed to any medium.

A selection of these Yosemite pictures is included in the exhibition called "Eadweard Muybridge: The Stanford Years, 1872–1882," which has now come to the New York Cultural Center. There are also some examples of Muybridge's stereo pictures, a print of the mural-size *Panorama of San Francisco from the California Street Hill*, which Muybridge executed in 1878, and some of the pictures he brought back from Central America. We are thus given a vivid sense of what he achieved in photography quite apart from the locomotion studies. But it is of course the latter that provide the main focus of historical and aesthetic interest.

The exhibition comes to New York from Stanford University, where it was shown last fall. It was organized by Anita Ventura Mozley, the curator of photography at the Stanford University Museum of Art, to mark the centenary of Muybridge's collaboration with Leland Stanford, the former Governor of California and later founder of the university who was then president of the Central Pacific Railroad and who also had a consuming interest in the breeding and training of horses. In 1872, Stanford invited Muybridge to conduct photographic experiments of horses in motion. Thus began the great series of locomotion studies for which Muybridge is now known, and also the technical work that led him, in 1879, to produce by means of a device known as the zoöpraxiscope a primitive mechanism for projecting moving pictures on a screen.

The work that Mrs. Mozley has brought together in this section of the exhibition is drawn from this early phase of Muybridge's motion studies and is based, for the most part, on the Stanford collections. (The New York Cultural Center has added certain examples of the later studies, which are more familiar to most of us, and there are also paintings here by Eakins and Meissonier reflecting Muybridge's immediate influence on painters on both sides of the Atlantic.) The exact stages of Muybridge's locomotion pictures are not always easy to follow, for these early pictures-in-series are tiny and often only silhouettes and have to be closely read in order for their details to be fully appreciated. Yet they are still remarkably thrilling. Using first twelve cameras and then as many as twenty-four, Muybridge effected the means of depicting animals and then the human figure in movement, and these images turned out to be remarkable in two quite different respects.

There was, first, the compelling but incomplete illusion of movement that was conveyed in the serial character of the images—an illusion that anticipated the still greater illusion of cinematic projection yet to come. But there was also something aesthetically remarkable in the quality of the serial images themselves, and remarkable not as pictures of movement but as still photography. To follow a single motif in a confined space through repeated variations of a given form is itself a brilliant aesthetic conception and, in Muybridge's case, yielded magnificent results. Certainly for most of us, it is precisely because these serial images do *not* move but must be encompassed in rapid succession, held in the mind simultaneously, and experienced as a single pictorial idea that they affect us the way they do. No one would deny Muybridge his place in the prehistory of moving pictures, but his great artistic achievement lies nonetheless in what he brought to still photography—the multiple image experienced as a single idea.

Still, the thrill of that primitive moving picture projected from the zoöpraxiscope is not to be denied. The current exhibition includes a reconstruction of the original zoöpraxiscope in working order, so that we are able to see what Muybridge's first projected moving images of a horse in motion actually looked like.

What we are offered, then, in this many-sided exhibition is a rich chapter in the life and work of a pioneer photographer who was also an accomplished and influential artist. Muybridge's career was a long and complex one, and this exhibition does not pretend to bring us a complete account of it. But it does illuminate the "Stanford Years" with exemplary intelligence and precision, and the catalogue that Mrs.

Mozley and her colleagues have produced to accompany the exhibition is a permanent contribution not only to the history of photography but also to the history of an era.

<div align="right">MAY 20, 1973</div>

3. The Young Steichen

With the early photographs of the late Edward Steichen, which are currently the subject of an absorbing exhibition at the Scott Elliott Gallery, we are once again put in close touch with that legendary era—roughly, the years from the turn of the century to the First World War and its immediate aftermath—in which so many of the salient issues of modern aesthetic culture were first debated and defined. In a good many of these pictures, the nineteenth-century inheritance still wields a surpassing authority, and part of the intensely interesting drama the exhibition holds for us lies precisely in the way this inheritance is confronted, exalted, and ultimately exorcised in the work of one of the leading exponents of the modern movement.

The very first item in the exhibition—a self-portrait gravure print, executed in Paris in 1901—places us firmly in this nineteenth-century ambiance, with its taste for pictorial chiaroscuro and its image of the artist as a heroic protagonist. In this remarkable picture, taken when the ambitions of the young Steichen were still divided between painting and photography, the subject is depicted with brush and palette in an attitude of romantic gravity. It could easily take its place beside Delacroix's portrait of Berlioz, except for one thing—the paradox of the painter's employing the camera for the purposes of his formal self-portrait as an artist.

It was a paradox Steichen would not finally resolve until 1922, when, at the age of forty-three, he made a bonfire of all the canvases in his Voulangis studio and thus committed his talents irrevocably to the photographic medium. By that time, of course, the ghosts of nine-

teenth-century pictorialism had been fully expelled from his photographic practice. When he returned to America the following year, he went to work for Condé Nast, becoming the chief photographer for *Vogue* and *Vanity Fair*, and also entered the world of advertising photography as an employee of the J. Walter Thompson Agency.

For votaries of the Stieglitz circle, in which Steichen had earlier played a crucial role—it was Steichen who selected the work for those pioneering exhibitions of Rodin, Cézanne, and Matisse that Stieglitz mounted at the Photo-Secession Galleries in 1908–10—this alliance with commercial journalism and advertising was never to be forgiven. Paul Rosenfeld, the most loyal of the critics whom Stieglitz held in thrall, later wrote a blistering attack on Steichen for allowing the sacred purity of the photographic vocation to be corrupted by commercial exploitation. Yet the work Steichen produced as a commercial photographer more than vindicated his decision to break free of the aestheticism that Stieglitz was determined at all costs to preserve. It proved that Steichen understood something about the nature of the photographic enterprise—about its relation to public experience and the role it was destined to play in modern culture—that eluded Stieglitz's more sectarian ambitions.

It was, I think, his experience in the First World War that altered Steichen's fundamental attitude. In the exhibition at the Elliott Gallery, the series of early gravures (dating from the first decade of the century) evokes a world in which aesthetic concentration is undisturbed by the harshness of history. The subjects are often artists or works of art—Isadora Duncan and Gordon Craig, Anatole France and George Bernard Shaw, Rodin and Rodin's *Balzac*—and even where the subject does not derive from an artistic milieu, the style does. In the portrait of Anatole France, especially, we are securely enclosed in the comfortable environs of nineteenth-century French letters, and elsewhere the soft shadows of the Whistlerian twilight filter out all of the rude angularities of modern experience.

When we turn from these gently modulated images of people and places to confront the *Self-Portrait with Camera*, dating from around 1917–18, we are suddenly in the presence of another kind of candor. The old artifice, with its poetic, insulating gloom, is abandoned in favor of a more straightforward, unembellished clarity. Gone is the costume and the attitude of "the artist"—that figure of nineteenth-century mythology—and in its place is the journeyman photographer,

with his collar open and his shirt sleeves rolled up, operating a machine without aesthetic disguise.

The figure in this self-portrait is clearly the author—as the phantom-artist in the earlier *Self-Portrait with Brush and Palette* could not be—of the remarkable series of aerial photographs, taken in the combat zones of France during the war, that are another special feature of the current exhibition. In one of these pictures, a view of the Château de Blois, we can see the shadow of Steichen's tiny aircraft cast against the immense façade of the building, a vivid reminder of the perils involved in this documentary enterprise. But the really unforgettable pictures are those of the war itself and of its devastation—of *Vaux after Attack*, with its grim topography of an entire city reduced to ruins, and *Front Lines*, which is a more graphic account of the horrors of trench warfare than any I know of in literature or on film. The gray-on-gray half-light of such pictures is no longer a poetic invention but the candid recording of a world under sentence of death.

After the war, Steichen was to put his experience as an aerial photographer to more exclusively aesthetic uses—in the Elliot show, there is a beautiful picture of Long Island farmland, taken around 1920, that looks like a "sketch" for the kind of pure-patterned geometrical abstraction our painters were not to attempt until many years later. And indeed, throughout the long career that followed—Steichen died only last year, at the age of ninety-four—he moved easily and restlessly between the world of disinterested aesthetic research and that other world where the photographer is enlisted in causes and campaigns of persuasion, whether commercial or political.

For many of Steichen's admirers, the capstone of his career was "The Family of Man" exhibition that he organized at the Museum of Modern Art in 1955 and that, both in its many traveling versions and in book form, was seen by millions of people the world over. This was certainly his most ambitious attempt to bring the two worlds he had long inhabited—the world of art and the world of affairs—into a meaningful union. For myself—distinctly a minority on this question—it was an attempt that failed utterly. That mammoth effort to distill some basic grammar of human experience out of a multitude of disparate images only succeeded, in my opinion, in reducing the complexities and particularities of so vast a subject to an arid liberal cliché. It was all a colossal reminder that what interests us in photography, what really engages and alters our emotions, is the precious particularity of

the thing seen. In "The Family of Man," a scrupulous aesthetic conscience succumbed to the wiles of a benign propagandist. One suddenly had reason to feel that Stieglitz's earlier opposition to the alliance of photography and persuasion was in defense of something important.

We are a long way from this denouement, however, in the current exhibition. We are brought back to the very beginning of the story, and a dramatic, fascinating story it is.

JUNE 16, 1974

4. Imogen Cunningham and Minor White

By an odd twist of fate, death came to two of our most illustrious photographers—Imogen Cunningham and Minor White—almost at the same time, but at opposite ends of the country just over a month ago. Reading their obituaries—printed side by side, like entries in an encyclopedia, in *The New York Times* of June 26—gave one a peculiar sensation. It was not only the sensation of loss, although that was certainly part of it, but also of pride and curiosity. What a lot of history is contained in these two careers, and what a lot remains to be learned about them! The so-called photography boom had arrived in time to elevate them to a new celebrity in the world beyond the photographic community that had long esteemed them, but not soon enough to give us a really comprehensive account of their work. With photographers, as with poets, there is a tendency to judge them by often reprinted anthology pieces. There is a tendency, too, to attribute consistency to a body of work that may contain a significant diversity, if not outright contradictions. We do better, I think, to begin with a recognition of their diversity.

Imogen Cunningham, who died in San Francisco, was ninety-three; Minor White, who died in Boston, was sixty-seven. Although their lives touched at various points—the most beautiful portraits I have seen of White's handsome, fawnlike face are Cunningham's—they

belonged to different generations, were very different personalities, and took very different views of their art. Cunningham was the least mystical of women; she was earthy, humorous, downright, and realistic; whereas for White the entire world of existence—and the place of photography in that world—was enclosed in a mysterious penumbra of spirituality. Cunningham reveled in playing the sassy old lady, celebrated for her candor, whereas White was the very archetype of the artist-as-guru. If for the one photography had become a form of straight talk, concerned above all with immediacy and truth, for the other it had long been a form of prayer.

I met each of them once, visiting Cunningham at her house in San Francisco a year before she died, meeting White a year before that at the exhibition he organized at M.I.T. on the occasion of his retirement as professor of photography. Cunningham spoke of what it felt like to be old; and her current project was photographing old people—"most of them," as she hastened to point out, "younger than me." White spoke of recovering a sense of "the sacred" in his art. He was not so much troubled as challenged by the thought that photography, unlike the other arts, traced its origin not to the mythic roots of ancient ritual but to modern technology. In Cambridge, at the very nerve center of a great technological institute, White yearned for spiritual transcendence. In San Francisco, at ease among the remnants of the mystical flower children, Cunningham remained the complete realist.

Yet each could look back on a career that embraced attitudes very different from those upheld at the end. Cunningham was, at the start and for some years thereafter, very much the romantic, producing dreamy, soft-focus pictures in the Whistlerian mode. Her early work recalls us to the spirit of bohemian aestheticism that flourished in the period before the First World War. Looking at the nudes and draped figures of 1910–15, we are reminded that she was a contemporary of Isadora Duncan.

She went on to become, among other things, an accomplished formalist, with a passion for abstract form that sometimes astonished her, in later years, when she looked back on it. Her pictures of agaves, water hyacinths, and the like, in the 1920s, bear comparison with Edward Weston's "Peppers." And the same photographer excelled as a portraitist of movie stars for *Vanity Fair* in the 1930s. (Her famous *Magnolia Blossom* of 1925 combines, in a way, both her formalist interests and her gift for capturing the special glamour of her movie star subjects— though she never photographed a star as beautiful as this "blossom.")

What we now tend to think of as the characteristic Cunningham style, because of its clarity and immediacy, probably dates from her association with the f/64 group founded by Ansel Adams, Willard Van Dyke, Cunningham, and others in San Francisco in 1932. (The name derived from the lens opening deemed to produce the most sharply defined image.) And it is certainly true that, from the 1930s onward, Cunningham's pictures acquired a new freedom and ease—a freedom from, among other things, what might be called artistic anxiety. It is worth remembering that the attitude we have come to prize in Cunningham's later work—that straightforward address to the subject that places the interests of life before those of art—was not something she came by quickly or easily. In 1933, Imogen Cunningham was fifty years old.

White, whose career was shorter and much occupied with writing and editing, with educational projects and exhibitions, was not without his own "contradictions." The mystic of the later years, producing photographic meditations on a Zen koan by concentrating his camera on the patterns of frost on the windows of his apartment in Rochester, New York, had earlier on—in 1939–41—worked as a master of the documentary mode. The pictures of iron-front buildings in Portland, Oregon, that White took in these years as part of his work for the Works Progress Administration are still, I think, among the best he ever made. I certainly prefer them to the nature abstractions that came to occupy so large a place in his art in the later years—but then, I have to confess to being of a very unmystical temperament myself.

The turn toward mysticism came, for White, in the 1950s, and in the chronology of his career that Peter Bunnell compiled a few years ago, one can find the sequence of titles and authors that influenced his course—Underhill's *Mysticism*, Herrigel's *Zen and the Art of Archery*, Huxley's *The Doors of Perception*, the *I Ching*, Gurdjieff, and so on. The camera became, for White, a form of spiritual meditation, and the things of this world lost, not their visual immediacy—for White had a flawless eye—but something of their material reality, becoming instead metaphors of the unseen. Looking at White's later work, I am reminded of what Paul Klee wrote about himself in 1918: "My work probably lacks a passionate kind of humanity, I do not love animals and other creatures with an earthly heartiness . . . the idea of the cosmos displaces that of earthliness . . . in my work, man is not a species, but a cosmic point."

This is what "the sacred" meant, I think, to Minor White, and it required a renunciation of that "earthly heartiness" that Imogen Cunningham made the mark of all her later work. How we shall miss them both!

AUGUST 1, 1976

5. Ansel Adams: Trophies from Eden

The exhibition of photographs by Ansel Adams, organized by Andrea Rawle and Phyllis D. Massar at the Metropolitan Museum of Art, brings us 156 prints by one of the most celebrated figures in the field. Mr. Adams has occupied so large a place in the development of American photography that its history, at least since the 1930s, could scarcely be written without ample consideration of his many-sided accomplishments. Although trained originally as a concert pianist, he has been exhibiting and publishing his photographs since the twenties. In 1932, the year that he was given his first one-man show at the DeYoung Museum in San Francisco, he founded the Group f/64 with Edward Weston, Willard Van Dyke, Imogen Cunningham, Sonia Noskowiak, and Henry Swift; and four years later he was given a one-man show at Alfred Stieglitz's An American Place.

Since that time, he has published a great many books, conducted numerous workshops, and given many lectures, organized important enterprises—he was, for example, one of the people responsible for establishing the Department of Photography at the Museum of Modern Art—and, in just about every way that the field affords, has made himself a force to reckon with. Academically, journalistically, and museologically he is a recognized leader, and few honors have been denied him.

Yet the work that one sees at the Metropolitan Museum does not strike one as the work of a major artist. True, the exhibition is not a comprehensive retrospective, but it ranges over the whole course of

Mr. Adams's work since the thirties, and one somehow doubts that a fuller exhibition would significantly modify one's judgment. Indeed, the present exhibition is somewhat larger than the work itself seems to warrant—not because of any repetition of images, but because of the radically delimited outlook that encloses so much of the work that is shown.

Mr. Adams is, above all, a photographer of nature, a man in love with the grandeur of uninhabited spaces. The High Sierras and Yosemite Valley, the national parks and other outposts of uncultivated and unmolested landscape have long been his favorite subjects, and he has lived long enough to see this personal aesthetic bias confirmed in the conservationist movement to preserve these landscapes from ecological disaster. His association with the Sierra Club dates from 1920, and in more than half a century of activity on its behalf he has only deepened his commitment to a view of nature that effectively separates it from the workaday world of human affairs.

Nature, in this view, is a romance that the fatal hand of civilization must never be allowed to penetrate. Of all the despised objects that modern technology has produced to dim our spirits and threaten our existence, only one—the camera—is exempted from adverse judgment. Only the camera is allowed to pass into paradise in order to bring back evidence of its superior attributes—superior precisely because of their untouched purity and their distance from the dead hand of human intervention.

In these photographs of untrammeled nature, we are given a world sealed off from time and history, where events are measured by the geological calendar and change occurs beyond the range of human perception. It is indeed a world of rare beauty, and no one has explored its myriad nuances with more painstaking attention or with a keener eye for their spectacular visual drama than Mr. Adams. But this rarity is exactly what places so fixed a boundary on the photographer's vision. Nature becomes a sanctuary where beautiful effects can be stalked with impunity, and as the trophies brought back from Eden multiply, they lose something important—if not their credibility, at least their power to engage our deepest emotions.

The very perfection that Mr. Adams brings to every print—a technical perfection for which he has few peers—contributes, moreover, to a certain air of unreality in his work. One marvels, of course, at this extraordinary clarity of image, in which every visual value, no matter how subtle, is brilliantly articulated. One takes pleasure in all this

technical virtuosity, but one also wonders about it—wonders about the meaning of this technological finesse placed at the service of a subject that seems to deny its significance. In the end, it isn't nature that one responds to in this work so much as the craft of the darkroom, and this response only reinforces one's feeling that nature, in this case, is somehow being "used"—that it may be only another resource exploited in the interests of a technological feat.

Fortunately, for those of us who entertain doubts of this sort, Mr. Adams's camera has not been completely confined to the romance of nature. His encounters with a world that you and I might easily recognize as our own are also represented in this exhibition, and it is in such pictures of people and places that the real strength of this exhibition is to be found, at least for anyone not easily susceptible to the contradictions and mystifications I have described.

For myself, the look on the face of Georgia O'Keeffe—in the 1937 photograph included here—is worth all the views of Yosemite Valley ever committed to film, and the *Family at Melones, Calif.*, from 1953, easily takes its place beside similar pictures of rural family groups that still haunt us from the photography of the thirties. The marvelous close-up portrait of Brassai, taken last year, is likewise one of those pictures so charged with life that it seems to flatten everything else in the vicinity.

In addition to these and other portrait photographs, there are some small gems of observation and composition in the group of original Polaroid Land photographs that is one of the most appealing sections of the exhibition. My own favorite among these is the picture of *Rundel Park Through Window Screen. Winter, Rochester* (1960), in which the mesh pattern of the screen, exquisitely visible, transforms frame houses, trees, and even a parked car into a "flat" pointillist image of extraordinary delicacy. How grateful one is, after so many stumps of trees and distant skies and orchestrated clouds, to see an automobile and a front stoop!

This particular picture resembles the portraits in one particular respect that seems to me important: in the way it immediately suggests a timebound subject. For photography is a medium in which time—both the moment captured and the very sense of its pastness—is an ineluctable collaborator. Where this collaboration is openly invited, or at least undisguised, our emotions are, I think, more deeply engaged. It is because so many of Ansel Adams's photographs of nature seem designed to escape this sense of time—to take refuge in the sanctuary of an eter-

nal present—that they seem to consign themselves to a realm where feeling no longer counts. One might even go so far as to say that to the extent that photography resists the texture of historical time, it is resisting an essential part of its own nature.

MAY 12, 1974

6. Walker Evans

The American photographer Walker Evans, who died on April 10 at the age of seventy-one, was one of the greatest artists of his generation. He was also, in my opinion, one of the most widely misunderstood— misunderstood in the way that photography itself was so often misunderstood in his lifetime. Like many great artists, he was a difficult man, often indeed a devious man, and never more devious than at those moments—and they were not infrequent—when he allowed his work to pass into the world and be praised as something he knew it was not. He was an artist who traveled, as it were, incognito, sometimes amused, sometimes cynical, sometimes merely resigned to what the world had made of his accomplishments. He was very far from being immune to vanity or the appetite we all share for praise, recognition, and preferment—he certainly savored to the full his well-earned position as a classic—but he was disinclined by temperament and intelligence to mistake the world's word for the precise measure of his artistic worth. To no other figure of our time does Rilke's dictum about the paradox of celebrity—that fame is but the sum of misunderstandings that accumulate around a well-known name—apply with greater force.

His early renown was based, for the most part, on his work as a chronicler of American life in the Depression years—first as one of the photographers employed by the Farm Security Administration and then as a member of the staff of *Fortune* magazine, where he was given the historic assignment that led to his collaboration with James Agee on the book *Let Us Now Praise Famous Men*, now the most cherished of all the documentary works that came out of the 1930s. The cultural ethos

of that period, with its emphasis on social consciousness and political commitment, did much to determine the way Evans's work would be perceived for several decades—and, in fact, it still determines the way many of his admirers look upon his achievement. For them, Evans remains above all a social documentarian, an artist defined by his empathy for the poor and the dispossessed, and for the humble circumstances in which their lives were so accurately observed.

It was not, however, in the crucible of social crisis that Evans began his artistic endeavors. The experience that shaped his sensibility was not the Depression of the 1930s but his fateful immersion in the literary and artistic culture of Paris in the 1920s. About his artistic debt to Flaubert and Baudelaire, especially, Evans was quite explicit. "I know now that Flaubert's aesthetic is absolutely mine," he said in an interview published in *Art in America* in 1971—incidentally, the best account Evans ever gave of his own career—and then he added: "But spiritually, however, it is Baudelaire who is *the* influence on me." Critics tend to make the same mistake about Evans they make about Nathanael West: Overlooking an aesthetic allegiance that was formed in the 1920s under the influence of the Paris avant-garde, they ascribe political motives to a style that owed its basic tenets to an education in French aesthetics.

In Evans's case, certainly, this mistaken emphasis has blinded a great many of his admirers to the fact that the human chronicle so dear to political sentimentalists of rural poverty and urban low life plays a relatively minor role in this photographer's total oeuvre. Evans took many pictures of people in the course of his long career, and these pictures deserve the fame that has been accorded them (though it is a fame somewhat out of proportion to the place they occupy in his work). But the direct depiction of human pathos was not Evans's principal interest.

He was a man profoundly detached from the common woes of the human spectacle. What interested him, more than anything else, was not the social fate of his subjects but what can only be called their aesthetic fate: the visible but usually unobserved effect of time and physical circumstance on the objects and structures and surfaces and spaces of American life. He was most at home, spiritually and artistically, where human actors had quit the stage—whether permanently or temporarily did not matter—and left the eloquent debris of their past free to be examined and "taken" (as we say of photographs) as a permanent statement of feeling. If he was a chronicler of anything, it was of

anonymous architecture and artifacts—of the objects that primitive or popular or unconscious taste had submitted to the harsh ministrations of time and the innocent juxtapositions of social change. Where others often saw only a wasteland of social decay or abandoned aspiration, Evans saw something poetic, something to be valued and "saved," and he garnered his poetic perceptions of this special landscape with the passion of an archaeologist digging out the remains of a lost world.

His closest affinity was, I think, with Atget—which takes us a very long way indeed from the social pieties of the documentary school. And something he wrote about Atget very early in his photographic career—it was an observation he made in the course of reviewing several books of photographs for the magazine *Hound and Horn* in 1931—tells us something important about the way Evans conceived of his work. "His general note," Evans said of Atget, "is lyrical understanding of the street, trained observation of it, special feeling for patina, eye for revealing detail, over all of which is thrown a poetry which is not 'the poetry of the street' or 'the poetry of Paris,' but the projection of Atget's person."

Evans brought that same "special feeling for patina," that same "eye for revealing detail," so abundantly and triumphantly lavished by Atget on the streets and the gardens of Paris at the turn of the century, to his examination of the American scene. His note, too, is one of "lyrical understanding," and he was equally triumphant in his artistic realization of it. It is not the note of a social documentarian. What gives Evans's career an aura of poignant paradox is the fact that so much of it was conducted in circumstances that required him to act as if he were the social chronicler so many of his admirers took him for. But compare his pictures for the Farm Security Administration with those of other photographers employed on that project, and you find that they actually tell us a lot less about the social condition of his subjects than they do about the photographer's own aesthetic interests. The same is true of the work he did for *Fortune*. Evans spent many years in the employ of Time Inc., writing for both *Fortune* and *Time* magazines, as well as taking photographs for the former, yet he never joined the ranks of *Life* photographers—the whole idea was alien to the kind of ambition he harbored for his photographic work.

He spent the better part of a lifetime working in the world of journalism, yet never being *of* that world in any fundamental way. He was, as I say, devious. His real life as an artist began in the late twenties, when his admirers were few, when the number of people who would

even read an article such as the one I have quoted from *Hound and Horn* could probably all have been accommodated in a single room, and it ended at a moment when photography had become the rage and Walker Evans one of its prized ornaments. Yet fame is by no means identical with true understanding, and it will probably be a while yet before his work is fully grasped—even by those who now mourn his passing.

MAY 20, 1975

7. Notes on Irving Penn

Once upon a time, fashion photography existed in a kind of aesthetic demimonde. Its practitioners were regarded as artists of easy virtue, accomplished in the arts of seduction, expert at inducing illusions of feeling, and utterly cynical in their manipulation of fantasy and artifice. As with other excursions into the demimonde, one was permitted to enjoy the superficial pleasure it offered us—there was never any question, of course, that it was pleasure of a superficial kind—but it was not to be taken seriously, and it was certainly not to be considered respectable. Everyone agreed it was an essentially heartless and mercenary enterprise.

Lately, however, there has been a strenuous effort to persuade us otherwise. The demimonde of fashion photography has suddenly been discovered to be a region of Parnassus, and its leading denizens figures of disguised but authentic virtue. Their canny artifice is now embraced as genuine art, and their worldly predilections forgiven—perhaps even admired—as a necessary strategy. Transferred from the world of advertising, promotion, and expensive taste to the higher and more rarefied altitudes of art, the fashion photographer has now emerged as a new hero—solemnized in the museums, elevated to academic rank, and seized upon by criticism as the very touchstone of achievement in a medium where standards remain open and adventitious.

This process was bound to have a profound effect on its principal beneficiaries. In the case of Richard Avedon, for example, it emboldened him to annex the world of political celebrity—now shrewdly perceived to be ripe for "decadent" treatment—to his already horrific universe of bloodless mannequins and decaying survivors of "society" and the arts. With Irving Penn, however, the process has stimulated a very different sort of ambition—to produce pictures so distant from the world of fashion, or indeed from any world that is inhabited by the human image, that they can be experienced only as the purest form of art.

To accomplish this end, Penn has been obliged to borrow from art itself—that is, from recent painting and sculpture—certain ideas essential to the realization of his aesthetic program. From Jean Dubuffet and the aesthetics of *art brut*, he has taken his cue in looking to the ruins of the gutter for his precious materials, which are precious (in this context) precisely because they are ugly, discarded, disfigured, soiled, and mere trash, and therefore useless—and perceived to be useless—for any but an artistic purpose.

The collapsed paper cups and dirty food wrappers and decaying cigarette butts in Penn's most recent photographs—already the subject of exhibitions at the Metropolitan Museum of Art and the Museum of Modern Art, and given the most prominent display in his large retrospective this fall at Marlborough Gallery in New York—are thus the offspring of an established pictorial tradition. In this tradition, mandarin taste redeems through the magic of art the "innocent" materials of the street, thereby reasserting the priority of sensibility over the objects of experience.

It was only (and literally) a step from the graffiti-inscribed cracks in the sidewalk that Dubuffet so successfully carried over into his paintings to the treasure house of the gutter, but for Penn it was decisive, and not so much for what he found there as for what, in a sense, he lost. It freed him from the tyranny of his subjects—from the glamour and celebrity and pathos that dominated his earlier work. All his professional life Penn has photographed what he or someone else thought to be beautiful or eminent, exotic or otherwise appealing, and his artistry remained in one degree or another tethered to subjects that guaranteed our interest. In making his descent into the rubbish of the gutter, he was at last free—or so it must have seemed—to create an interest of his own invention.

Still, even the most abused cigarette butt or paper cup remains an object, and for purist art of the sort Penn now clearly aspired to, objects—while often necessary, especially in photography—are something of a problem. They must somehow be transformed, and made to seem, if not entirely expendable, at least ancillary or extrinsic. One obvious way to do this is to alter scale—to miniaturize the monumental, or, as Penn now did, to so isolate and enlarge a small object that it assumes a visual existence independent of its "true" reality. The artist in our time who has done the most to effect such changes of scale is, of course, Claes Oldenburg, with his clothespin monuments and giant hamburgers and lipsticks the height of a room. When, in confronting Penn's cigarette pictures and feeling that they somehow resemble the World Trade Center towers or the decaying columns of an ancient temple, what we are seeing first of all is the entry of the Oldenburg aesthetic into photography.

This is not something that can be fully appreciated from seeing these pictures reproduced in a catalogue or a magazine. The actual prints are, in relation to their subjects, enormous—often twenty-five or thirty inches high. Significantly, these prints are larger than any of his photographs of people. The only thing that comes close to them in feeling, though they remain smaller in size, are the series of nudes that Penn made in 1950, but these are not photographs of people either. They are pictures of forms, at times almost abstract, coaxed into a kind of sculptural monumentality by the elimination of both a "human" context—the cropped, isolated bodies seen in close-up are photographed as if they were stones—and the kind of modeling that makes the flesh palpable and sensuous to the eye. But even this dehumanized account of the nude could not quite meet the purist standard. The human form remains, even in the age of abstraction, remarkably resistant to total aesthetic liquidation. On the slimmest visual evidence, the mind tends to restore what the eye has eliminated—something that Matisse understood, and counted on, in making his radical reductions of the figure in his late cutouts. And the human body was, perhaps, too large an object encumbered with too many "artistic" associations to serve as the basis of aesthetic absolute. Penn did not, in any case, stay with it long enough to find out.

The cigarette butt, once he discovered how to use it, was more to his purpose. The feeling engendered by these elegant and austere pictures of street trash is not easily described. As one entered the vast

space of the Marlborough show, these were the first pictures that one saw, and there was something at once very familiar and very strange about them. They recalled, altogether involuntarily, those pictures of Egyptian pyramids and Greek temples and Indian shrines we know from nineteenth-century photography, not only in their monumental scale, but in their uncanny evocation of an archaeological romance. Yet an archaeology of the gutter can convey nothing but aesthetic information, and the attention that Penn lavished on refinements of "line, tone, shape and pattern," as John Szarkowski pointed out when he showed these handsome platinum prints at the Museum of Modern Art, made certain that this aesthetic dimension would remain uppermost in our attention. This is what made them so strange and so seductive—that they could capture the romance of archaeology for a purpose so purely aesthetic.

Everything else in the exhibition, which numbered 126 items covering a period of twenty-seven years, was something of an anticlimax after this blitz of aestheticism. The human element in Penn's pictures, always vulnerable to the extreme artifice he brought to them, seemed positively imperiled in this context. His portraits of celebrities, even the most famous ones of Colette and Picasso that are now museum classics, acquired a certain fictitiousness. One could see now, in this gallery of worldly glamour, that it was never character or personality that interested Penn but only fame itself, and it was *that* that he captured so masterfully. In his portraits of celebrities, he thus remained the quintessential fashion photographer, intent upon producing an icon in which all the contingency and commonplaces of experience are stripped away. This, of course, is what the fashion photographer has always been obliged to do—remove his subject from the real world, where clothes and the people who wear them have some contact with life, and relocate them in another, more ideal, more abstract realm where fashion itself is an absolute.

There is really only one series of pictures in Penn's entire work that escapes this tendency toward abstraction, and that is the series on workers in Paris and London that he made in 1950. In these pictures of a butcher, of pastry chefs and a cucumber merchant and a fishmonger and others, he poses his subjects in a space as "empty" and abstract as anything in his fashion pictures or nudes or celebrity portraits, and does everything he can to eliminate their "world" from our view. But the subjects themselves carry too much of that world with them for Penn to succeed completely in aestheticizing them. They introduce

something resistant to his refinements; and as a consequence, these pictures have a tension and a pathos we do not often find elsewhere in his work. We are never given the identity of these figures, yet in a sense they are the only true portraits Penn has given us—the only portraits of character.

Everything else in his work, as we can now see, was a preparation and a rehearsal for his flight into the abstractions of the gutter. Fashion photography is itself, of course, a mode of abstraction that removes the beautiful from all contact with reality, but it is an unsatisfactory mode of abstraction since it is obliged to wear the disguises of reality. This the dishonored cigarette butt is no longer obliged to do. Discarded in the street, it makes its exit from the world of observation, and becomes at that moment the perfect *donnée* for an art that aspires to be purely itself.

OCTOBER 27, 1977

8. Avedon

Art begets antiart. Politics spawns antipolitics. Both in literature and in public life, the exploits of heroes give way to the depredations of antiheroes. Is it any wonder, then, that in the world of glamour and celebrity, where fashions in culture enjoy an authority second only to the fashion of hemline and neckline, the same antiphonal impulse should make itself felt? In an age of sweeping reversals, glamour too will search out ways to perpetuate its spell by negating all customary expectation.

This, more or less, is the hidden scenario—the subtext, if you will—of the extraordinary exhibition of photographs by Richard Avedon that has now come to the Marlborough Gallery. The faces that we meet in this large and absorbing exhibition belong, with few exceptions, to the romance of celebrity. From the Duke and Duchess of Windsor to the Chicago Seven, from Rose Mary Woods and Alger Hiss to Igor Stravinsky and Claes Oldenburg, the roster of subjects insistently evokes the glamour of publicity and rides effortlessly on the pub-

licity of glamour. We are totally enclosed in a world already made both familiar and mysterious to us through the interventions of the media.

Yet the interest of Mr. Avedon's pictures is by no means confined to our instant recognition of their subjects—though that recognition is essential to their power. For we recognize something else in these photographs too: a candor designed to disabuse, an act of demystification intended to strip these celebrities of their aura in order to place them in a world more ''real'' and workaday than the never-never land of media fantasy. Glamour, fame, preferment undoubtedly bring their coveted rewards, but—so we are remorselessly reminded in image after image—worldly glory offers no permanent shield against the ravages of time.

Such ravages, especially as they are made painfully manifest with advancing age, form one of the principal vehicles of Mr. Avedon's special candor. In the triptych of Stravinsky, taken in 1969, we are spared no wrinkle in the neck, no twist of the mouth, no weariness of the flesh. We are treated to similar niceties in the photographs of Jean Renoir, Ezra Pound, Oscar Levant, and a great many others. There is an awful intimacy in this geriatric portraiture—an unearned invasion of privacy bordering at times on the voyeuristic—that fascinates and offends in equal measure.

But age is not the only deformation that excites Mr. Avedon's energetic curiosity.

Wherever the limelight has isolated some spectacular deviation from the norm—whether in culture, politics, or ''society''—and elevated it to an exalted or controversial status, Mr. Avedon has turned his elegant camera eye. A drag ballet dancer shares attention with the sons of Ethel and Julius Rosenberg, the crippled Alexey Brodovitch with the picturesque John Szarkowski. The men who made up the American mission council in Saigon, in 1971, join Andy Warhol and members of The Factory in earning mural-size aggrandizement.

The latter picture, dating from 1969 and measuring thirty feet wide and eight feet high, restores to dubious glory the whole disreputable crew familiar to us from Mr. Warhol's antierotic movies of the 1960s and will undoubtedly be the exhibition's most talked about single work. It contains all the essential features of Mr. Avedon's accomplished style—its air of scandal combined with an unerring elegance, its earthiness mitigated by a very distinct sentimentality.

For in the end, Mr. Avedon is very much a sentimentalist. Just as antiart is, after all, only another form of art, and antipolitics only an-

other expression of politics, so finally is Mr. Avedon's candor only another mode of romance. We see this most emphatically, perhaps, in the political pictures—the mural-size panels of the Chicago Seven and the portraits of Alger Hiss, the Meeropol brothers, et al.—which lavish a sympathy on their subjects denied, say, to William F. Buckley, Jr., or Truman E. Capote. (There is a very definite politics to the exhibition.) Even in the harshest pictures of celebrities, antiglamour serves to give the romance of glamour a new and unexpected lease on our attention.

The work gathered in this exhibition—the Marlborough Gallery's first venture into the photography market, by the way—is no small achievement. Mr. Avedon's is a powerful and original talent, and it adds a significant increment to—indeed, it significantly alters—one of the great traditions of photography: the tradition of the posed celebrity portrait. But for all its franknesses, it remains tethered to that tradition and offers photography little that can be usefully applied outside its narrow boundaries.

SEPTEMBER 11, 1975

9. The New American Photography

One of the most striking developments in the recent history of the visual arts in this country has been the elevation of photography to an exalted new status. In popular journalism it has become a commonplace to speak of the "photography explosion," and in professional photographic circles there is an emphatic new sense of pride, opportunity, and achievement as the old barriers separating photography from the other arts diminish to the point of total disappearance. Once considered an upstart rival of the more traditional artistic media, and frequently reduced to an ancillary role in the arts—of more use as a visual aid to the real thing than as a mode of creative expression in its own right—photography has now been welcomed to the aesthetic sanctum of our culture on a scale that even its most devoted champions of an earlier day might have hesitated to predict.

We see the evidence of this change wherever we look. Museums and galleries once rigorously restricted to painting and sculpture and the allied arts of drawing and printmaking now accord photography a significant place both in their exhibition schedules and in their acquisition budgets. Publishers, among them some of the most hard-nosed commercial operatives in the business, now sponsor photography books in lavish profusion, and there seems no end to the courses, workshops, and special conferences currently devoted to the subject.

The art market, too, has responded enthusiastically to this development. The prices of both vintage prints—early photographic classics printed in the period of their creation—and certain new photographs by well-regarded contemporary figures—continue to soar. Criticism of photography has also expanded at every level, from the space given reviews of books and exhibitions in the press to scholarly tomes reflecting the latest research into the photographic past. More and more is now written *about* photography than ever before in its history—a trend that reached a kind of climax this year when Susan Sontag's controversial book *On Photography* found its way onto the best-seller lists and into bookstore window displays of popular books across the country.

Clearly, the sheer interest in photography is now both intense and widespread. It commands the kind of attention that our culture reserves for phenomena of a special appeal—for objects that elicit a sense of excitement and discovery about the emotions and ideas that are felt to govern the very terms of our existence.

What often remains baffling about this development, even to the large public that is so obviously responsive to it, is the place to be accorded *contemporary* photography in all this activity. In the midst of the so-called photography explosion, what has actually happened to photography itself—to photography as it has evolved in this new climate of acceptance and as it is now practiced as a self-conscious art? This is the question that often bewilders the public otherwise so ardently disposed to embrace photography—but mostly, of course, the photography of the past—as an important new experience.

From time to time, a new contemporary figure emerges from the ranks of the many photographers competing for our attention and succeeds in capturing the public imagination. The late Diane Arbus did this only a few years ago with her startling pictures of "freaks." Even so, the more general climate of photographic thought in which a Diane Arbus functioned remains difficult to perceive. We tend to see contem-

porary photography as fragments, picking out what we like and reject-ing what we dislike, without attempting a coherent account—even a provisional account—of the scene as a whole.

Now an ambitious attempt to provide such an account has been made in an exhibition called "Mirrors and Windows: American Pho-tography Since 1960," at the Museum of Modern Art in New York. Organized by John Szarkowski, director of the museum's Department of Photography and author of the book that serves as the exhibition's catalogue, this is a show bound to wield considerable influence and to generate a great deal of discussion and controversy. No newcomer to this field, the Museum of Modern Art has made the art of photogra-phy an integral part of its museological program for some forty years. It has assembled a great permanent collection, mounted many defini-tive exhibitions, and published some of the classic books on photogra-phy. Its authority is therefore immense, especially in certifying new reputations. Its judgments are the closest thing we have to an "offi-cial" opinion on photography as an art.

Mr. Szarkowski, moreover, has very definite views on where the mainstream of photographic achievement lies in the work of the last two decades, and the pictures he has selected for this exhibition—some 200 prints representing 95 photographers—are likely, in many cases, to astonish and even offend the public that is now so avid for photogra-phy. (It is likely, too, to alienate even further the part of the public that remains skeptical about photography's claims to artistic importance.)

"Mirrors and Windows" is a "tough" show that makes few obvi-ous concessions to the traditional gratifications to be found in photog-raphy. And since Mr. Szarkowski is also one of our most respected and eloquent writers on photography, his text for the catalogue of the show is certain to become an object of enduring argument. The history of photography in our time may or may not turn out to be exactly what Mr. Szarkowski says it is, but his views on the subject are certain to have a place in that history—a more permanent place, I suspect, that some of the photographers he has included in the exhibition.

Before approaching "Mirrors and Windows," however, it is well to be reminded that much of the attention that photography receives today is attention lavished on the past, for this deeply affects our re-sponse to new pictures. It shapes expectations that the new photogra-phy has little or no interest in satisfying. Certain linkages between the new photography and the familiar classics may be discernible—as we

shall presently see, Mr. Szarkowski makes a point of establishing such connections—but it is in the way the new differs from the old that the new is likely to remain most striking.

Julia Margaret Cameron's portraits of Victorian worthies, Eugène Atget's pictures of Paris at the turn of the century, even Ansel Adams's idyllic photographs of Yosemite and the American West—to name only three of the most popular oeuvres that have endeared themselves to the new public for photography—are, whatever their differences from each other, alike in conjuring up a world remote from our own. The very pastness of the past that is so movingly evoked in such pictures has something to do with the pleasure we now take in them.

So much so, indeed, that this pleasure now extends to even less remarkable pictures of the more recent past—to old press photographs of political campaigns and society events; to publicity pictures of film stars and sports figures and popular entertainers; to just about any picture, in fact, that vividly records a glimpse of a time and a place and an object now almost mythical in their distance from the observable realities of our own lives. Call it nostalgia or history or romance—for all of these play a role, though not necessarily the dominant or final role, in our taste for pictures of the past. But however we define the appeal of these pictures, what they have in common is their pastness—their status as documents of experience (and emotions) remote from our own.

To the extent that photography still remains committed to the documentary function, we are not made to feel any disturbing breach with the photographic traditions of the past. It is the times that we perceive to have changed, not the conception of the medium employed to record change. Immense numbers of photographs—no doubt the majority, even in today's atmosphere of heightened aesthetic consciousness in photography—continue to be devoted to the documentary task, and these are easily admired and eagerly consumed. Most of us, indeed, can hardly have enough of them whether we see them in exhibitions, in the pages of newspapers, magazines, and books, or take them ourselves. They come in all varieties—the "beautiful," the "ugly," the whimsical and the banal, even (lately) the pornographic—and our appetite for them is prodigious.

Their status as documents of something "real" guarantees our attention, and exacts from us no special consideration of the medium used in their creation. They are now firmly established as the "prose"

of photography, and it is hard to imagine a time when we will not continue to be addicted to them.

But these documentary pictures, perhaps because of their very ubiquity and utility and their tendency to degenerate into easily recognized clichés, are not the photographs now most ardently admired as works of art. The conventions of documentary photography presuppose a certain kind of "liberal" interest—shared by the photographer and his public—in society, and this is not the foremost interest that artistically ambitious photographers now bring to their work.

The photographers themselves may be liberals, even radicals—my impression is that many of them are the one or the other—but they no longer conceive of their function as that of serving the goals of social consciousness.

Eschewing the "prose" of the documentary tradition, the new photographers are in search of a more personal "poetry" in their pictures. In looking at the world "out there," their concerns are essentially inward. It is not society that commands their allegiance, but something else—the imperatives of a personal vision. Certain details of the social landscape may still figure in the iconography of their pictures—they usually do, in fact—but these tend not to be the kind of details that define social issues. They are images of an interior dream, and emblems of private sensibility.

"The general movement of American photography during the past quarter century," Mr. Szarkowski writes, "has been from public to private concerns," and this is the premise upon which the "Mirrors and Windows" exhibition has been built. One may regret or even deplore this development—many observers do, decrying the defection of yet another powerful artistic medium to the realm of aestheticism, subjectivism, and formalist irony that has already claimed so many of the other arts in our time. We have seen the same essential course traced in the development of poetry and fiction, and its triumph in painting and sculpture has long been taken for granted. The wonder, perhaps, is not that photography has succumbed to a trend so widely observed elsewhere in the arts but that it has taken so long for us to recognize it.

What Mr. Szarkowski has undertaken to do in the "Mirrors and Windows" exhibition and its accompanying catalogue is not to bring us news of this trend—this he has repeatedly done already in a succession of smaller exhibitions and publications at the museum—but to examine its constituent parts, explain its aesthetic principles, offer us

wide-ranging examples of the excellence he believes it to have achieved, and aid us in understanding the relation in which the movement stands to the immediate past.

Within the realm of "private concerns" that Mr. Szarkowski believes to have dominated photography in the last two decades, he sees a significant division of impulse—"a fundamental dichotomy . . . between those who think of photography as a means of self-expression and those who think of it as a method of exploration." A division, in other words, between the photograph as a "mirror" and the photograph as a "window." The first, he suggests, derives from an essentially "realist" view—though Mr. Szarkowski's use of the term "realist" in this context strips it of any suggestion of the social ideology that has traditionally been attached to it.

> The distinction, [he writes] may be expressed in terms of alternative views of the artistic function of the exterior world. The romantic view is that the meanings of the world are dependent on our own understandings. The field mouse, the skylark, the sky itself, do not earn their meanings out of their own evolutionary history, but are meaningful in terms of the anthropocentric metaphors that we assign to them. It is the realist view that the world exists independent of human attention, that it contains discoverable patterns of intrinsic meaning, and that by discerning these patterns, and forming models or symbols of them with the materials of his art, the artist is joined to a larger intelligence.

(It should be noted, perhaps, that this view of the realist aesthetic, which effectively separates it from the social documentary impulse, goes a long way toward turning realism into its opposite—that is, into a mode of formalism. And this, incidentally, is very much the revisionist concept of realism now in force among some of the contemporary painters who have been responsible for the revival of realism in *their* medium.)

The romantic in photography thus functions as a fantasist and visionary, more interested in the materials and techniques of the imagination than in the observable "raw" data of experience, whereas the realist functions as, in Mr. Szarkowski's words, "a disinterested chance witness" of the world around him. For each of these dichotomous approaches to the photographic vocation, Mr. Szarkowski provides a distinguished lineage. He traces the romantic "mirror" photographers back to the mystical Minor White and his great mentor, Alfred Stieglitz; the realist "window" photographers to Robert Frank and his great predecessor, Eugène Atget. (Whether the masterly and

systematic Atget, who applied himself to photographing Paris and Versailles as if he were the curator of a museum, cataloguing its store of precious objects, can really be made to serve as patron saint of "chance witness" realism is doubtful, to say the least—but this is only one of many points likely to be disputed in Mr. Szarkowski's historical scenario.)

In this reading of history, then, the world of photography—which only yesterday, it seems, looked so ample and far-reaching, so capacious in encompassing every kind of experience and event, and so authoritative in its depiction of an objective social macrocosm—this world radically recedes to the reduced microcosmic dimensions of "private concerns." The bold appetite with which photography once devoured the big world is dismissed as an aspiration based on an illusion.

Mr. Szarkowski writes the epitaph for a whole era of photographic ambition when he observes, apropos of the decline of photojournalism as it existed in the era of *Life* and similar magazines—and his verdict extends far beyond photojournalism, of course—that "good photographers had long since known—whether or not they admitted it to their editors—that most [public] issues of importance cannot be photographed." This dour dictum, warning against undue expectations, might well be inscribed over the entrance to the "Mirrors and Windows" exhibition. It alerts us to the "dropout" mentality that prevails in so many of the pictures to be seen in it.

With the large ambitions and "big" subjects of the past now deemed either illusory or obsolete, what (we may ask) *can* be effectively photographed? Well, as it turns out, quite a lot—even by the rather special standards of the pictures Mr. Szarkowski has assembled in this survey. There is the theater of the self, for example—that rich vein of aesthetic narcissism that we see given a stunning realization in one of Lucas Samaras's "Photo-Transformations." Compressed in the tiny space of a Polaroid picture is an elaborate image of the artist's own naked body artfully metamorphosed into a Surrealist object-tableau. This, perhaps, is the purest instance of the "mirror" aesthetic in the whole show.

But there is quite a lot of Surrealism in the exhibition. This is what might be called "late" Surrealism—the Surrealism of Magritte paintings and Buñuel movies and Joseph Cornell boxes—now translated into a photographic idiom. We see it in Jerry N. Uelsmann's haunting dream pictures deftly constructed out of vividly incongruous images; in

Joseph Bellanca's *A Special Place*, in which the perfectly legible figure reclining in a leaf-strewn autumn landscape in the lower half of the picture appears to be "dreaming" the blurry image depicted in the upper half; and in Ralph Gibson's *The Enchanted Hand*, another mysterious dreamscape in which we see only a hand (the rest of the body remains "offstage") silhouetted in the unearthly light of an open doorway. There is even a Magritte-like air of incongruous juxtaposition in Mark Cohen's "chance witness" picture of a young girl's head "masked" by an immense balloon (or is it some grossly distended bubble gum?) with a mysterious hand raised behind it.

There are quite a few naked bodies in "Mirrors and Windows," too. Usually it is the female body that we are shown—that much has not changed here—and more often seen as a "mirror" of the mind than as a "window" on the world. Tetsu Okuhara gives us a remarkable multiple-image picture of a nude in the form of a Cubist mosaic. Robert Heinecken, in his *Refractive Hexagon*, divides the nude into twenty-four movable segments, each enclosed in a triangular module, thus (like Okuhara) translating the imagery of the body into the language of abstraction.

Elsewhere, in Duane Michals, the nude is used as an element in a narrative fantasy, or, in a picture by Leslie Krims showing a naked figure half covered by a pile of autumn leaves (we see the figure only from the waist down), as a stunt-man's prop. Happening upon a picture of a young girl's head and torso like Sheila Metzner's *Evyan* in this context is something of a shock—the shock of a picture that is very straight and very beautiful and utterly unembarrassed about the affection it conveys.

As the foregoing references to Surrealism, Cubism, and abstraction may suggest, one of the things we see in "Mirror and Windows"—it is one of the points Mr. Szarkowski has deliberately set out to make—is the way recent photography has availed itself of forms and devices already familiar to us in modernist painting, drawing, and collage, and has itself influenced these forms and devices.

This convergence of the photographic and the non-photographic in recent art is underscored by the inclusion here of work by Robert Rauschenberg, Andy Warhol, and Sol LeWitt, who, like Lucas Samaras, are well-established artists in other media. This is a move certain to cause offense to photographic purists, but it does have the virtue of signaling the degree to which photography now yearns both to emulate the other arts and to influence them.

Another index of this new "art" emphasis in photography is the serious attention given to color—something the purists used to scorn. In Joel Meyerowitz's *Hartwig House, Truro*, we can see the uses of color employed to great effect, as he alternates between a formalism in which the subject is reduced to its purist elements and the "chance-witness" view of a commonplace subject.

Then there is photography about photography—the kind of photograph that looks at photography itself in a mood of ironic self-examination. The outstanding example is Ken Josephson's *Drottningholm, Sweden*, in which an austere view of this lovely rococo summer-theater retreat, shown off-season with its open-air statuary boarded up for the winter, is juxtaposed to a hand (presumably the photographer's) holding up a more romantic picture-postcard view of the same scene at the height of the summer season.

Still, there is a great deal here to satisfy the photographic purist. For one thing, both the landscape and the cityscape can still be seen to hold the photographic mind in thrall; and in work by Paul Caponigro, George Tice, Richard Misrach, Lewis Baltz, Art Sinsabaugh, Robert Adams, Eliot Porter, and Tod Papageorge (especially in the last's wonderful picture of New York during Operation Sail in 1976), photography of this persuasion shows itself to be alive and well, and quite capable of sustaining comparison with the masterworks of the genre.

The individual portrait, however, makes a more fugitive appearance. I have already mentioned Sheila Metzner's *Evyan*. There is also a fine portrait of a woman by Judy Dater, two stunning portraits of slaughterhouse workers by Jerome Liebling, and several of Diane Arbus's now well-known pictures of human oddities. But, the truth is, the individual person is not paid much significant attention in this exhibition. People are glimpsed more often than looked at; it is their "choreography" rather than their individuality that is singled out for our attention. Even in Danny Lyon's fine *Ellis Prison, Texas*, the prisoners look like figures in a modern dance performance—something that does not happen to the children in Helen Levitt's beautiful street picture, which conveys a pathos beyond the aesthetic.

For the most part, there are no individuals to be observed in "Mirrors and Windows"; they have been displaced by the sensibility of the photographer. And something curious has happened to this sensibility in the period covered by this exhibition—it has become addicted to aggrandizing trite happenstance, to making a cult of banality.

The "dumb" photograph has been made into an artistic conven-

tion, admired precisely because there is so little of obvious interest in it to admire. Garry Winogrand is the leading prophet of this movement, Lee Friedlander is one of its most celebrated votaries, and their disciples abound, traveling the length and breadth of the world in search of unremarkable subjects and situations, and finding them, too.

Mr. Szarkowski holds such work in very high esteem, and so it is naturally given a central place in this exhibition. Its aesthetic attractions, frankly, escape me, but there is no denying that it is much admired, especially by other photographers. It is, perhaps, the quintessential statement of the "dropout" sensibility, appearing to celebrate an egalitarian vision of the objects of experience while actually making the photographer himself his own central subject of interest.

Perhaps this is what inevitably happens when photography turns away from the big world to become primarily a museum art. In an exhibition of "American Photography Since 1960," there is scarcely a hint of the civil-rights movement, the moon shot, or the war in Vietnam and the protest movements it spawned: nothing of Watergate and its traumas, either. One could, indeed, compile quite a list of things that are left unrecorded in "Mirror and Windows," which gives us instead an aestheticized "dropout" view of American civilization in the last two decades. In this respect, at least, it may be telling us something important not only about what has happened to photography but about what has happened to *us*, too.

JULY 23, 1928

V. Critics and Controversies

1. Tom Wolfe and the
 Revenge of the Philistines

Midway through the 1970s, it looks more and more as if the present decade is destined to become the graveyard of all those illusions and chimeras spawned in the radical culture of the 1960s. The signs of recoil and retrenchment, hesitant and uncertain only two or three years ago, now gather momentum with dizzying speed: the noise of recantation fairly fills the air. In certain notable cases, the very protagonists of the ''new sensibility'' of the sixties have suddenly reemerged— chastened, one would like to think, but perhaps only well-practiced in their reading of the opportunities—as spokesmen for the values they so recently lavished with furious contempt. When we open the pages of *The New York Review of Books* to find Susan Sontag energetically rebuking ''the infantile leftism of the 1960s,'' we may be reasonably certain that we are in the presence of one of those geologic shifts that completely alter the ideological terrain on which we stand.

Because the visual arts have occupied the center of the cultural stage in this country since the international success of the New York School in the 1950s, the evidence of change is perhaps a little more blatant in this realm than in others—but what is happening in the visual arts is surely emblematic of something widespread and momentous. We are witnessing the final collapse of the great myth that dominated the aspirations of high culture in the West for more than a century—

the myth of avant-garde intransigence and revolt that gave to all of modernist culture its aura of moral combat—and we are seeing, at the same time, the opening skirmishes of a new contest to determine precisely what the relation of culture to power will be in the postmodernist era upon which we have now entered.

This contest is taking two forms, and it is imperative—imperative, at least, for those of us who wish to distinguish and defend the values of high culture from the onslaught of its trashy simulacra—that we make a clear and unequivocal distinction between them. We have, on the one hand, a growing movement—among artists and art historians, and among the critics and curators who pay close attention to their shifts of taste and allegiance—to reconsider all those options and alternatives so long foreclosed by the pieties of vanguard doctrine. This is a movement of the greatest consequence, for whatever it may eventually produce, or fail to produce, in the way of new art—and it has already reestablished realism as a viable artistic enterprise in painting—it has initiated some drastic revisions in the way the history of modern painting is perceived and evaluated. No longer are the legendary *cénacles* of avant-garde incendiaries presumed to have an exclusive patent on artistic excellence. The official Salon of nineteenth-century France, once the most detested of all the institutions that conspired against a just appreciation of avant-garde achievement, is now the subject of an intense and competitive research. Forgotten Academicians are being exhumed by the carload, and museums vie with each other for the honor of exhibiting the enemies of Manet and Cézanne, who, coincidentally, are suddenly discovered to have links with the Academy never suspected by their radical defenders of yesteryear.

This revisionist attack on the orthodox reading of modernist art history has the virtue of reopening some fundamental questions about the relation of art to the society that produces and exalts it—questions that are now, as the result of this effort, seen as no longer susceptible of the simplistic answers provided by *révolté* ideology. Bourgeois taste, in this new reading of history, is not regarded as necessarily fatal to the life of the imagination; an art that flatters or at least accommodates itself to established power is not automatically dismissed as contemptible. It is more readily assumed that in a decent and enlightened modern society, art—including the highest art—may have a plurality of functions to perform and that the one honored above all others in the mythology of the avant-garde—the celebrated charge, *épater* the bourgeoisie—is not invariably the most important or the most endur-

ing. It does not require any special genius, I think, to see in this sweeping revisionism an oblique, or at least an unacknowledged, reflection of the peaceful accommodation that now obtains between art and the middle class, and—what is already looming as a factor of even greater consequence—between art and the various government agencies responsible for art's support. A society more and more dependent upon government subsidies for its own cultural prosperity will naturally have some second thoughts about the role of patronage and approved taste in the era that allegedly saw the artist and the bourgeoisie locked in mortal combat, though it is still part of the comedy of culture for these thoughts to remain disguised in the rhetoric of disinterested research.

On the other hand—and this is the darker and more threatening aspect of the contest I speak of—this whole revisionist enterprise has contained from the beginning a large element of philistine revenge. That the excesses and exclusivities of modernist art are beginning to be denied the easy ordination and overblown praise that would have been granted them, say, ten years ago, as if by divine right, is not, in my opinion, a vicissitude to be despised. But something other than critical intelligence is also at work in this refusal to embrace the latest inanities of the far-out fringe of modernism—something virulent and reactionary that looks dangerously close at times to an assault on mind itself. It is not merely the peripheral rubbish foisted upon us in the name of modernism that is being scuttled in this accelerating reversal of taste. What we are seeing, I think, is the beginning of a resurgent campaign to discredit the mainstream of modernist achievement. In no other branch of the arts, in no other arena of public taste, has the hegemony of the avant-garde ideal enjoyed such sustained and unbounded patronage and prestige as in the visual arts, and it is the latter, therefore, that provide the broadest and most accessible target for the feelings of revulsion and nostalgia that are now gathering force. Not only is there now an epidemic desire to restore to the highest respectability some of the very worst examples of the kind of art that the modern movement seemed, only a few years ago, to have permanently retired from serious consideration—as I write, the Metropolitan Museum of Art is showing a collection of paintings originally exhibited at the Royal Academy during the reign of Queen Victoria, and the New York Cultural Center, always eager to raise the ante in such matters, is showing French military paintings from the 1870s—but there is, along with it, a correlative passion to turn back the clock of history, to liquidate all

those difficulties of perception and discriminations of feeling that are the very essence of the modernist accomplishment.

If one had any lingering doubt that the revenge of the philistines is upon us, it would surely be put to rest by the spectacle of Tom Wolfe's energetic assault on contemporary art in the April number of *Harper's* magazine. There is, of course, a tradition of philistine hostility to modernist art at *Harper's*—one can read about it in Russell Lynes's history of the Museum of Modern Art, *Good Old Modern,* published in 1973—but Wolfe's attack cannot be dismissed as just another peevish argument about styles and reputations. He is out for far bigger game—the kind of trophy he successfully carried off in his celebrated portrait of *Radical Chic*—and while he does not, I think, score quite the same success in *The Painted Word*, for reasons that are worth exploring, it would be foolish indeed to pretend that he has not caught hold of a fairly sizable carcass. About art, modernist or otherwise, Wolfe appears to know next to nothing. But about manners and the volatile ethos of our cultural life, he knows a great deal—as much, in my opinion, as anyone now writing—and he brings a buccaneer's audacity to anatomizing the secret scenarios of hypocrisy and pretension that govern the social and intellectual existence of the "advanced" middle class—precisely the class that gave to the votaries of the avant-garde their conspicuous and protracted purchase on our cultural affairs. His sense of timing, moreover, is flawless. If, as I believe, *The Painted Word* announces that this class has now suffered a surfeit of interest in the avant-garde phenomenon and is in the process of withdrawing assent from the more opprobrious, obscurantist, and addlebrained fruits of its endeavors, then that is news of considerable import. For it means that the "scene" inaugurated by the Pop art antics of the sixties—not just a style of painting and sculpture, which has, in any event, long since passed into eclipse as an artistic force, but the whole movement that saw swingers of every variety commandeer the institutions of the avant-garde and swiftly transform them into a raucous and conscienceless parody of the once lofty intentions of the avant-garde—has passed into limbo, and the class to whose needs and illusions it ministered is busily nursing a gigantic historical hangover.

Tom Wolfe and his famous style—"Hernia, hernia, hernia, hernia, hernia, hernia," etc., to quote from the opening words of *The Kandy-Kolored Tangerine-Flake Streamline Baby* (1965)—are themselves the offspring of this discotheque culture, and this places him at a certain disadvantage in dealing with anything that occurred in the art world

before the dawn of the Pop art era. He writes, so to speak, from inside the bubble, and this inevitably gives him a distorted perspective on everything that occupies a place in the historical distance. At the same time—and this is distinctly *not* a disadvantage for a chronicler of manners—he sees all of modernist art exactly as the new swinging audience that came to it in the sixties saw it: through the lens of the Pop scene, with its instant reputations and carnival changes of fortune, whence everyone and everything—art and artist, critic and criticism, collector and dealer, and museum curator and the various powers they wield—are perceived as little more than magical counters in a game of money, status, and fashion. He sees it, in other words, exclusively as a form of chic.

And that, really, is what *The Painted Word* is about: avant-garde chic in the sixties. Its ostensible focus, however, is not on the art itself but on the criticism written about it, and this unexpected emphasis—on, as the title indicates, *words* rather than on pictures—allows him to engage in a good deal of high-handed comedy at the expense of the ideas and the personalities that have dominated the discussion of modernist art in this country for a generation or more. It also gives him immediate access to the larger public that knows nothing about modernist art but knows what is rumored to have been said on its behalf and is alternately irritated, incredulous, and angry that anything serious and "deep" should be said on behalf of a body of work so remote from commonsense notions of urgent human expression. To turn the language of criticism into a form of social farce is not in itself a formidable task: the solemnities of criticism often meet the satirist more than halfway in providing the materials of comedy, and it does not require any special gift to isolate what is patently absurd in its more hermetic disquisitions. But Wolfe once again carries all this a step further than expected: he makes the critics themselves—principally Clement Greenberg, but also Harold Rosenberg and Leo Steinberg—not only figures of fun, but (worst insult of all!) fiercely competitive *apparatchiks* in the bureaucracy of chic. In Wolfe's scenario of the contemporary art scene, theory—ever more elaborate, ever more demanding, ever more jealous of its prerogatives—casts its infamous spell over every endeavor. "Theories? They were more than theories, they were mental constructs. No, more than that even . . . veritable edifices behind the eyeballs they were . . . castles in the cortex . . . mezuzahs on the pyramids of Betz . . . crystalline . . . comparable in their bizarre refinements to medieval Scholasticism."

According to *The Painted Word*, these "edifices behind the eyeballs" constructed by Greenberg et al., constitute the first cause of what artists do, what collectors and museums favor with their money and attention, what you and I see, or think we see, when we look at the results, and, most important, what the people Wolfe calls "Le Chic," or alternately (reaching into Mencken's old phrase book), "*le monde*, the culturati," will lavish with their golden publicity and patronage. By combining, collage-fashion, oddments of gossip and invidious speculation of the sort usually confined to cocktail parties and museum openings with tag ends of quotations and bits of potted history, Wolfe constructs a social comedy in which critics issue their absurd fiats and artists hustle to carry them out to the letter until the day dawns when a new generation of artists—seeing where the real power lies—stages a coup, takes over the reins of theory, and exposes the aging theoreticians of earlier days as passé.

Some of this is very amusing, and the general attitude of skepticism and suspicion that Wolfe brings to the subject—the suspicion that something more than disinterested aesthetic inquiry may be at work in this labor of critical theory—is both well-deserved and overdue.[1] He has a particularly wicked eye for those moments when the ante is abruptly raised in the avant-garde sweepstakes by hungry newcomers to the scene, thereby calling the bluff of the "advanced" theories of the reigning mandarins and instantly revealing them to be establishmentarians with vested territories to protect. Thus, on the *Kulturkampf* staged by the firebrands of Minimalism in the 1960s, Wolfe writes:

> Faster and faster art theory flew now, in ever-tighter and more dazzling turns. It was dizzying, so much so that both Greenberg and Rosenberg were shocked—*épatés.* Greenberg accused the Minimalists of living for "the far-out as an end in itself." Their work was "too much a feat of ideation . . . something deduced instead of felt or discovered." A little late to be saying that, Clement! Rosenberg tried to stop them by saying they really weren't far-out at all—they were a fake avant-garde, a mere "DMZ vanguard," a buffer between the *real* avant-garde (his boy de Kooning) and the mass media. Very subtle—and absolutely hopeless, Harold! Theory, with a head of its own now, spun on and chewed up the two old boys

[1]Regarding Wolfe's questioning of the pieties of this criticism or the avant-garde mythology on which it is based, I myself, as the author of *The Age of the Avant-Garde*, feel a bit like Bertrand Russell, who, in acknowledging receipt of a book by C. E. M. Joad, wrote: "Dear Joad, I would praise your new book, but modesty forbids." But Wolfe is, undeniably, the first to turn the subject into outright comedy.

like breadsticks, like the Revolution devouring Robespierre and Danton—faster and faster—in ever-tighter and more dazzling turns—let's see, we just got rid of the little rows of *hung pictures*, not to mention a couple of superannuated critics, and we've gotten rid of illusion, representational objects, the third dimension, pigment (or most of it), brushstrokes, and now frames and canvas—but what about the wall itself? What about the very idea of a work of art as something "on a wall" at all? How very pre-Modern!

Wolfe is very sharp, too, on catching critics out on those minute adjustments they sometimes make in amending their pronouncements in order to protect their reputations. Thus, about Leo Steinberg's rhapsodic discovery of Jasper Johns, Wolfe notes the following little hedge:

As soon as he realized what Johns's work meant, said Steinberg, "the pictures of de Kooning and Kline, it seemed to me, were suddenly tossed into one pot with Rembrandt and Giotto. All alike suddenly became painters of illusion." Later on Steinberg changed that to "Watteau and Giotto"; perhaps for the crazy trans-lingual rhyme, which, I must say, I like . . . or perhaps because being tossed into the same pot with Rembrandt, even by Leo Steinberg, was a fate that any artist, de Kooning included, might not mind terribly.

All this is, as I say, amusing and well-deserved, and it remains amusing so long as Wolfe addresses himself to the world he knows best—the world of chic, and the scramble for fame, money, influence, and sheer visibility that makes that particular world go round. Wolfe knows exactly what the role of highbrow theorizing, the role of *mind*, is in that world, and the exact rewards it brings to the happy few—whether artists or critics or collectors—who become the beneficiaries of what he aptly describes as its "art-mating ritual." "The artist's payoff in this ritual," he writes, "is obvious enough. He stands to gain precisely what Freud says are the goals of the artist: fame, money, and beautiful lovers." And for the collectors who hand over the large sums of money for the art certified by all this critical cerebration? "What's in it for them?" Wolfe asks, and he gives the best answer I have ever seen:

Today there is a peculiarly modern reward that the avant-garde artist can give his benefactor: namely, the feeling that he, like his mate the artist, is separate from and aloof from the bourgeoisie, the middle classes . . . the feeling that he may be *from* the middle class but he is no longer *in* it . . . the feeling that he is a fellow soldier, or at least an aide-de-camp or an honor-

ary cong guerrilla in the vanguard march through the land of the philis-
tines. This is a peculiarly modern need and a peculiarly modern kind of
salvation (from the sin of Too Much Money) and something quite com-
mon among the well-to-do all over the West, in Rome and Milan as well as
New York. That is why collecting contemporary art, the leading edge, the
latest thing, warm and wet from the loft, appeals specifically to those who
feel most uneasy about their own commercial wealth. . . . Avant-garde
art, more than any other, takes the Mammon and the Moloch out of
money, puts Levi's, turtlenecks, muttonchops, and other mantles and lau-
rels of bohemian grace upon it.

All of this is in a class with *Radical Chic*, for it addresses itself to the
same kind of material: the secret life of the bourgeois psyche, and the
marriage of manners and ideology it exacts—the historic vulnerability
of the prosperous middle class to any pressure that threatens to expose
its lack of perfect alignment with the fashions of the day. (Is it to the dy-
namic of capitalism, and to the rootlessness and restlessness that its up-
ward mobility induces, that the middle class owes this vulnerability to
chic? It would be interesting to know, though a serious account of
middle-class society is about the last thing one can expect from the aca-
demic historians of the present day: they tend, if I may borrow a
phrase, to be part of the problem rather than of the solution.) The kind
of cowardice—not only about aesthetics, but about politics and morals
as well—that this fear of appearing out-of-date and out-of-style breeds
in the middle class—a fear of appearing illiberal in the eyes of one's
contemporaries and ridiculous in the eye of history—is, of course, one
of the traditional subjects of bourgeois comedy, and it is a subject that
Wolfe handles with great finesse. Who will ever forget those "Roque-
fort cheese morsels rolled in crushed nuts" ("It's the way the dry sacki-
ness of the nuts tiptoes up against the dour savor of the cheese that is so
nice, so subtle") that usher us into the scene in Leonard Bernstein's liv-
ing room, where the Black Panthers are being entertained by the *haut
monde*? Wolfe is without peer in detailing the world in which the culti-
vated middle class acts out its elaborate comedies of conformism to
whatever taste—"in" taste, "advanced" taste, the taste that distin-
guishes it from the common herd—requires of it, whether it is a passing
political alliance with its own worst enemies or a more benign commit-
ment to far-out styles of painting.

When it comes to the analysis of ideas, however, when it comes
down to actual works of art and the thinking they both embody and in-
spire, Wolfe is hopelessly out of his depth. So long as he is dealing with

the theory and practice of art as a comedy of manners, he is illuminating and often hilarious. But a reading of *The Painted Word* suggests that it is *only* as a comedy of manners that these subjects exist for him. He has no real grasp of their inner substance, and he has no language, in any case, in which they can be accurately discussed. The principal reason why *The Painted Word* fails to repeat the success of *Radical Chic* is that its subject requires, as *Radical Chic* did not, an effort of historical exposition and critical explication that is beyond Wolfe's powers (and, no doubt, beyond his true interests). In this realm, he is obliged to rely on secondhand observation and hearsay evidence, and these prove insufficient, to say the least. *The Painted Word* is a relatively short text, but it has its longueurs wherever the history of either an idea or an aesthetic impulse must be recounted, for these take place offstage, in regions of the mind unfrequented by this expert voyeur of *"le monde"* and effectively closed to the world of chic until the moment when an idea-whose-time-has-come suddenly emerges, at which point, more often than not, it has already been sadly diluted, distorted, and vulgarized. This vulgarization is, to be sure, a proper subject for comedy, but to mistake it for the real thing—as Wolfe so often does—is also comic, and in a way he does not intend.

Wolfe has some merry moments with Harold Rosenberg, for example, and it would require a more saintly immunity to the emotion of *Schadenfreude* than it is within my power to muster not to feel that the ridicule is eminently well-earned. But in the end Wolfe is unable to deal either with Rosenberg's career or with his ideas. He correctly recognizes that the term *Action painting* became, as he says, "the single most famous phrase of the period," and—always alert to internecine jealousies—that this was "a fact that did not please Greenberg." Wolfe is amusing, too, about the preposterous image of the painter that emerges from Rosenberg's famous essay on "The American Action Painters"—"a Promethean artist gorged with emotion and over-loaded with paint, hurling himself and his brushes at the canvas as if in hand-to-hand combat with Fate"—but he does not really grasp that the autogenous phrase on which Rosenberg's entire career as an art critic was founded was a fraud from the outset. "At a certain moment the canvas began to appear to one American painter after another as an arena in which to act—rather than as a space in which to reproduce, re-design, analyze or 'express' an object, actual or imagined," the famous passage reads. "What was to go on the canvas was not a picture but an event." Yet these nonpictorial "events"—the residue of an

"action" alleged to be devoid of conscious aesthetic intention—somehow managed to be exhibited and looked at and bought and sold and coveted and written about—by, among others, Harold Rosenberg in the pages of *The New Yorker*—as if they really *were* pictures. Rosenberg himself even managed to acquire a sufficient quantity of these "events" to exhibit his private collection of them in a museum, just the way you or I would exhibit our collections of pictures. How interesting it would be to know if the insurance coverage of that exhibition was for "pictures" or for "events": one of the many comic details attaching to this career that Wolfe has missed out on.

The whole concept of "Action" was, alas, a complete fiction, an aborted attempt to confer the luster of an Existentialist ethic—an aura of Sartrean authenticity—on an essentially aesthetic enterprise. "The new painting has broken down every distinction between art and life," we were told in this same essay, and yet in real life, where artists (even "Action painters") die and bequeath estates, and their work becomes the object of investment analysts and the subject of protracted litigation, the distinction somehow persisted. It was the art rather than the life, after all, that brought all those record prices at Parke-Bernet auctions and turned whole areas of the New York gallery world into an obscene money market: a subject you will not find much discussed in the column called "The Art World" that Rosenberg writes in *The New Yorker*. But then, the art world discussed in that column is a curiously truncated version of the one most of us see with our eyes week after week. Exhibitions great and small fill the galleries and museums season upon season, but only the very few that lend themselves to the purposes of ideology—to renewing the romance of "Action" art as the latest and the last avowal of the myth of the avant-garde—are ever acknowledged and dilated upon. By now, the concept of "Action" has acquired in Rosenberg's universe of discourse a status comparable to that enjoyed by the concept of the Trinity in certain works of theology: it is the vehicle by means of which all contradictions of logic and evidence are rhetorically reconciled.

Rosenberg is a particularly egregious example of the critic as ideologue, trimming every aesthetic reality to fit the procrustean bed of an adored myth. In his latest collection of essays, *Discovering the Present* (University of Chicago Press), he reprints without embarrassment yet another affirmation of the myth—the piece called, simply, "The Avant-Garde"—in which he blithely repeats the notion that "The chief antagonist of the avant-garde is the middle class," overlooking for the moment that this very discourse was written on invitation, in 1969, for

a poshy anthology, entitled *Quality*, destined for the Christmas trees and the coffee tables of the class he heaps with scorn: which is to say, the class to which he belongs. (And what class is it, I wonder, that Rosenberg imagines he writes for in the pages of *The New Yorker*? The proletariat?) This, too, would be comic if it were not part of the tragedy of the intellectual life of our time that refuses to acknowledge, in its high-flown social and cultural formulations, the fundamental conditions of its own existence.

Wolfe is no better, either, in dealing with the career or the writings of Clement Greenberg. (As for Leo Steinberg, even Wolfe must be aware that this writer is entirely marginal to the subject, introduced for purely dramaturgical reasons. Steinberg's is the case of a professor on holiday, enjoying an occasional fling in the demimonde of new aesthetic experience, but at home only in the world where reputations are already certified by tradition.) Wolfe does not understand that whereas Rosenberg's criticism belongs only to the ideological super-structure of the art world, Greenberg's belongs, like it or not, to art history—to the making of art as well as to the making of reputations. Even about the latter Wolfe is curiously ignorant. He seems totally un-able to comprehend that Greenberg's ideas wield immense influence over sizable cadres of critics and curators and collectors and dealers and *artists*, and that these ideas are as influential as they are not only because they now bear a demonstrable relation to monetary reward and worldly prestige but because they answer to some fundamental yearning of modernist sensibility. Wolfe makes great sport of the issue of "flatness" in painting, one of Greenberg's cardinal tenets, appar-ently unaware that this was a crucial issue for the critics of Gauguin and Puvis de Chavannes—to go no further back in history than that. He has a lot of fun with the concept of "purity" in Greenberg's criticism—but can he really be dumb to the knowledge that this has been one of the central aesthetic ideals of modernism at least since Mal-larmé? The truth is, it is no more absurd to invoke the "flatness" of the picture plane in speaking of painting than it is to discuss the aes-thetic viability of the iambic line in poetry or the diatonic scale in mu-sic: these are the recognized modalities of artistic expression. In all such matters, Tom Wolfe simply shows himself to be a stranger to the ordinary distinctions of criticism—a stranger, indeed, to the experi-ence of the art that forms his subject.

For this reason, I suppose, he has no notion of what the case against Greenberg's aesthetic really consists of. Greenberg is a formalist who has seized upon one of the essential imperatives of modernist

sensibility—the impulse to isolate and aggrandize the purely aesthetic attributes of style, to identify them as entirely coextensive with their technical realization, and thus to elevate them as the true subject matter, the only permissible subject matter, of art—and has effectively attached this idea to a dialectic of art history derived from the mechanisms of Marxist teleology. This formalist aesthetic is persuasive for the very reason that it allows its adherents to strip the artistic enterprise of everything that might complicate or compromise its headlong pursuit of an ever more specialized ratification of its own ends. It keeps all intercourse with common experience in abeyance, substituting "laws" of its own for the more familiar empathies of human exchange, and does so in the name of an impersonal history not susceptible to accidents of feeling or taste.

But it is, of course, only a mode of taste itself, and one that expresses, in its larger implications, a profound distaste for the world it inhabits. This is the source of its powerful appeal—that it shuts out the world, in all its imperfections and vulgarities and commonplace emotions, and offers us instead an aesthetic utopia in which nothing that is merely contingent need ever be considered in the human equation. It makes of art exactly what Mallarmé dreamed of—an alternative universe in which all quotidian realities are dissolved into the vapors of aesthetic sensation and all earthly pain triumphantly transmuted into the untroubled pleasures of the mind.

To reject this aesthetic is to reject something fundamental in the high culture of the modern age, and that is a task not lightly undertaken. Which is the reason why the attacks on this formalist aesthetic tend to be picayune and unpersuasive, confined to local arguments over particular artists and styles and reputations and rarely, if ever, addressed to the fundamental issue of what, precisely, we want and need the function of art to be in the world that encloses our workaday lives.

But to discuss the problem in terms such as these carries us well beyond the drawing-room comedy of *The Painted Word*. In Tom Wolfe's world, it is comical even to entertain a theory of art, comical perhaps even to create a work of art that attempts to modify consciousness and alter our view of experience. It is this fundamental incomprehension of the role of criticism in the life of art—this enmity to the function of theory in the creation of culture—that identifies *The Painted Word*, despite its knowingness and its fun, as a philistine utterance, an act of revenge against a quality of mind it cannot begin to encompass and must therefore treat as a preposterous joke.

The case of the function of criticism in our culture has been made many times and never better, I think, than when Henry James wrote:

> Art lives upon discussion, upon experiment, upon curiosity, upon variety of attempt, upon the exchange of views and the comparison of standpoints; and there is a presumption that those times when no one has anything particular to say about it, and has no reason to give for practice or preference, though they may be times of honor, are not times of development—are times, possibly even, a little of dullness. The successful application of any art is a delightful spectacle, but the theory too is interesting: and though there is a great deal of the latter without the former I suspect there has never been a genuine success that has not had a latent core of conviction. Discussion, suggestion, formulation, these things are fertilizing when they are frank and sincere.

It is, I think, because we are no longer certain that the higher criticism of art is entirely "frank and sincere"—because we suspect that its relation to money and the market and the kind of social ambition so expertly delineated in *The Painted Word* has compromised its essential disinterestedness—that the revenge of the philistines will now find a receptive audience, not only outside the art world, but within it as well. We seem, in any event, to be at the end of a period in art criticism, if not in art itself. If one looks these days into a journal like *Artforum*, which, month after month, year after year, during the 1960s, published quantities of the most learned and disputatious formalist criticism, one finds that it is the sociology of the art world that now commands the greatest interest. Not the aesthetics of contemporary art, but its socialization is the issue of the moment—which is another confirmation that the so-called vanguard is in the process of peaceful assimilation. If the age of criticism is coming to an end in the art world, it is for the same reason that the age of criticism in the literary world—the New Criticism—came to an end a generation ago: its task has been completed, it has placed us in possession of the essential issues raised by the art in question and no longer seems to have any pressing functions to perform. In this sense, perhaps, *The Painted Word* is a comic epitaph to a bygone era.

MAY 1975

2. The "Apples" of Meyer Schapiro

It is the fate of certain intellectual figures to achieve a position of such unassailable eminence that their actual writings—the basis upon which less exalted laborers at intellectual tasks are routinely judged—come somehow to be regarded as *hors concours*. If these writings are mainly papers for learned journals and special occasions, and are thus likely for long periods to remain scattered, out of print, or otherwise difficult to obtain, so much the better. Compared to the aura that attaches itself to figures of this sort, whose writings acquire in time a kind of archival status, the scribbling of books—especially on a regular basis—comes to seem an almost vulgar enterprise, something best left to the second-rate minds that produce the great majority of them in any case. If, in addition, there is a reputation for unusual eloquence in the classroom and spectacular virtuosity on the lecture platform and for a range of learning and experience all but universal in scope, then the legend of the genius-scholar-intellectual is likely to remain immune to serious inquiry. The sheer splendor of such renown has the effect of discouraging the critical instinct.

Therefore, when the writings of such figures are at last gathered into books, they tend to be treated less as objects of analysis than as reliquaries containing the remains of a sacred substance. To criticize or to question such writings seems, under the circumstances, a little gross—an act of impiety if not of impertinence—when what is clearly called for is a kind of obeisance. And so, little or nothing of the content of the writing is seriously challenged. Reverence serves not to clarify but to quarantine whatever concrete contributions to learning or criticism may be found in it.

Meyer Schapiro has long been a legendary figure of this sort, and something like this odd, nullifying process of uncritical *homage* has been very much in evidence in the reception of his *Selected Papers*. Three volumes of these have now appeared: *Romanesque Art* (1977), *Modern Art: 19th and 20th Centuries* (1978), and *Late Antique, Early Christian and Mediaeval Art* (1979), all under the imprint of George Braziller, Inc. The fourth and final volume, *The Theory and Philosophy of Art*, is being prepared for publication. Even as we await this final volume, however, there can be little doubt that these *Selected Papers* represent an unusual achievement. The range of learning to be found in them is both wide and deep, and the sheer passion for art that informs their every detail is

itself exemplary, and at times exhilarating. Yet what sort of thinking *about* art lies at the heart of these voluminous writings? Schapiro's scholarly prowess certainly fulfills—and on occasion may even be said to overfulfill—our expectations. The encyclopedic knowledge of many different fields of learning is amply demonstrated. In this respect, at least, the legend of the scholar and polymath long associated with the name Meyer Schapiro is easily confirmed. But what, in the end, does the richness and variety of all this learning actually tell us about art itself?

This is the question that has yet to be asked about Meyer Schapiro's work as a writer on the visual arts, and I think we pay him a dubious sort of *hommage* by avoiding it. An intellectual enterprise on this scale calls for scrutiny, yet scrutiny is precisely what these *Selected Papers* have not received. It is almost as if the quality of thought to be found in the more than one thousand pages already published is somehow to be regarded as incidental to their importance.

At the risk, then, of appearing to dishonor so prodigious an accomplishment, let us examine what I believe there is good reason to consider the central contradiction of Schapiro's thought in these papers. Briefly—and no doubt too simply—put, this contradiction may be stated as follows: Whereas the author of these papers is consistently concerned to find in works of art conceived in circumstances of total religious belief a "free," even secular, and purely *aesthetic* component more or less akin to the artistic autonomy we have come to associate with the art of the modern period, he is just as consistently determined to deny to the art of the modern period precisely the kind of autonomous aesthetic interest that has long been thought to be its most distinctive characteristic. Or, to state this contradiction in the form of a question: Why is so much importance attached to what Schapiro calls the "strong current of aestheticism in the culture of the twelfth century" while the stronger and far more explicit current of aestheticism in late nineteenth- and twentieth-century art remains relegated to a place of almost marginal significance?

Surely one of the most beautiful of Schapiro's essays—as well as one of the most revealing of his own outlook on art and culture—is "On the Aesthetic Attitude in Romanesque Art" (1947), which he has placed at the opening of Volume I of his *Selected Papers*, and to which he refers the reader again in a prefatory note to Volume III. Schapiro has devoted a large part of his academic career to the study of the Christian art of the Middle Ages, and this essay may therefore be taken as a

credo, even perhaps as a manifesto. In it, Schapiro is concerned to cel-
ebrate the vitality of that "strong current of aestheticism in the culture
of the twelfth century" I have already mentioned, and thus to combat
"the common view," as he calls it, "that mediaeval art was strictly re-
ligious and symbolical, submitted to collective aims, and wholly free
from the aestheticism and individualism of our age." In this endeavor
he goes so far as to speak of a "new art" emerging in Western Europe
in the eleventh and twelfth centuries—"a new sphere of artistic crea-
tion without religious content and imbued with values of spontaneity,
individual fantasy, delight in color and movement, and expression of
feeling." Accompanying this new art, he argues, was "a conscious
taste of the spectators for the beauty of workmanship, materials, and
artistic devices, apart from the religious meanings." Much of the con-
tent of "On the Aesthetic Attitude in Romanesque Art" consists, in
fact, of quotations from "random texts" (as Schapiro calls them)—
"passages in chronicles, biographies, letters, and sermons"—that are
felt to define this "conscious taste" for "ornament, artistic skill, and
imagination." A taste, in other words, for all those attributes of form,
shape, texture, and the processes of execution that are so central to
modern aesthetic criticism. These texts, Schapiro avers, "surprise us
by their resemblance to the more developed critical awareness of later
periods when art criticism and the theory and history of art have
emerged as distinct fields."

Exactly how seriously Schapiro intends us to take this revisionist
view of Romanesque art is difficult to say, however. He certainly states
the matter forcefully, and it is only upon rereading this essay that we
are likely to be struck by the author's somewhat cavalier acknowledg-
ment—made in passing, as it were—that this "new art" exists "on the
margins of the religious work" that forms the central body of medieval
art. Only then, perhaps, are we left wondering why so much is being
made of something so admittedly marginal to the subject. Is it because
this marginal aesthetic current is somehow to be preferred to the domi-
nant religious attitude? Does its elevation not make even medieval art
conform to the standards of our own modernist culture, and thus make
the Christian art of the Middle Ages in some curious way consistent
with our own?

The questions raised by this revisionist view are only com-
pounded—and indeed confounded—when we turn our attention to
Volume II of the *Selected Papers* and notice that something very odd hap-
pens to this same current of aestheticism—so vividly apparent to Scha-

piro on the margins of medieval art—when he takes up the study of the modernist art in which it might be expected to manifest itself with an even greater clarity and force. It is there, of course, but it no longer appears to be of very compelling interest to him. In any case, it is swamped by all sorts of extra aesthetic interests, and its vaunted autonomy is made to shrink into insignificance under the burden of the many other meanings it is made to bear. Specifically, the central place that is denied to symbolism in medieval art is somewhat too readily—I should even say somewhat too promiscuously—granted to modernist art through the agency of certain disciplines (most notably psychoanalysis) that tend to obscure rather than to illuminate this purely aesthetic factor. Cézanne—to cite the outstanding example in these pages—turns out, strange as it may seem, to have been a lot less free in his pursuit of a purely aesthetic realization in his art than were those anonymous carvers and painters of the twelfth century that Schapiro has been so eager to acquit of anything but an aesthetic intention.

The crucial text here is Schapiro's essay, in Volume II, "The Apples of Cézanne: An Essay on the Meaning of Still-Life" (1968). This is a virtuoso performance of a sort that will be familiar to anyone who has ever listened to Schapiro on the lecture platform. The polymath with an ardent command of many disciplines surrounds the art objects under analysis with a range of reference that has the appearance of significantly deepening our understanding of the mind that produced them. Yet the appearance proves to be deceiving, for in the course of the analysis—which, in this case, proves only to be a psychoanalysis, and a pretty crude one at that—the mind of the *painter* all but disappears from view as our attention is fastened upon the troubled history of his libido. Writers either quoted or alluded to in this essay include Horace, Virgil, Propertius, Philostratus, Tasso, Jacob Boehme, Andrew Marvell, Flaubert, Baudelaire, Hervey de St. Denys—author of a study of dreams, *Les Rêves et les moyens de les diriger*, published in 1867—and the American philosopher George H. Mead; but as the references accumulate and the texture of the prose thickens, their relevance to an understanding of Cézanne's still-life painting grows ever more distant. In the end, though we have been taken on a grand tour of the place occupied by nudity and apples in Western art and folklore, Cézanne's own exquisitely painted apples are seen to be little more than hostages to the miserable sexual timidities of his youth.

The apples in a Cézanne still life are said by Schapiro to represent "a displaced erotic interest." This, finally, is the "meaning" we are

promised in the title of the essay. And if the painter chose on occasion to place his apples in juxtaposition with some onions, this is naturally assumed to suggest—what else?—"the polarity of the sexes." These apples, you may be sure, are really female breasts in disguise, for "in Cézanne's habitual representation of the apples as a theme by itself," writes Schapiro, "there is a latent erotic sense, an unconscious symbolizing of a repressed desire."

But there is even more to this curious scenario than that, of course. The analysis of Cézanne's "frustrated," "repressed," and "shameful" desires—to cite only a few of the terms employed by Schapiro to describe the animating impulse at work in the still-life paintings—inevitably leads us back to the disturbances of the painter's childhood. "It may be," writes Schapiro, "that Cézanne's interest in still-life goes back to unknown early fixations in the home." He then offers us a conjecture that "in Cézanne's intense concern with still-life there was an effort of reconciliation, of restoration of order to the family table, the scene of conflicts with the father and of anxiety about his own shameful desires." Why those rumpled tablecloths in the still lifes are not found to be rumpled bedsheets in disguise, I cannot imagine. What an opportunity has been overlooked in this detail! But it comes as no surprise, in any case, to be told that "Cézanne's pictures of the nudes show that he could not convey his feeling for women without anxiety." That Cézanne's pictures of mountains, houses, rocks, trees, and the light and landscape of Provence also show a certain anxiety—that this "anxiety" is, indeed, central to his style and his vision as a painter—seems to have been forgotten in the quest for a higher (or is it a lower?) meaning.

Quite apart from the crudity of the method employed in this analysis—and, in my opinion, its application in this facile manner brings discredit upon the whole Freudian enterprise—what are we to make of the way Schapiro strips the aesthetic impulse, so far as Cézanne is concerned, of the least semblance of that prized autonomy which was so enthusiastically discovered on the margins of Romanesque art? Surely we are confronted here with a sizable contradiction, for the repressions of the bourgeois family are accorded a reality—indeed, a domination and priority—in Cézanne's art that Christian belief and "religious content" are denied to the same degree in a significant portion of Romanesque art. How was it that Cézanne failed to achieve a freedom of artistic expression so emphatically won by the artists of the twelfth century?

This is but one—I think it is the central one—of the many questions raised by Schapiro's writings on the visual arts, and the answer, I suspect, will be found to lie beyond the disciplines of art history. It is more likely to be found in the realm of biography and ideology. When the biography of Meyer Schapiro comes to be written, it will have to be explained, for example, how the outlook of a secular Jew of radical political sympathies shaped his interpretation of a profoundly religious Christian art. Approached from this perspective, the aesthetic autonomy that is made so much of in "On the Aesthetic Attitude in Romanesque Art" acquires another order of significance. It looks more and more like a reflection of the scholar's yearnings in the presence of a body of art that, in its very essence, upholds a religious attitude that is so profoundly opposed to his own most cherished convictions. Similarly, the radical socialist in Schapiro could scarcely be expected to allow an artist like Cézanne—no matter how sincerely admired—a freedom from the depredations and deformities of bourgeois life that his own ideological cast of mind regards as an iron law of history. At the heart of these voluminous *Selected Papers* there thus remains an unresolved conflict—the conflict between the aesthete and the ideologue— that sooner or later will have to be faced if their author is to be taken seriously as a significant analyst of our artistic heritage.

WINTER 1980–81

3. Fairfield Porter as Critic

"When Fairfield Porter died in 1975," writes Rackstraw Downes, "he was known as one of the best painters in America. His own opinion was that he was stronger as a critic."

This is a judgment that few of Porter's admirers would have been prepared to assent to—or, indeed, even to consider—before the publication of the present volume. The art criticism that Porter wrote for *Art News, The Nation,* and a few other journals in the 1950s and early 60s, though always read with interest by professionals in the art world,

did not—I think it is fair to say—make a very emphatic impression at the time. His painting, on the other hand, gained steadily not only in aesthetic power but in public esteem. And whereas his criticism seemed to influence almost nobody—it was scarcely ever quoted or argued over by the reigning authorities—his painting was clearly a creative influence on a sizable number of younger painters, especially those who were turning away from abstraction in favor of one or another mode of realistic representation.

I do not think I was alone, then, in assuming, however mistakenly, that while painting for Porter was clearly a vocation, criticism was something of an intellectual hobby—a serious interest, to be sure, but essentially marginal to his life as an artist.

The publication of *Fairfield Porter: Art in Its Own Terms*[1] obliges us to alter this view, and leaves this particular reader feeling somewhat chagrined that he ever entertained it. For this is an extraordinary book, one that places Porter among the most important critics of his time. What once seemed fragmentary and somewhat unfocused (owing perhaps to its original mode of publication) now turns out to have been the most consistently sensitive and thoughtful writing on new art, and on the art of the recent past, that any critic of the time gave us. Mr. Downes, himself an accomplished painter who is also a fine critic, has performed a valuable service in rescuing Porter's fugitive essays and reviews and giving them a permanent form. Art criticism is a highly perishable mode of literary discourse, but I suspect that *Art in Its Own Terms* will be read long after some of the glossier reputations in this field have turned to dust.

There is no easy way to summarize Porter's special quality as a writer on art, however. He was unlike anyone else. There is nothing of the ideologue in his work, no resounding historical pronouncements, no attempt to substitute catch phrases for the hard work of observation, no showy theories or academic jargon or bantering rhetoric. There are no wasted words in his writing; there is always a visual center, a deep and attentive attachment to the *work* of the artist.

He was more than an eye, though his eye was amazing. He knew a great deal. At Harvard in the 1920s, he had studied art history with Arthur Pope and philosophy with Whitehead. He knew Bernard

[1]Fairfield Porter: *Art in Its Own Terms, Selected Criticism 1935–1975*. Edited and with an Introduction by Rackstraw Downes (Taplinger, 1979).

Berenson, and was the only writer on modern painting to make creative use of Berenson's ideas—something that Berenson himself, with his distaste for modernism, was unable to do. Porter had studied at the Art Students League with Boardman Robinson and Thomas Hart Benton, but the painters he felt closest to were Willem de Kooning and Edouard Vuillard. Though he was something of a radical in politics, a visit to Russia in the 1920s left him with a permanent antipathy to totalitarian ideas. About poetry, too, he was very knowledgeable; his comments on Mallarmé, John Ashbery, and others are the work of a first-rate literary mind.

Writing about art, especially the art of his own time, Porter was a complete independent. He was suspicious of art-historical categories and very shrewd in dealing with them. In the debate about abstraction versus representation—an issue that once deeply divided the New York art world and continues to do so, though not with the same vehemence, even today—he was particularly intelligent. "Realist painting, which has an obvious subject matter," he wrote in 1958, in the heyday of the New York School, "can be most valuably discussed in terms of its form—how and how well is its reality presented? Abstract painting in which the sensuous elements are undisguised and obvious can perhaps best be written about in terms of its subject matter, which is largely the artist himself, that is, his character."

It was more or less on this basis that Porter wrote about, and remained open to, the work of artists of diverse persuasion; and he had a remarkable gift for placing unlike things in an illuminating perspective. On the relation of Impressionism to the painting of the New York School, he noted: "The Impressionists taught us to look at nature very carefully; the Americans teach us to look very carefully at the painting. Paint is as real as nature and the means of a painting can contain its ends." Elsewhere in the book there is a brief, vivid comparison of Franz Kline and John Singer Sargent, and the entire volume abounds in such unexpected linkages. What Porter said (in a beautiful observation) about Bonnard as a painter may truly be said of his own writing: it is "full of the tenderest tangencies."

About a wide variety of artists—de Kooning, Mondrian, Jasper Johns, Giacometti, Rodin, Whistler, Homer, Alex Katz, Richard Stankiewicz, Ad Reinhardt, Joseph Cornell, even happenings, earthworks, and the murals of the 1930s—Porter wrote brilliantly and, in the case of living artists, often wrote first. He had the gift of brevity, too, and

some of his terse formulations tell us more than other critics' lengthy essays:

On Giacometti's figures: "The thinness makes the volume of a figure secondary to the volume of infinite space: the figure places infinity as much as it places itself."

On Jasper Johns's painting: "He manipulates paint strokes like cards in a patience game."

On Cornell's boxes: "Cornell uses his elements as though they were words, but what they allude to have no verbal equivalents."

On Allan Kaprow's happenings: "Like so many science fiction movies about the future, his subject matter is the undigested immediate past."

On Jean Arp's sculpture: "Arp's tour de force . . . is to reconcile infinite variety with absolute definition."

On Rodin's drawings: "His hurry to get the figure on paper eliminates its relation to the ground."

On tradition and provincialism in art: "An artistic capital is a place where tradition has been assimilated . . . What 'assimilation of tradition' means is an understanding on the part of artists of the essential nature of the form of the art of the past, or of another artistic capital, or the previous one. Artistic provinciality means that the artist does not understand the essential nature of the form of art in the capital, though he may be strongly attracted to it . . . A provincial artist's work . . . depends on art somewhere else."

Fairfield Porter was preeminently a critic of New York, the artistic capital of our time, and *Art in Its Own Terms* gives us the best account of the art seen and produced here that I have yet read.

JUNE 3, 1979

4. Sanford Schwartz

The emergence of a really fresh and distinctive voice in the realm of art criticism is a rarer phenomenon than is commonly supposed—rarer, certainly, than the emergence of a striking new talent in art. For this reason, as well as for others, the publication of Sanford Schwartz's *The Art Presence* (Horizon Press) must be regarded as something of an event. For this collection of essays on nineteenth- and twentieth-century painting, sculpture, and photography is the real thing—criticism that can be trusted to illumine rather than to obscure the objects of its attention. It displays a remarkable independence, too, both in the quality of its perceptions and in the very choice of its subjects. And it is written in a prose style that, while not without certain flaws, is lively, lucid, friendly, and completely faithful to the experience that animates it. Few recent books of art criticism have been written with such immediacy and verve.

Mr. Schwartz, who is now in his early thirties, is not exactly a newcomer to the New York art scene, but he writes at a certain remove from the current hurly-burly. For the better part of a decade, he has been contributing art criticism to a variety of journals—including, from time to time, *The New Yorker*—and writing prefaces to exhibition catalogues. Yet because he has not been regularly employed by a prominent periodical or officially attached to some powerful academic mafia, he has been slow to win the readers he deserves. During the period that Mr. Schwartz has been writing about art, much of the so-called serious criticism devoted to the current scene has passed into the hands of ponderous academics, who, besides being incapable of producing a clear and understandable sentence about anything they have experienced firsthand, have been far more interested in attaching themselves to the reigning intellectual orthodoxies—structuralism, semiology, deconstructionism, feminism, Marxism, and sundry other impediments to aesthetic perception—than in examining what artists actually do in their work or, for that matter, fail to do. It is much to his credit, therefore, that Mr. Schwartz has remained something of an outsider in this situation.

He has also remained unswayed by the din of publicity that inevitably attends the activities of an art scene as busy and as competitive as New York's has been in the past decade. He follows the scene closely, he knows what is going on, but he invariably follows the dictates of his

own sensibility and taste in choosing his subjects. These, more often than not, he has found among artists—most of them Americans—whose work, though it may be well known, other critics have lately neglected, misunderstood, or not adequately appreciated. Many of these artists belong to the first generation of American modernists—Marsden Hartley, Arthur Dove, Georgia O'Keeffe, Max Weber, Charles Demuth, Elie Nadelman, Gaston Lachaise, Paul Strand, et al.—and about them Mr. Schwartz writes with a depth of feeling that no critic has equaled since the publication of Paul Rosenfeld's *Port of New York* in 1924. Indeed, these essays are so sharp and sympathetic, so inward in their understanding of both the successes and the failures of the artists of this generation, and so attentive to their individual qualities, that they leave us a little irritated with their author for not having gone further and written a full-length study of the subject. But that is a feeling that the best criticism is always likely to leave us with.

Something of Mr. Schwartz's quality as a writer and critic may be gleaned from the very first essay in the book, which is devoted to one of the "textbook classics," as he calls it, of nineteenth-century American painting—Thomas P. Anshutz's *Ironworkers: Noontime* (circa 1880–82). When this smallish picture, which measures seventeen by twenty-four inches, was included in an Anshutz exhibition at the Pennsylvania Academy of the Fine Arts in 1973—the occasion that prompted Mr. Schwartz's original article—it was very much in the limelight, for it had just fetched a quarter of a million dollars at auction. Yet the painting, which gives us, in Mr. Schwartz's words, "a sunlit panorama-like picture of factory hands in various stages of a midday break—washing, playing tag, strolling, posing, lounging, flexing muscles, daydreaming," was something of a sport, both in Anshutz's oeuvre and in the American painting of the time. He never painted anything like it again, and neither did anyone else, and he never painted anything as good, either.

It seems to me that Mr. Schwartz has gone right to the heart of the matter in his account of this odd little masterpiece, to which, as far as I know, no other critic has paid such thoughtful attention. He understands that the social and historical implications of its subject matter are likely to mean more to us than they ever meant to Anshutz, but he does not neglect the historical dimension of the painting on that account. "In his unrhetorical, plain way," Mr. Schwartz writes, "Anshutz captured the sleeping-giant strength of post–Civil War America as no historically self-conscious painter did, or, perhaps, could have.

His terms matched those of his Wheeling, West Virginia, factory hands. He was as self-confident and as emotionally unformed—even blank—as they were.'' Mr. Schwartz then goes on to make a brilliant comparison with Eakins, a far greater painter, who was Anshutz's teacher:

> Eakins, with his more complicated feelings about American society and his bohemian personal style, perhaps knew too much to be able to look at ironworkers as anything other than remote figures—animated, at best, by a dour persistence in doing their work right. As a picture of the American industrial scene, that would have been subtly wrong. It would have given that scene a quality of underlying tragedy that wasn't there.

For Mr. Schwartz, the enduring appeal of *Ironworkers* does not lie in the realm of social documentary, but in a very different area of art and experience:

> From reproduction, *Ironworkers* looks as if it's a blood relative of the naturalistic American novels, but the painting's spirit is closer to later, more modern writing, to the chaste, word-perfect symbolic naturalism of Stephen Crane and Hemingway. Like these writers, Anshutz's first loyalty is to his exalted idea of craft, which pressures him into accepting the scope of a miniaturist. I think there is also a connection between the picture's deliberate ''smallness'' of vision, its self-conscious refinement of means, its fastidiousness of paint handling, and the fact that it presents a world made up only of what one nineteenth-century writer called ''a group of half-naked men,'' most of whom are in their late teens, twenties and early thirties. Anshutz was on the track of a picture that could measure up to Eakins; along the way, he knew he was doffing his cap to infant American industrialism; but his truest subject for us, buried possibly from his conscious mind, was his own burgeoning self-confidence as a young man about to step into full manhood. . . . *Ironworkers* is the great ''young man's'' painting of American art.

This is indeed a new voice in American art criticism and in the criticism of American art. Its principal interest lies precisely in those places where art intersects with life—first the artists's, then our own and the life of the culture that is inevitably modified, however subtly or piecemeal, by the experience of some genuine achievement in art. This is criticism that does not so much argue with either the formalist or the sociological views of art as absorb them, without making any special fuss about it, into a looser, more direct, more commonsensical response to aesthetic experience. It is not the kind of criticism that fights

battles or enlists itself in causes. It may at times even sound a little in-
nocent about the battles ranging elsewhere, but it isn't. It simply does
not regard them as more important than the art itself.

Even so, Mr. Schwartz does not hesitate to call attention to the
ways in which other writers on art display their special interests—and
thus run the risk of misrepresenting what they have set out to elucidate.
In this area, he does not select small and easy subjects for discussion,
either. He is always mannerly, he never raises his voice, but his points
are clearly and firmly made—and they are often devastating. Thus, on
Leo Steinberg's study of Rodin:

> This is probably the most intelligent and scrupulous case that will be made
> for the French sculptor for some time. But it has a fancy tone that doesn't
> really do him justice. You feel that Rodin would have liked the elegantly
> formulated analyses Steinberg lavishes upon his pieces. Yet they profun-
> dize what doesn't feel profound. They serve to keep pushing away from us
> what we can't help coming back to when we think of Rodin: his vulgarity.

And this on Robert Rosenblum's essay for the catalogue of "The
Natural Paradise" exhibition at the Museum of Modern Art:

> . . . what happens when illustrational resemblances are emphasized is
> that, whether it's intended or not, all art is reduced to the same weightless-
> ness. Rosenblum's method allows you to talk about the museum master-
> pieces and the shlock classics in the same tone. He extracts the "mood"
> and the "look" of a work and doesn't judge the level of feeling in either.

And this on Susan Sontag's *On Photography*:

> Atget is one of the few [photographers] she admires, yet she can only give
> herself to him after she has converted him into a class-conscious, socially
> subversive figure. To do it, she has him follow in the "footsteps of the rag-
> picker, who was one of Baudelaire's favorite figures for the modern poet."
> Atget is sent on his anti-bourgeois way, picking up "marginal beauties of
> jerry-built wheeled vehicles, gaudy or fantastic window displays, the raff-
> ish art of shop signs and carousels," etc. Sontag's point would be valid if
> we knew that Atget was attracted to the shop signs because they were
> "raffish," but from what we know of him, we have no idea that that was
> his motive. And since she wants him to be concerned only with "marginal
> beauties," she leaves out of her list of his subjects over half the things he
> did: the pools and walks at Versailles, the Austrian embassy, the Luxem-
> bourg gardens, the court at Fontainebleau, the scenes of the Marne and
> the Seine, modest and neat middle-class interiors, and so on . . . Making
> him into a collector of kitsch, which is what Sontag means by rags, mis-
> uses his spirit.

Such criticisms of criticism are all the more remarkable when one realizes—as one does in reading these essays—that Mr. Schwartz is something of an admirer of all of these writers.

I have already mentioned his essays on the early American modernists. He is particularly penetrating about the artists of the Stieglitz circle, for he appreciates better than most other writers on the subject the extent to which the modernism of these American artists, unlike that of their European contemporaries, amounted at times to a rejection of the modern world insofar as it was defined by the speed and crowds and intensities of urban, industrial civilization. In his fine essay on Hartley, for example, Mr. Schwartz observes: "Except for Demuth, whose appetite for nature was satisfied by what was in the garden, and who is most alive as an artist when he suggests the erotic underlife of things, all the painters in the Stieglitz circle worked from landscape. Like Ryder, they weren't interested, in their art, in society, history or personality. They were private, lyric poets of places and moods that stayed the same regardless of society . . ." And it is this insight that allows him to grasp one of the essential impulses in the photography that came out of the Stieglitz circle. Thus, about the photography of Paul Strand he writes:

> His language—his plain, documentary-like, straightforward style—has a modern feeling to it, but the story he wishes to tell is a nineteenth-century one, or at least one that is far from us in time. Like other members of the group that periodically clustered around Alfred Stieglitz, Strand was an urban intellectual who, in his work, was more at home with a romanticized dream of a pastoral—or at least non-urban—existence. Strand did make art out of city life. When he was young, New York was his leading theme as it had been Stieglitz's. But Strand dropped the city, and its pace, from his work.

It is in this light that one can understand the degree to which Strand's photographic journeys to Ghana and rural Vermont and the Outer Hebrides, among other places, represented, in effect, a lifelong quest to repeal the twentieth century.

Mr. Schwartz is equally sharp in writing about certain of his own contemporaries—Alex Katz, Lucas Samaras, Myron Stout, Diane Arbus, and Helen Leavitt, for instance—but the weight of *The Art Presence* is largely carried by the essays on an earlier generation of American artists and on recent criticism. There is very little attention paid directly to the great European modernists in this book, though we are made aware of them—in the wings, so to speak. But if Mr. Schwartz's

recent essay on de Chirico (published in *The New Yorker* on June 28, and thus too late for inclusion in this book) may be taken as an augury, it is to a consideration of these figures that he may now be turning. If so, it will certainly be interesting to see what he does with them. If *The Art Presence* is a guide, it will not in any way conform to the cant and clichés that afflict so much of the criticism devoted to the visual arts today.

OCTOBER 1982

5. The Hoving Era at the Met

The departure of Thomas P. F. Hoving from the directorship of the Metropolitan Museum of Art on December 31, 1977, will mark the end of an extraordinary chapter in the history of American museology. The Hoving decade at the Met has been a decade of ebullition, and we shall be a long time coming to terms with the vast changes that have resulted from the incessant, sometimes inspired, often solid, but also often damaging and wearying activity that has been the distinguishing feature of this most publicized of all museum careers.

Whatever else the Metropolitan may have been in the Hoving era, it has not been dull. There were times, indeed, in this decade when one almost prayed for a little dullness—the kind of dullness that once allowed us to visit this noble repository of works of art and concentrate on *them*, without having to worry much about what might happen next. But it was not to be. Mr. Hoving, if he accomplished nothing else (and he did, of course, accomplish a good deal more), kept us constantly alerted to the fact that the art museum would never again be what it once was—a place where time seemed to stand still, where change came (if at all) discreetly and without fanfare, where we might feel (if only for a few blessed moments) safely beyond the reach of the devouring pace that ruled our lives elsewhere. There were many pleasures to be experienced at the Met in these years, but a sense of distance from the dynamics and even the vulgarities of the world outside was not often among them.

It is important, I think, to recognize that Mr. Hoving, though he did much—more, perhaps, than anyone else, and certainly more visibly—to abet and enlarge and exacerbate this phenomenon, did not himself create it. (It might be more accurate to say that it was this phenomenon that created him.) The 1960's and early 1970's have constituted a period of unprecedented museum expansion everywhere—an expansion not only of physical facilities, financial expenditures, public services, and exhibition schedules, but (what is probably even more significant) an expansion of the place occupied by the art museum in our culture as a whole. One does not have to be very old to remember a time when the art museum existed, even for people who regarded themselves as well educated, intellectually curious, and even chic, on the margin of their cultural interests. This is distinctly not the case today. The art museum is now triumphantly "in." It has moved to a position of centrality in our culture, and it shows every sign of remaining there.

To occupy such a position entails awesome responsibilities, of course, and the wonder is not that the museums make so many mistakes in meeting them but that they make so few. There are very few precedents, after all, for the kind as well as the volume of activity that museums now undertake to offer to the public, and there are few standards that can be applied with complete confidence. Especially in a culture like ours, in which attention tends to flag in the absence of ballyhoo and showmanship, the temptation is to turn everything—no matter how serious or esoteric or resistant to easy understanding—into a branch of show business. Yet one of the reasons why more and more people go to art museums, I believe, is that what they find in them seems so much more genuine and, yes, so much more beautiful—so much more the product of great gifts and great minds—than what they find in the ballyhoo culture on the outside.

The paradox of the art museum today is that it has felt itself obliged to adopt some of the methods—which inevitably means, some of the values—of this ballyhoo culture in order to preserve and propagate what in reality exists at a very great spiritual distance from it. It is a paradox that has both its tragic and its comic aspects, and it is worth remembering, I think, that we see in all this the essential paradox of democratic culture, with its struggle to sustain excellence and accessibility on more or less equal terms.

This, in any case, is the paradox that has presided over Mr. Hoving's robustious tenure as the director and guiding spirit of our greatest museum. He has added a great deal to the art life of the city and the

country, but he has also taken something away. He has mounted splendid exhibitions, acquired a great many marvelous objects, and enlarged the museum to a size that can only be described as imperial. But he has also helped to create a large blur—a huge question mark on the mind—where there formerly existed a clearly perceived distinction: in the area where the experience of high art is distinguished from vulgar imitations and commercial substitutes. In everything from the creation of overglamorized installations to the actual manufacture of reproductions, the Metropolitan in the Hoving era has led the way in erasing a precious distinction—the distinction, after all, that is the museum's very reason for being—between the authentic and the inauthentic in art. This is what Mr. Hoving has taken away: our confidence that the museum can be completely trusted to defend the interests of high art. Long after "Harlem on My Mind" and the other scandals of his administration have been forgotten, this is the issue that will continue to haunt us.

About Mr. Hoving's abilities as a museum showman, no one can any longer entertain any serious doubts. He has proved to be a consummate master of the revels. The crowds turn up again and again in record numbers, and he seems to have an unfailing sense of what will, as the saying now goes, turn them on. For better or worse, he has succeeded in making the museum—at least for some of the people, some of the time—a branch of mass culture.

About his sense of excellence, it is more difficult to arrive at a consistent judgment. He has often woefully overpaid for his purchases of works of art, but these have generally been works of outstanding quality. Most museum directors are afflicted with a greedy appetite to acquire everything in sight—it is, you might say, one of the requirements of the job—and Mr. Hoving's appetite has been larger than most. But there is no question that it has sometimes led him astray.

The more one looks at the Lehman Pavilion, for example, the more dubious the whole enterprise becomes. The structure itself is an architectural absurdity, and the rooms it encloses—pretentious "period" rooms that lack a period—already look tacky, dated, and faintly ridiculous. There are some great pictures in the Lehman collection, but there are others less worth hanging on the walls of the museum than some of the things Mr. Hoving handed over to the dealers in his deaccessioning misadventures. The whole affair looks more and more like a colossal and costly mistake, and will one day have to be undone—at God knows what trouble—by one of Mr. Hoving's successors.

On the other hand, where Mr. Hoving has turned his attention to reorganizing the display of what the Met already owned—in the magnificent Islamic galleries and in the newly opened Egyptian galleries, for example—he has brought real splendor and intelligence to the museum. For this reason, one has a certain confidence that the American Wing, when it opens, is likely to uphold this high standard. By and large—the Lehman Pavilion being the outstanding exception—Mr. Hoving has done a better job at reinstalling the museum's permanent collections than at installing its temporary exhibitions. It is as if two quite separate standards of taste have been applied, with the show-business treatment generally reserved for the temporary exhibitions—another example, no doubt, of Mr. Hoving's sense of what it takes to have a box-office success.

Mr. Hoving's tenure as director will be remembered, too, for his ventures into two other areas—the exhibitions the Met has organized with foreign governments (France and the Soviet Union especially) and its effort to establish a serious division of twentieth-century art. The foreign loan exhibitions have certainly brought us some great things—the medieval tapestries from France and the Scythian gold objects from the Soviet Union—and the forthcoming exhibition of the "Treasures of Tutankhamen" promises to be another spectacular event of this sort. If the political implications of some of these shows have been troubling, the shows themselves have been excellent.

The Met's attempt to move into the area of twentieth-century art, however, remains something of an enigma. In this field, there now seems to be no relation between the temporary exhibitions at the museum and the labor of building a permanent collection of some distinction. The current Andrew Wyeth show, organized by Mr. Hoving himself, only adds to the mystery of what he has hoped to accomplish in the realm of modern art. But there is one aspect of the Wyeth show about which there can be no mystery. It was certain to be both a popular success and a financial boon to the museum. When we come to the last room of the show and suddenly find all the things that are for sale in connection with it, we certainly get the point. Murray Kempton once wrote of Mr. Hoving that "there must be moments when he feels as if he had strayed, like his father before him, into being manager of some great department store." Seeing the brisk business being done these days in the Wyeth shop at the Met, one doubts that the word "strayed" is quite accurate, but Mr. Kempton's observation otherwise needs no amendment.

In the end, I suppose, it will be in terms of sheer size that Mr. Hoving's career as director of the Metropolitan will be remembered. He has greatly increased the physical size of the museum, he has increased the size of the public that comes to it, he has paid more money for what he has acquired for it, and he has acquired more and more objects to put in it. He has made the museum bigger in almost every respect, including the size of its problems. We shall be a long time, as I say, coming to terms with all that he has wrought. But like it or not, it adds up to a considerable, if also a troubling accomplishment.

NOVEMBER 14, 1976

6. On the "Failure" of the Museums

At the seventieth annual conference of the American Association of Museums, which took place here last month, there were repeated references—none of them favorable or sympathetic—to the bad old days when art museums were commonly regarded as "sanctuaries," "ivory towers," and "snobbish enclaves" (to quote only some of the gentler epithets). Museums were alleged to be indifferent, if not actually hostile, to the interests of the public and mainly concerned with the judgment of (as one speaker put it) "eternity." In session after session, day after day, for the better part of a week, one speaker after another came forward to uphold what he felt to be the public interest, and was vigorously applauded for saying something nasty about the museum as citadel of privilege and elitism. The public interest was almost universally perceived by the speakers as existing in an adversary relationship to the traditional practices of museums, and the call for reform verged at times on the demagogic.

What was generally missing from these speeches was any reference to personal experience. Everyone seemed content to speak in what might be called the ideological present tense, fulminating against some alleged (and usually abstract) violation of a populist ideal and carefully avoiding the particulars of personal history. What, one often won-

dered, had brought these speakers into this foul museum world in the first place, and what was the thing that had kept them there? What quality of experience—what revelation—had touched them so deeply that they wanted to make a renewal of it a central part of their lives? What had been particularly precious to them, and what needed to be protected and nurtured now in the face of the radical changes to come? I do not think it was modesty that inhibited these speakers from venturing into the autobiographical mode. They spoke as a body in the new national style, emphasizing—one might almost say, celebrating—failure, in relation to which the particulars of individual experience were no doubt deemed irrelevant.

There was, to be sure, a passing reference to "the fact that museums have succeeded outrageously" in the inaugural address of the association's new president, Joseph V. Noble, director of the Museum of the City of New York, but the point was quickly buried as Mr. Noble hurried on to speak at length of "shortcomings." "The successes are there for all to see," he said, but he did not pause to identify them, and the spirit of the conference left one in some doubt as to what these "successes" might be. On another occasion, speaking informally to the closing session of the museum educators, Mr. Noble mentioned his own early experience as a youngster at the University Museum in Philadelphia—an experience that shaped his lifelong interest in the art of antiquity—and this was by way of establishing a credential, not an effort to invoke something that might be used as a model in thinking about the museums of the future.

Clearly, museums now face the task of accommodating larger and larger numbers of people who on their own volition are turning to the so-called failed sanctuaries, as never before, for aesthetic gratification and spiritual illumination, for knowledge of the human enterprise and a confirmation of humanistic values. And some serious thought was certainly manifested at this conference on the ways that might be devised for executing and encouraging that accommodation. But there was also, I think, an alarming tendency to think in terms of packaging and promotion and a corollary suspicion of the unstructured, uninstructed, freewheeling experience of the curious individual, young or old, who does not prosper under the pressure of predigested information and anticipatory programming. Museums are coming more and more to resemble progressive parents of an earlier generation who, anticipating the spontaneous and creative impulses of their own children, unwittingly imprisoned them in rigid scenarios of self-realization and

thereby often deprived them of their essential autonomy. There was always a hidden element of authoritarian control in this "progressive" attitude, and one finds something similar in the new modes of museology.

One must recognize, of course, that an extraordinary spirit of social generosity lies behind the new museology—a social idealism intent upon making museums "responsive," as the current jargon goes, to the "needs" of a large majority of people and classes who have heretofore lived their lives without the benefit of museum pleasures. But this idealism should not be allowed to blind us to the subtle—and sometimes not-so-subtle—coercions and distortions that are now being insinuated into the museum experience under the guise of "education" and "public information" and other benevolent rubrics. The temptation to manipulate the museum visitor for his own "good"—to predetermine and control what he should think and feel at every turn—is now an especially strong one, and it is abetted not only by the spirit of social generosity I have already mentioned but also by the glittering array of technological devices that museum people are increasingly drawn to.

Unacknowledged in the new museology is a terribl fear of boredom—a fear that the object itself, unaided by programs and techniques and ideologies designed to explain and embellish it, will prove to be insufficient in interest. Unacknowledged, too, is an assumption that the museum visitor brings to the object a lazy, slumbering mind that must be constantly shocked and stimulated and reawakened into paying attention. There is, to say the least, too little faith that the art object is capable of generating its own kind of excitement—the only kind worth having in a museum—and too little understanding that aggressive interventions between the object and the perceiver act in the end to impair a genuine aesthetic response.

The new museology has a horror of difficulty and complexity. It is prejudiced in favor of the easy and the quickly assimilable. By that dubious standard, perhaps, the speakers who carried on here about the "failures" of the museums had good reason to complain. Traditionally museums, like the artists whose work they exhibit and collect and preserve, have not exactly specialized in making things easy. But in eliminating difficulty, are we not in danger of eliminating the very thing that gives the museum its unique value?

JULY 6, 1975

7. Reproductions for the Plebes

It is one of the curiosities of modern cultural life that a great many people who have neither an interest in art nor any real knowledge of it—people for whom art has never, in the normal course of things, become a significant factor in either their experience or their thought—nonetheless find themselves, for a variety of nonaesthetic reasons, compelled to have a great many opinions about it. In a perfect world (we may suppose) they would live their lives and pursue their specialized tasks, whatever these might be, without feeling obliged to give a moments' thought to the vexing issues that are likely to suggest themselves to anyone who has formed the habit of reflecting upon the complexities of aesthetic experience. But as the modern world tends—in this respect no less than in others—to be a highly imperfect place, more and more of these aesthetic illiterates (as I believe they may accurately be described) are tempted to speak out on a subject that is wholly alien to their customary outlook on life and its established frames of reference.

Why do they do it? For we are not speaking of fools or knaves, but of intelligent, well-intentioned people who are likely to have some sense of the intellectual risks involved when they venture into realms they know nothing about. Often they are professionals in other fields who have devoted much time and labor to the mastery of their own disciplines, and when it comes to the ongoing work in their own disciplines they are not in the habit of looking kindly upon the intrusion of ignorant outsiders who volunteer muddled opinions based on mistaken assumptions. Yet these same professionals nonetheless expect to be taken seriously when they offer up similarly muddled views on the experience of art. What is even more dismaying is that, in some quarters at least, they *are* taken seriously.

Why they do it is not really a mystery, however. They do it because they are asked to do it. Their opinions are anything but unprompted. More often than not, their views are solicited in high places where, owing to the increased visibility that art has now come to enjoy in our cultural life, the need for an ''outside opinion'' on the ramifications of its social utility is more and more felt to be a prerequisite to the formulation of an enlightened social policy on the arts. In the councils of government, in private foundations, and in the executive offices of the major corporations it is taken for granted, moreover, that an ignorance

of art is not in any way to be regarded as an impediment to the formulation of social policy on the arts. What is looked for, after all, is not a key to the aesthetic mysteries but something that is assumed to be more easily obtainable: an intellectual framework that will enable all parties concerned—artists, patrons, the public, and the various bureaucracies that claim to speak for their interests—to reach a correct assesssment of the needs to be met and of the consequences of any policy designed to meet them. Ideally, from this point of view, questions having to do with purely aesthetic matters need not—and should not—enter into the discussion of government policy at all.

In the real world, however, aesthetic questions are not so easily quarantined. Wherever large sums of money are allocated for the arts, whether the money comes from Mobil or the United States Treasury or some private bank account, critical decisions on aesthetic questions are unavoidable, and in fact they are made every day as a matter of course. The same holds true for all attempts to formulate a social policy for the arts. The creation of an intellectual framework to be used as the basis of such a policy may initially be thought to be free of aesthetic prejudice, but this never turns out to be the case. Sooner or later every theory of arts patronage and every analysis of its actual or probable consequences will be found to harbor an aesthetic position. There is no way to avoid it, and attempts to pretend otherwise must therefore be regarded as strategies for avoiding public responsibility in the matter.

It is a particular virtue of Edward C. Banfield's new study, *The Democratic Muse: Visual Arts and the Public Interest* (Basic Books)—it may, indeed, be its only virtue—that its author never for a moment pretends that he has not brought a good deal in the way of aesthetic prejudice to bear on his inquiry into government support of the arts. *The Democratic Muse*, the latest in a series of Twentieth Century Fund studies of this subject, purports to examine public funding of the visual arts as it has manifested itself in three specific spheres: the National Endowment for the Arts, the "typical" American art museum, and art-education programs in American public school systems. Toward the activities in all three of these spheres *The Democratic Muse* takes a very dim view.

> None of the arts agencies under study [Banfield writes]—not the NEA, the art museum, or the public school—has a defined purpose in any proper sense of the word, let alone one arrived at with knowledge and deliberation. What passes for purpose with each of them is a set of vague and conflicting statements of good intentions based on gross misperceptions of the nature of art and of the amount and character of the public demand for

it—the precipitate, so to speak, of competitive struggles among interest groups and of adaptations by administrators endeavoring to maintain and enhance their organizations in the face of changing circumstances.

It wouldn't much matter, however, if the NEA, the art museums, and the public schools ever did succeed in bringing a greater degree of "knowledge" and "deliberation" to the task of defining their purposes. Banfield, who is George D. Markham Professor of Government at Harvard University and author of *The Unheavenly City*, is categorically opposed to government support of the arts, in any case. "The American regime exists for purposes that are not served by art," he writes, "and the support of art is not among the powers that were given to the federal government."

It is in statements of this kind—and *The Democratic Muse* fairly abounds in declarations of a similar sort—that Banfield registers his categorical opposition to government programs for the arts, and it was no doubt precisely for the purpose of articulating its strong and obdurate position on this question—a position, we may suppose, presumed by its sponsors to be politically "conservative"—that the book came to be written (and supported by the Twentieth Century Fund) in the first place. Yet for anyone with a keen interest in the experience of art and its place in contemporary cultural life, the importance of *The Democratic Muse* is not to be found in its many disquisitions on "the powers" that may be seen to have been "given to the federal government" but in its analysis of what Banfield himself, over and over again, insists on describing as "the nature of art." What makes *The Democratic Muse* a really startling and bizarre book is not in fact what is says about government but what it says about art—for it is really upon the latter that its author comes to base his adversary position on government support.[1]

What, then, does the author of *The Democratic Muse* have to tell us about the nature of art? This, alas, is not a question easily answered. Banfield is rather more certain and more forthcoming about the al-

[1] As for what *The Democratic Muse* actually says about "the powers" of government, this is by no means as unequivocal as it might seem. In the very last paragraph of this very strange book, Banfield himself offers an observation that effectively capsizes his entire argument against government support of the arts. "The role of the government in a free society," he writes, "must be a matter of continuous negotiation among members of its public." One can only wonder what sort of book Banfield might have written if this interesting observation had occurred in the first—rather than in the last—paragraph of the book. For nowhere in the main body of the book is this "matter of continuous negotiation" acknowledged to be a legitimate option for a "free society" in determining the "role of the government."

leged failure of others to do justice to the nature of art than he is about
the nature of art itself. In this respect, the failure of what he calls the
"typical" American art museum is claimed to be complete.

> The one standpoint from which the museum is not an astonishing achieve-
> ment [he writes] is the artistic. If the proper function of an art museum is
> to collect and display works of art and, beyond that, to make the experi-
> ence of art more widely and intensely felt, then the art museum has failed.
> Although it has afforded countless moments of aesthetic enjoyment to
> countless viewers, it has mainly misrepresented the nature of art, put ob-
> stacles in the way of experiencing it, and encouraged the substitution of
> pecuniary and curiosity values for aesthetic ones. Because it has so long
> been the principal intermediary between visual art and the public, the art
> museum must bear much responsibility for widespread confusion about
> the nature of art.

Now it should be noted that an art institution which is acknowledged to
have succeeded in affording "countless moments of aesthetic enjoy-
ment to countless viewers" would not, by the reckoning of most ob-
servers, be regarded as having failed to perform the task for which it
had been created. But in Banfield's peculiar reckoning, some mysteri-
ous gulf is presumed to separate these "moments of aesthetic enjoy-
ment" from a proper understanding of "the nature of art," and aes-
thetic enjoyment must therefore be discounted in measuring the
museum's achievement.

About aesthetic experience itself—not exactly an incidental issue in
this discussion—Banfield shifts his position so frequently in this book
that is finally impossible to discern any coherent view of the subject.
Yet at each stage in his discussion of aesthetic experience and the bear-
ing it may or may not have on formulating a proper social policy on the
arts, Banfield writes as if his own confusions and contradictions are
somehow irrelevant to the resolution of the issues he is addressing.
About the art museum's alleged "substitution of pecuniary and curios-
ity values for aesthetic ones," for example, he is highly indignant, and
a good many pages of *The Democratic Muse* are devoted to what he re-
gards as professional malpractice in this realm. But would he really
prefer a museum policy which met his own standard—which he never
troubles to define, of course—for isolating aesthetic values in, so to
speak, a germ-free environment? Clearly he would not. He castigates
the museum for encouraging (as he sees it) the practice of "art viewing
[that] is done more and more for nonaesthetic purposes, especially to
learn about art and cultural history"—as if, by the way, there existed

some natural opposition between the acquisition of aesthetic experience and a knowledge of art and cultural history. Yet he is equally opposed to the pure aestheticism that he elsewhere seems to uphold as the art museum's only legitimate concern, for aesthetic experience—in yet another shift in the argument—is deemed to be "private" and therefore to be regarded as either irrelevant to our society or actually destructive of its values:

> . . . insofar as art is responded to aesthetically, the response [he writes] tends more and more to be a private one, having its effects mainly upon the viewer and little upon those he lives among and thus indirectly upon society. Finally, insofar as the experience of art does affect the society, it may sometimes be destructive of the values upon which social well-being depends.

Are we then to assume that "the values upon which social well-being depends" will not "in a free society . . . be a matter of continuous negotiation among members of its public"? Oddly enough, neither the George D. Markham Professor of Government at Harvard University nor his sponsors at the Twentieth Century Fund have judged it important to address this question in a book called *The Democratic Muse*.

The truth is, Banfield stands opposed to whatever policies and practices our museums now pursue, for he is deeply suspicious of art itself. He doesn't like the fact that art costs money. He doesn't like the idea that its social utility may not easily be described or controlled. He is against the doctrine of art-for-art's-sake, if only because "it means that aesthetic values are not to be weighed against other values—moral ones, for example," but he is equally opposed to any attempt to impose "other values" upon our intercourse with art. Above all, he doesn't like the fact that certain works of art are, by their very nature, unique and irreplaceable, and thus come to be regarded as having a special value—an aesthetic value that, precisely because of this uniqueness, inevitably results in it's being assigned a high financial value in the marketplace for art. Indeed, one sometimes has the impression in reading *The Democratic Muse* that the only thing in modern life about which Banfield is even more suspicious than art is the free marketplace itself. It is his grave and abiding suspicion of the art market, in fact, that has prompted Banfield to make his most startling proposal in this book.

For it must be said that Banfield is not one of those writers who merely denounce the practices of others. At least as far as museum policy goes, he has a program of his own to offer. He has thought deeply

about that problem of substituting "pecuniary and curiosity values for aesthetic ones"—for Banfield, one of the great cultural crimes being committed by the museums. He has also thought—not so deeply, perhaps—about that other vexing problem, "the nature of art." And in putting his thoughts about these two problems together, he has come up with a solution for both. If we are ever to succeed in separating the pecuniary value of art from its aesthetic value and thus make it possible for the true nature of art to enter our consciousness in an uncorrupted condition, this can only be accomplished, Banfield believes, by the creation of what he calls "two markets for art: one for art as art and the other for art as a collectible and for investment." In other words, the museums should turn over the original works of art in their possession to the traders in the second of these markets and replace the originals with—*reproductions*!

Lest the reader think that I am misrepresenting Banfield in this discussion, I am obliged to quote from the text:

> In effect, enterprises that put high-quality reproductions on the market serve precisely this publicly advantageous separation of aesthetic from other values. They make separate commodities of what would otherwise be joint ones: art as an aesthetic experience and art as a collectible or investment. . . .
>
> The art world will object, saying that a copy, however good, cannot have the artistic value of the original. It is clearly true that most do not. But is it true that they *cannot*? From a purely aesthetic standpoint, it can make no difference when, where, or how a work was produced: all that matters is its quality as art. A priori there is no reason to believe that a copy—even a poor copy—cannot be an even *better* work of art than a very good original. . . .
>
> Perfection, however, is not in all circumstances the appropriate standard. If one is willing to settle for copies that are "excellent" (meaning that no one but an expert can detect a difference with the naked eye), the cost will be less. And if one is willing to have copies that are just "very good" (meaning that an experienced and careful viewer gets almost as much aesthetic satisfaction from them as from an original), the cost will be lower still. A reasonable person must ask in what circumstances the difference between "very good" and "excellent," or between "excellent" and "perfect," is worth the difference in cost.

Of course, the cost—in dollars, anyway—would be lower still if we just chucked art out of our lives altogether, which is pretty much what the Banfield proposal would mean if it were ever to be seriously acted upon.

This whole farcical attempt to play the disinterested aesthetic theorist, postulating hypothetical distinctions between "excellent" reproductions and merely "very good" ones, as if the problem of substituting a piece of printed paper for, say, a painting by Rembrandt were merely a question of calling upon the requisite mode of technology for its production, is nothing but a ghastly intellectual fraud. Pretty ghastly, too, is Banfield's apparent inability to distinguish between artists' copies of works of art and deliberate attempts at forgeries, and between both of these, on the one hand, and the machine production of printed reproductions, on the other. In the protracted discussion of art reproductions which so gruesomely disfigures the analysis of government's role in supporting the arts in *The Democratic Muse*, Banfield quite simply reveals himself to lack even the most elementary understanding of what a work of art *is*. He seems to be under the impression that a painting, for example, somehow enjoys an aesthetic existence easily separable from its physical realization—quite as if it were something like a Platonic archetype awaiting the ministrations of the camera and the printing press in order for the painting's pure aesthetic essence to be liberated at last from its despised imprisonment as a commodity.

Banfield just doesn't have a clue as to what the word "work" means when we speak of a *work* of art. Not surprisingly, he invokes the expected and completely bogus analogy with music. If we can enjoy recorded versions of Beethoven symphonies, he asks, why not machine-made reproductions of Rembrandt paintings—conveniently overlooking the fact that it is in the nature of a Beethoven symphony to be *performed* and thus replicated, while it is in the very nature of the Rembrandt painting to be unique. It is tiresome to have to point out that what we see in a reproduction of a painting is something far removed from the artist's *work*. In a reproduction we see only some of what the camera saw in the original and what the printers presiding over the printing process made of what the camera saw. This bears no relation whatever to the process of aesthetic realization that occurs when musicians perform a musical work, and it is sheer demagogy to pretend otherwise.

Perhaps this is the place for me to declare my interest, as they say. Six years ago, when the late Nelson Rockefeller went into the business of producing and marketing reproductions of works of art from his own private collection, I wrote an article in *The New York Times* which severely criticized the entire project. Banfield takes note of this event in *The Democratic Muse*, completely swallowing the publicity generated

by the Rockefeller organization about "bring[ing] art to the people,"
and criticizing me for raising questions about the matter. Defending
the Rockefeller reproductions, which he describes (in yet another clas-
sification) as "of unusually high quality," Banfield writes that
"Kramer could hardly have supposed that Rockefeller, generous and
high-minded all his life, had suddenly turned unprincipled." Since this
statement, in Banfield's mind at least, settled the question of Rockefel-
ler's motives in launching his reproduction business, he goes on to say:
"More likely, what so upset Kramer was that Rockefeller had turned
traitor to the art world."

Now the fact is that my view of Nelson Rockefeller's character had
nothing to do with what I wrote about his reproduction project and
neither did my alleged "loyalty," if that is the word, to what Banfield
calls "the art world." (It is not entirely clear if he means to include
artists—those who actually make works of art—in this reference to
"the art world.") If I wrote out of loyalty to anything in my criticism
of the Rockefeller project, it was out of loyalty to the experience of
art—and a recognition of the frauds, commercial and otherwise, that
are perpetrated in its name. The notion of bringing art to the people
can mean many things, of course. What it meant in the case of the
Rockefeller reproductions was, among much else, that people with
eight hundred and fifty dollars to waste could buy a piece of paper with
an image based on Picasso's painting *Girl with Mandolin* machine-
printed on its surface. The whole Rockefeller project was a cynical at-
tempt to exploit the ignorance of the affluent—or those among them,
anyway, who, because of the glamour of Rockefeller's name, had come
to associate art with wealth and status and knew little or nothing about
the difference between a painting and a reproduction. It had precious
little to do with bringing art to "the people," as these words are gener-
ally understood. In *The Democratic Muse*, Banfield is simply trying to
give his proposal for filling the art museums with reproductions a free
ride on a dead man's coattails.

Because Banfield's approach to government funding of the arts—
its merits, its shortcomings, its proper extent, its ultimate effect on
art—is so superficial, dogmatic, and meanspirited, he does not ad-
vance the necessary discussion of this problem in any way. So far as art
itself is concerned, what the Banfield proposal would actually mean, if
we were ever so unfortunate as to see it implemented, is that "the
people"—those citizens who do not and cannot acquire great works of
art as private possessions but who are nonetheless keenly interested in

looking at them in the art museums and are now able to do so—would never again have the opportunity to see the real thing. Original works of art would be withdrawn from public perusal, and the experience of them would once again become a privilege of the rich. Reproductions for the plebes, originals for the rich: this is the policy that Banfield's reflections on the "failure" of the American art museum and on the nature of art itself have brought him to propose. It is a proposal that should be categorically rejected—not only in the name of art, but in the name of democracy. For Banfield's *The Democratic Muse*—which might have been more accurately entitled *The Democratic Medusa*—turns out to be antidemocratic as well as anti-aesthetic.

JUNE 1984

8. Criticism Endowed

"All this talk about good writing," the speaker declared, "sounds very fascistic to me." It was a remark guaranteed to stir the memory of at least one member of the "seminar" to which it was addressed. Years before, in the palmy days of the counterculture (as it was then called), a writer named Ellen Willis had earned a modicum of notoriety by solemnly confiding to the readers of *The New American Review* that—I quote from memory—"There is a saying in the movement that good writing is counterrevolutionary." Later on, I believe, Miss Willis publicly disavowed this remarkable doctrine. Perhaps she had found it cast an invidious light on the contributions she was then making to *The New Yorker* and *The Village Voice*. But there can be little doubt that she had reported the doctrine itself with complete accuracy; and here it was again, these many years later, looming in an unlikely circumstance.

For on this occasion we were a long way—or so one might have thought—from the "movement" of the sixties. We were seated around a capacious conference table in the headquarters of the National Endowment for the Arts in the third year of the Reagan administration. We had been brought together for a two-day "seminar" on art

criticism—or, more precisely, on government subsidies to art critics. For more than a decade the NEA had been giving money—not tremendous sums, to be sure, but public money all the same—to writers, editors, and sundry others under an art critics fellowship program, and the time had come (or so we were informed in the words of the official memorandum) to "focus on the nature, needs and problems of arts criticism" and "advise the Program concerning future support to this activity and possible new program initiatives."

Among the "problems" that quickly emerged as central to the deliberations of this official "seminar," none inspired a more heated discussion than this problem of "good writing." To require such a thing of art criticism—or at least of art criticism that is funded by public money—was deemed by most of the more outspoken participants in the discussion to be an intolerable idea, at best the sign of a degraded "philistine" or "middlebrow" taste, and at worst an outright threat to some of the basic freedoms guaranteed to us by our political system. It was really quite amazing to hear speaker after speaker—university professors, magazine editors, etc., the kind of people whom students and readers look to for intellectual guidance—deliver passionate attacks on the notion that clarity might be a desirable attribute in critical discourse. Yet the denunciations flowed on a tide of indignant feeling, and it was mainly on this issue of clarity that the "problem" of "good writing" came to rest. For—interestingly—no one seemed to doubt that in criticism there might exist some ineluctable relation between clarity and good writing, and it was precisely *that* which provoked so much dread and opposition among the speakers. I doubt if a greater degree of moral indignation would have been aroused by a discussion of censorship or a witch-hunt. Come to think of it, clarity in criticism was debated at times quite as if it *were* a discussion of censorship, and certain speakers made it abundantly clear that, in their view, the very fact that an issue like clarity could even be broached on this occasion was evidence enough that a witch-hunt of some sort was already upon us. Thus, when Linda Frey Burnham, the editor of a journal called *High Performance*, declared on the second day of the conference that "all this talk about good writing sounds very fascistic to me," she was only summarizing—a little more vividly, perhaps, than she intended—the spirit of the preceding debate.

To understand how all this could have happened—how ostensibly intelligent people, professionally engaged in writing or thinking about the visual arts, could bring themselves to such a preposterous pass—it

is necessary to know something about the participants in the NEA "seminar" and something, too, about the curious history of the Endowment's art critics fellowship program. That the program itself has been something of a disaster was tacitly acknowledged by the Endowment when it suspended fellowship grants to art critics in 1981 and commissioned an outside writer to look into what, if anything, this outflow of money had achieved. It was the preparation of this report, written by John Beardsley, a critic and curator who was himself the recipient of a small grant ($1,000) under the program in 1979, that occasioned the present seminar. Yet in a typical bureaucratic maneuver, the program for awarding fellowship grants to art critics was reinstituted for the fiscal years 1983–84 well in advance of Mr. Beardsley's report, and the lucky recipients of the new round of grants will be receiving even larger sums than have gone to critics in the past—another example, I suppose, of nothing succeeding like failure. All of this naturally lent to the discussion of Mr. Beardsley's report—the major item on the agenda for the second morning of the meeting—a certain air of unreality, and all the more so since his report was absolutely devastating in the highly specific criticisms it made of virtually every aspect of the fellowship program.

On the matter of Mr. Beardsley's report, and of the group's response to it, there will be more to say presently. But let us look first at the roster of participants who had been invited to sit in judgment on this report and "advise" the NEA on the future of the fellowship program. Of the twenty-four critics, noncritics, and anticritics who had been invited to take part in this seminar, at least ten had either received money under the fellowship program or had served as panelists (that is, jurors voting on grants) for fellowships or both. How many others had received money or represented institutions receiving money under other NEA programs it was not in every case deemed appropriate to disclose. Thus, at the very least close to half of the participants in this so-called seminar were either direct beneficiaries of the NEA's program or had a voice in shaping the program, or both.[1] One could imagine the outcry that would greet a conference called to sit in judgment and "advise" the White House, say, or General Motors or your local police department on one of its most dubious programs that was found to consist so largely of the program's mentors and/or beneficia-

[1]In fact a clear majority of the participants were or had been either beneficiaries, consultants, or panelists in one or another program of the NEA.

ries. The air would be so thick with accusations of conflicts of interest that the whole procedure would be instantly disbanded and discredited. For those attending this meeting, however, the very concept of a conflict of interest seemed not to exist. Not surprisingly, most of those who served as panelists for the art critics fellowship program or had been recipients of fellowship money thought the program was a wonderful thing, and they fought like tigers for its continuation.

How, then, did this wonderful program actually work? Oddly enough, it turned out that one did not actually have to be an art critic with a sustained record of publication in order to receive a fellowship under this program or to serve as a panelist awarding fellowships to others. It was apparently enough to have the right connections. In 1975, for example, John Coplans, the former editor of *Artforum*, who has lately emerged as a photographer and now exhibits his pictures in a prestigious Fifty-seventh Street gallery, was given a grant of $5,000. And in 1981, with the world still waiting to read what Mr. Coplans might write if he ever turned his talents to criticism, he was given a second grant of $10,000. Not that Mr. Coplans was special in this respect; he was only luckier in winning rather larger sums than some of the other noncritics who received fellowship money. May N. Tabak, for example, received only $1,000 in 1975, but perhaps as a consolation she was invited to serve as a panelist for the 1980 fellowships. Miss Tabak is certainly no stranger to the world of art criticism. As the widow of the late Harold Rosenberg, she can be assumed to be acquainted with it. But her own contribution to criticism remains, like Mr. Coplans's, more than a little obscure. It is not irrelevant, perhaps, to point out that the panelists who took this rather liberal view of the critical vocation in awarding the fellowships in 1975 were Elizabeth Baker, Lucy Lippard, and Peter Plagens, all of them recipients of fellowships in other years.

Which brings us to one of the other outstanding features of the fellowship program: the mutual-admiration principle that seems to have governed so many of its decisions. Thus, when Cecile McCann served as a panelist in 1976, one of the $5,000 fellowships went to Lucy Lippard. (Lippard had been awarded an earlier fellowship in the amount of $3,000 in 1972.) This was only fair, I suppose, since in 1975, when Lucy Lippard served as a panelist, Cecile McCann had been given a $5,000 fellowship. This was often the way the program worked. It wasn't exactly a closed shop, to be sure. Numerous people one had

never heard of—itself an oddity in the small world of art criticism[2]—
were also given fellowships over the years. But at the core of the pro-
gram there was certainly a nucleus of friends and professional col-
leagues who were assiduous in looking after one another's interests. In
fact, the record suggests that the whole fellowship program functioned
as a kind of private club to which a number of outside guests—always
carefully selected on the basis of geography, race, and gender—were
each year invited.

There was, moreover, no discernible intellectual standard applied
to the granting of the art critics fellowships. It was on this point that
Mr. Beardsley's report was particularly emphatic. "It is . . . with no
little sense of disappointment that I begin writing this evaluation of the
Art Critics Fellowship program," he remarked in the opening para-
graph of his report, and then went on to offer the following reflections:

> . . . it is my observation that this program fails to achieve the standards of
> other Endowment activities. In part, this merely reflects the generally
> lamentable quality of recent visual arts criticism. But the problem is com-
> pounded by a lack of clarity within the [NEA's] Visual Arts Program of
> the objectives of the fellowships for art critics, and by the tendency of pan-
> elists to overlook the principal stated criterion of quality in favor of less im-
> portant considerations. These have the consequence of undermining the
> cause of an intelligible and widely disseminated criticism, replacing it with
> one that is of benefit and interest to an ever narrower group. While there
> is no doubt that these grants provide a psychological and financial boost to
> their recipients, there is little evidence that they positively affect the char-
> acter and quantity of the recipients' work, and even less that they help to
> raise the standards of art criticism more generally.

Mr. Beardsley went on to point out—with remarkable restraint, I
think—that "in a discipline as narrow as art criticism, a strict adher-
ence to the peer panel review system makes it very difficult to find
panelists who are at once knowledgeable and disinterested." For this
and other reasons, he was clearly troubled by the concept as well as the
execution of the program.

[2]Exactly how many art critics there might be at the present moment was a matter of
some dispute. Kenneth S. Friedman, publisher of *The Art Economist* and author of a
"position paper" commissioned for the seminar, stunned the meeting by reporting
that his "research" could account for some twenty-five hundred art critics currently
at work. I think it is fair to say that this figure was regarded as a wild exaggeration—a
case of statistics being able to prove anything.

Two major questions still loom in my mind. First, is there a large enough group of good critical writers to justify giving awards that are largely honorary in effect, if not in intent? I am not at all certain. Second, if the major objective of the critics fellowship program is, as stated in the 1972 Council pages, to enhance professionalism and raise standards of quality, has the program achieved that objective? The answer to this is a less equivocal no.

And if there was no intellectual standard governing the program, was there then a discernible political bias at work in the fellowship awards? Mr. Beardsley spoke of the "recurring desire to support alternative publications," and went on to point out that "specific ideological biases were more pronounced in 1979 than in other years." (It was in 1979 that the program awarded more fellowships than in any other year of its existence.) "The 1979 panel," Mr. Beardsley wrote, "seemed bent upon correcting at one sitting two centuries of male dominated, geographically centered criticism." One of the panelists for that ill-fated year told the seminar that the 1979 panel had been bluntly instructed at the outset not to give too many fellowships to white males. But it would be unfair to single out 1979 as a special year on political grounds. My own impression, after studying the list of fellowships from 1972 onward, is that a great many of them went as a matter of course to people who were publicly opposed to just about every policy of the United States government except the one that put money in their own pockets or the pockets of their friends and political associates. In this respect, it is worth noting that there seemed to be an annual fellowship reserved—unofficially no doubt—for one or another writer for *The Village Voice*.

To say that the seminar largely rejected Mr. Beardsley's findings would be an understatement. Donald B. Kuspit, recipient of a 1977 fellowship and author of one of the "position papers" commissioned for the meeting, described Mr. Beardsley's report as a "slander." Others used stronger language. The report had, after all, severely criticized decisions many of them had made and work that many of them had done, and there is nothing these critics dislike more than criticism of themselves. By and large, however, much of Mr. Beardsley's report— despite the hue and cry raised against it—went undiscussed. He was often attacked, but the issues he raised were rarely engaged. Most of those present were pleased with the program as it was, and were more concerned to safeguard it than to analyze or question it.

To give the meeting some semblance of intellectual seriousness

there were of course those "position papers," the discussion of which occupied a good deal of time. Mr. Kuspit's was called "Two Modes of Art Criticism," and in it he juxtaposed something called "aesthetic criticism" (which was thought to be bad) with something called "Bildung criticism" (which was thought to be good). Reading his paper and listening to its author enlarge upon it, one could certainly understand his opposition to clarity in critical discourse. Another vocal opponent of clarity, Rosalind Krauss—recipient of a fellowship in 1975 and a panelist in 1977—contributed a paper called "Regarding 'Marginal' Criticism." Its general spirit may be gleaned in the epigraph it bore from Jean François Lyotard: "Masculine imperialism either relegates women to its borders or, if it educates them, makes them homologues of men." It was an exercise in feminist nihilism feebly attempting to disguise itself as critical theory. Adrian Piper, described as having "produced conceptual, performance, and political art since 1968" and the recipient of NEA fellowships in 1979 and 1982 (though not from the art critics program), offered a paper called "Critical Hegemony and the Division of Labor in Art," which was unalloyed politics hardly even attempting to disguise itself as anything else. Douglas Davis, a senior writer for *Newsweek*, a 1981 panelist for the art critics program, recipient of an NEA artists fellowship, and director of something called the International Network for the Arts, composed a lengthy opus entitled "The Contemporary Audience: the Radical Bourgeoisie," which was more politics. In none of these "position papers" was the subject of art discussed.

It was, then, from such disinterested minds that the NEA seminar on art criticism was expected to find guidance in discussing the future of the art critics fellowship program, and thus "advise" the NEA on the wisest course of action. I have no doubt that the organizers of the seminar got exactly the results they were looking for. Whatever "new program initiatives" might now be introduced into the program, it is clear that the same people and the same values will remain in charge. We were not, after all, as distant from the "movement" of the sixties as one might have thought. The only difference was that the "movement" was now on the inside, running or advising the bureaucracy, instead of being on the outside making demands. And it isn't only art criticism, of course, that can be counted among the casualties of this turn of events.

NOVEMBER 1983

VI. Art for the Eighties

1. The New Scene

The single factor that most completely dominates and defines the art scene at the present moment is the sheer number of objects and events that crowd upon it. Any attempt to acquire a sense of the quality or vitality of art in the 1980s must therefore be seen in relation to the immensity and variety of the activity itself. We have literally known nothing like it in the past.

There are now, first of all, more artists creating more works of art (of some sort) than ever before in our history. There are also more galleries eager to show it, and therefore more exhibitions of it. There is more discussion of it, too, and more study of it, and more money spent on it. And there is, of course, more competition, often very fierce competition—among both artists and their agents—for the kind of high visibility and distinction that will place them above the hustling herd of talents vying for attention and success.

To this uninterrupted flow of new art and all of its attendant publicity and clamor must be added, moreover, the unprecedented number of museum exhibitions and publications now devoted to the art of the past. These, in turn, have generated a vast increase in the number of people who attend lectures, sign up for courses and guided tours, or otherwise attempt to acquaint themselves with the rudiments of art history and art appreciation. The expansion of the art public—including the public that spends nothing on art directly but a good deal on cultivating its own pleasures and interests—is no less remarkable than the

growth in artistic production. It is sometimes a question, indeed, whether the public is racing to keep up with art or whether art is racing to keep up with its new public. Either way, the pace is intense, the scene hectic, and the numbers growing.

Now, there is a price to be paid for all this frenzy and hubbub. There usually is for success on this scale. The atmosphere of huckster-ism, the confusion of values, the manufacture of false reputations, the spawning of instant "movements" and carefully orchestrated "trends"—the whole tendency of the art world to adopt "show-biz" or "network" tactics in the promotion of its wares and services is deeply disturbing to many experienced observers of the scene, includ-ing many of the artists who stand to profit from it, and pleasing to al-most no one who isn't in a position to make a lot of money out of it. Artists of the older generation, with fond memories of an art scene that was smaller in size, more personal in its professional transactions, and less hurried in its pursuit of success, are often especially dismayed by this radical change in the ethos of their vocation. And many younger artists, too, are simply frightened by this new competitive environ-ment into either dropping out entirely or seeking some alternative course at a safe distance from the noise of the limelight.

One does not have to be an unqualified admirer of the new scene in order to point out, however, that there is now a corollary tendency to be pious and sentimental about the so-called good old days. Were they really the pastoral idyll they are nowadays made out to have been? Too often forgotten are the indignities that impecunious artists—including many of our best—were regularly obliged to endure at the hands of dealers and collectors ruthlessly exploiting their advantage in a buyers' market. Overlooked, too, is the general indifference and ignorance with which the museum profession, with few exceptions, tended to treat new developments in art. Informed and sympathetic critics were also fewer in number and influence than is the case today. And as for the great public, it could hardly be said to exist as far as the living artist was concerned. No doubt the art world of yesteryear was in many re-spects a cozier and more agreeable place than ours can be said to be to-day. But lest nostalgia blind us to its harsh reality, let us also remember that it was a place of severe economic hardship and very limited oppor-tunity for most of the artists who inhabited it.

Economic prosperity always brings its share of excesses and abuses, and the art world is certainly not immune to them. In some ways—especially in the way it often mistakes success for achievement—it may

be especially vulnerable to them. Yet prosperity also brings opportunity and development, and much that is vital in the visual arts today owes its existence to the greatly expanded horizons of possibility that now exist in our society—and are vividly seen to exist—both for the individual artist and for the institutions that minister to his, and our, aesthetic needs and aspirations.

Of course, vitality in the arts is always a relative thing, and there is no absolute way to measure it. (Even posterity, the closest thing we have to a final arbiter in these matters, is anything but absolute in the verdicts it renders. Its periodic changes of mind are what we study in the history of taste.) Much depends on the perspective one adopts. Compared, say, to the achievements of the European avant-garde in the years 1900-20, most of the art produced in this country in the last twenty years shrinks in significance, if only because it has remained so closely attached to the basic modalities created in the art of that period. On the other hand, if we look at the sculpture that has been produced in this country in the present century—or even, indeed, in the last twenty years—and compare it to the dim accomplishments of American sculpture throughout the entire nineteenth century, then we can only conclude that ours has been a period of high achievements in the field. It is precisely the task of criticism to create the comparisons and contexts that are most appropriate to an understanding of the art in question.

In this respect it may be that at the present moment the most illuminating way to gauge the creative vitality of the visual arts is not by comparison with past achievement but by examining the relation in which the visual arts now stand to certain other fields of contemporary artistic endeavor. If, for example, we were to attempt to identify the playwrights or the new composers or the new choreographers whose works—that is, newly created works seen for the first time—have made an especially emphatic impression on either the critics or the public in recent seasons, what sort of list would we have? I shall leave it to my colleagues in these fields to determine what, if any, names have unequivocally earned a place on such a list. But I venture to predict that we are not in any danger of being overwhelmed by unmanageable numbers. It seems to an outsider, at any rate, that the real problem would be to come up with enough names to make a persuasive list at all.

Unlike today's art public, the audience for theater and music, and even a large part of the more adventuresome audience for dance,

seems neither to want nor to expect to encounter new creative work in those fields. For the minority with an appetite for something "new," it seems enough to have Hamlet dressed up as an astronaut, say, or to see Don Giovanni put into a cowboy suit. The "new faces" that emerge in the theater and in the music and dance world every season thus tend to be performers or directors, not the creative artists responsible for the making of original works of art. Where, for example, is there an opera house eager to mount a retrospective of the major operas written by a composer under the age of fifty? (How many such operas exist? Is there a significant oeuvre we have overlooked?) Where is there a theater eager to do similar duty for the younger generation of playwrights? It seems almost utopian even to suggest the possibility.

Yet in the visual arts today, this is precisely the kind of task that is regularly undertaken, year in and year out, and not by one or two isolated museums or especially venturesome art galleries, but by scores of museums and galleries the country over. The visual arts flourish today as a living creative enterprise—and are seen to do so by an eager and intelligent public—in a way that the other arts do not. One does not have to believe that every painter or sculptor showing new work on Fifty-seventh Street or having a retrospective exhibition in some museum is a genius to see the difference.

There are, to be sure, many practical reasons for this difference. The composer needs an opera house or a concert hall. The choreographer needs a company. The playwright needs a theater. Whereas the painter or sculptor works alone. His art is not in its very conception dependent on a collaborative enterprise. But there is, I think, a further and perhaps even more important reason why there is so much more creative freedom and creative opportunity and creative activity in the visual arts today than in other fields, and it is this: the visual arts are not involved in the dynamics of the entertainment industry. Despite complaints about "show-biz" tactics and no matter how large the size of their public may be, the universe of discourse for the visual arts remains that of high culture, not popular culture. It is this loyal attachment to the disciplines of high culture that acts to preserve the creative energy and intellectual independence of the visual arts, and to protect them from the coercive influences and debilitating compromises that are inevitable when art plunges into the arena of entertainment.

There is a considerable irony, of course, in the fact that this particular branch of high culture—long famous for its tendency to alienate the public and offend respectable taste—has now acquired a large and

devoted following. Is it that our understanding of art has improved, or that the art itself has changed, or that the public has itself changed in ways that make the experience of high art seem more than ever necessary to its spiritual survival and well-being? Whatever the causes of this great historical reversal may be, the change itself surely goes a long way in accounting for the kind of vitality that we see in the visual arts at the present moment.

<div align="right">SEPTEMBER 6, 1981</div>

2. Jackie Winsor

The art of sculpture is now so different from what it once was, it's now so firmly established in areas of visual discourse not formerly considered sculptural—or even aesthetic—that we tend to forget the enormous distance this art has traversed in a matter of a decade or two. Living in a culture in which new artistic practices quickly acquire the status of conventions has obvious advantages, of course—particularly for artists working to roll back the boundaries of the aesthetically permissible—but it has the disadvantage of blunting the sense of surprise that used to attend every significant change in art.

Nowadays we're only genuinely surprised—happily or not, as the case may be—when we encounter an art that does not attempt to roll back some hitherto acknowledged boundary. In our experience of new sculpture, especially, we are so inured to assaults on our expectations that we expect just about anything. The distance separating the unthinkable from the commonplace has all but disappeared, and the commonplace is all too often mistaken for an act of imaginative audacity.

Thus, well in advance of the Jackie Winsor exhibition that Kynaston McShine has organized at the Museum of Modern Art we have grown used to the ways in which sculpture has attached itself to the hardware store and the lumberyard. Sculpture that works as if it had been cobbled into shape by a carpenter's assistant or a mason's apprentice on a holiday from useful employment is no longer a shock even

when encountered in a museum. It is very much what we have come to expect of sculpture, or at least the branch of it known as "advanced" sculpture.

Miss Winsor's sculpture is, in a number of respects, representative of what might be termed second-generation Minimalism. In the work of the first-generation Minimal sculptors, it will be recalled, the emphasis was all on simple shapes and smooth surfaces. Sculpture was given an impersonal, quasi-industrial look, as if its ultimate ideal was to resemble something untouched by human hands. In Miss Winsor's work, the shapes are likewise abstract and similarly simple, but the surfaces are no longer smooth. There is a handicraft quality in this new sculpture that is alien to the spirit of first-generation Minimalism. Polished plastic forms are out, and in their place we find materials that resist any association with slickness or glamour—twine, copper wire, plywood, logs, cement, rope, bricks, and nails.

These raw materials, deliberately left in a raw state, are employed without embellishment or "magic." Everything is addressed to us on the plane of literal perception. We are forcibly reminded that a lot of dumb labor has gone into the production of this new sculpture—the routine of securing those endless coils of twine and wire, setting those repetitious cement forms in strict retangular alignment, matching those grids of exactly measured plywood slats. We are clearly meant to experience the absence of all metaphor and fantasy as a token of artistic earnestness. But the basic spirit of the thing is to wrest sculpture away from the factory and the fabricator and return it to the realm of the handmade object.

The imagination nurtured on sculpture of a more traditional sort inevitably feels estranged in the presence of Miss Winsor's work and is clearly meant to feel so estranged. But so might a sensibility nurtured on first-generation Minimalism. There is always in sculpture like Miss Winsor's a certain polemical intention basic to its very conception, and one aspect of its polemic is to put into question what has immediately preceded it.

Still, despite its new look of handicraft abstraction, is there not in this work an occasional allusion to the art of the past? I cannot share in the notion that Ellen H. Johnson offers us in the brief text of the catalogue of the show that Miss Winsor's sculptures "are like Cézanne's apples in their 'stubborn existence.'" This latter phrase is Rilke's, and the introduction of Rilke, or even Cézanne, into a discussion of Miss Winsor's sculpture strikes me as the sort of thing that gives art criti-

cism a bad name among readers who feel that commentaries on even the most difficult art ought still to be required to meet the demands of common sense. When Miss Johnson gives us, in the catalogue, a visual comparison consisting of a Cézanne still life *Apples and Oranges*, a Steichen photograph of an apple, and a Winsor sculpture consisting of four balls of twine, she is simply adding another chapter to the history of unnecessary mystification that already overburdens the literature of contemporary art. As often happens nowadays, her "explanations" of Miss Winsor's work requires more explanation than the work itself.

Still, certain allusions do appear to be present in the work, even though they are not allusions to Cézanne. Take, for example, the length of rope, coiled around an invisible steel rod, that stands in vertical, unembellished rectitude some 74 inches high, and is entitled, with engaging wit, *Rope Trick*. Is there a reference here to Brancusi's *Endless Column*? I rather think so. If we "get" the reference to Brancusi when we see *Rope Trick*, the object—otherwise so unremarkable—acquires a certain aura. It enters into an art-historical dialogue. It becomes a sculpture about sculpture. This is what the new sculpture often is: a comment—however oblique or hermetic—on other sculpture.

But the primary allusion in Miss Winsor's work is not to Brancusi but to something more general—to primitive sculpture, with its attachment to ritual and preindustrial modes of workmanship. There is a yearning in this work for the kind of meaning that the sculpture in a primitive culture could take for granted: the meaning that derives from a traditionally ordained ritual function. It is in this yearning that the true significance of Jackie Winsor's sculpture lies—a yearning that attempts to convert the slick forms of Minimalism back into the language of primitive feeling. The poignancy of the work is to be found in the fact that the only rituals available to the sculptor in this task are the rituals of aesthetic ratiocination.

FEBRUARY 4, 1979

3. Neil Jenney

In an art scene as fast paced and publicity conscious as the present one, where every microshift in style is closely monitored by cadres of knowledgeable curators, critics, dealers, collectors, and cultural historians on the *qui vive* for any sign of a significant new talent or a promising trend, museum retrospectives tend to come early to certain artists. Neil Jenney, for example, is having one at the age of thirty-five. At the University Art Museum on the campus of the University of California, Mark Rosenthal has organized the first comprehensive survey of the painting and sculpture that Mr. Jenney has produced since 1967. It is a show that has much to tell us about the fate of art in a period that saw the radical styles generated by the counterculture of the sixties swiftly succeeded by the very different artistic strategies of the seventies.

Mr. Jenney, who lives and works in New York, is probably best known for his participation in two widely disparate exhibitions at the Whitney Museum of American Art. One was the show called "Anti-Illusion: Procedures/Materials," which took place in 1969. The other was the more recent show of "New Image Painting" in 1978. The first of these, it will be recalled, sounded a vociferous note of rebellion against all the "polite" forms of art then deemed generally acceptable to established taste. The "New Image" exhibition, on the other hand, proved to be more accommodating. Painting was once again upheld as the primary medium of artistic discourse—and painting, moreover, in which certain representational elements were again given an important place.

In bridging this transition from the antiart conventions of the counterculture to the more traditional strategies of New Image painting, Mr. Jenney is, indeed, a representative figure. Not the least interesting thing about his work is the way it attempts to preserve the ethos of the sixties counterculture in paintings that otherwise eschew the bad manners and disruptive rhetoric of the antiart tradition. Yet these paintings are now so elegant and accomplished, so entrenched in traditional modes of pictorial representation, and so little dependent upon the "messages" they convey for their effect, that their attachment to a radical ethos strikes one at times as an irrelevant and receding piety. This, in turn, presents us with a conundrum, for Mr. Jenney has been insistent all along on the social mission of his art. He is the only artist I

know of to have declared art itself to be, as he says, "a social science."
This is not a credo easily ignored.

It may be, of course, that Mr. Jenney simply talks too much. He is
certainly a very talky artist—quite the talkiest of his generation—and
Mr. Rosenthal has therefore been obliged to give his utterances on art
a prominent place in the catalogue of this exhibition. Normally, one
would be inclined to ignore these utterances, or at least to discount
them in any consideration of the art, and let the pictorial images speak
for themselves. But we are prevented from doing this, in Mr. Jenney's
case, for the very good reason that the words have quite literally gotten
into the pictures—or at least into the increasingly elaborate frames that
the artist has declared to be an integral part of his pictures. The titles
of Mr. Jenney's paintings—which he has insisted are "as important as
the painting" itself—are conspicuously stenciled on the black frames
that enclose them, and both the frames and the words containing them
have gotten bigger and bigger as the pictorial images have grown pro-
portionately smaller. In some of the most recent pictures—*American Ur-
bania*, for example, and *Melt Down Morning* (both 1975)—the words are
just about equal to the pictorial images in the space they occupy, and so
it is obviously impossible to discount them in coming to terms with the
paintings themselves.

Let us go back, however, and retrace the course by which Mr. Jen-
ney has arrived at this odd and quite interesting amalgam of words and
pictures. He began, after all, as one of the wordless artists of the six-
ties, working mainly in a mode of three-dimensional construction we
are obliged to call sculpture for lack of any better term to describe it.
In the exhibition that Mr. Rosenthal has assembled in Berkeley, the
first and least impressive section is devoted to these constructions. The
earliest of them—the *Linear Pieces* of 1967—are simply variations on the
kind of Minimal art that was all the rage when Mr. Jenney arrived in
New York (from Massachusetts) in 1966. The irregularities they intro-
duced into the rigidities of the Minimal aesthetic were clearly insuffi-
cient to make much of a difference, and so the modality of Minimalism
was quickly abandoned in favor of a more aggressive mode of tableau
construction in which benches, tables, lights, and sundry other objects
were combined in real, roomlike space to create a succession of sculp-
tural environments. The materials were rough, drab, and common-
place, and thus represented a break with the smooth surfaces and fab-
ricated look of Minimal art, but the sense of scale and gesture was
curiously familiar. It was the scale and gesture of Abstract Expression-

ism projected in three dimensions. This, too, proved to be a dead end. Sculpture was not to be Mr. Jenney's forte.

Words make their initial appearance in a wall construction called *The Press Piece* (1969). This is said to be the artist's last attempt at sculpture, but the conception is already more pictorial than sculptural. Five framed pages from the New York *Daily News*, all dealing with the success of the New York Mets, are lined up on a black shelf, while on another black shelf below, the word "americana," fragmented into separate syllables, is spelled out for us in red, white, and blue neon tubing. "He wanted," writes Mr. Rosenthal, "some form of social content, in a fashion similar to Pop art," and Mr. Jenney has himself declared: "I think that the most profound art in American history is Pop art."

It was with this point of view that Mr. Jenney turned to painting in 1969, and it is in the presence of the paintings he has done since that time that we feel the real energy and momentum of this exhibition. These paintings are in two series. The earlier, larger pictures, painted in 1969–70, have brilliant, smeary, Color-field surfaces in which figures and other objects—fighter planes in *Them and Us*, harnessed oxen in *Beasts and Burdens*—are drawn in a cartoon manner that clearly owes much to the Pop aesthetic. They look a little like melt-down versions of Alex Katz's paintings of the fifties, and they are immensely seductive to the eye. The words of their titles are discreetly stenciled on their unobtrusive black frames.

The more recent pictures are mainly eccentrically shaped fragments of landscape subjects executed in a meticulously realistic style derived from nineteenth-century American landscape painting. The painting in these pictures is very accomplished—quite beautiful, in fact—and many of them have the haunted, romantic quality that is now very much prized in the work of those nineteenth-century artists who have lately been the subject of much attention and who have clearly served as Mr. Jenney's models. Yet something else is going on in these pictures. They are anything but a pious revival of a nineteenth-century style. Their pastoral landscape imagery constitutes only a part—and in some cases, not the larger part—of what we are given to look at. The enclosing black frames, adorned with the bold, stenciled words of their titles, are stouter, more elaborate, and far more obtrusive than they were on the earlier paintings; and the titles serve as a kind of warning. Lest we unthinkingly succumb to the delights of the landscapes we glimpse in these paintings, their titles alert us to a sense of danger.

We are, in short, in the presence of what are known as "environmental concerns." The landscapes that are depicted for us are to be viewed as threatened landscapes. Their grandeur is implicitly contrasted with their imminent destruction. The pastoral mode, with all of its sweetness and light, is thus made to serve as a form of political statement. The stark contrast between the luminous landscape and the heavy black frame has a meaning, after all. These weighty, gloomy frames signify an attitude of mourning. They invite us to lament the destruction of an earthly paradise. Their purpose is at once didactic, admonitory, and allegorical.

Mr. Jenney has been quite explicit in declaring that he wants his paintings to contain "allegorical truths," and we can now see what he means by this. We can better understand, too, what he meant when he said that, for him, "art is a social science." I am not myself persuaded that the art of painting is an ideal medium in which to conduct a debate over the future of the environment. Yet the paintings themselves, together with their funereal frames and editorializing titles, have an undeniable power. They will not be soon forgotten. Nor should we miss something else that is significant in this work—something that can only be described as its cultural or political strategy. In the way Mr. Jenney has succeeded in preserving the radical ethos of the sixties in a very polite, well-mannered, mainstream pictorial style for the eighties, he has produced an art that is in many respects a perfect analogue for much that is now observable in our culture outside the realm of art. He is, in this sense, a very political artist; and we do not begin to understand him until we have grasped the political dimension of his work.

MAY 17, 1981

4. Charles Simonds

Ten years ago, or thereabouts, there arose among certain artists of the younger generation a strongly held conviction that art, in order to remain spiritually uncontaminated by the evils of a wicked society, must henceforth take only the most perishable forms. It was assumed, of

course, that ours was an especially wicked society, and the whole notion of producing a durable art object, such as a painting or a sculpture, that would, if successful, take its place as a valued part of an established cultural tradition, was therefore rejected as a morally odious compromise with a corrupt and moribund system. Permanence in art was judged to be incompatible with the ideals of the social revolution that many of these artists professed to espouse.

To implement the desired new agenda for art—an agenda more in keeping with the values and outlook of the radical counterculture that had nurtured this rejection of permanence and "success"—various alternatives to the despised conventions of bourgeois art were quickly pressed into service. It was then that Conceptual art, earthworks, on-site improvisation, certain modes of video and performance art, and sundry other "alternative" movements of the period won their place on the art scene.

It is worth remembering, too, that it was in this period that "dropping out" acquired for many of the young—and most especially, perhaps, for the offspring of the comfortable middle class—the status of a moral imperative. For it was in these "alternative" movements that many fledgling artists of that class found an opportunity to "drop out," while at the same time remaining professionally engaged in some sort of artistic pursuit. Whether or not these artists actually believed that society would be brought to heel by digging a hole in a prairie, or videotaping a cross-country hegira in a VW van, many of them acted quite as if they did. It was a period rich in the rituals of radical credence.

This, in any case, is the background that it is essential to bear in mind in approaching the Charles Simonds exhibition that John Hallmark Neff has now organized at the Museum of Contemporary Art in Chicago. Mr. Simonds is an artist whose entire outlook has been shaped and stamped by the ethos of the counterculture that emerged in the late sixties. He in fact belongs to the generation and to the class that proved to be especially susceptible to its beguilements and especially successful in making them the basis of an impressive art world success. Indeed, Mr. Simonds's whole career offers us a particularly vivid example of how much can be achieved in our culture, at least as far as reputation and renown are concerned, by appearing to reject the fundamental tenets of the culture itself and adopting in their place a scenario of adversary intransigence.

Here, in Mr. Neff's lucid account, is the biography—or "Outline of Events," as it is called—that the artist has chosen to disclose to us on the occasion of this solo exhibition, his first in an American museum.

He was born November 14, 1945, in New York, the younger son of two Vienna-trained psychoanalysts, and raised on the upper West Side. His grandparents had immigrated to the United States from Russia. He attended the New Lincoln School in Manhattan, then the University of California at Berkeley where he majored in art, receiving his Bachelor of Arts degree in 1967. He married in 1968 and attended Rutgers University, New Brunswick, N.J., earning his Master of Fine Arts in 1969. From 1969 to 1971 he taught at Newark State College, having moved back to New York where he shared a building at 131 Chrystie Street with artists Gordon Matta-Clark and Harriet Korman. He began in 1970 his ritual Mythologies in the Sayreville, N.J., clay pits and other impromptu street activities with Matta-Clark around New York and the vicinity. At this time the first Dwellings were made outdoors.

From 1971 to 1972 Simonds lived in a building on 28th Street owned by his brother, who managed rock bands which occupied the other floors. First in Jeffrey Lew's loft at 112 Greene Street and later at 98 Greene Street, Simonds joined friends in informal, experimental art activities and performances. In 1971 he met art historian and critic Lucy Lippard, with whom he has lived on Prince Street since 1972. In that year he came to know Robert Smithson. During the 1970s, as his work became known beyond a small group of friends and critics, Simonds traveled widely as a visiting artist or participant in group exhibitions. Since the mid-1970s he has been included in most of the major international and national invitational exhibitions and his works have entered the permanent collections of museums here and abroad. He has recently started work at a new studio on East 22d Street and still conducts his affairs without a gallery or agent. As this catalogue goes to press, he is exploring the possibilities of a visionary, environmental museum of natural history.

I have quoted this account at length for two reasons—first, because it offers some essential clues to the understanding of his art; and second, because it so graphically conveys the atmosphere of self-importance and historical self-consciousness in which the art has been created. Not since Picasso, I suppose, have we been vouchsafed the addresses of so many studios and residences associated with an artist's career—and Mr. Simonds, let it be recalled, has just turned thirty-six! It is almost enough to make one believe that the much-discussed hous-

ing crisis for young artists desiring to live and work in Manhattan has been greatly exaggerated.

Mr. Simonds made his artistic debut in the early seventies with films that focused entirely on himself. These he calls, not inappropriately, his "Mythologies," and what they record is the artist's naked body—Mr. Simonds is a good-looking young man with an attractive physique—in the process of acting out a succession of self-contrived rituals of rebirth in the unappetizing clay pits of Sayreville, New Jersey. In the first of these films, called *Birth* (1970), Mr. Simonds is shown slowly reemerging from what can only be described, I suppose, as the primeval slime. In others—*Landscape—Body—Dwelling* (1970) and *Body—Earth* (1971)—the same naked body reclines and/or writhes in the slimy clay landscape in a further elaboration of the same self-invented and self-aggrandizing ordeals.

Videotapes of these and other films, showing Mr. Simonds at work on his "Dwellings," are included as part of the present exhibition, and there are also enlarged stills from them mounted on the walls for the benefit of viewers who may wish to study their finer points at greater length.

The bulk of the exhibition, however, is devoted to the miniature "Dwellings" that have been Mr. Simonds's principal preoccupation for the past decade. These are tiny, quasi-primitive structures made of unfired clay bricks so small that they can only be put in place by using metal tweezers. Paint is then applied to these clay surfaces, and the look that is obviously aimed for is that of a ruin, or survival, of a lost, or at least a threatened, primitive civilization. Mr. Simonds conceives of these "Dwellings" as the habitations of an imaginary race of migratory "Little People." He does not actually show us this race of miniature beings, however. Presumably they have been driven from their "Dwellings" by the pressures and cruelties of the modern world. The "Dwellings," too, are thus a species of "Mythologies."

At the outset of his work on these "Dwellings," Mr. Simonds was content to think of them as throwaway creations, more or less in keeping with the cult of perishable art that flourished in the early seventies. He is said to have constructed some three hundred of these works in the crumbling walls and on building ledges and windowsills in neighborhoods where he had every reason to expect that they would be destroyed, and most of them have been. They did not go unrecorded, however. In one of the films we are shown at the museum, we see Mr. Simonds at work on location in an urban slum, looking rather like a

missionary intent upon bringing the gospel of the "Little People" to a neighborhood where, as Mr. Neff puts it, "the concerns of both museums and the art market are worlds away."

Still, life in our wicked society being what it is, the concerns of the art museum—and even, alas, the art market—could not, apparently, be permanently resisted. And so Mr. Simonds has lately taken to giving his "Dwellings" a more permanent and—dare one say it?—a more salable form. They are now constructed as tabletop landscape sculptures, and very pretty they often are, too! I am not too keen on the 1978 series that are made to look like landscapes consisting entirely of female breasts—and painted a very fleshy pink, lest we miss the point!—but the landscapes adorned with towers and toylike fortresses and settlements have an undeniable childlike charm. Their contribution to the art of sculpture may be nil, but they have a certain visual interest, all the same, and they have much to tell us about the appeal that archaism, regression, and the romance of primitivist sensibility continues to exert on the contemporary mind.

And this, in turn, brings us back to the ethos of the counterculture of the sixties from which Mr. Simonds's art derives. As we can see in his early films, that feeling of nostalgia for mud and dirt—what the French call *la nostalgie de la boue*—was especially strong in Mr. Simonds, a telltale sign of an immaculate, urban middle-class upbringing. (No one brought up on outdoor toilets, rural poverty, or the care of farm animals would be likely to share this feeling to anything like the same degree.) And in Mr. Simonds's "Dwellings," this same nostalgic impulse is projected into a fantasy-rejection of the entire civilization that has produced him.

Yet how appealing this radical rejection continues to be to the culture, to the class, and to the institutions that are ostensibly spurned in every detail of its vision! Mr. Simonds is no longer the mendicant-missionary so lovingly depicted in his films. He is now one of the darlings of the international museum world. Much of the work that we see in Chicago has already been the subject of exhibitions in Cologne and Berlin, there are essays in the catalogue written by museum curators in Washington and Paris—in addition to Mr. Neff's own contributions—and this exhibition will travel to still other museums in Los Angeles, Fort Worth, and Houston.

And, for Chicago, Mr. Simonds has now executed an ambitious series of permanent "Dwellings" that occupies an entire wall of the Museum of Contemporary Art—the wall, as it happens, of the museum's

café, where visitors can relax over coffee and pastry while they ponder the artist's dreams of cultural regression. And private collectors, too, are eager to have specially executed "Dwellings" for their posh middle-class residences, and Mr. Simonds is no longer, I gather, reluctant to provide them. It would all be a wonderful tale of success triumphing over modesty and adversity if, in what it tells us about the state of our cultural life, its implications were not so dreadfully creepy.

DECEMBER 13, 1981

5. The Return of the Realists

It looks as if 1981 is going to go down as the year of the realist blitz. Not since the 1930s has realist art—the kind of painting, drawing, and sculpture that appears to give us an accurate and unembellished account of what we see in the world around us—enjoyed such widespread exposure and esteem. Long regarded in avant-garde circles as the exclusive terrain of academics and old fogeys, on the one hand, or of political and commercial hacks, on the other, realism has lately acquired a new prestige and a new visibility on the international art scene. Young artists now flock to its swelling ranks, which are already well populated with defectors from abstraction and other well-established modes of modernist art; and museums and galleries are hastening to adjust to what amounts to a major turnabout in the course of contemporary taste.

Portents abound. Paintings that, ten years ago, were regarded as vaguely *démodé*, if not simply reactionary, have now acquired a certain chic, and the artists who painted them are hailed as the heroes of the new movement. Last month the magazine *Art in America*, which is always concerned with the latest thing, devoted an entire issue to the subject of realism, and hardly a day now passes without some announcement of a new show, a new publication, or the organization of a

conference or symposium on the subject. Clearly we are in the presence of a phenomenon.

Consider what has been happening:

Last winter the Cleveland Museum of Art organized a behemoth called "The Realist Tradition: French Painting and Drawing 1830–1900." A little earlier, the Minneapolis Institute gave us "German Realism of the Twenties," and in the spring the San Antonio Museum gave us a show called "Real, Really Real, Super Real: Directions in Contemporary American Realism." The San Antonio show has just moved to the Museum of Art of the Carnegie Institute in Pittsburgh. Also last winter the Pompidou Center in Paris mounted a mammoth survey called "*Les Réalismes*," which attempted to document the diverse achievement of realist art in the years 1919–39.

Meanwhile, the Whitney Museum's Edward Hopper retrospective has come to the Art Institute of Chicago, there is currently a Robert Graham exhibition at the Walker Art Center in Minneapolis—Mr. Graham is one of our leading Realist sculptors—and a retrospective devoted to the Realist painter Neil Welliver is on next month's calendar at the Worcester (Massachusetts) Art Museum.

A survey of contemporary realism from Britain is installed at Yale University's Center for British Art in New Haven, and an exhibition of American Photo-Realism painting has come to that citadel of abstraction, the Guggenheim Museum in New York. The Philadelphia Museum of Art has just inaugurated the biggest exhibition ever to be devoted to the paintings of Sir Edwin Henry Landseer, a realist of the Victorian period, and at the Pennsylvania Academy of the Arts there is currently in progress a show called "Contemporary American Realism Since 1960," the largest and most ambitious attempt yet made to encompass its subject in a single exhibition.

The campaign has been building for some time, of course, especially on behalf of the contemporary realist movement, as more and more artists have come forward to claim a place in the movement, and more and more dealers, curators, collectors, critics, and historians have abandoned their initial resistance to it and taken it up as a cause. The momentum is now so unmistakable that even the enemies of realism have been obliged to acknowledge its existence, if only for the purpose of denouncing it, while the friends and supporters of the movement are experiencing the odd sensation (for them) of finding themselves in the limelight. One begins to feel a certain pity for people who

are genuinely repelled by realist art. The art world at the moment must be a terrible trial to them.

In attempting to understand this phenomenal development and its governing impulses, it is essential to keep certain things firmly in mind. The first is that the realist movement is not homogeneous in its style, its methods, or its ideology. Despite its unwavering commitment to the depictive functions of art, this is a movement deeply divided in its aims and outlook. The second thing to bear in mind, which follows from this first basic fact, is that the realist movement is by no means uniformly antimodernist in its fundamental aesthetic attitudes. While there are, to be sure, a great many realists who categorically reject all of modernist art and profess to have no interest in any painting later than Ingres's or Corot's, a large part of the movement derives very directly from the theory and practice of modernist art and may thus legitimately be said to represent the continuation of modernist art by other means.

Of the issues that are much debated within the movement, the most divisive, perhaps, turns on the role that is assigned to subject matter in realist art. Is the subject of primary importance, or is it—as some realists claim—aesthetically irrelevant to what the artist sets out to achieve? For the innocent viewer contemplating a still-life painting by William Bailey, say, or a portrait by Philip Pearlstein, or an allegorical tableau by Jack Beal, this would hardly seem to be an issue at all. The objects and the figures are evidently *there*, and they so clearly dominate what we see, that the argument over subject matter seems, at times, a little unreal. Yet this is not the way that certain realists see the matter at all.

Philip Pearlstein, for example, who has achieved an international renown for his paintings of nude models in studio settings as well as for his commissioned portraits, especially his portraits of married couples, is adamant in insisting ''I'm interested in abstraction—subject matter never interests me in any work except Dickens.'' William Bailey too, though his work differs markedly from Pearlstein's, has similarly decried the emphasis that has been placed on the representational element in his painting. And as Bailey and Pearlstein are among the most accomplished and most influential figures in the contemporary realist movement, what they say on this issue must obviously be taken seriously—even though, it is worth reminding ourselves, we are always wiser to give priority to what artists do, rather than to what they say they are doing, in attempting to come to terms with their work.

The argument is equally vehement in defense of the subject's importance, and there are clearly many realists on the current scene for whom the whole idea of realist art is inseparable from an interest in a particular subject matter. One of these is Alfred Leslie, who made his debut in the 1950s as a second-generation Abstract Expressionist and who has yet rejected many of the basic assumptions of modernism in the Realist painting to which he has devoted his talents in recent years. "I wanted to put back into art all the painting that the modernists took out by restoring the practice of pre-twentieth-century painting," he has said; and for this purpose he has concentrated on the kind of portraiture and narrative painting that allows him to explore character, evoke its social context, and examine certain moral and historical problems through the medium of pictorial allegory.

Social allegory that is aggressive in its moral didacticism has likewise been the primary concern of Jack Beal. And in Beal's case, this didactic impulse has led to an interest in reaching a wider public than that afforded by the art world itself. It has led, in other words, straight into the kind of Social Realist political painting that enjoyed a great vogue in this country in the 1930s. In the presence of Beal's ambitious mural on the subject of *The History of Labor in America*, executed for the Department of Labor in Washington in the late 1970s, the argument over subject matter in realist art is quickly dissolved. This painting exists entirely *for* its subjects, which are pursued with a missionary zeal seldom encountered elsewhere in the realist movement today.

Then there are the many artists—they may even constitute a majority among contemporary realists—whose work does not easily or unequivocably fit into either side of the argument about subject matter. In the paintings of Alex Katz, for example, formal invention is clearly the dominant interest, and this formal interest—which is an interest in color, surface, scale, and the relationship that obtains between shapes and the space they occupy—clearly owes much to the precedents of abstract art, especially to the art of the Abstract Expressionist painters of the generation immediately preceding his own. In this respect, his art is very close in spirit—if not in style—to Pearlstein's. Yet Katz's paintings, unlike Pearlstein's, are so filled with the most acute observation of contemporary dress and personality and manners, with the look and feel and pace of the contemporary social scene, that they are not finally reducible to their formal attributes, striking as these may be. There is a social content in that painting that, while not political, isn't strictly formalistic either.

The landscapes of Neil Welliver likewise embrace this double vision. Scrupulous as they are in their account of the particularities of nature, Welliver's paintings similarly affirm the kind of emphatic allegiance to their medium that we recognize as deriving from the painterly conventions of Abstract Expressionism. Yet his paintings are not abstractions in disguise, however much they may owe to the precedents and practices of abstraction. Their attachment to their landscape subjects is so obviously intense and loving and unequivocal that the pictures leave us in no doubt about the place of nature in the mind and in the emotions of the artist who produced them. Subject matter, in short, may not account for everything, but it accounts for something, and sometimes for a great deal.

Yet divisive as the argument over subject matter may be for many contemporary realists, it is not nearly as exacerbating as another of the issues that causes dissension in the movement—the issue of photography and its use in realist art. This is an issue that goes to the heart of what, for many dedicated realists, is an all-but-inviolable principle—the principle of direct observation, of basing their art on what they see with their own eyes rather than on what the camera sees for them.

Especially vexing, therefore, is that subdivision of realist art that goes under the name of Photo-Realism—painting that is not only based on photography but actually attempts, in one degree or another, to simulate the look of modern color photography—and the kind of Super-Realist sculpture that is often allied with it. Photo-Realist painting and Super-Realist sculpture are, in fact, a good deal closer in spirit and attitude to Pop art, which derives its imagery not from direct observation but from the visual conventions of the mass-produced artifacts of machine civilization. With the central impulse of the Realist movement, which set itself the task of reestablishing a vital link between the experience of the eye and the creation of artistic form, neither Photo-Realism nor Super-Realist sculpture has anything artistically in common. Indeed, by the standards that mainstream realism has set for itself, these photo-derived styles are little more than vulgar parodies; yet because they are bright, brassy, and attention-winning in their stupefying feats of dumb representation, they continue to be confused with the real—which is to say, the realist—thing.

An art movement that embraces so many contradictory aspirations, that flouts so many modernist pieties, and that has already, in a relatively short time, generated so much argument and controversy, even within its own ranks, does not lend itself to easy summary. It

should therefore come as no surprise to learn that the exhibition that Frank H. Goodyear, Jr., has organized at the Pennsylvania Academy under the title "Contemporary American Realism Since 1960" is something of a conundrum. This is a big show, consisting of 152 works by 104 artists, and for this and other reasons, it is a show that partisans of the realist movement are going to be quarreling about for a long time. It is an exhibition that does not so much define contemporary realism as heap up a vast miscellany of random examples—good, bad, marvelous, indifferent, and irrelevant—from which all sorts of definitions and counterdefinitions can and will be drawn.

Its very size is at once impressive and problematical. It contains just about everything that could conceivably be included under the realism rubric, from Andrew Wyeth's genteel version of American pastoral to Duane Hanson's ugly Super-Realist effigies of American city dwellers. Some of the movement's finest achievements can be found in this show—beautiful paintings by William Bailey, Philip Pearlstein, Alex Katz, Catherine Murphy, Paul Weisenfeld, and Neil Welliver, and sculpture by Robert Graham, among much else—yet there appears to be no rigorous principle of selection or standard of quality at work in its organization. Mr. Goodyear's aim, one gathers, is to be encyclopedic, and there can be no question about the diligence of his research. (The book he has written to accompany the show includes even more artists and more works of art than he has managed to cram into this very large show.) But the result is a show that verges at times on sheer incoherence. The realist movement will be a long time digging out from under the debris of this unwieldy, unselective, unfocused, and fundamentally unintelligent mishmash in which the failures of realist art are given conspicuous parity with its successes.

The decision to include Photo-Realist painting and Super-Realist sculpture on the same footing with mainstream realism was but one of several fatal mistakes made in the organization of this exhibition. Another was the decision to saddle the show with an installation that could be counted on to divert attention from the art itself. Designed by the prestigious architectural firm of Venturi and Rauch, this is the kind of installation—full of banner headlines, eye-grabbing mottos, tendentious wall labels, and the segregation of objects into subject-matter categories—guaranteed to confirm the suspicion many artists have that architects are the natural enemies of painters and sculptors. The Pop-style design adopted by Venturi and Rauch for this installation is not only vulgar and ostentatious in itself; it conspicuously violates the

very tone and gravity of the best works in the show. This is the kind of exhibition disaster that other museums would do well to pay careful attention to, in order to learn what not to do to a serious exhibition.

Never mind. The Academy show may not be the success we had hoped for, the installation may be bad, the selection may be obtuse, and the rationale somewhat nonsensical, but the realist movement itself—despite the quarrels that afflict it, and the refusal of so many of its partisans to face up to the questions of quality that haunt it—is not about to diminish or disappear. It has succeeded in reestablishing something fundamental to the art life of our time—a way of thinking about art that binds its forms, its imagery, and the very process of its creation to the act of individual perception, to the self as it negotiates its difficult progress in the world of experience. This was precisely the development that modernist art, with its emphasis on theory, fantasy, psychic disorder, subjective improvisation, and conceptual freedom— on anything and everything, in fact, but what the eye attaches itself to in the world of immediate experience—had long told us was moribund and out of reach, outdated and exhausted. How amazing, then, that it should—against such odds—now be thriving with so much energy and talent! Later, perhaps, it will get the kind of elegant and intelligent exhibitions it deserves. For the moment, it is astonishing that it has won so conspicuous a place in an art world that was hardly prepared to receive it.

OCTOBER 25, 1981

6. Signs of Passion: The New Expressionism

The fact is, that both finish and impetuosity, specific minuteness and large abstraction, may be signs of passion, or of its reverse; may result from affection or indifference, intellect or dullness. . . . Now both the finish and incompletion are right where they are signs of passion or of thought, and both are wrong, and I think the finish the more contemptible of the two, where they cease to be so.

—John Ruskin
Modern Painters

The eruption of new stylistic initiatives in art, although anything but a novelty in the cultural history of the present century, can still be counted on to have a disconcerting effect on established taste. At times it may even inspire anger and resentment among the very people who pride themselves on being ready for anything in art—especially anything radical. Exactly why, at this late date, this should continue to be the case is, on the face of it, a little baffling.

Change, after all—incessant and insistent change—has been the rule in the life of art for as long as anyone can now remember. It was the basic principle that governed the development of art in the age of the avant-garde. And the velocity of change, far from slackening in recent generations, has, if anything, only accelerated. Certainly no other culture in the recorded history of civilization has been subjected to the kind of unremitting pressure of innovation in art that has long been a commonplace feature of ours.

Yet, although the phenomenon is a familiar one, we still seem to be very divided in our response to it. We are at once inured to it and disturbed by it. We embrace it and we resist it in equal measure. Change represents vitality to us—but it is also threatening. Stability suggests a loss of energy and momentum, inspiring fears of sterility and decay, but there is a place in our minds—and in our hearts!—that nonetheless longs for some permanent or protracted release from the constant hammer blows of change. It is thus one of the peculiarities of our cultural condition that we are made as anxious by the absence of change as we are made apprehensive by the demands of its headlong course. Our relation to art is, in this respect, rather like our relation to marriage. We may be deeply dismayed by the dramatic rise in the divorce rate, feeling that it represents a form of social pathology, but we nonetheless cherish the freedom it offers us. At the same time—a further paradox!—we recognize that the number of divorces is constantly swelled by those who divorce only in order to remarry at the earliest opportunity. We seem to "marry" and "divorce" new styles in art today with a similarly divided heart. It is one of the enduring legacies of the avant-garde tradition.

The eruption of a new expressionist movement in art—the so-called Neo-Expressionism that has lately achieved such a swift and formidable presence on the international art scene—unquestionably represents one of the most spectacular and unexpected "divorce" cases in recent cultural history. Not since the emergence of Pop art in the early 1960s have we seen anything of comparable consequence in the realm of contemporary painting. In some important respects, of course, this

movement has been impelled by an outright desire on the part of a new generation of artists to repeal some of the characteristic features not only of Pop art but of certain other styles, too—especially Minimal art and Color-field painting—that won an easy and unassailable dominance in the sixties and have ever since exerted an immense influence on contemporary taste. This, certainly, has given the movement its central animus and accounts for much of its appeal. It is the appeal of an art movement that reopens many questions that, for a generation or more, had mistakenly been considered closed by what passed for "advanced" opinion.

What these rejected features of the art of the sixties are, and what Neo-Expressionist painting offers as an alternative to them—these are issues that go to the heart of the fateful revision in artistic outlook that is now upon us. Yet it must also be recognized that the Neo-Expressionist movement, however radical its break with the art of the sixties may be, has something in common—sociologically, at least, if not aesthetically or spiritually—with the Pop movement itself. For like Pop, it belongs unmistakably to the post-avant-garde era. Which is to say, to a period when virtually every new initiative in art has enjoyed an immediate and untroubled access to the limelight, and has thus been condemned—or should one say privileged? opinions will naturally vary on this question—to develop its strengths, display its weaknesses, and otherwise shape its destiny in full view of an eager and curious public. Thus, the historical entry point of Neo-Expressionism inevitably plays a role in determining the spirit as well as the dynamics of the art which the movement has produced.

It is no exaggeration to say that at the moment of the movement's entry onto the art scene in the 1970s, expressionism—particularly the kind of expressionism that attached itself to figural and/or symbolic motifs—had long been regarded as a despised and moribund style. Abstract Expressionism was honored as a museum classic, of course, and its living representatives continued to be esteemed even by the generation that rejected its artistic practices. The art of the sixties may have placed itself in opposition to Abstract Expressionism, but it was the kind of opposition that granted its opponent a high status and never for a moment questioned its right to exist. A good many of the artists who achieved fame and influence in the Pop and Minimal movements had, in fact, begun their careers as apprentices to the Abstract Expressionist style, and the Color-field painters were never concerned to deny their debt to it. It was a very different story, however, with the figural Ex-

pressionism that had its origins in Northern and Central Europe in the years preceding the First World War. For the artists of the sixties, this earlier Expressionist school hardly counted. Even painters of the stature of Munch, Kokoschka, and Beckmann were condescended to as *démodé* figures representing a distant and alien tradition. To suggest that their art remained a vital and valuable component of the modern movement and might even have something important to contribute to the art of our time was, in the smug and "swinging" art world of the sixties, to invite ridicule.

The reasons for this attitude are anything but obscure. There existed, first of all, a widespread assumption that the ascendancy of abstract art represented a permanent and irreversible condition of contemporary artistic expression. The international art scene could boast of many admired figures whose work did not conform to this assumption—Dubuffet, de Kooning, Morandi, Balthus, and Bacon were only the most famous, and there were others as well. But these artists were too diverse in their respective styles and spirit to constitute an alternative tradition. They could be imitated—and they were, often shamelessly. But they could not be made the basis of a powerful new initiative in art. Established critical opinion regarded them as glorious exceptions. It was abstraction that was thought to embody the mainstream.

Abstraction, moreover, was itself undergoing a significant change. In the art of the sixties it was systematically stripped of its expressionist attributes. All evidence of subjective emotion, every impulse toward improvisation and what Ruskin had called "impetuosity" and "incompletion," anything that suggested the role of the unconscious or of the irrational in art was suppressed in favor of clean surfaces and hard edges, of instant legibility, transparency, and order. The rising generation seemed to harbor a profound aversion to anything in art that smacked of mystery or interiority. There was a virtual ban on revelations of the soul. Incitements to feeling were looked upon as a kind of vulgarity. For the first time in the history of criticism, boredom in art was upheld as an exemplary emotion.[1] We had entered the era of "cool" and impersonal styles.

[1]Lest anyone think that I exaggerate, it is worth recalling what Barbara Rose, then one of the champions of the emerging Minimal art movement, wrote in its defense at the time. In an essay called "ABC Art," which appeared in *Art in America* in 1965 and exerted a considerable influence on the contemporary art scene, Miss Rose wrote as follows: "If, on seeing some of the new paintings, sculptures, dances, or films, you are

Pop art, which decisively challenged the authority of abstraction by seizing upon the imagery of mass culture and elevating it to the status of fine art, carried this tendency toward impersonality in art a fateful step further. It added an insouciant and infectious element of irony—and at times, even mockery—to the dandified detachment that had already overtaken abstraction, It was in Pop art, indeed, that the tendency toward a "cool" and impersonal style was given its historic apotheosis. For it brought to this tendency an easy sociability, and made it both entertaining and accessible. Unlike the austere and utopian art of the Minimalists, Pop art was worldly and relaxed. It winked at its public and invited it to have a good time. It beckoned us to furlough our doubts and anxieties, to expel the very idea of the metaphysical and dwell forever in a universe of bright, untroubled social surfaces.

It will be readily seen, then, why no place could be found for the expressionist impulse in the atmosphere generated by this attitude. Expressionism does not lend itself to tidiness or detachment. Its tendency is to be "hot" rather than "cool." It abounds in references to the visionary and the irrational, and the very marks it makes on canvas or paper are unabashed avowals of feeling. Expressionism, indeed, looks upon painting as a medium of discovery and exploration. It exults in painting's physical properties, which it looks to as a means of generating images and stirring the emotions. Above all, it has a hearty appetite for the metaphysical and the mysterious.

Historians will be pondering for a long time to come exactly why it was that the art of the sixties proved to be so categorically inhospitable to these impulses. It was, after all, a decade otherwise remarkable for its heat. With its drug culture and dropout mentality, its social radicalism and sexual revolutionism, its opposition to bourgeois order and its embrace of apocalyptic and irrational visions of the future, the whole ethos of the sixties—especially in what came to be called its counter-

bored, probably you were intended to be. Boring the public is one way of testing its commitment. The new artists seem to be extremely chary; approval, they know, is easy to come by in this seller's market for culture, but commitment is nearly impossible to elicit. So they make their art as difficult, remote, aloof and indigestible as possible. One way to achieve this is to make art boring. Some artists, often the most gifted, finally end by finding art a bore." And Barbara Rose was by no means the only art critic of the period to discover a kind of aesthetic honor in the phenomenon of deliberate boredom in art.

culture—would seem to have offered extremely fertile ground for the growth of an expressionist movement. But it was not to be. Instead, as we know, this hottest of decades was adamant in favoring the coolest of art styles. The expressionist impulse was reserved for life, not art.

The fact is, the relations that obtain between art and society, between creation and history, are generally more paradoxical and less straightforward than is commonly supposed. Which is why, when the Neo-Expressionists broke upon us in the late seventies and early eighties, a good many people were stunned and unprepared. Compared to the upheavals that had occurred in the sixties, the Western world was a cooler place in the late seventies. Its art seemed to have settled into a placid pluralism. After years of resisting the notion that the age of the avant-garde had passed, the last diehards had just about given in. The big events commanding the attention of the international art community were mainly retrospective in character. Almost no one was ready to face a new and unfamiliar disruption that challenged the reigning taste. Yet when the Neo-Expressionist challenge came—and it came swiftly, in several countries at once—it obviously struck a nerve. There were cries of horror and cries of fraud, of course, and the usual allegations of conspiracy. Critics who had not been averse to endorsing every fashionable reputation for twenty years found themselves in the odd position of denouncing, of all things, a new "fashion." The situation was not without its comical aspects for anyone with the wit to appreciate them.

Clearly, something important had occurred. A genuine change in taste was upon us. In this respect I should like to quote, if I may, from a review article I wrote in *The New York Times* in April 1981. It was occasioned by the coincidence of two solo exhibitions in New York—those of Malcolm Morley and Julian Schnabel—and my warrant for quoting it here lies in the fact that it has already been much quoted (not always correctly or sympathetically) elsewhere. "Nothing is more incalculable in art—or more inevitable—than a genuine change in taste," I wrote, and then offered the following observations: "Although taste seems to operate by a sort of law of compensation, so that the denial of certain qualities in one period almost automatically prepares the ground for their triumphal return later, its timetable can never be accurately predicted. Its roots lie in something deeper and more mysterious than mere fashion. At the heart of every genuine change in taste there is, I suppose, a keen feeling of loss, an existential ache—a sense that some-

thing absolutely essential to the life of art has been allowed to fall into a state of unendurable atrophy. It is to the immediate repair of this perceived void that taste at its profoundest level addresses itself.''

The feeling of loss that I spoke of in this article was keen indeed. For nearly two decades, all the styles approved by "advanced" opinion had prohibited large areas of experience from playing any role whatever in the creation of new art. More specifically, the experience of the sixties—not the art styles of the sixties, but the social and spiritual experience—had been programmatically denied entry into the pictorial imagination. Toward this realm of experience the visual arts adopted an amnesiac stance. Art seemed to have lost its capacity to pay attention to the world it occupied. The experience of the sixties and the changes it effected—in family life, in the relation of the sexes, in clothes and work and education and religion—caused havoc in a great many lives, yet the trauma brought about by these profound changes was more or less declared off limits as far as painting was concerned. An intolerable tension was thus created between art and life.

It was in the attempt to relieve and resolve this tension that the Neo-Expressionist movement was born. Its first task was to restore to painting its capacity to encompass the kind of poetry and fantasy that had long been denied to it, and toward that end it was obliged to mount an attack—sometimes, it seemed, literally—on the picture surface. What was discarded straightaway was the easy legibility and transparency that, in truth, had long ago degenerated into a facile convention. Instead of leaving everything out of painting, and making a neat, clean, perfect form of what remained, the Neo-Expressionists were clearly determined to put everything in. Their paintings swamped the eye with vivid images and tactile effects, relying more on instinct and imagination than on careful design. The mystical, the erotic, and the hallucinatory were once again made welcome in painting, which was now determined to shun the immaculate and the austere in favor of energy, physicality, and surfeit.

It was this experience of surfeit, I think, that had the most unsettling effect on established taste. We had grown used to the idea that changes in pictorial style inevitably entailed depletion and purification. For a hundred years or more, the vitality of painting had seemed to depend on stripping it of its conventions and resources in order to isolate some irreducible core or essence. By placing itself in open opposition to this tendency, the Neo-Expressionist movement did something more than offer itself as a new style. It put into question the very prac-

tice of identifying the vitality of art with this process of progressive depletion. It was this that proved so disturbing to purist taste. A precious piety was being challenged, and a long-standing trend reversed. No wonder there were cries of anguish and fraud. Something similar had occurred in response to the Surrealist movement in the twenties and thirties, and even today there are partisans of abstract art who look upon all of Surrealism as a phenomenon that lies outside the boundaries of the modern movement, which is redefined to exclude such "aberrant" tendencies. But exercises of this sort belong to the realm of polemic rather than to art history or criticism.

It is too early, of course, to chart the boundaries of the Neo-Expressionist movement, or to offer more than tentative judgments about its achievements. The movement is still young and new—a fact that is sometimes forgotten in the midst of the publicity and the controversy it has inspired. We have lived with it for less than a decade—more like a half decade really. Its leading figures are anything but fixed in their course, and, as usually happens with such movements when they achieve an overnight celebrity, new painters seem to join its ranks with every sunrise. Just now it seems to me that the best of the Neo-Expressionist painters is probably Malcolm Morley, the British-born artist who now lives in the United States. His exhibition at Fourcade's in April 1981 was one of those rare art events that stays fixed in the mind with an extraordinary vividness. Interestingly, Mr. Morley's work is quite close in some of its aspects to that of the contemporary realists—more so, anyway, than the work of any other Neo-Expressionist I have seen. His landscape paintings, for example, have the kind of weather-perfect depictive accuracy we so much admire in certain realist landscapes. Yet elsewhere, especially in a wild picture called *Camels and Goats* and even in a very funny one called *The Grand Bayonette Charge of the French Legionnaires in the Sahara*, he generates a heat that has less to do with faithful observation than with the inventions of the imagination. It is as if the pastoral element in Constable had been crossed with some of the sweep and fury of Delacroix's mythological paintings. Mr. Morley is, in any case, a painter of large powers.

If Mr. Morley is probably the best of these painters, the worst just now—although competition for the position will soon be fierce—is very likely David Salle, an American painter whose facile conjunctions of abstraction and representation (a vague bit of Mondrian, say, placed in artful juxtaposition to a rough sketch of a female nude) are little more than a formula designed to satisfy every taste. Far more interest-

ing is the work of Julian Schnabel, another young America painter who has been elevated to precisely the kind of overnight stardom that causes many people to assume he must be wholly lacking in talent. (Scarcely thirty years old, Mr. Schnabel has already had the distinction of having "retrospective" exhibitions of his work mounted at the Tate Gallery in London and the Stedelijk Museum in Amsterdam.) The truth is, the critics who have attacked his work are not entirely wrong. He is a very uneven painter. But when he is really painting, and not just covering the surfaces of his pictures with broken crockery and sundry other unlovely objects, he brings a nightmare energy and imagination to his art that is powerful indeed. The marvelous picture called *Death Takes a Holiday*, for example, takes authoritative possession of one of the archetypal themes in Western art—the figure of death as a human skeleton mounted on horseback—and transforms it into an image of epic force. Mr. Schnabel is the kind of artist who will always be a problem for criticism, for there is an element of vulgarity and a coarseness of feeling in his work that is very much at odds with an authentic vein of poetry.

Yet, however uneven some of their work may be, these and other painters in this movement—Georg Baselitz, A. R. Penck, and Markus Lüpertz in West Germany, Francesco Clemente, Sandro Chia, and Enzo Cucchi in Italy, Ken Kiff in England, and Susan Rothenberg in the United States—have already made an enormous difference in our experience of contemporary art, and a great difference, too, in what might be called the geography of contemporary art. For the first time in a generation or more, painters are no longer constrained to conceal their native roots. The American artists in the movement are not easily confused with the Italians, and the Italians strike us as very different from the Germans—as well as from each other. The pressure upon art to look anonymous and "international" is clearly inappropriate to a style that requires of an artist that he put more of the self into the very center of his work. Art is once again a medium of dreams and memories, of symbols and scenarios of the affective life. It has reacquired its capacity for drama—most especially the drama of the self in both its conscious and unconscious intercourse with the world "out there." This is in itself an historic reversal of considerable consequence, and we shall be living with the result for years to come. It alters our very expectations about art.

In the passage from *Modern Painters* I have quoted as the epigraph to this essay, John Ruskin reminds us that in every pictorial style—whether governed by "finish" or "impetuosity"—what we most value

and most vividly respond to are what he calls "signs of passion or of thought." Neo-Expressionism is certainly not the only painting on the contemporary scene that meets this demand. But because—just now, anyway, when its energies are still fresh and its capacities are expanding—it so abounds in those precious "signs of passion," its appeal is irresistible.

NOVEMBER 1982

7. Malcolm Morley

There is a sense in which the contemporary retrospective exhibition—especially a retrospective devoted to the work of a living artist or of an artist only recently deceased—is almost as much of a "creation" as any of the objects it is designed to display. There is usually no question of such an exhibition being complete. Our artists tend to be too copious in production, too uneven in quality, and too repetitious in their ideas for completeness in these exhibitions to be either desirable or endurable. What is aimed for instead is a kind of saturation which can be counted on to overwhelm the spectator with an impression of energy, audacity, individuality, and—never mind the apparent contradiction—conformity to current expectations. Somehow the question of the quality of individual works seems not to enter into the equation as a paramount consideration. Beyond the inclusion of certain key works, availability is likely to be a more decisive factor than discrimination. That a painting or sculpture might need to be omitted as not up to standard is nonsense, of course, where the only applicable standard is authorship. This does not mean that judgment plays no role in the decision to organize a retrospective. It does. But it does not seem to extend beyond the decision to do the show. Once *that* decision is made, it seems to be taken for granted that the artist selected for the retrospective will have produced no failed works. The very notion of a failed painting or sculpture is now, in any case, practically obsolete, and the contemporary retrospective is one of the things that has made it so.

It often happens, therefore, that it is the retrospectives of the artists whose work we admire that turn out to be the most problematical for us. We know in advance that failures are unlikely to be excluded or even recognized; that the exhibition catalogue—a cultural artifact that looms large on these occasions—will not pause in its task of ritual celebration to acknowledge that anything has ever gone amiss in the oeuvre under discussion; and that criticism, which in principle has no vested interest in upholding the illusions fostered by these procedures, in practice is more likely than not to endorse their acceptance. The intellectual etiquette governing retrospective exhibitions has come more and more to proscribe not only skepticism but precisely the kind of discrimination they are ostensibly intended to serve.

Yet there are retrospectives that make a mockery of this convention, and the Malcolm Morley exhibition[1] that is currently going the rounds of the international museum circuit is one of them. Morley, let it be said straightaway, is a painter I much admire. Some of his recent pictures seemed to me on my initial encounter with them to constitute a very solid accomplishment, and seeing them again in the current retrospective has confirmed that first impression. There is no question, in my view, that he is an artist of ample gifts and remarkable ambition. At his best he is a marvelous painter. That he is also a quirky and unsteady painter, given to flights of fancy—a kind of imaginative mania—that often exceed his powers of control, has been evident for some time. But the importance of what can only be called the neurotic strain in Morley's work has never before been so fully revealed to us. In the light of the current retrospective, it can now be seen to occupy a central place in his painting, and this inevitably modifies our understanding of what he has achieved. It shows us, among much else, that he is an artist of divided—if not indeed warring—sensibilities. If this accounts for the highly dramatic aura that attaches itself to much of his recent work—as I believe it does—it may also explain something about its waywardness and willfulness. In Morley there is clearly a conflict between the "cool," classical artist he sometimes yearns to be and the "hot," romantic fantasist he more often feels compelled to be. It should not be surprising, then, that his complete successes are few, for

[1]"Malcolm Morley: Paintings 1965–82" has already been seen at the Kunsthalle in Basel, the Museum Boymans van Beuningen in Rotterdam, and the Whitechapel Art Gallery in London. It opens this month at the Corcoran Gallery of Art in Washington and then travels to the Museum of Contemporary Art in Chicago and the Brooklyn Museum in New York.

they tend to depend on isolated episodes of resolution in the conflict which remains largely—and perhaps deliberately—unresolved in his work.

Morley was born in London in 1931. According to the "Chronology" included in the catalogue of the exhibition, "he spent a year in borstal and subsequently three years in prison [we are not told for what offense] and it was there that he developed an interest in painting, beginning a correspondence course in art." At the age of twenty-one he enrolled in the Camberwell School of Arts and Crafts, painting landscapes in the tonal style of Sickert; and in 1954 he entered the Royal College of Art, where he completed his diploma in 1957. One of the events that transformed the London art scene in the fifties was the exhibition called "Modern Art in the United States," which came to the Tate Gallery in 1956 and gave many English painters their first glimpse of the American Abstract Expressionists. It was seeing the work of these painters, we are told, that prompted Morley to visit New York in 1957. He moved here the following year, and New York has remained his principal place of residence ever since. His first solo exhibition took place at the Kornblee Gallery in New York in 1964.

The retrospective organized by Nicholas Serota, director of the Whitechapel Art Gallery in London, begins one year later with the Photo-Realist paintings of ocean liners that won Morley an international reputation as a votary of the Pop art movement, which was then in full swing. The exhibition thus omits both the landscapes and the abstract paintings that occupied Morley prior to 1965. This was probably a mistake for two reasons. Some of the finest of Morley's recent paintings have in fact been landscapes, and it might have been illuminating to have been able to compare the early landscapes with the later ones. Then there is the question of what exactly the artist owed to the Abstract Expressionist painting that prompted his move to New York. Without Morley's own abstract paintings on view, this pivotal episode in his development remains a matter of surmise.

As it is, by commencing with the Photo-Realist Pop paintings of the sixties, the exhibition gives the visitor coming to Morley's work for the first time a somewhat misleading impression of his talents. Like much of Pop art, the ocean liner paintings are based on commercial photographic images—in this case, postcards and advertisements—which are enlarged to a scale that is at once ironic, incongruous, and insouciant. Although they are painted with a studied, deadpan exquisiteness that was very stylish in the sixties, this particular vein of foppish irony

was never Morley's forte, and he soon abandoned it in favor of something more robust. It is a matter of interest, of course, that these are the paintings that earned the artist his first fame. But their emotional range was clearly too narrow to accommodate the pressures that were building up in Morley to let loose with something freer and more compelling. What remains impressive in these paintings is their tonal purity—which makes one all the more curious to see in what relation they stand to the earlier pictures he is said to have painted under Sickert's influence. But in most other respects they remain enclosed in a kind of "period" style—neat, clean, elegant, detached, and somewhat lifeless.[2]

It was no easy matter, however, for Morley to move beyond this buttoned-up period style. When he did let loose, he did so with a good deal of violence and chaos. Attempting to appropriate the resources of Expressionism as a means of endowing his art with a kind of raffish vitality, Morley nonetheless tried to remain loyal to the Pop iconography, and the results were mostly a mess. Thus, in the early seventies, he turned to Rauschenberg and Johns for inspiration and to Jim Dine— the Dine of the early sixties—for his model. This was an odd choice, for the art he now attempted to emulate consisted of combining objects— clothing, hardware, trinkets from the dime store, or anything else that came to hand—with unlovely, overloaded surfaces executed in a headlong parody of Expressionist mannerisms. It was a model already moribund when Morley turned to it—quite as if he were determined to go back to the early sixties and start over—and there was no way even for a painter of his remarkable energy and drive to resuscitate it with success.

[2]Michael Compton's essay for the exhibition catalogue is certainly no help on these or any other paintings. Even by the debased standards of the genre, this essay is a travesty. Here is Compton on the ocean liner paintings: ". . . it seems to me perfectly justifiable for us to go further in associating meanings with the work than ever the artist was conscious of at the time. . . . Both the ship and the sea are classically 'women.' Morley's ships are 'cruise' ships, they offer pleasure without other purpose. The picture—the ship—is sold for pleasure, etc. Morley would not repudiate any interesting meaning or association even though, for him, the work has its own specific private meaning. That meaning is partly autobiographical, he had been a seaman on a cargo ship and had aspired to work on a grand ocean liner. He had come to America on such a ship. His ships have great names, signifying heroic and glamorous figures and places. . . . They symbolize an ordered and protected shell against the wild environment of the sea. They are going somewhere or arriving. All this, together with the ordering of sensation, is part of the available meaning." Mr. Compton, sad to say, is Keeper of Exhibitions and *Education* (my emphasis!) at the Tate Gallery.

Still—such are the paradoxes of artistic creation—this "back-ward" move proved to have the desired catalytic effect for Morley's work. Starting over was pretty much what he was attempting to do in these failed paintings of the early seventies. The truth is, though they *are* failed pictures (and thus raise legitimate questions about the place to be assigned to them in a museum retrospective), they *did* represent a new start for the artist, giving him for the first time a purchase on the kind of Expressionist fluency that he later developed into some of the most powerful pictures of the late seventies and early eighties—the paintings that have made him one of the stellar figures of the Neo-Expressionist movement. To accomplish this change, however, he had to perform some radical surgery on the model he was working from. All those unlovely objects had to be stripped away from the picture surface—the coil of rope and plastic bag and women's shoes attached to *Piccadilly Circus*, for example, and the straw hat and plastic rose attached to *Untitled Souvenirs, Europe* (both 1973)—and something akin to a more traditional painterly syntax reestablished as a governing principle. One of the further paradoxes of Morley's development may be found in the fact that while his finest paintings—*La Plage* and *Landscape with Horses* (both 1980), *Landscape with Bullocks* (1981), and *Macaws, Bengals, with Mullet* (1982)—owe much of their quality to the role which this more traditional syntax is allowed to play in their realization, the artist himself is so far from being at ease with it that he takes considerable pains to disrupt and subvert it in some of his most ambitious efforts. I have in mind such recent pictures as *Arizonac* (1981), *The Palms of Vai* (1982), and the wild, untitled beach painting of 1982 that looks like a nightmare version of *La Plage*. Is it yet another paradox of Morley's work that his most ambitious paintings are not always his best?

Be that as it may, since his turn toward the Expressionist mode over a decade ago, Morley seems to have adopted a deliberate policy of producing two very distinct types of work—pictures that, on the one hand, are carefully integrated in design and fairly placid, even pastoral, in their imagery and, on the other, pictures that are highly disjunctive in both their imagery and their syntax. The latter, apparently, are an attempt to achieve by purely painterly means the kind of violent shifts and symbolic juxtapositions formerly accomplished by the introduction of incongruous physical objects. For this purpose Morley now draws upon a vein of archaic and primitivistic iconography that is blatantly contrasted with the purely naturalistic elements in painting. The aspiration, I suppose, is to create an art that addresses the spectator at

two levels simultaneously, the mythic/symbolic and the naturalistic. This is precisely the kind of aspiration that inspired some of the greatest paintings in the Expressionist tradition—among others, the magnificent series of triptychs that were Max Beckmann's crowning achievement. (We find its literary counterpart in *The Waste Land* and a good many other modernist poems.) It is, in fact, one of the classic aspirations of high modernism, and one from which painters turned away when they lost their faith in the aesthetic efficacy of a "literary" subject matter. It tells us much about Morley's vision—as well as his ambition—that he should aspire to produce an art at this level of complexity and completeness. Yet much as I admire certain elements in these paintings and laud the kind of aspiration they represent, I am obliged to report that his work in this mode has yet to achieve the kind of integrated vision essential to the task he has undertaken.

What these paintings nonetheless boast an abundance of is a kind heated feeling and visceral intensity that we hardly expected to find in pictorial art in the days when it was so completely dominated by the ideals of clarity, irony, and orderly form. Morley has come a long way since those neat ocean liner paintings of the sixties. And if he has so far shown a greater mastery over the naturalistic component of the style he now aspires to than over its mythical and fantastic elements—as I believe he does—he has nonetheless succeeded in reviving the possibility, if not yet the reality, of something far grander.

At this stage in his development Morley is clearly an artist still reaching for something he has not yet achieved, however close he seems at times to getting there and however much we are engaged by the spectacle of his unremitting assault on his objective. Which brings us back to the problem of the retrospective exhibition. Is its function fundamentally that of documentation, which allows us to follow the rises and falls in an artist's development—and thus give to his failures a place equal to that of his artistic successes? Or should it be the function of a museum retrospective to concentrate solely on achievement? The question is complicated, in Morley's case, by the artist's obvious partiality toward his own most outrageous pictures—which in my view are rarely his best pictures. One often has the impression that the real subject of the contemporary museum retrospective is the artist's career rather than his achievement, and that as spectators we are expected to bring to this subject the curiosity of the voyeur rather than the stan-

dards of the connoisseur. This is not a happy thought, but it is one that our intercourse with art is undoubtedly going to have to live with for a long time to come.

<div align="right">SEPTEMBER 1983</div>

8. Julian Schnabel

It has been the peculiar fate of Julian Schnabel to become, and at a very early age too, the most controversial painter of his generation. He has also been one of the most successful. Well before he was thirty—he was born in 1951—his work was the subject of heated critical discussion. Because it was in such demand by collectors and museums, moreover, it quickly became the subject of the kind of rumor and gossip that shifts attention from the art to the artist and his career, his income, his dealer, and his personal life. All of which, in turn, prompted the artist himself to make statements and grant interviews that—more often than not—contributed more to the haze of publicity surrounding his work than to its clarification or understanding. Thus, from the very beginning of his public career, Schnabel has been the very archetype of the young artist plying his wares in the limelight—which, though it guarantees a certain kind of visibility, is rarely the best light in which to view an artist's work dispassionately or judiciously.

On the other hand, there is no denying that there is something appropriate about the clamor that has greeted Schnabel's work, for his is both a clamorous and a "public" style. However subjective and allusive his imagery may be at times, the work that contains it is always conceived on a scale and in a manner that preclude an intimate or merely "private" response. It deliberately sets out to overwhelm the spectator with a greater multiplicity of impressions than can be easily assimilated in a single viewing and to so orchestrate those impressions that a certain conflict in interpreting the result is, as it were, built into the very experience of seeing the work. An element of bluster, of sheer assault on our senses, on our expectations, and on our taste, is never

entirely absent from the artist's calculations. Often, in fact, it is the dominant note that is struck in picture after picture, so that we come to feel that it is this element, more than any other, that supplies Schnabel's work with its principal momentum.

It was inevitable, perhaps, that this element of bluster would be deplored when Schnabel's work first came to light and that it would remain a controversial issue even after the artist had become an established figure on the international art scene. For no other aspect of his work so vividly signifies the change in artistic outlook that Schnabel's pictures have been taken to represent, and it is the implications of this change, quite as much as the artist's own exploitation of them, that lie at the heart of the controversy which has enveloped his art from the outset. To grasp what this change in outlook has entailed is therefore essential to any fundamental understanding of what Schnabel has achieved—or, for that matter, has failed to achieve—in his work.

Schnabel belongs to an artistic generation that came of age in an art world ready and eager to receive an assault on its established norms. It was not an art world that could be said to be characterized by the old conflict between an avant-garde and a benighted, complacent public, firm in its resistance to new ideas. That particular conflict had been amicably resolved in the 1960s; and in the new art world which came into existence in the aftermath of that resolution, a premium was placed on precisely the kind of audacity and innovation that public opinion had formerly made it a point of rejecting. At the same time, however, an implicit limit was placed on what the permissible parameters of audacity and innovation might be. What seemed to be excluded from this otherwise open invitation to innovation was anything that smacked of backsliding, anything that suggested a reversion to or revival of artistic practices which had already been rejected in the name of innovation itself.

What, then, most distinguished this new art world at the moment when Schnabel and the artists of his generation were preparing to make their entry into it was the persistence of an orthodoxy—a specifically modernist orthodoxy—which presented itself, somewhat misleadingly, as an open situation. There was much about the artistic situation that *was* open, to be sure, but there was much that remained closed, too. What defined the new orthodoxy, above all, was the aesthetic of Minimalism, which had emerged as the principal heir to the modernist tradition, and the various challenges to the authority of Minimalism to be found among the Postminimalist abstract styles of the 1970s. Within

this tidy, "open" dialogue of abstract styles ample provision was made for the reintroduction of expressionist gestures as well as for an art more overtly decorative than Minimal art had been concerned to be. But the dialogue itself nonetheless contained an important prohibition, and what was prohibited was precisely the introduction of the kind of expressionist imagery likely to pose a threat to abstraction itself.

It was just there, however, in that realm of expressionist imagery so long despised and rejected by the exponents of modernist orthodoxy, that an opportunity presented itself to Schnabel and others of his emerging generation to alter the course of art in their time, and the opportunity was seized with a display of energy and ambition, and a lack of inhibition and decorum, that has left heads reeling and tongues wagging ever since. Nothing quite like this rupture in taste, in aesthetic orientation, and in the sheer look of painting had occurred since the advent of Pop art nearly twenty years earlier, and whereas Pop art had shocked its initial public with a show of campy humor and facetious charm—by being, in effect, almost too easy and accessible to be taken seriously—the new expressionism looked to be in dead earnest. Suddenly painting had become grave, mysterious, and messy again, and not in any of the familiar ways. It had also become boisterous, swaggering, and "tough." Charm, elegance, and reductive understatement were all firmly rejected and so was the tendency to anorexic aestheticism that had come to characterize the Minimalist impulse at its outermost extremes. Excess and surfeit were embraced as a principle of vitality.

In the case of Schnabel, who straightaway established himself in the forefront of this development, the tendency to excess and surfeit was concentrated as much on the handling of the picture surface as it was on the creation of a new imagery. The priority that Schnabel gave to building up the surfaces of outsize pictures with plaster, broken crockery, and sundry other materials and objects was by no means an entirely original idea, of course. There was ample precedent for it in the work of Rauschenberg and Johns. Yet the spirit informing this familiar practice was significantly altered. All trace of Duchampian elegance and supercilious irony was gone, and in its place was the expressionist bluster and bombast that was to give Schnabel's work its own special resonance. The expressionist mode is, by its very nature, inhospitable to dandyish elegance and Neo-Dada irony. Its forte lies in its unsparing forthrightness, and this was the quality that Schnabel made palpable in the very density and materiality of the surfaces he employed.

As a corollary to the physical properties with which Schnabel endowed these surfaces, he was equally forthright in the conspicuous use he made of overscale images appropriated from literature, films, photographs, religious symbols, and other paintings—images that blatantly proclaimed their presence without readily disclosing their meaning. With the energy of a madcap anthologist scooping up the fragments and tag ends of anything that interested him in the abandoned debris of contemporary cultural life, Schnabel seemed to be as much in search of the meaning that these images might have for him—and for us—as he was in search of the images themselves. His principle in selecting them appeared to be random and associational, and it was certainly anything but systematic. Yet a rough consistency could nonetheless be discerned in the pattern they traced from picture to picture, for these images tended to be drawn from the world of culture rather than from the realm of nature. They tended, too, to have an archetypal rather than a discrete character and to be used less as subjects than as symbols. However incongruous their juxtaposition might be in a given picture, Schnabel's images were also consistent in evoking something akin to an elegiac attitude toward their content. There has indeed always been something ghostlike in the appearance of these images in Schnabel's pictures—something that suggests that the images do not so much occupy these pictures as haunt them. As vivid as the images are to the eye, they tend to hover on the picture surface without quite taking root in its material existence, almost as if they were images flashed on a screen. Whereas the surfaces in Schnabel's pictures have been invariably dense, sensuous, and palpable in the extreme, his images have generally given the impression of something conjured. We are never quite certain about what to make of them. We are never quite certain that Schnabel has known what to make of them.

What this suggests is that there is a certain disjunction in Schnabel's work between surface and image—between the work's material realization, on the one hand, and its imaginative conception, on the other. Among the new expressionists of Schnabel's generation, he is by no means alone in this respect. To one degree or another, a similar disjunction will be found to characterize a good deal of the work of his contemporaries as well. If it tends to be more conspicuous in Schnabel than elsewhere, it is only because everything in his work has a tendency to be highly charged and bluntly stated—he is an artist who shuns the lower registers of expression in favor of saturation and a revved up intensity. That is one of the things that gives him a natural affinity for the expressionist mode.

The very nature of this disjunction between surface and image tells us something important, I believe, about the fate of the expressionist impulse in Schnabel's generation. It reminds us of how profoundly a work of art remains tethered to its moment in cultural history—to the whole complex of beliefs, assumptions, and received ideas that comes to dominate the conception of art at a given point in time—even when the artist himself is in open rebellion against the artistic status quo. In Schnabel's case, we are reminded of the extent to which his art remains tethered to the triumph of Minimalism and the various aesthetic strategies that the artists of the 1970s adopted in their resistance to it. To the art that belongs to this anti-Minimalist resistance the critic Robert Pincus-Witten has given the name ''Maximalism,'' and it is a term that describes Schnabel (among others) very well. For it offers us a useful clue as to why the surface in Schnabel's work, whether he is painting on velvet or a dropcloth or working in high relief with plaster, crockery, and other materials, tends to achieve a more persuasive authority than the images that trace a ghostlike course upon that surface. It suggests that the crux of the anti-Minimalist resistance was to be found precisely in this question of surfaces and their visual attributes and that the problem of imagery was, perforce, a matter of secondary importance.

It is in the nature of Minimal art to give an absolute priority to surface and scale and to render all other considerations subsidiary if not actually nugatory. In Minimal art, surface and form are coextensive; so are surface and expression. The integrity of surface must therefore be regarded as absolute and inviolate. It follows, then, that any attempt to resist or transcend the strictures of the Minimalist aesthetic is likely to make the violation of that surface its first and most fundamental interest. And it is in this act of artistic violation, by whatever means it takes, that the crucial breach with Minimalism occurs. Once this violation of surface has been achieved, the question of introducing images into the artistic equation is a matter of discretion—which is to say, a secondary consideration. It is not the introduction of images—and still less is it the specific identity of those images—that has defined the fundamental break. In the anti-Minimalist art that Pincus-Witten dubbed ''Maximalist,'' it scarcely matters whether images are employed or not. It is from the urge to alter the surface—to open it up to a greater multiplicity of visual sensation than Minimal art allows—that the new aesthetic impulse derives its momentum.

This is one reason—the main reason, I believe—why Schnabel's radical modification of the placid Minimalist surface in painting has

proved to be more persuasive than his use of images. The Minimalist aesthetic, with its strict prohibitions, provided him with a well-defined *donnée* he could act upon and transform with all the expressionist bluster that was natural to his sensibility. It gave him, so to speak, a tradition that could be overturned, and overturn it he did. But there was no comparable tradition to act upon and transform in the realm of pictorial image-making. There he was on his own—a freelance, as it were, obliged to create an iconography out of his own imagination and out of his own cultural situation and with no certainty that the images he introduced into his work would have the resonance and meaning for others that they appeared to have for him. His response to this challenge has been to adopt the outlook of a scavenger anthologist for whom the sheer multiplicity of images is inevitably more important than the identity of any single one of them. This has yielded him some striking results at times, yet the question of exactly which images are necessary to his art and which are merely an added-on component of it remains unresolved. And this, in turn, suggests that the revitalization of the expressionist aesthetic that lies at the heart of his work also remains to be completed.

1984

9. Turning Back the Clock: Art and Politics in 1984

It is understood by now that all art is ideological and all art is used politically by the right or the left, with the conscious and unconscious assent of the artist. There is no neutral zone. Artists who remain stubbornly uninformed about the social and emotional effects of their images and their connections to other images outside the art context are most easily manipulated by the prevailing systems of distribution, interpretation, and marketing.

—Lucy R. Lippard, in the
catalogue of the "Art & Ideology"
exhibition at the New Museum of
Contemporary Art in New York

Everyone who follows the course of current events in the art world must nowadays be aware of a troubling development that has lately manifested itself with increasing frequency. This is the concerted attempt now being made by a dedicated alliance of artists, academics, and so-called activists to politicize the life of art in this country. Not since the heyday of the antiwar movement in the sixties and the early seventies have we seen anything quite like the present effort to impose a sectarian political standard on both the creation and the criticism of art. In more and more exhibitions, publications, symposia, and other public events, we are once again being exhorted to abandon artistic criteria and aesthetic considerations in favor of ideological tests that would, if acceded to, reduce the whole notion of art to little more than a facile, preprogrammed exercise in political propaganda.

The tone in which these exhortations are articulated varies from the stridently militant to the earnestly "concerned." But the message is invariably the same: in art, priority must now be given to a politically inspired "content," as it is called; and in criticism, the governing assumption is a belief that all claims to aesthetic quality are to be regarded as mere subterfuge, masking some malign political purpose. It (almost) goes without saying that the politics being served by this effort to discredit all disinterested artistic activity are the politics of the radical Left. The favored themes at the moment are nuclear disarmament, radical feminism, and support for revolutionary movements in Central America. The favored targets, of course, are the policies of the United States government in particular and the political and cultural institutions of democratic capitalism in general. Adding some piquancy to the whole shabby endeavor is the fact that a sizable part of this blatant political activity is funded, precisely because it claims to speak in the name of art, by such public agencies as the National Endowment for the Arts, the New York State Council on the Arts, and the Department of Cultural Affairs of the City of New York—yet another example, I suppose, of supplying the rope to those who are eager to see us hanged.

Thus, since early December—to look no further back than that—the art calendar has been fairly crowded with these unlovely political events. The busiest sponsor of them has no doubt been the New Museum of Contemporary Art in New York. In a four-month period, it has organized, with the aid of federal, state, and municipal funds, two full-scale exhibitions on the requisite themes: "The End of the World: Contemporary Visions of the Apocalypse" and "Art & Ideology." "The End of the World" was mainly (though not entirely) devoted to the cause of nuclear disarmament and, while paying ceremonial lip ser-

vice to George Orwell's *Nineteen Eighty-Four* as a source of inspiration, actually derived its political rationale from Jonathan Schell's *The Fate of the Earth*. In "Art & Ideology" we were offered a more explicitly Marxist account of American society together with arguments (in the catalogue) calling for the political criticism of all cultural activity. The New Museum would appear to have embraced Lucy R. Lippard's dictum—that "There is no [politically] neutral zone" for art in our society—as a fundamental principle, and one naturally wonders if anyone involved in the governing of this institution understands that the principle itself is totalitarian in its very essence.

Meanwhile, the mall of the Graduate Center of the City University of New York, another institution supported by public funds, was given over to a more specialized political event—a show of objects and installations produced (as it was said) "by artists who are concerned about current U.S. policy in Central America." This was an undisguised propaganda effort in support of the Marxist-Leninist revolutionary movement in Central America and was staged to coincide with a program of exhibitions and speaking events, both in New York and elsewhere, organized by a group calling itself "Artists Call Against U.S. Intervention in Central America." In January this "Artists Call" group also won the support of a number of private art galleries, which gave over their space to its activities, and the eager cooperation of publications such as *Arts Magazine, Art in America, The Nation, The Village Voice*, and sundry "alternative" journals around the country. At the same time, the Edith C. Blum Art Institute on the campus of Bard College chimed in with a political exhibition called "Art as Social Conscience," which, not surprisingly, included many of the same artists featured in the shows at the New Museum and the City University mall and was praised in the pages of *Art in America* and *The Village Voice*. There was also a show devoted to "Women & Politics" at the Intar Latin American Gallery—another event, by the way, supported by funds from the NEA, the New York State Council on the Arts, and New York City's Department of Cultural Affairs. And then, lest the point of all this effort be lost on us, two of our leading art schools— Cooper Union and the Pratt Institute—joined in sponsoring a symposium in the Great Hall at Cooper Union on the theme of "War in Art." The speakers, of course, were mainly those prominently represented in the exhibitions and publications already mentioned. Their basic message is easily summarized: Since war is a terrible thing, we should all take up a position of radical pacifism and leave military victory to our enemies.

No doubt there have been other similar events which have escaped our attention. In the midst of such a well-organized campaign, one cannot be expected to keep track of every episode. But one other exhibition should be mentioned here—the show called "Dreams and Nightmares: Utopian Visions in Modern Art" at the Hirshhorn Museum in Washington. This, too, claimed *Nineteen Eighty-Four* as its ostensible inspiration and was not only more historical in its outlook but a good deal more circumspect than the other shows I have mentioned in keeping a discreet distance from the kind of open political commitment that is now standard policy, for example, at the New Museum of Contemporary Art. Yet "Dreams and Nightmares" was, all the same, a political exhibition. Careful as it was to exclude anything that might contain an explicit condemnation of current U.S. government policy—the Hirshhorn Museum is itself, after all, a government institution—the whole conception of the exhibition was pacifist in spirit and clearly owed its inspiration to the antinuclear movement. It certainly showed no interest in distinguishing artistic quality from the most facile exploitation of political emotion, especially in its selection of contemporary examples.

I do not propose to attempt a detailed critical evaluation of all of the art which has been offered to us in these political exhibitions and extolled in the various texts and speeches written to advance its fortunes. Except for the historical examples included in the "Dreams and Nightmares" exhibition at the Hirshhorn, most of the art brought together in this ideological extravaganza exists on such a low level of artistic discourse that almost any critical analysis, even the most negative, would inevitably have the effect of suggesting a higher degree of aesthetic seriousness than, in fact, can be found in the work itself. The whole notion of artistic achievement is, in any case, what most of the art is specifically intended to repudiate, and it would therefore violate the spirit of the art—as well as the function of criticism itself—to pretend otherwise. Linda Weintraub, director of the Blum Art Institute at Bard College and organizer of the "Art as Social Conscience" exhibition, made the point herself with admirable candor in declaring that "The works are designed, unabashedly, for political and societal ends." Whether or not the show could claim any aesthetic merit was not a question she found it appropriate to address.

She was right not to do so, of course. Where aesthetic merit, or even aesthetic intelligence, is not the issue, the discriminations appropriate to the study of art are clearly not called for. Yet what, then, was the show doing in the Bard College art gallery, which exists (we may

presume) for the purpose of educating students in the experience of art? The whole point of an exhibition like "Art as Social Conscience" is not to illuminate the experience of art but, in Linda Weintraub's words, to "jolt the viewer into a new awareness of today's most pressing social issues." The exhibition announcement, gotten up to resemble the front page of a newspaper, helpfully enumerated what these "pressing social issues" were assumed to be: "nuclear war, unemployment, toxic waste, feminism, Reaganomics, and other timely social issues." (The list was by no means complete, by the way. It omitted, among other things, the subject matter of a particularly odious little video tape in which the purposes of the American CIA and the Soviet KGB were presented as very much alike, quite as if the political systems they serve were equally evil.) It is theoretically conceivable, perhaps, that there might somewhere exist an artist capable of making a significant work of art out of such materials, but I frankly doubt it. What we can be certain of is that neither Linda Weintraub nor anyone else has yet discovered such an artist—and the awful fact is that she doesn't even know that she hasn't, so eager has she been to present these political substitutes as if they were artistic achievements.

It may be worth adding that the artistic nullity of the work in this and similar exhibitions would not, in my opinion, have been affected in any degree *as art* if its political content had been designed to promote the interests of President Reagan's economic program or an increase in the defense budget or his reelection campaign. (It's not likely that it would have been so designed, of course—or, if it had been, that Bard College would have exhibited it.) Bad art is bad art, whatever its political purpose, and only the most zealous supporter of the "no neutral zone" doctrine could seriously believe otherwise. I frankly doubt that Linda Weintraub is a true believer in this pernicious doctrine. Unlike the folks at the New Museum of Contemporary Art, who seem to believe in little else, she is probably not keenly interested in most of these issues or terribly well-informed about them, but has only succumbed to a current cultural fashion—but that, alas, is precisely the way the politicization of art is hastened on its course. Every militant "activist" like Lucy R. Lippard needs a great many Linda Weintraubs in order for her political goals to be realized.

Let us look a little more closely at some representative objects that have been presented to us in these exhibitions as works of art. In the show at the City University mall we were shown, among much else, a huge, square, unpainted box constructed of wood and standing ap-

proximately eight feet high. On its upper sides there were some small openings and further down some words stencilled in large letters. A parody of the Minimalist sculpture of Donald Judd, perhaps? Not at all. This was a solemn statement, and the words told us why: "Isolation Box As Used by U.S. Troops at Point Salines Prison Camp in Grenada." The creator of this inspired work was Hans Haacke, who was also represented in the "Art as Social Conscience" exhibition by a photographic light-box poster attacking President Reagan. Such works are not only devoid of any discernible artistic quality, they are pretty much devoid of any discernible artistic experience. They cannot be experienced as art, and they are not intended to be. Yet where else but in an art exhibition would they be shown? Their purpose in being entered into the art context, however, is not only to score propaganda points but to undermine the very idea of art as a realm of aesthetic discourse. President Reagan and his policies may be the immediate object of attack, but the more fundamental one is the idea of art itself. If it were possible to entertain any doubts on this score, they would surely be put to rest by several of the essays that the guest curators of the "Art & Ideology" exhibition at the New Museum have contributed to its catalogue. Benjamin H. D. Buchloh, for example, who teaches art history at the State University of New York at Westbury, defends the propaganda materials he has selected for this exhibition by, among other things, attacking the late Alfred H. Barr, Jr., for his alleged failure to comprehend "the radical change that [modern] artists and theoreticians introduced into the history of aesthetic theory and production in the twentieth century." What this means, apparently, is that Alfred Barr would never have accepted Professor Buchloh's Marxist analysis of the history of modern art, which appears to be based on Louis Althusser's *Lenin and Philosophy.* (Is this really what is taught as modern art history at SUNY Westbury? Alas, one can believe it.) On this point, at least, Professor Buchloh is surely correct, for what he offers us as art in this exhibition would probably never have been accepted by Alfred Barr as any sort of work of art at all. Here is Professor Buchloh describing one of the propaganda items that he has selected for the show—a series of photographs and printed documents assembled by Fred Lonidier and given the title, *L.A. Public Workers Point to Some Problems: Sketches Of The Present For Some, Point To The Future For All?*:

> *L.A. Workers Point to Some Problems* . . . was published in excerpts in two issues of the weekly paper *The Citizen,* the official publication of the Los

Angeles County Federation of Labor, AFL-CIO and was exhibited in both union halls and at the Los Angeles Institute of Contemporary Art. The work addresses the questions of the detrimental impact, not to say disastrous consequences of federal and state legislation in favor of corporate and entrepreneurial interests on those sectors of public life and culture, that we would not normally be confronted with as a museum- or gallery-visiting art audience, since the system of representation that we traditionally refer to as "the aesthetic" by definition extracts itself—as it seemed—from the economic and the political reality of the basis of culture in everyday life, in order to construct the aesthetic mirage that generates pleasure due to its mysterious capacity to disembody and dissociate our perception from the weights and demands of the real. Lonidier's work successfully counteracts that tendency . . .

We can at least be grateful that Professor Buchloh is not employed to teach expository writing, but this still leaves students of the history of modern art at SUNY Westbury in quite a lurch.

The situation at SUNY Stony Brook appears to be no better. Another guest curator of the "Art & Ideology" exhibition is the redoubtable Donald Kuspit, professor of art history at SUNY Stony Brook, and here are his concluding remarks on the two artists—Nancy Spero and Francesc Torres—he had selected for this show:

The works of Spero and Torres deal with martyrdom in the cause of freedom, humanity, and justice, a cause which seems uncertain because we see it only in critical, oppositional form, as a kind of protest against existing reality. We do not see what a world without torture of women and war would be like. Spero and Torres do not want us to see that future, for that would be to offer the utopian in place of the critically effective—the critical as social action. Such critical action is the only kind that can heal the split of spirit, for it alone shows us the futility of administrative control—the planned bombing missions, the planned murder of women—of destructive dominance.

I should explain, perhaps, that when Professor Kuspit refers early on in his essay for the catalogue to "the totalitarian mentality"—which he does repeatedly—he appears to have in mind the "existing reality," as he calls it, of American life.

This, then, is the kind of mentality—to use Professor Kuspit's term—that characterizes not only the "Art & Ideology" exhibition but the larger drift toward politicization we see making such headway on the art scene today. The notion that "There is no neutral zone" for art in our society has by no means become the dominant point of view of

the art world. Far from it. At the moment it remains the program and commitment of a dedicated and well-organized minority faction. Yet to judge by the position lately won by an institution like the New Museum of Contemporary Art, it is now an *accepted* notion—quite as if it represented little more than an aesthetic option—and this is itself a frightening prospect. It is to the New Museum, strangely enough, that the Reagan administration has entrusted responsibility for representing American art at the 1984 Venice Biennale. This is a development so bizarre that it quite takes one's breath away. Having worked its way up from an "alternative" space to an established institution, enjoying the patronage of government agencies and private foundations, the New Museum has now become a power in the art world, and that is very bad news indeed.

Yet the role of the New Museum, dismaying as that may be, and the other events I have been describing here, ghastly as they are, are finally less important in themselves than for the larger historical impulse they represent. For what we are now witnessing in this movement toward the politicization of art in this country is an attempt to turn back the cultural and political clock. And it is not to the radical counterculture of the sixties that this movement looks back for its model and inspiration, despite the many resemblances it may bear to the outlook of the sixties, but to the radicalism of the thirties when so much of American cultural life was dominated by the hypocritical "social consciousness" of the Stalinist ethos. It is to a contemporary version of this old "social consciousness" that the protagonists of this political movement in the art world wish to confine the life of the artistic imagination. Hence the attacks on modernism and on such champions of the modernist aesthetic as Alfred Barr. For this new generation of radicals, it is the cultural life of the forties and fifties—when American art and literature finally vanquished the last respectable traces of the Stalinist ethos—that can never be forgiven. The forties marked a great turning point not only in the history of American art but in the life of the American imagination, and any attempt to return American culture to the ideological straightjackets of the thirties must inevitably attempt to discredit both the achievements and the values that belong to the post-World War II period. Hence, too, the increasingly raucous attempts to dismiss the accomplishments of the forties and fifties as nothing more than the political products of the Cold War.

Reflecting on this curious turnabout in our artistic affairs and on the apocalyptic note that is sounded again and again, ever more insis-

tently, as the battle cry of the new cultural radicals in their campaign to politicize the life of art, I am reminded of a passage in one of the last of Lionel Trilling's many essays on this theme. In "Some Notes for an Autobiographical Lecture," which was posthumously published in a volume called *The Last Decade: Essays and Reviews, 1965–75*, Trilling gave us a glimpse into the train of thought that had led him to devote so much of his critical attention to what he described as the "unmasking" of "Stalinist-colored liberal ideas."

> Behind my sense of the situation [Trilling wrote] was, I think, a kind of perception that I might call novelistic—that there was in the prevailing quality of the intellectual-political life a kind of self-deception: an impulse toward moral aggrandizement through the taking of extreme and apocalyptic positions which, while they *seemed* political, actually expressed a desire to transcend the political condition—which, as I saw things, and still do, meant an eventual acquiescence in tyranny.

It is, once again, toward precisely such "an eventual acquiescence in tyranny" that the doctrine announced in the statement, "There is no neutral zone," promises to lead us.

APRIL 1984

10. MoMA Reopened
The Museum of Modern Art in the Postmodern Era

I. Toward the New MoMA

The Museum of Modern Art in New York has long been regarded— and has long regarded itself—as the greatest institution of its kind in the world. Its collections are acknowledged to be unrivaled in quality and number, and for more than half a century its exhibition program together with the publications that derive from it have played a crucial role in shaping our understanding of what, in fact, the very notion of "modern art" may be said to encompass. From the outset, moreover,

the museum undertook to define its interests—and thus those of modern art—in broad terms, embracing not only painting, sculpture, and the graphic arts, but also architecture, photography, industrial design, and film. In this respect, too, MoMA (as it has come to be called) has exerted an immense influence. For other institutions in the field it has served as something of a model and inspiration, and for its large and constantly expanding public it has served as a source of pleasure and instruction as well as a touchstone of taste and certification. So central has been its role in defining both the standards and the scope of modern art that the museum's own activities and ideas have in themselves come to constitute a distinct chapter in the cultural history which MoMA was originally conceived to monitor, to document, to pass judgment upon, to preserve. Indeed, it is no exaggeration to suggest that in 1984, fifty-five years after the founding of the museum, no single living artist can now be said to rival MoMA itself for the sheer glamour and prestige it has come to enjoy in the eyes of its adoring public.

It was to be expected, then, that the reopening of the museum in May of this year would be seen to be an event of historic importance. After all, for the better part of four years MoMA has been more of an absence than a presence on the art scene, and it has been an absence keenly felt. Giving full priority to its long-awaited rebuilding and expansion program, the museum pretty much ceased to be what it had been for half a century—the central reference point for anyone seriously interested in the history of modern art. With its collections either dispatched to other venues or locked up in storage and its exhibition schedule drastically curtailed when not altogether suspended, MoMA gradually became something of a ghost of its former existence, continuing to haunt the life of art yet no longer an active participant in it. Expectations for its return were made all the higher, of course, by the promise of a "new" MoMA—a transformed museum boasting a glittering new building, with vastly expanded facilities both for the installation of the permanent collections that are MoMA's greatest glory and for the temporary shows that have been so essential a part of its contribution to contemporary cultural life. And it is assuredly a new MoMA that we have now been given—a museum not only greatly enlarged physically but significantly altered in its general outlook and spirit.

Much that we cherished in the old MoMA remains as it was and at times looks even better than one remembered. Certainly a great effort

has been made, especially in the galleries devoted to the permanent collection of painting and sculpture, to concentrate (as the museum always has) on quality—to give us the best of the art that the modern era has bequeathed to us, and to confer upon our intercourse with this art that special feeling of intimacy and awe we gratefully recall from years in attendance at the old MoMA. Yet there is no avoiding the fact that a great many changes—some of them quite subtle and some not subtle at all—have gone into the making of the new MoMA, and the most important of these is the revised perspective it now brings to modern art itself.

For the new MoMA is, among many other things, a museum even more deeply entrenched than hitherto in the history of modern art and in modern art as history. It is also a museum now governed by a sharper and more narrowly defined view of that history than formerly obtained in the museum. It is a view that owes much to the critical thought of the last quarter-century. Its outlook may best be characterized, I think, as that of art-historical formalism; and it is in the nature of the strengths and the weaknesses of this outlook that it serves as a better guide to some kinds of art than to others and that it is generally more useful in charting the art-historical past than in coming to grips with the present. For as a means of dealing with the present, this formalist outlook tends—one is tempted to say, inevitably—to lead to a false orthodoxy. And attempts to compensate for, or guard against, such orthodoxy tend, in turn, to lead to a virtual abandonment of any discernible standards.

The consequence of this for the new MoMA is made vividly clear in its inaugural installations. Whereas the task of tracing the history of modern art has been undertaken with an impressive sense of confidence, intelligence, and discrimination—even if the confidence may be said at times to border on overconfidence—the more challenging task of coming to terms with the art of the present has been badly botched. At least as far as painting and sculpture are concerned—and it is these that remain the principal interest of the new MoMA, as they were of the old—the museum now reveals itself to be an institution that finds it increasingly difficult to get its bearings in a contemporary art scene that does not lend itself to the fixed ideas and tidy categories of the formalist outlook.

It must be acknowledged in any discussion of this problem that the division separating MoMA's role as a custodian and codifier of history from its other role as an arbiter of contemporary taste has been the

source of a built-in conflict in museum policy from the very begin-
ning—as, indeed, it usually is for any cultural institution that under-
takes to fix our understanding of the past at the same time that it seeks
to discriminate among the claims of the present. It is not the problem
itself that is new, but the extent to which history has now given it a new
dimension and thereby rendered it all but unmanageable. For the pas-
sage of time, far from ameliorating this division and enabling the mu-
seum to reconcile the conflicting pressures it brings in its wake, has
only succeeded in exacerbating these contradictory consequences. So
deeply has this division penetrated to the core of the museum's sense of
its own identity that it has now gone a long way in determining not
only the aesthetic character but even the physical structure of the new
MoMA.

What is really new in the new MoMA is not so much the added
space the museum has acquired—important as that may be—as the
way it has utilized that space as a means of institutionalizing this cate-
gorical separation of the past from the present. As a result, the new
MoMA is no longer a single museum with a unified purpose and out-
look, but two (or more) museums, which pursue vastly different objec-
tives and uphold very different standards.

All of this is plainly legible in the design of the new MoMA. Here
again, in the very disposition of the museum's new space as well as in
the way the space has been appointed, the policy already familiar to us
in the old MoMA—the policy of making a sharp distinction between
the parts of the museum in which we are intended to view modern art
as history and those in which we are left to deal with contemporary art
as an element of a new and uncodified cultural experience—has been
elevated to the level of a structural principle. There may even be a cer-
tain symbolism in the way visitors to the museum are obliged to ascend
to the second, third, and fourth stories in order to commune with the
certified masterworks of modern art, whereas they must descend from
these higher elevations to the lower levels of the building in order to
study the "temporary" productions garnered from the current art
scene. (In keeping with this symbolism, the movies of course are con-
signed to the lowest levels of the museum.) Even for contemporary
works that have been nominated for permanent status and, on that
provisional basis, accorded temporary lodging on the third floor—
where, presumably, they may be properly tested for durability in the
neighborhood of permanence—the same sharp distinction obtains be-
tween paintings and sculpture deemed to be permanently permanent,

so to speak, and those judged for the moment to be only potentially permanent.

I do not mean to mock this policy. There are few alternative courses open to a museum that invests so large a portion of its space and resources in codifying a correct "reading" of the past at the same time that it persists in the vexing task of explaining the present. Still, while the alternatives may be few, if any, the comedy as well as the contradictions and pitfalls inherent in such a policy are worth noting, for they tell us something important about the way judgments in art come to be institutionalized. They alert us to the fact that history—in this case, the history of modern art—rests not on some immutable system of interpreting what artists have achieved but on particular acts of judgment made at particular times in particular circumstances.

Something else is also plainly legible in the design of the new MoMA. This is the important role played in the very conception of the building's design by the change that has lately occurred in the size and in the character of the museum's public. Indeed, the role played by this change is so important that it may very well be considered dominant. Which is to say that the new MoMA is a museum designed, as the old MoMA never was, to accommodate huge crowds of people—not all of whom, moreover, can be expected or in fact are expected to have an informed or even a very compelling interest in the art to be seen in the museum (though they may have—what is not the same thing—a compelling curiosity to see what it is). The new museum is designed, we may say, for a public nurtured on blockbuster exhibitions—exhibitions that are as much media events as they are art events, and that have the inevitable effect of arousing, by means of high-intensity publicity campaigns, the kind of interest which art in and of itself can probably never fully satisfy.

It will be recalled that MoMA was itself responsible for mounting what remains in many ways the most spectacular of the recent blockbuster exhibitions. This was the great Picasso retrospective, numbering around one thousand works by the artist, which occupied the old MoMA building in its entirety during the spring and summer months of 1980, and filled it with capacity crowds (seven thousand visitors a day). Although it was little noted at the time—probably because Picasso has a way of consuming all of our attention, and this was more of Picasso than anyone had ever before met with in one place at one time—this exhibition can now be seen to have been a watershed event in MoMA's own history as a museum. It marked the end of the old

MoMA and the beginning of the new. The galleries were emptied of every item in its collections that did not bear directly on this mammoth show. A new system of admission by advance reservation was devised, a new traffic pattern was designed for handling the crowds, and an augmented publicity department was created to insure that the crowds would keep coming. Whether by accident or intention, the Picasso retrospective proved to be a trial run for the operation of the new MoMA, and central to its success was the public that turned out for this exhibition—a public so eager not to miss out on what became the media event of the season, and of many a season, that it was willing to put up with almost any discomfort or distraction (and there were many!) in order to have been there. Those who said at the time that MoMA would never recover from this assault turned out, in some sense, to have been right. The new MoMA was born the day this exhibition opened its doors to the waiting throng.

It would not be quite correct, I think, to suggest that blockbuster exhibitions of this sort have converted the museums that embrace them into agencies of mass culture, for something less easily categorized—a cultural development that has not yet been defined or described—resulted from this planned introduction of huge new crowds into museums thitherto largely devoid of them. But if the blockbuster exhibition did not transform the museum into a branch of mass culture, it nonetheless brought us a fairly radical change in the museum-going public. It created, in effect, a new public, which, while lacking both the knowledge and the sensibility to be found in the elite art public, must all the same be differentiated from the mass public that seeks its principal cultural gratifications in television and other commercial entertainments, professional sports events, and similar mass-market enterprises, and takes no interest whatever in the experience of high art.

Nor would it be correct to characterize this new public as middlebrow. The middlebrow public of yesteryear, with its perfect confidence in its own philistine taste and its indifference, if not outright hostility, to avant-garde culture, has pretty much ceased to exist—a casualty, perhaps, of the death of the avant-garde itself and the absorption of so many of its characteristic attitudes by the institutions (the academy, the mass media, et al.) which once served as a kind of support system for middlebrow taste. In contrast to the old middlebrows, the new public I speak of is anything but confident of its taste. In a sense that I do not mean to be invidious but merely descriptive, this public may even be said to have no taste—none, anyway, where art is concerned—but to

be possessed instead of a keen appetite for whatever modes of cultural experience are persuasively and conspicuously commended to its attention.

That exhibitions of high art now constitute one of these modes—and a very important one, too, to judge by the attendance figures—is, of course, a matter of considerable interest, and it would be nice to know what accounts for it. Is it to be explained—as I suspect—by the fact that art exhibitions do not necessarily require any sustained effort of cerebration in order to be enjoyed at some level of pleasure or, for that matter, demand the kind of protracted intellectual attention in real time we are obliged to give to books or even plays of comparable seriousness if we are to derive any satisfaction from them at all? Is the explanation to be found, in other words, in the decline of literacy among the so-called educated classes? A dismaying thought. But however we attempt to explain this phenomenon, the phenomenon itself is an important new factor in the museum world, and the pressure it now exerts on that world is enormous.

Its influence certainly makes itself felt in the very look and atmosphere of the new MoMA. We are made to feel it straightaway in the enormous lobby area and in the computerized checkroom and then most conspicuously in the so-called Garden Hall, the vast atrium-like, glass-enclosed space that now rises on the north side of the museum to its topmost story and has the effect of re-orienting the entire building away from the West Fifty-third Street entrance and toward the Abby Aldrich Rockefeller Sculpture Garden and the neighborhood of West Fifty-fourth Street. This dazzling, light-filled space, with its elegant banks of escalators, its spacious halls, its busy display of structural detail (itself a visual experience of considerable interest), and its dramatic views, is now the museum's main traffic artery. Interestingly, it is also the new MoMA's principal architectural signature—its most expressive identifying image.

It is therefore of some significance that it is a space remarkably inhospitable to the exhibition of works of art. There are works of art displayed there, of course, and some very important ones, too—among them, Umberto Boccioni's *The City Rises* (1910), Francis Picabia's *Dances at the Spring* (1912), and Joan Miró's *Mural Painting* (1950–51), on the second floor and large-scale works by Helen Frankenthaler and Frank Stella on the third floor. Yet most of the art on display in the Garden Hall wages a losing battle against atrocious visual circumstance. Owing to the unremitting volume and intensity of the circum-

ambient light, even sculptures as powerful as Gaston Lachaise's *Floating Figure* (1927) and Alberto Giacometti's *Large Head* (1960) are reduced to silhouettes; and because of the overwhelming scale of the space in the Garden Hall, the paintings—though no doubt selected on the basis of size (and the fact that size precluded their installation in the neighboring interior galleries)—tend to be sadly diminished. The result is not uniform, to be sure. With their bold forms and intense color, the Frankenthaler painting and the Stella construction manage to survive, if only barely, this diminishing effect. But Boccioni's *The City Rises*, one of the classics of Futurist painting (though a heavily restored one), is simply wiped out by it, and there is not a single object on display in the Garden Hall that gains anything by being shown there.

The truth is, as a space in which to exhibit works of art—at least of the kind that have been placed there for the inauguration of the new MoMA—the Garden Hall is irredeemably makeshift, irrational, and unrewarding. But it is not, of course, the primary function of this space to serve as an exhibition area. Exhibiting works of art there is clearly a secondary consideration, if not indeed an afterthought. The real purpose of this space is to provide a place where crowds can gather and take their ease without having to be in any way concerned with the works of art they have ostensibly come to the museum to look at. For that purpose the Garden Hall is suitably commodious and very entertaining. It is sheer spectacle and gives the visitor a lot to look at when he doesn't want to look at art.

In some respects—especially in the cityscape views it provides—the Garden Hall resembles the glassed-in hallways of the upper floors of the Pompidou Center in Paris, but it also calls to mind the great hall of the East Building of the National Gallery of Art in Washington. Both, of course, are pioneer examples of blockbuster-inspired museum design; and one has the impression that they have been carefully studied. If so, it must be said that some of the less appealing features of these buildings have not been avoided in the design of the new MoMA. On the contrary, they seem to have been emulated. The Garden Hall is an infinitely more elegant and refined space than anything to be found at the Pompidou Center, but the very purpose which the Garden Hall serves guarantees that the irksome sense of bustle and commotion which can nowadays make a visit to the Pompidou Center such a ghastly experience—ghastly, that is, for anyone seriously interested in art—will be pervasive here as well. As for the great hall of the East

Building of the National Gallery, it has proved from the outset to be a great space for crowds but an abysmal one in which to show works of art. The exhibitions which the National Gallery devoted to the works of Auguste Rodin and David Smith proved this unfortunate point beyond dispute, and it looks very much as if the Garden Hall—whatever its felicities as a design experience—is going to prove equally resistant to the museum's basic artistic purposes.

II. Choosing a Façade

Creating an architectural structure that would be perfectly consistent with MoMA's artistic purposes—a building that would reflect in all respects its special artistic mission while at the same time serving its practical needs—is a familiar problem for the museum. It has bedeviled MoMA for nearly fifty years—since 1936, in fact, when its founding director, the late Alfred H. Barr, Jr., and MoMA's trustees and benefactors set about the task of selecting an architect to design the museum's original building at 11 West Fifty-third Street. In the resolution of that distant episode we are given the first chapter of the curious history that has now been concluded in the new MoMA of 1984.

It was Alfred Barr's hope in 1936 to be able to engage the services of one of the great architects of the modern movement for this important commission. Since its opening in 1929, the museum had occupied temporary quarters in existing buildings—first in the Heckscher Building at Fifth Avenue and Fifty-seventh Street and then, from 1932, in the townhouse at 11 West Fifty-third Street. During this period the museum had made the cause of modern architecture one of its principal concerns—its historic survey, "Modern Architecture: International Exhibition," was organized in 1932, the year the Department of Architecture was established—and it was therefore to be expected that when the time came for MoMA to put up a building of its own, the commission would go to one of the figures it had already singled out as modern masters. Barr's own choices were three: Ludwig Mies van der Rohe, Walter Gropius, and J.J.P. Oud, a Dutch architect associated with the avant-garde De Stijl group. Mies was clearly the director's first choice. In a letter, written in July 1936, to Mrs. John D. (Abby Aldrich) Rockefeller, Jr., who had supplied the funds for purchasing the land on which the museum was to be built, Barr referred to Mies as "the man who is possibly the world's finest architect." And in another letter that

month—this one to A. Conger Goodyear, the museum president—
Barr left little doubt about what the selection of an architect would
mean (as he saw it) for the museum itself. "The Museum, presumably,
stands for the best," he wrote, "not only in the art of our time but in
architecture, too. I cannot but feel that if we took a second best, or,
what is just as likely, a fifth best we would be betraying the standards of
the Museum in general and in particular the standards which it has up-
held in architecture." To Mrs. Rockefeller, Barr stated the matter in
even stronger terms: "To rest content with a mediocre building on
such a site would be to betray the very purposes for which the Museum
was founded as well as to make a laughing stock of the Museum's five
years' work in the cause of the best modern architecture."[1]

Barr, as we know, lost his battle. The ideal museum that he envi-
sioned in 1936—a museum that would embody in the very concept of
its design the exalted standards which MoMA, under his direction, up-
held in its architectural exhibition and publications program—was
never built. The commission went instead to two Americans—Philip
L. Goodwin and Edward Durrell Stone. Goodwin, though a MoMA
trustee and a collector of modern painting and sculpture, was about as
far from being a modernist as an architect could be in 1936. Russell
Lynes, in *Good Old Modern*, described him as "an architect with the ec-
lectic tastes of the Edwardian era and his roots . . . in the neo-
classicism of the Paris Ecole des Beaux Arts." Stone was a young, un-
distinguished convert to modernism who happened to be in the employ
of Wallace K. Harrison, the architect of Rockefeller Center. Barr had
warned Mrs. Rockefeller that awarding the commission to Goodwin
and Stone "will almost certainly result in a mediocre building," but
the trustees were adamant. Even the last-ditch effort made by Barr to
keep up the appearance of architectural virtue by allowing Mies to de-
sign the facade of the Goodwin-Stone building—a curious idea in itself,
but a prophetic one, as it turned out—came to nothing.

There are several things to be observed about this fateful episode,
and all of them have a bearing on the architectural character of the new
MoMA. One is that the trustees' decision to settle for a "safe" solution
in 1936 led to a fundamental split in MoMA's architectural policies—a
split that, from the thirties down to the present day, has separated the
ideas put forward in the museum's architectural exhibition and publi-

[1]See "1936: The Museum Selects an Architect. Excerpts from the Barr Papers of the
Museum of Modern Art," by Rona Roob: *Archives of American Art Journal,* Volume 23,
Number 1 (1983), pages 22–30.

cations program from those put into practice in the museum's own building program. It is a split, moreover, that is now likely to remain permanent. But another thing to be observed about this decision is that it did not result in the predicted disaster. It may even have been responsible for averting one. We cannot know, of course, exactly what sort of building Mies would have designed for MoMA in the thirties. What we do know is that the two most conspicuous museum facilities which Mies was given the opportunity to design in later years—the Brown Pavilion addition to the Museum of Fine Arts in Houston and the National Gallery in West Berlin—have proved, as spaces in which to exhibit works of art for public viewing, to be among the very worst on the international museum scene.[2]

Glass-box architecture—as the Miesian mode has come to be called—is nowadays unduly maligned, in my opinion, for at its best it is surely one of the great artistic achievements of the modern age; and as the basis of skyscraper design it remains, more often than not, vastly superior to the gimcrack postmodernist architecture which has lately supplanted it. But this is not to say that the aesthetic attributes of the Miesian mode easily lend themselves to every architectural function, and we now know that as museum design it is all but guaranteed to be utterly dysfunctional. So it was undoubtedly a lucky stroke for the museum that Alfred Barr lost his battle to have Mies design the original MoMA building in the thirties. I would go further and say that it was a lucky stroke for Barr himself—which is to say, for the kind of museum that he went on to create in the building he was finally given. Barr was the greatest museum director of his time, and much that we have reason to cherish in the new MoMA as well as in the old we owe to his vision and his judgment and to the courage and tenacity with which he

[2]William S. Rubin, the present director of MoMA's Department of Painting and Sculpture and Alfred Barr's successor in that department, recently offered his own view of this matter. In an interview in *ARTnews* (May 1984), Mr. Rubin spoke as follows on the question of Mies and museum design:

"A lot of museums got built by architects who are more interested in their own creation of an interesting architectural space than in a space right for paintings. The *ne plus ultra* of this is Mies van der Rohe's museum in Berlin, where the entire main floor is useless. They've had to turn it into a lobby and carve out a museum below grade, which is where you see the collection. But you come into this immense, meaningless space. There's nothing that could survive in that space. They've put in a few giant sculptures, but it's a totally useless space, as was the upper terrace in our old garden.

"Museum people have to watch out for architects. The better they are, the worse they are, in the sense that the more powerful their vision, the less they are likely to consider the needs of paintings."

pursued his goals. But it does no honor to his achievement to pretend that he was always equally wise in all matters of museum policy, and on the architectural question he was clearly wrong. I think I know why he was wrong, too, for the reason goes to the very heart of Alfred Barr's conception of what kind of museum he wanted MoMA to be in the earliest stages of its development.

This subject will be discussed in due course—for it is central to our understanding of what sort of museum MoMA has become in our time. For the moment, however, there is still a further and final observation to be made about that architectural decision in 1936 and its relation to the present. Barr lost out in his final plea to have Mies design the façade of the original MoMA building. With the new MoMA of 1984, alas, we have not been quite so lucky. For in the multi-storied, glass-enclosed Garden Hall which Cesar Pelli, the architect of the new MoMA, has now made its most conspicuous design feature, the museum has at long last achieved its (more or less) Miesian façade. And chances are that it is a far grander façade, though also one that is far more *élaboré* in its dramatic display of structural detail, than any that MoMA would have gotten in the thirties. But is this the right style for the museum even today? There is certainly reason to doubt it. The fact that the Garden Hall is in many respects a very beautiful space—and just the kind of modern, light-filled space that Barr had no doubt envisioned for the museum in its original building—does not alter its almost total uselessness for showing works of art to the public. Nor does the beauty of the Garden Hall alter the irony of its belatedness as architectural history: precisely the kind of belatedness, by the way, that would be likely to exclude it from any future MoMA survey of distinguished architectural design.

It must be said that the task which confronted Cesar Pelli in designing the new MoMA was decidedly more complicated and unwieldy than any in the recent history of museum building. The new MoMA was never intended to be an entirely new building, and of course it isn't. Certain elements of the old Goodwin-Stone building as well as the addition of the garden wing designed by Philip Johnson in 1964 had somehow to be preserved and harmoniously integrated into the new museum, however much they might be modified in the resulting structure. At the same time, the museum's elegant, open-air sculpture garden—probably the most beloved open space of its kind in New York City—had likewise to be preserved and protected from the potentially overpowering contrast of the new fifty-two-story Museum Tower, the

luxury apartment house that now rises above the west wing of the museum as a sort of admonitory symbol of MoMA's farewell to visionary urbanism. And dominating all these considerations were two others: the all-but-absolute authority given (and properly given) to the museum's chief curators to control—and thus, in effect, to design—their own exhibition galleries; and the need to provide ample, nonviewing space for the museum's huge new public. Such an assignment could not have been expected to yield a completely coherent architectural structure; still less was it likely to inspire a great architectural idea. It is no wonder, then, that the new MoMA is not exactly an architectural masterpiece. The real wonder is that, given the circumstances and conditions to be met, it is as fine as it is, and that what is now the museum's primary function—to exhibit as extensively and as intelligently as possible the masterworks from its own permanent collections—is so beautifully served. One somehow doubts that a building which really was an architectural masterpiece would have served the museum nearly as well.

III. The Louvre of Modernism

"The Louvre," wrote Cézanne, "is the book in which we learn to read." For a great many artists, as for a great many art critics, scholars, collectors, curators, and dealers, and for its ever-expanding public, too, MoMA has long been the principal "book" in which we have learned to "read" the history of modern art. It has in this sense come closer than any other institution in the world to serving as the Louvre of modernism, and it is in this spirit that the installation of the permanent collections has been carried out in the new MoMA.

By and large, and despite some important flaws and failures to be noted, the execution of this formidable task has proved to be a triumph. At least this is the case for the installation of the European masters of painting and sculpture on the second floor of the museum, and for the departments devoted to drawings and to prints and illustrated books on the third floor. Far more problematic are the galleries largely but not exclusively devoted to American painting and sculpture on the third floor and the new installation of the outdoor sculpture garden. As for the Department of Photography on the second floor and the Department of Architecture and Design on the fourth, these—like the Department of Film which now presides over two movie theaters in the

ᵢower levels of the building—tend more than ever to address us as virtually separate museums, independent entities with standards, agendas, and historical perspectives that differ in important respects from those of the Painting and Sculpture, the Drawings, and the Prints and Illustrated Books departments as well as from each other.

It is, in any case, of the permanent collection of painting and sculpture that I wish mainly to speak here. Mounted at the entrance to the second-floor galleries housing the European masters is a quotation from Alfred Barr—in whose memory, appropriately, these galleries are named—which alludes to "the conscientious, continuous, resolute distinction of quality from mediocrity," and it is clearly in this spirit of uncompromising connoisseurship that William S. Rubin, the curator responsible for this department, has carried out his task. We enter the first gallery in this series directly from the Garden Hall, of course, and the shift in scale, in feeling, in the density of light that surrounds us, and in the kind of demand that is made on our faculties is abrupt and startling. We have left the anonymous, overscale pretensions of late twentieth-century modernism for the most intimate, profoundly inward art of the late nineteenth century—Cézanne's. It is like crossing to another civilization.

Now it is a more distant civilization, too. When the museum was founded in 1929, Cézanne had been dead for less than a quarter of a century. Monet had been dead for only three years, Degas for twelve. In 1984 an entire century separates us from Cézanne's *The Bather* (1885–90), which hangs in the first gallery of the permanent collection—the same amount of time that separates the Cézanne from David's *Oath of the Horatii* (1784). Clearly we are in another period, not only chronologically but culturally. Yet in commencing its survey of modern painting with Cézanne, along with certain other Postimpressionist masters in the adjacent galleries, the new MoMA has remained faithful—and properly so, I think—to the historical outlook of the old. It was with an exhibition of Cézanne, Seurat, Gauguin, and van Gogh that the museum opened its doors fifty-five years ago. This is not, to be sure, the only way to chart the history of modern painting, but the alternatives are to locate its origins even earlier—in the work of Courbet or Manet or the Impressionists—and not any later. And there is a strong case to be made for beginning such a survey with Cézanne and the major Postimpressionists. It was directly from their work, after all, that the most radical art movements of our own century—Fauvism, Expressionism, Cubism, and the abstract art that derived

from them—drew their inspiration. It was never a practical proposition for MoMA to become a full-scale museum of nineteenth-century art, in any case. Even when it joined in the general rediscovery of Monet in the fifties and early sixties, it was the artist's late work—which belongs to the twentieth century in scale and spirit as well as chronologically—that was acquired for the permanent collection.

It is, then, as a prologue to the mainstream of twentieth-century modernism that these initial galleries devoted to Cézanne and his contemporaries have been planned. The art is magnificent, of course, and the galleries, with their discreet proportions, easy lighting, and unobtrusive décor—white walls and gray carpeting—are altogether agreeable. Except for one minor but irritating detail—the mistaken decision to put every picture into a uniform gold frame of innocuous design—we feel ourselves on solid ground. The ambiance is at once grave and pleasurable.

As we proceed on our course, moreover, we discover some important and delightful acquisitions which have lately been added to the collection—among them, Seurat's *The English Channel at Grandcamp* (1885), Signac's *Portrait of Félix Fénéon* (1890), Matisse's *La Japonaise (Mme Matisse)* (1905), and Bonnard's *Basket of Fruit Reflected in a Mirror* (1946). But there are some real disappointments, too. Years ago it was Alfred Barr's habit to hang Maurice Prendergast's wonderful *Arcadia* (1922) in the same gallery with Vuillard's *Mother and Sister* (circa 1893) and Bonnard's *The Breakfast Room* (circa 1930–31). It was unusual, even then, for MoMA to accord an American painting of that period such a distinctive place in the permanent collection, but it was fully justified by the superb quality of the picture. Alas, the Prendergast was removed from this sympathetic company in the sixties when Mr. Rubin reinstalled the permanent collection in the old MoMA. It was then placed in a sort of crowded ghetto reserved for some early American modernists. This time around, though others among the early American modernists are once again consigned to a small, crowded isolation ward on the third floor, *Acadia* has disappeared from view altogether—and by this observer, at least, it is keenly missed. But then, as we shall see, there is something definitely askew about the handling of all American art prior to 1940 in the new MoMA.

It isn't as if every recent addition to the European painting collection is an undoubted masterpiece, either. Neither the new Klimt—*Hope II* (1907-8)—nor the new Schiele painting—*Portrait of Gerta Schiele*

(1909)—can be claimed to represent either artist at his best. (Unlike the 1911 Schiele watercolor, *Girl with Black Hair*, which is first-rate, or the 1910 Klimt landscape, *The Park*, which has been in the collection for some years.) In this matter, I am afraid that Mr. Rubin has allowed the academic art historian, with his compulsion to fill in "gaps" left vacant by his predecessors, to overrule the connoisseur for whom the quality of the specific object is the primary consideration. No doubt it was unfortunate for the museum to have overlooked figure paintings by Klimt and Schiele when some real masterpieces were still readily available, but that time has apparently passed. What is disturbing about all this is that Prendergast's *Arcadia* is a far better painting than Klimt's *Hope II*, but so-called gaps in American art prior to 1940 are now of very little concern to the museum.

There are other problems as well. The most surprising is to be found in the new installation of Picasso's *Les Demoiselles d'Avignon* (1907), one of the most important pictures in the entire collection. There are few living souls who have studied Picasso's work more closely than Mr. Rubin and fewer still who know more about it. Yet something has gone wrong with the installation of *Les Demoiselles* in the new MoMA. It is crammed into a shallow space that is partially obstructed by an extremely infelicitous temporary wall supporting a slightly earlier picture—Picasso's gentler and more realistic *Boy Leading a Horse* (1905–6). The point, I gather—it is anything but subtle—is to drive home to us the enormous leap that *Les Demoiselles* represents not only in Picasso's development but in all of modern painting. Yet the actual effect of this heavy-handed juxtaposition is to diminish the painting's impact, something I would not have thought possible until now. The picture should strike us—as it struck the artist's contemporaries when they first saw it, and as it has struck subsequent generations ever since—like a thunderbolt, but here it is reduced to a lesson in art history. It doesn't help matters, either, that another key picture of the period—Picasso's *Two Nudes* (1906)—is virtually hidden away on the reverse side of the ugly wall supporting the *Boy Leading a Horse*. This is, perhaps, the most glaring example in the entire installation of the permanent collection of a tendency to allow the mentality of the seminar room to triumph over museological judgment—to allow art history, in other words, to triumph over aesthetics.

Notwithstanding such disappointments—and there are others to be noted—there is something at once magisterial and deeply pondered

about the installation of the European masters, and one is continually
made to marvel at the sheer quality and scope of the collection itself. As
was to be expected, much space and attention have been lavished on
the achievements of Picasso and Matisse, MoMA's reigning deities.
There is surely no other museum in the world where these artists are
represented on anything like the same scale or at anything approaching
the same depth. The vast Matisse gallery—the single largest space de-
voted to the work of a single artist and one of the few that enjoy the
benefit of some natural light—is the greatest thing of its kind that I
know of. It amply confirms Matisse's place as the preeminent painter
of the century and as one of its greatest sculptors too. This is one of the
galleries in the new MoMA where one feels most inclined to linger, and
it was therefore a happy idea for the museum to equip the gallery with
a comfortable place to sit. Matisse is the only artist in the collection
who is accorded this amenity.

The largest of the several Picasso installations—a huge gallery
mainly devoted to work of the thirties and forties—does not have quite
the same power, however. The main reason for this lies entirely beyond
the museum's control, of course. *Guernica* (1937) and its many prepara-
tory studies, long the centerpiece in MoMA's display of Picasso's work
of the thirties, were never part of the permanent collection. They had
been placed on long-term loan by Picasso himself at the beginning of
the Second World War, and they now repose (as the artist wished) at the
Prado in Madrid. In preparation for this loss, MoMA some years ago
acquired *The Charnel House* (1944–45), a later and smaller picture simi-
lar in theme and style. But this picture, though haunting in its imagery
of death and destruction, is more an epilogue to *Guernica* than a substi-
tute for it, and the largest paintings of the thirties—the rather benign,
oversized *Night Fishing at Antibes* (1939)—just doesn't bear comparison
with the artist's strongest work. (Ironically, it is given the kind of instal-
lation that *Les Demoiselles d'Avignon* is denied.) On the other hand, the
recent acquisition of one of the great plaster heads of the thirties—the
Head of a Woman (1932) that now dominates the gallery devoted to this
period—is a marvelous addition to an already superb collection of Pi-
casso sculpture.

There is one further criticism to be made of this Picasso gallery,
and that is the way the sculptor Julio González has been assigned to this
space and thus made to seem a mere appendage to Picasso's career.
González owed much to Picasso's example, to be sure, but once the for-

mer was launched on the course that led him to create his masterpieces of open-form, welded-metal sculpture in the thirties, he proved to be one of the most original sculptors of his time—and an immensely influential one too. He should be treated like one.

Two other sculptors—Brancusi and Giacometti—have fared very much better. Our first glimpse of the Brancusi installation gives us indeed one of the truly sublime moments in our visit to the new MoMA, and return visits in no way diminish its impact. The museum has long owned some of the best examples of Brancusi's work and another important sculpture has lately been added—*Endless Column* (1918). Most of these sculptures are mounted on a raised platform, painted white, that isolates them from the space that we, as spectators, occupy, and this has the effect of enclosing them in an ideal world of their own and thereby underscoring their "perfect," otherworldly quality. This is a brilliant solution to a difficult problem.

So is the very different installation accorded Giacometti's work. With Giacometti, it is not distance and separation that the work calls for, but just the opposite. Its nervous, febrile, anguished imagery beckons us to draw near as it encloses us in a vision of great poignancy. There are more than a dozen of the artist's works displayed in a very small space—just the kind of confined space in which Giacometti himself liked to work—and this turns out to be exactly right. Each of the objects is distinctly legible, yet together they create a spiritual ambiance that is somehow larger than the sum of its parts: Giacometti had come to believe that he represented the end of a certain tradition in art, and in this installation we are made to feel that we have experienced a kind of coda in the history of civilization. In this sense, too, it is remarkably faithful to the artist's vision.

Equally successful is the Mondrian gallery, an oasis of utopian order and purity compared to which almost every other installation and object in the museum—not to mention the world outside—looks woefully fussy and self-indulgent. This was certainly Mondrian's view of the matter, and the gallery devoted to his work is properly infused with that sense of the absolute that so completely governed his vision as an artist.

Distinctly less successful, if not indeed inept, is the treatment given to Expressionism. Has a decision been made to downgrade the entire Expressionist movement? It would seem so. Thus, no room has been found in the galleries devoted to the European masters for the greatest

German painter of the century, who is also the culminating figure
of the Expressionist movement—Max Beckmann. The magnificent
triptych in the museum's collection—*Departure* (1932–35)—has been
parked outside in the glaring light of the Garden Hall, but there is
nothing by Beckmann to be found in the galleries. It does seem absurd
for Chagall, for example, to be given so much space—wonderful as the
museum's early Chagalls are—when Beckmann is given none, for
there can be no question that Beckmann is the greater artist. (For that
matter, even inferior talents like Tchelitchew and Delvaux are given a
warmer welcome.) Still another picture that seems to have disappeared
is Lovis Corinth's *Self-Portrait* (1924), a far stronger painting than the
highly decorative Schiele portrait the museum has gone to so much
trouble to acquire.

It was a mistake, too, I think, in the one gallery devoted to Expres-
sionism, to arrange a sort of tableau in which Lehmbruck's two ex-
traordinary sculptures—*Kneeling Woman* (1911) and *Standing Youth*
(1913)—are made to form something like an honor guard for Kokosch-
ka's haunting *Hans Tietze and Erica-Tietze Conrat* (1909). Whereas the
sculptures are heroic idealizations, the portrait is a picture of the most
intense psychological analysis. Not only is there a disjunction in scale
and subject matter—the sculptures representing youth and the portrait
middle age—but these are works that inhabit totally different worlds of
feeling, and only a taste utterly indifferent to the nuances of the Ex-
pressionist mode would lead one to think otherwise. Perhaps it was
those elongated fingers, to be found in both the portrait and the sculp-
tures, that inspired this unhappy juxtaposition, but even these serve
very different artistic functions. Someday the entire subject of Expres-
sionism is going to have to be reconsidered at the museum. Elsewhere
in the art world it is a particularly hot subject just now, but word of this
development does not seem to have reached the museum's Department
of Painting and Sculpture.

Far more sympathetic and extensive are the installations devoted to
Futurism, Dada, and Surrealism. The museum's fine de Chirico col-
lection, which must surely be the best in the world, is given a gallery of
its own, and while one feels a certain regret that a similar space could
not be found for Miró, that great artist—in whose work MoMA has al-
ways taken a keen and perspicacious interest—is nonetheless well rep-
resented. So are (on another level of accomplishment) Dali and Ma-
gritte. As a result, the entire history of the European avant-garde from
the Postimpressionist period to that of the Surrealists is, except for the

scanting of Expressionism, represented at a level of quality that is truly unrivaled.

IV. Revising the American Century

It is interesting to note that in this admirable survey of the European avant-garde, which occupies the second-floor galleries devoted to painting and sculpture, only three American artists have been included: Alexander Calder, Man Ray, and Joseph Cornell. There can be no question, I think, that they belong in this company, for their work is closely connected with that of their European contemporaries and represents a further and sometimes original development of ideas that came out of the European (mainly Parisian) avant-garde.

Yet the exclusion of so many other American artists from this second-floor survey, which ends (more or less) on the eve of the Second World War, alerts us to what is undoubtedly the most important art-historical revision to be seen in the new MoMA. This consists of a radical downgrading of the first four decades of American art in the twentieth century. There are some peculiar omissions even from the period after 1940, but it is in its handling, or rather its mishandling, of the early American modernists that MoMA has carried out its most categorical act of historical revisionism.

This is a matter that MoMA has never been entirely comfortable with. From the day it was founded in 1929, the museum has traced a very erratic course in its relations with modernist American art. In the thirties, while it devoted much energy to exhibiting and acquiring examples of the European avant-garde (and properly so, in my opinion), the museum tended paradoxically to give priority to regionalist, neo-romantic, and realist painting whenever it turned its attention to the contemporary American scene. With rare exceptions, the American avant-garde was ignored and disparaged. Even in the forties, when MoMA began for the first time to take cognizance of what was stirring in American art, its grasp of what was happening was uncertain and confused. Certain things were acquired for the collection and certain artists were shown, but there was no coherent policy. For MoMA, modern art was still, for the most part, something that happened in Europe.

Despite this uncertainty, the museum in Alfred Barr's day made a very deliberate effort to include American artists of the early modern

period in its collections and in its exhibition program. Barr's perspective on all of modern art was a highly ecumenical one; in his commitment to a particular "school" or style he was anything but sectarian. It is this broad-based, non-sectarian outlook that has now been modified into something rather more pointed and rigid.

It wasn't until 1951 that the museum organized an exhibition of "Abstract Painting and Sculpture in America," and thereafter, with such exhibitions as "Fifteen Americans" (1952) and "Twelve Americans" (1956), both organized by Dorothy Miller, and with shows devoted to Jackson Pollock (1956) and David Smith (1957), MoMA began shifting its course to give greater attention to "advanced" American art. The culminating event of this phase of its history came in 1959 with the exhibition of "The New American Painting"—the museum's first major survey of the Abstract Expressionists and the show that more or less established the New York School as a major turning point in the history of twentieth-century art.

Yet even in the fifties, while this shift was occurring, there were other impulses at work. I vividly recall an evening at the Artists' Club in New York in 1954 when Alfred Barr predicted that in the next phase of American painting there would be a return to what he called "history painting." What he had in mind, obviously, was Larry Rivers's *Washington Crossing the Delaware* (1953), which the museum was just about to acquire for its collection. The implicit judgment was that American abstract art was probably finished. This judgment, though mistaken, was made more explicit when the museum organized a disastrous exhibition of figurative art, called "New Images of Man," in the very same year that it mounted "The New American Painting" show. The truth seems to be that Barr took a somewhat ambivalent attitude toward the New York School.

All of this changed in the sixties. Except for Dorothy Miller, whose record as a curator was outstanding in this regard, the late William Seitz was probably the first curator at the museum who wholeheartedly embraced the New York School. And when Mr. Rubin came to the museum in 1967, he made it a priority item of business from the outset to strengthen MoMA's collection of Abstract Expressionism and indeed to make it a major focus of the permanent collection.

That he has amply succeeded in fulfilling this ambition will be clear to anyone who visits the new MoMA. For the third-floor gallery space belonging to the Department of Painting and Sculpture is preponderantly devoted to the New York School. In keeping with the scale of Ab-

stract Expressionist painting—there is actually very little sculpture in this section of the installation—the main space is fairly gigantic, the only approximate counterpart to the huge Matisse gallery on the second floor. There is much to admire—and a good deal to question, too—in the way Mr. Rubin has gone about building this New York School collection, and his installation of the collection itself is enormously impressive. My guess is that it will prove to be a mecca for young artists for many years to come.

The implications of all this are fairly obvious. According to the new MoMA, the history of modern art until 1940, or thereabouts, belongs to Paris and its satellites, and after 1940 it is to be found in the New York School and its aftermath. Everything else is to be regarded as marginal or negligible or nonexistent. Mr. Rubin is not a man afflicted with a sense of ambivalence when it comes to making artistic judgments. He thinks in categorical terms. As a result, the history of modern art in America prior to 1940 has largely been obliterated. The work of a few expatriate artists remains and a few other isolated examples survive, but for the most part it is a history that the museum has simply dropped. The mean little gallery at the entrance to the third-floor installation that contains whatever remnants of this history have been allowed to survive is, as a survey of the first forty years of American modernism, simply ludicrous. And it is installed in a way that seems almost intended to inspire contempt, with pictures crowded together and a gem like Nadelman's sculpture *Woman at the Piano* (circa 1917) crammed into an absurd little niche, as if it were an appliance on display in a shop. (Actually, some of the objects on display in MoMA's retail shop are accorded much better treatment.)

To specify in detail what has been omitted in this museological maneuver would require a volume in itself. I shall therefore cite only a few outstanding cases. Hartley is represented by a single painting—naturally, it is from his expatriate period—and Maurer by none. There is no painting by Marin—does the museum own one?—and nothing by Milton Avery! Dove and Stuart Davis are reduced to token representation, and the painters of the American Abstract Artists group are denied even that. But room has been found for a Ben Shahn—it would be interesting to know what Mr. Rubin really thinks of it—and for two minor Hoppers, and the prize acquisition is a painting called *Dunes* (circa 1930) by Augustus Vincent Tack, who is now being "rediscovered" and pressed into service as some kind of forerunner of the Abstract Expressionists. One has the impression that the only painting in

this gallery which truly interests Mr. Rubin is the Tack he acquired for the museum five years ago.

It would be a mistake to suggest that the task of selecting an adequate and appropriate representation of early twentieth-century art for MoMA is an easy one. The last thing we would want to see at the museum would be the kind of catch-all survey of minor and innocuous talents of the sort that we see in so many of the galleries of the Pompidou Center, where it seems to be regarded almost as a civil right for a French artist, no matter how abysmal his work, to be represented by something. But between that unhappy practice and the museum's current policy there are many choices to be explored, and no one at MoMA seems to have given them any serious thought. What is now missing at MoMA as far as American art before Abstract Expressionism is concerned is precisely that—serious thought.

Even in the period after 1940 the policy seems to be to exclude any and all figurative painting unless it is European. It is this, I suppose, which accounts for the exclusion of Avery. One would have thought that, even in the formalist perspective that Mr. Rubin characteristically brings to these matters, Avery would have been thought to provide the essential link between Matisse and Rothko. But the prejudice against such art is apparently very deep, and so the link has been ignored.

For all practical purposes, then, what MoMA give us in this third-floor installation is the history of American art *as* the history of the New York School and its aftermath—and from this aftermath, in the so-called contemporary section, almost all forms of representational art are likewise excluded. Who could guess from this "contemporary" section that the last twenty years have witnessed a remarkable resurgence of realist painting? Except for a single work by Chuck Close, the policy seems to be that you have to be European to be representational. It is a policy woefully out of touch with the artistic realities of the present moment and reflects a concept of modernism that has hardened into academic orthodoxy.

Where Mr. Rubin is most at ease—confident of his taste and meticulous in his selection—is in his handling of the New York School, and the museum-going public owes him a considerable debt for persevering in the building of the Abstract Expressionist collection. For anyone who wants to see the New York School as a whole, with major works by Pollock, Motherwell, Reinhardt, Still, Rothko, Gottlieb, Pousette-

Dart, Tomlin, Kline, de Kooning, et al., MoMA is now the place to go. I think it was a mistake to include Morris Louis in this company, and Newman has been given a place in the collection that far exceeds his actual accomplishment, but these are matters likely to be corrected with the passage of time. I doubt, too, if every one of the minor Pollocks is worth hanging, and I regret the omission of anything by Pousette-Dart after 1951. (Still, it is marvelous to see the 1940 Pousette-Dart, *Desert*, rescued from storage.) It would have made sense to have had something of Helen Frankenthaler's from the fifties, but she is well represented by later work.

If there is a major criticism to be made of the New York School installation, it is in regard to sculpture. Quite properly, David Smith is given priority here. Mr. Rubin's gift of the sculptor's great *Australia* (1951) some years ago gave the museum its single finest sculpture of the Abstract Expressionist school, and it looks wonderful in its new setting. All the same, and despite the inclusion of several other Smith sculptures—one of them in the garden—this artist remains seriously underrepresented in the museum collection. Smith was the greatest American sculptor of the twentieth century. From the early thirties until his death in 1965, he produced an extraordinary and copious oeuvre, and he should be accorded a gallery of his own so that we can follow the course of his development the way we can now follow Picasso's (as a sculptor) and Giacometti's.

This, in turn, reminds us that with the exceptions already noted— and they are important ones—MoMA does not really seem to have a very extensive sculpture collection. Noguchi is another artist given the merest token representation, and Nevelson is still another. (The classic Nevelson wall owned by the museum has been left in storage.) The problem seems especially acute where American sculpture is concerned, and the decisions that have been made about what to exhibit and what not to exhibit are often baffling. Allowing an overblown work like Newman's *Broken Obelisk* (1963–67) to dominate the museum's sculpture garden is particularly regrettable. Hasn't anyone noticed how totally it confounds the scale of everything else in that space? But there are still many problems to be worked out in the installation of the sculpture garden as a whole. It contains many fine works—I was delighted to see that a Bryan Hunt bronze has recently been added to them—but little thought seems to have been devoted to their proper disposition. This is too beautiful a space to be left in its current state of disarray.

V. The Return of the Salon

Of the many questions that have been raised about the museum's role and the future scope of its responsibilities, none is now more vexing than the problem of its relation to the contemporary art scene. On this question opinion seems to be divided—outside the museum, anyway, if not inside. (Officially nobody at MoMA even acknowledges that a problem exists.) One view is that MoMA should get itself out of the business of putting on contemporary shows altogether. According to this view, the museum is now an institution very largely devoted to the art of a certain historical period, and it would be unwise as well as impractical for it to persist in the attempt to impose its authority in a sphere of artistic endeavor that lies outside its range. Another view, however, insists that direct and continuous involvement in judging, acquiring, and exhibiting new art remains one of the most essential tasks of the museum, if not indeed *the* most essential. According to this view, it would represent a kind of spiritual death for the museum to withdraw from the contemporary scene and become, as it were, a repository of modernist antiquities.

What complicates all attempts to come to terms with this question is the fact—for a fact it surely is—that MoMA, whether or not it persists in its effort to keep up with the contemporary scene, is henceforth going to devote its major energies and resources to exhibiting and documenting modernism's past achievements. This, after all, was the main component of the museum's mission from the beginning, and it remains a still larger part of its mission today. Even if its directors wished to do otherwise, they could not. The modernist classics are now big box office while new and unknown artists are, by MoMA's standards, hardly any box office at all, and the museum needs the revenues that famous names and big historical subjects guarantee. It is in this sense, as well as others, that the museum is now hostage to the new public it has created for itself. Whatever else it may attempt to do, MoMA now seems locked forever into concentrating primarily on the classics.

This being the case, the real question then becomes: how much time, space, and money will be available at the museum for dealing with the contemporary art scene, and what sort of staff will the museum muster for the task? The contemporary art world is now enormous and steadily expanding, both here and abroad. It constitutes, among much else, an awesome logistical problem for any museum at-

tempting to keep abreast of its activities. It represents an even more daunting challenge to critical discrimination—and all the more so, I think, because the established conventions and familiar ideologies of modernist art are no longer a reliable guide to quality. Some of the most important art on the contemporary scene may even be said to be antimodernist in its fundamental assumptions, or to occupy a zone of feeling and conception that is indifferent to the modernist ethos. For MoMA to adopt a policy of categorical resistance to such art and impose rigid tests of modernist orthodoxy would inevitably guarantee a certain sterility and ossification. A tendency in that direction can already be observed in the installation of the "contemporary" section of the third-floor galleries devoted to the permanent collection. Although the installation of this section will be changed, I understand, every three months in order to give the public a broader sense of what the museum has culled from the art of the last two decades, there are unlikely to be any real changes in the spirit of the enterprise. The "line" adopted by the museum is all too clear in the initial selection. It is a line that favors, for example, a third-rate modernist pasticheur like Alexander Liberman over a less easily classified but nonetheless first-rate painter like Fairfield Porter. It is a line that is bound sooner or later to lead to the academicization of modernism, if it hasn't already.

Yet in dealings with the contemporary art scene it is no solution to this problem for the museum to adopt an "anything goes" policy. But that is more or less the policy that the new MoMA has settled for in mounting "An International Survey of Recent Painting and Sculpture," the huge exhibition of contemporary art with which the museum has opened its new facilities. Organized by Kynaston McShine, the senior curator in the museum's Department of Painting and Sculpture, this exhibition brings us one hundred and ninety-five works, all executed since 1975, by one hundred and sixty-five artists from seventeen countries. It occupies two immense gallery spaces on the first floor and in the upper basement of the museum. As the catalogue of the exhibition has not yet been published—a sure sign that even after four years' work the selection (if that is the word) involved a great many last-minute decisions—we cannot know for certain what, if anything, Mr. McShine had in mind in assembling this motley survey. All we can be certain of is that the show itself is the most incredible mess the museum has ever given us, and it is different in kind from anything the museum has done in the past.

For it is an exhibition that seems to be based on no discernible stan-

dard. Even the claim that the show is limited to artists who have made their reputation since 1975 is a specious one, for there are more than a few artists in the exhibition—among them, Frank Auerbach, Rafael Ferrer, Howard Hodgkin, Neil Jenney, Malcolm Morley, Gerhard Richter, William T. Wiley, and Christopher Wilmarth, to name only the most obvious cases—whose work was well known, at least to the world beyond 11 West Fifty-third Street, well before that date. If the exhibition bears a resemblance to anything, it is to the old Salon surveys of the nineteenth century in which discrimination was suspended in favor of a sprawling miscellany. It is precisely this Salon quality that makes the "International Survey" an exhibition different in kind from anything that MoMA has ever done, for it is a throwback to the time when museums devoted to contemporary art did not exist. Some fine work found its way into the Salon, but it was there, more often than not, despite its quality, not because of it, and this is the case with the present exhibition, too. As between work of notable quality and vitality and work of no quality at all, Mr. McShine seems to have adopted an attitude of complete impartiality. Of anything resembling connoisseurship or critical acumen there is not a trace.

What *is* discernible in the exhibition, both in the choices and in the installation, is not a standard but something else—a certain taste and attitude. The taste is easily identified, for it is fatally circumscribed by the facile irony and mocking facetiousness of Camp. This does not mean that every object in the show bears the imprint of a Campy sensibility—though there are plenty of objects here that obviously do, such as those by Longo, Fischer, Smyth, and the remarkably adaptive team of Komar and Melamid. But it does mean that even works of art that are conceived at a great distance from this mode of sensibility are presented to us in a way that compromises their gravity and reduces them to playing the role of a "straight man" in a comic skit. It is appalling, in this respect, to see artists like Anselm Kiefer, Howard Hodgkin, and Christopher Wilmarth—who must be counted among the most accomplished talents on the current scene—exhibited in such an atmosphere. The public that comes to the artists for the first time in this exhibition is actually being cheated of something important.

As expected, there is a significant representation of Neo-Expressionist painting in the "International Survey," and there are some good or at least representative examples of it, too—among them, paintings by Baselitz, Chia, Fischl, Immendorf, Kiefer, Penck, and an Australian named Peter Booth, whose work was new to me. Yet there is

no way for the visitor to the exhibition to make any sense of this movement, for it is not treated as a coherent artistic development, with an aesthetic and an ethos of its own. Its strengths are in fact mocked by the egregious triviality of so many of the surrounding objects, and the effect is to make Neo-Expressionism look like just another "outrageous" style we are not expected to take seriously. Here again, the public coming to this art for the first time is being cheated, and an opportunity has been lost to present to that public a truly serious account of one of the most important developments in contemporary art. I suppose there is even a certain symmetry to be found in the way Expressionism has been scanted in the installation of the permanent collection and the way Neo-Expressionism has been blurred in the "International Survey," but if so, it is probably accidental—though a sign, perhaps, of the uncertainty that surrounds the whole subject of Expressionism at the museum.

I doubt very much if we shall ever again see an exhibition like the "International Survey" at MoMA. It seems to have been conceived as a cynical attempt to "catch up" in a single stroke on what has been happening in contemporary art while the museum has been so preoccupied with its own internal affairs, and to regain its lost position as an arbiter of contemporary taste in art. If so, the show is a decided failure in this respect as well as in others. Even the critics who, in the spirit of celebration that surrounded the reopening of the museum, have found ways to praise the exhibition do not really seem to believe in it. The truth is, the show is a huge embarrassment—to the museum, and to the art world at large—and its failure is still another reminder that MoMA and its staff have not yet found a way to come to terms with an art scene which can no longer be fitted into the formalist perspective governing its view of the modernist past.

VI. MoMA in the Postmodern Era

It has already been observed that the museum, since its founding more than half a century ago, has undertaken to define its interests—and thus those of modern art—in broad terms. At that time it was a very radical motion for the museum to give to architecture, industrial design, photography, and film a kind of parity with painting, sculpture, and the graphic arts, and it was from radical precedents—in Germany and Russia—that Alfred Barr derived his ideas about what a museum

devoted to modern art should encompass. He had been to Germany and Russia in the twenties and had been deeply impressed with the art—and with the ideas governing the art—which he studied there. These ideas were radical in more than an aesthetic sense—though they were certainly that. They were radical, or at least were thought to be at the time, in their social implications as well. At the Bauhaus in Germany and in the councils of the Russian avant-garde in the early years of the Revolution, the very conception of what art was or should be was altered under the influence of a powerful utopian ideology. As a result, the boundary separating fine art from industrial art was, if not completely abandoned by everyone concerned, at least very much questioned and undermined. Henceforth, from this radical perspective, there were to be no aesthetic hierarchies. A poster might be equal to a painting, a factory or a housing project as much to be esteemed as a great work of sculpture.

It is my impression that at no time in his life was Barr very much interested in politics. It was not, in any case, the political implications of this development that drew him to it. What deeply interested him were its aesthetic implications; and therefore, under his influence, what governed the museum's outlook from its earliest days was a vision that attempted to effect a kind of grand synthesis of modernist aestheticism and the technology of industrialism. It therefore became part of the museum's aesthetic mission to proselytize on behalf of modern architecture and modern design and also, paradoxically, to elevate photography and film to the realm of fine art. This was something genuinely new in the American art world and in the world of the American art museum.

As everyone can now see just by looking around at the visual and cultural environment we in the West inhabit today, MoMA's mission in these matters proved in the end to be a great success. The aesthetic that originated at the Bauhaus and other avant-garde groups has been stripped of its social ideology and turned into the reigning taste of the cultural marketplace. Modalities of design that were regarded as difficult or esoteric or impossibly "advanced" in the thirties are now the commonplaces of our civilization. So popular have modern architecture and its accessories become in the last forty years that there is now a widespread (postmodern) reaction against it. In the academy as well as in the media there is a virtual industry dedicated to extolling the aesthetic attributes of film—while film itself, oddly enough, has either declined in quality or become highly esoteric or both. The elevated artis-

tic status of photography in recent years is too well known even to discuss. It would be absurd to claim that MoMA accomplished these important shifts in our cultural life entirely on its own, but the museum certainly played a key role in the history that set them in motion. In important ways, it created the role.

The question that inevitably looms in regard to this phenomenon fifty-five years later, when we find ourselves in a very different era, is this: does the museum—does any museum—any longer have an imperative function to perform that is not simply archival? Or is the museum's main mission in regard to such activities now limited precisely to preserving and codifying past achievement? Is MoMA, in other words, to become simply an archive of the movement it has done so much to popularize and win acceptance for?

Certainly in regard to the Department of Architecture and Design there is every sign that its principal tasks have been completed, and that it now has its attention firmly focused on the past. To the extent that the museum has played an active part in formulating ideas and shaping taste in the field of architecture in recent years, its role has been highly ambivalent. The two most important architectural events that MoMA has been responsible for in the last twenty years have actually been profoundly antimodernist in substance and influence. The first was the publication, in 1966, of Robert Venturi's brilliant manifesto, *Complexity and Contradiction in Architecture*, which in many ways set the agenda for the postmodernist movement. The second was the dazzling exhibition devoted to Beaux Arts architectural drawings in 1975. Together these events wrote *finis* to the whole modernist era in architecture and certainly to MoMA's own contribution to the history of that era. Yet one has the impression that the architecture which has resulted from this turnabout in taste and theory and practice is abhorrent to the museum. Otherwise why would it have withheld the commission to design the new MoMA from Philip Johnson, who founded the Department of Architecture in 1932 and who, after a first architectural career as a practitioner of modernism (it was Johnson who designed the garden-wing addition in 1964), has gone on to become the most famous postmodernist architect on the contemporary scene? Instead of commissioning Johnson to design the new MoMA, the museum named its new architectural gallery, which consists of models and drawings by the classic figures of modernism, in his honor. The irony is a perfect index of the contradiction in which MoMA now finds itself in its relation to architecture.

As for design at the new MoMA, it has been given the single most sensational installation in the entire museum, with a twenty-four-foot-high space containing the great classics of modern poster design, a showcase of handsome industrial design products, a sleek Italian automobile from the forties, and—in the most audacious *coup de théâtre* anyone has ever attempted at MoMA—a helicopter suspended over the escalator from the ceiling! In the inside galleries there are wonderful objects from the Art Nouveau era and then—well, we suddenly find ourselves in something that looks vaguely reminiscent of Bloomingdale's furniture department. It is very hard to believe at that point that such an installation has any real museological function. As history the installation is woefully incomplete, as aesthetics it is something of a comedy, as a standard of good design it is arbitrary. As a cultural experience it is simply supererogatory. Except for the dreadful furniture display, design at MoMA is still a good show, with wonderful things to look at, but it becomes more and more difficult to believe such an installation is necessary.

MoMA as historical archive and MoMA as a living artistic force: to what extent can these roles, which in the course of recent decades have become distinctly separate from each other, be successfully combined? I have already observed that as far as painting and sculpture are concerned, the museum has no choice but to put its principal energies and resources into showing great names and important historical subjects. The same emphasis will very likely prevail in the Department of Architecture and Design, and it has always been the primary interest of the Department of Film and its loyal public. Almost the only department of the museum which currently plays a leadership role in judging and codifying new work is the Department of Photography—the Department of Prints and Illustrated Books is the other—but the taste of the Department of Photography is so specialized and often so wayward and self-reflexive that there are times when one wishes that it, too, would go back to showing mainly the classics. But that, alas, is a tale for another day.

The new MoMA remains, all the same, a great museum, and one that is still central to our understanding of the culture of this century. Yet with its expanded facilities and its glamorous new image, with its huge new public (and the incessant radio commercials designed to draw the public in) and its incomparable permanent collections, it is now a museum curiously devoid of intellectual leadership. Alfred Barr had set out to create a new kind of art museum in America—a mu-

seum that would bring together all the many disparate activities of the modern movement. It was in many ways a noble as well as a novel aspiration, yet in the museum he actually created he was obliged in the course of time to abandon some of the more doctrinaire and utopian aspects of his original program. As a result, even the old MoMA became a museum more preponderantly devoted to high art than Barr had intended it to be at its founding. Today, it is only as an institution specializing in high art that the new MoMA can claim to have a great and necessary purpose. It is for this reason, above all, that it is in such obvious need of the kind of leadership that can do for the postmodern era what Barr and his distinguished colleagues did so successfully in the heyday of modernism. One hesitates to say it, but the truth requires that it be said: Alfred Barr has had no successor.

SUMMER 1984

Index